Gustav Klimt

MODERNISM IN THE MAKING

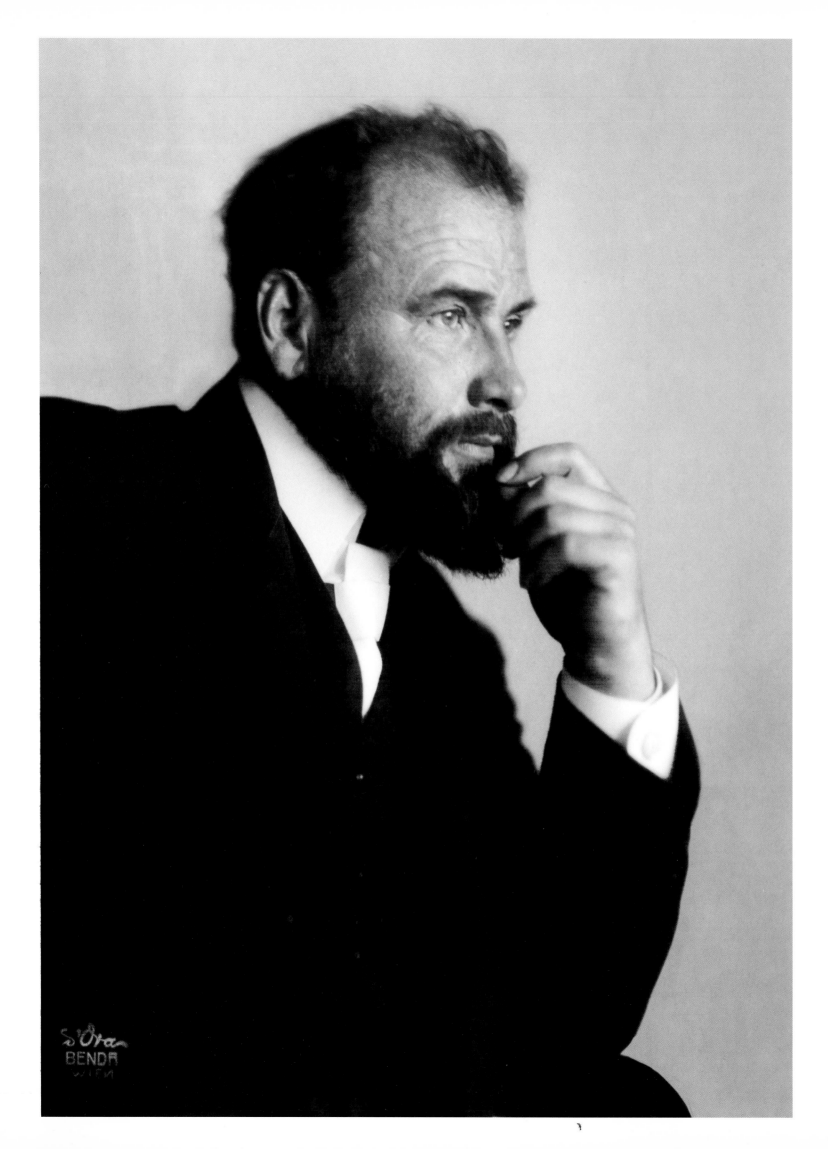

Gustav Klimt

MODERNISM IN THE MAKING

COLIN B. BAILEY

General Editor

Curator of the Exhibition

Essays by

COLIN B. BAILEY, PETER VERGO, EMILY BRAUN

JANE KALLIR, MARIAN BISANZ-PRAKKEN

Catalogue by

JOHN COLLINS

HARRY N. ABRAMS, INC.

New York

in association with

NATIONAL GALLERY OF CANADA

Ottawa

Published in conjunction with the exhibition
Gustav Klimt: Modernism in the Making,
organized by the National Gallery of Canada

National Gallery of Canada, Ottawa
15 June–16 September 2001

Published in 2001
by Harry N. Abrams Incorporated, New York,
in association with the National Gallery of Canada

NATIONAL GALLERY OF CANADA
Chief, Publications Division: Serge Thériault
Editors: Lynda Muir and Jacques Pichette
Picture Editor: Colleen Evans

Translation from German: Translation Bureau
of the Government of Canada

HARRY N. ABRAMS, INC.
Senior Editor: Barbara Burn
Editorial Assistant: Julie Di Filippo
Designers: Judith Michael,
Tina Thompson, and Brankica Kovrlija

Frontispiece:
Gustav Klimt. Photo by Studio d'Ora, Vienna, 1908/09
Bildarchiv, Österreichische Nationalbibliothek, Vienna

LIBRARY OF CONGRESS
CATALOGING-IN-PUBLICATION DATA

Klimt, Gustav, 1862-1918.
Gustav Klimt, modernism in the making / Colin B. Bailey, general
editor; essays by
Peter Vergo ... [et al.]; catalogue by John Collins.
p.cm.
Published simultaneously in French under the title: Gustav Klimt,
vers un renouvellement de la modernité.
Catalog of an exhibition held June 15—Sept. 16, 2001, at the
National Gallery of Canada.
Includes bibliographical references and index.
ISBN 0-8109-3524-4 – ISBN 0-88884-718-1 (pbk.)
1. Klimt, Gustav, 1862-1918 – Exhibitions. 2. Art
nouveau–Austria–Vienna–Exhibitions. I. Title: Gustav Klimt. II.
Title: French title:
Gustav Klimt, vers un renouvellement de la modernité. III. Bailey,
Colin B. IV. Vergo,
Peter. V. Collins, John. VI. National Gallery of Canada. VII. Title.

N6811.5.K55 A4 2001
759.36–dc21

2001022273

NATIONAL LIBRARY OF CANADA
CATALOGUING-IN-PUBLICATION DATA
Gustav Klimt: modernism in the making.

Exhibition catalogue.
Issued also in French under title: Gustav Klimt,
vers un renouvellement de la modernité.
Includes bibliographical references and index.
ISBN 0-88884-718-1

1. Klimt, Gustav, 1862–1918—Exhibitions.
2. Modernism (Art)—Austria—Vienna—Exhibitions.
3. Art, Modern—20th century—Austria—Vienna—
Exhibitions. I. Bailey, Colin B. II. Vergo, Peter.
III. Collins, John Bruce, 1957– IV. National Gallery
of Canada. V. Title.

N6811.5 K65 A4 2001 759.36
C2001-986002-1

HARRY N. ABRAMS, INC.
100 FIFTH AVENUE
NEW YORK, N.Y. 10011
www.abramsbooks.com

Printed and bound in Italy

10 9 8 7 6 5 4 3 2 1

Contents

Lenders to the Exhibition

When modernism began sweeping Europe before the turn of the twentieth century, Gustav Klimt helped found the breakaway Secession movement in Vienna. The Secessionists introduced the Viennese to the avante-garde French Impressionists, as well as to van Gogh, Gauguin, and the robust work of Auguste Rodin.

Klimt, one of the most remarkable artists to have emerged from Vienna, developed his own highly recognizable style of painting, a style influenced by Symbolism and Art Nouveau. Whether in portraits or landscapes, Klimt's signature approach to painting—filling the surface with elaborate and exquisite decoration, sometimes overlaid with gold—is always evident. His decorative commissions for the Imperial theatres and museums on the Ringstrasse continue to amaze viewers with their sensuous beauty.

AIM Funds Management is pleased to assist the National Gallery of Canada with the presentation of this magnificent exhibition, the first ever comprehensive Gustav Klimt retrospective on this continent. The National Gallery of Canada now joins the roster of other major museums in New York, Paris, Zurich, Milan, and Vienna which in the past fifteen years have undertaken a serious re-examination of Viennese modernism and Klimt's central role as its proponent in the visual arts.

AIM continues to support the arts in Canada in the belief that culture enriches our lives and opens our minds to new ideas. As a global company, with offices in twenty countries, we know how important it is to be open to new ways of thinking. Klimt, among the most original of modern artists, still provokes controversy amongst academics but continues to grow in public favour. Now Canadian audiences can be the judges and form their own opinions.

ROBERT C. HAIN
President and CEO
AIM Funds Management Inc.

The exhibition Gustav Klimt: Modernism in the Making *has been supported by the Department of Canadian Heritage through the Canada Travelling Exhibitions Indemnification Program.*

It is with great pride and pleasure that the National Gallery of Canada presents *Gustav Klimt: Modernism in the Making*, the first exhibition of its kind to be mounted in North America. Exclusively devoted to paintings and drawings by this renowned Austrian artist, the exhibition was inspired by the National Gallery's own *Hope I*, 1903, arguably the most important work by Klimt on this side of the Atlantic.

"The mysterious countenance of Pan beneath the beard and hair of St. Peter," was how Klimt's younger colleague, Albert Paris Gütersloh, described him. The artist, however, painted no self-portrait and wrote little about his art, save to recommend "the careful study of his pictures" to those who wished to understand him as a painter. The present exhibition provides ample opportunity to become acquainted with the artist on his own terms. Dr. Colin B. Bailey, Chief Curator of The Frick Collection, New York, and former Deputy Director and Chief Curator at the National Gallery of Canada, has done a magnificent job of assembling an outstanding array of paintings and drawings from collections around the world—an all the more impressive feat given the manifold difficulties of organizing an exhibition of Klimt's work. Our gratitude to colleagues in museums and to private collectors who have generously agreed to participate in this undertaking is beyond measure.

The absence of certain well-known masterpieces must be immediately acknowledged. Klimt's best-loved works, such as *The Kiss* and the *Portrait of Adele Bloch-Bauer*, are among his most fragile because they contain gold leaf; their size and state of conservation must preclude their travelling overseas. Furthermore, Klimt's relatively modest production of canvases was reduced tragically in 1945 when a large collection of his work was destroyed by fire, including his most ambitious achievements, the University paintings *Philosophy*, *Medicine*, and *Jurisprudence*. Thus, the thirty-six paintings assembled here make up a significant portion of the artist's oeuvre, and we are fortunate to be able to evoke the scope of his talents through the ninety drawings selected. Outstanding as individual sheets, Klimt's graphic work also becomes the only means of representing his large-scale decorative commissions, for example, the University paintings, the *Beethoven Frieze*, or the mosaic decorations for the Palais Stoclet. The drawings illustrate the remarkable range of Klimt's hand, from the arresting subtlety of his early studies for the Burgtheater ceiling paintings, to the fluent, coloured line of his later sheets, aptly described by Hermann Bahr in 1922 as "shorthand notes that inquire into the secret behind all appearances."

We are especially thankful to our corporate sponsor, and I take this opportunity to extend our gratitude to AIM Funds Management Inc. for their generous support.

We are particularly pleased to be presenting in this catalogue, co-published with Abrams, a series of authoritative essays. Peter Vergo's introduction masterfully illuminates the content and meaning of Klimt's work, providing a highly readable examination of the artist's philosophical milieu. Jane Kallir explores the crucial issue of Klimt's relationship to Art Nouveau and the decorative reform ideology that swept Europe around 1900. Emily Braun has brought much new material to light in her study of Klimt's critical reception, focusing on the Paris Universal Exposition of 1900 and two important Italian shows, the 1910 Venice Biennale and the 1911 *Esposizione internazionale* in Rome. John Collins, Assistant Curator, has written lucid and probing studies of each of the paintings exhibited; in the course of his research he discovered new archival and photographic material, which is published here for the first time. In her introduction to the substantial drawings section, Dr. Marian Bisanz-Prakken offers a sensitive critical survey of the expressive transformation of Klimt's work on paper over a period of forty years.

Let me also express my appreciation for the exemplary enthusiasm and dedication of the staff of the National Gallery who—in their various capacities—have contributed to the organization of this exhibition.

Beloved by his patrons, revered by his fellow artists, reviled by the conservative art establishment, Klimt enjoyed both financial success during his lifetime and critical respect as a misunderstood genius. According to Hans Tietze, "To outsiders Klimt presented a simple and ordinary appearance, to those who knew him, an existence full of mystery." "Mystery" seems to be the word favoured by critics and friends alike to convey the artist's enigmatic personality, and while it is not the intention of this exhibition to unravel Gustav Klimt's mysteries completely, it is our hope that the visitor will leave moved and inspired by the compelling and intriguing nature of his work.

PIERRE THÉBERGE, O. C., C. Q.
Director
National Gallery of Canada

Acknowledgements

As a specialist of French art who since his teens has harboured a love of Klimt's work (to which it was not always fashionable to admit), I thank Pierre Théberge, Director of the National Gallery of Canada, for presenting me with the challenge of organizing a monographic exhibition devoted to the artist; his trust and support were unfailing. Without the understanding and generosity of our Viennese colleagues, such a project would have been still-born, and here I must acknowledge Dr. Günter Düriegl, Director, Historisches Museum der Stadt Wien; Dr. Gerbert Frodl, Director, Österreichische Galerie Belvedere; Dr. Klaus Albrecht Schröder, Director, Graphische Sammlung Albertina; Dr. Rudolf Leopold, Leopold Museum; and Dr. Helga Dostal, Director, Österreichisches Theatermuseum. The cumulative significance of loans from Vienna encouraged other collectors—both institutional and private—to part with the rare works by Klimt that are to be found outside Austria; to our lenders from Europe, Japan, Australia, and North America we are no less grateful. Although they are thanked by name in the Director's Foreword, I must acknowledge the exceptional contribution of our four essayists, Professor Peter Vergo, Ms. Jane Kallir, Professor Emily Braun, and Dr. Marian Bisanz-Prakken, each of whom has also offered sound practical advice to the project since its inception. I hope that they are as pleased as I am with the beautifully produced catalogue, co-published by the National Gallery of Canada and Harry N. Abrams, that adds substantially to the somewhat meagre repository of scholarship on Austrian modernism in English. I am particularly grateful to John Collins, Assistant Curator at the National Gallery, who has not only written fine catalogue entries for each of the paintings exhibited, but has shepherded the exhibition through its various stages with unfailing care and attention to detail. His enthusiasm for the project—and his growing stature as a Klimt specialist—made him an ideal collaborator. I must also thank Samuel Sachs II, Director of The Frick Collection, for his patience and understanding in allowing me to maintain supervision of a project that would finally reach fruition only nine months after I had assumed my duties at his museum.

At the National Gallery of Canada, I am particularly grateful to members of Senior Management: Daniel Amadei, Director of Exhibitions and Installations; Mayo Graham, Director of National Outreach and International Relations; James Lavell, Deputy Director, Administration and Finance; Joanne Charette, Director of Public Affairs; and Marie Claire Morin, Director of Development. Karen Colby-Stothart, Chief of Exhibitions Management, and Danielle Allard, Exhibition Manager, have overseen every aspect of this project with customary efficiency and good humour; the demands on their time, patience, and ingenuity cannot be overestimated. The catalogue of which I am proud to be the general editor has benefited enormously from the scrupulous and exacting scrutiny of Serge Thériault, Chief of Publications, who has overseen the many production demands in a seamless and even-handed manner, and of Lynda Muir and Jacques Pichette, the most demanding and hard-working of editors; Colleen Evans has been steadfast in pursuing and securing illustrations of the highest quality. Lesley Bell and Michèle Borchers have provided excellent translations of the German source material. On behalf of my colleagues at the Gallery, I thank also the congenial and responsive Abrams team: editor, Barbara Burn; assistant editor, Julie Di Filippo; designers Judith Michael, Tina Thompson, and Brankica Kovrlija; and production by Hope Koturo. One cannot emphasize the importance of a research library to the success of any serious exhibition and catalogue, and much is owed to Murray Waddington, Chief Librarian, and his staff, who were undaunting in their support of the project. Among them I would like to single out Bonnie Bates, Steve McNeil, Peter Trepanier, Jo Beglo, Lisa DiNoble, Anna Kindl, and Maija Vilcins for their efforts. The distinctive installation of the exhibition is due to the keen eye of Ellen Treciokas, Senior Designer. Marie Lugli, Media Relations Officer, has proven a tireless and imaginative advocate for Klimt, as have Anne Hurley, Chief, Bookstore, and Sheila Weeks,

Assistant Chief, and Abby Warren, Production Development Officer.

I thank also Ceridwen Maycock, Exhibition Transit Coordinator; Lise Villeneuve, Administrative Assistant, Exhibitions Management; Louise Filiatrault, Chief, Education and Public Programmes; Monique Baker-Wishart, Exhibition Interpretation Manager; Jean-François Léger, Education Officer; David Monkhouse, Education Officer and Coordinator, Docent Program; and Emily Tolot, Chief, Special Events; Léo Tousignant, Chief, Visitor Services; Jean-Charles D'Amours, Chief, Corporate Giving; Delphine Bishop, Chief, Registration; Jacques Naud, Chief, Technical Services; Marion Barclay, Chief, Restoration and Conservation Laboratory; James Trimm, Chief, Facilities Planning and Management; James Nicholson, Chief, Security Services; and Mark Paradis, Chief, Multimedia Services, for their contribution to the organization of the exhibition and its related programs in Ottawa. To Pauline Labelle, Executive Assistant, Office of the Deputy Director and Chief Curator, a special thank you for her ongoing support, also to Arline Burwash, Secretary, for all that she has contributed.

In the three and a half years during which I have been engaged upon this exhibition, I have incurred the debt of so many people that it seems churlish merely to name them in alphabetical order (as one must). For their invaluable help in so many ways and generous support of the project, it is a pleasure to thank the following individuals:

Gert Ammann, Richard Armstrong, Peter Assmann, Nellie and John Auersperg, Hildegard Bachert, Paul Barry, John Barton, Linda Bemben, Ulla Bergman, Richard Bérubé, Christiane Böker, Stephen Borys, Christian Brandstätter, Terrence Brennan, Kaliopi Chamonikola, Paul Chenier, Melanie Clore, James Cuno, Magdalena Dabrowski, Ted Dalziel Jr, Paul Dubois, Hanna Egger, Rainer Egger, David Ehrenpreis, Christine Eipeldauer, Wendelin Ettmayer, Marina Ferretti di Castelferretto, Ulla Fischer-Westhauser, Marie Elise Flatz, Esther Fleischmann, Kurt Forster, David Franklin, Rainald Franz, Sarah Freeman, Herbert Friedlmeier, Cheryl Gagnon, Susan Grace Galassi, George R. Goldner, Elizabeth Gorayeb, David R. Graham, Joanne Greenhalgh, Gloria Groom, Pierre Guimond, Eleonore Gürtler, Francis Gutmann, Renata Guttman, Rosemary Haddad, Matthias Haldemann, Kristin Helmick-Brunet, Julie Hodgson, Marianne Hörmann, Michael Huey, Charles Hupé, Agnes Husslein, Margaret Iacono, David Jaffe, Birgit Joos, Michael Kalwoda, Christa Kamm, Peter and Christine Kamm-Kyburz, Peter Klinger, Georg J. Kugler, Elizabeth Kujawski, Herbert Koch, Helmut Kretschmer, Sue Lagasi, Leonard and Evelyn Lauder, Ronald Lauder, Manfred Leithe-Jasper, Walther Lichem, Irene Lillico, Gunnel Lindelöv, Glenn D. Lowry, Henri Loyrette, Victoria Lunzer-Talos, Klaralinda Ma, Neil MacGregor, Anne Maheux, Haito Masahiko, David McTavish, Philippe de Montebello, Rosemary Moravec-Hilmar, Edgar Munhall, Céline Nadreau, Richard Nagy, David Nash, Tobias G. Natter, Christian and Renée Nebehay, Diana Nemiroff, Peter Noever, Elisabeth Nowak-Thaller, Marion Oberdorfer, Konrad Oberhuber, Walter Obermaier, Ferdinand Opll, Sharon Patton, Carol Payne, Karin Perez, Earl A. Powell, Renee Price, Christian and Joanna Primavesi, Kajetan Primavesi, Gerhard Renner, Brenda Renwick, Christopher Riopelle, Cora Rosevear, Elisabeth-Gustava de Rothschild, Liliane de Rothschild, Françoise Roux, Anne Ruggles, Caroline Schmidt, Elisabeth Schmuttermeier, Carl E. Schorske, Romana Schuler, Wilfried Seipel, Benedict A. Silverman, Beate Stock, Judy Sund, Peter C. Sutton, Margarethe Szeless, Mitsuhiko Tara, Ann Thomas, David K.R. Thomson, Gary Tinterow, Katka Tlachová, Kirk Varnedoe, Regina Vogel, Valerie Von Volz, Alfred Weidinger, Mrs. H. Weiss, Jeffrey Weiss, Alois Maria Wienerroither, Marjorie Wieseman, Maria Wilflinger, Elfriede Wiltschnigg, Susanne Winkler, Alan Wintermute, Christian Witt-Dörring, Dai-Rong Wu, Eric Zaffran, Michaela Zeitler, Wera Zelenka.

COLIN B. BAILEY
Chief Curator
The Frick Collection, New York

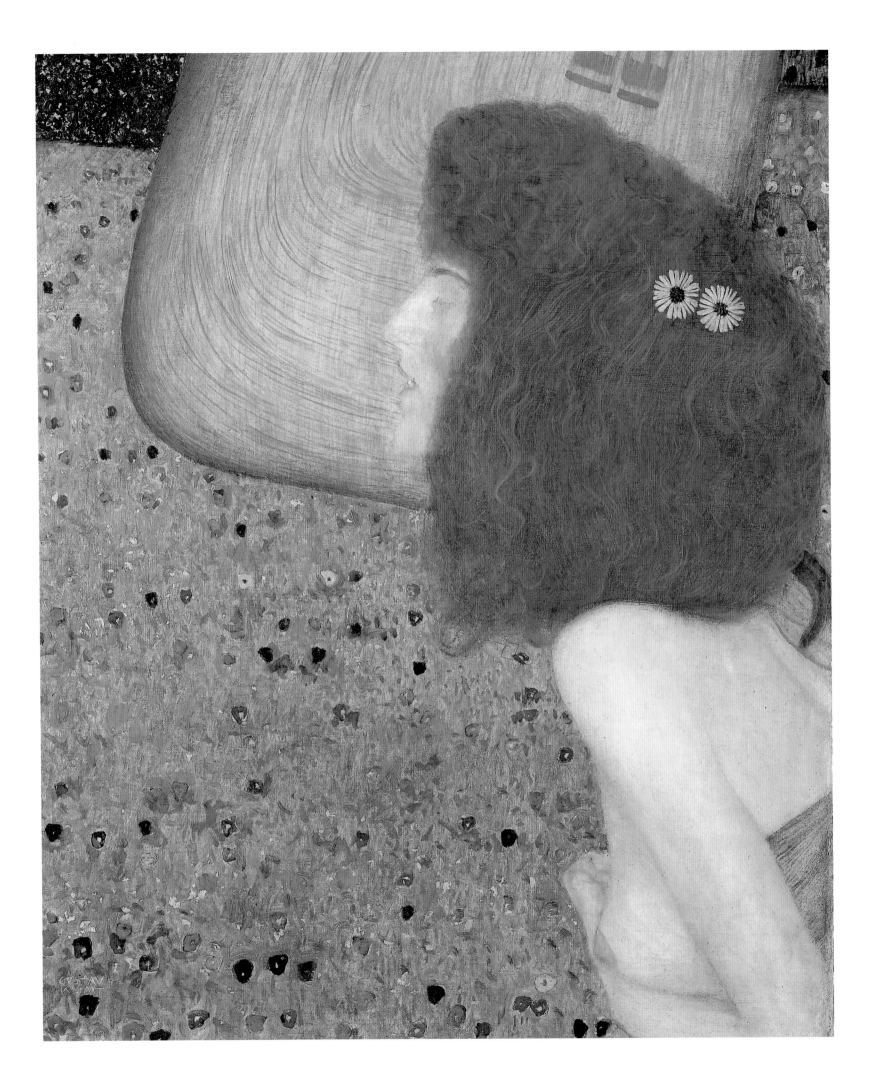

COLIN B. BAILEY

At the auction of her choosing, how many Rembrandts, Klimts, de Kooning?
—Zadie Smith, *White Teeth*, New York, 2000

Vienna, like every other large city, consisted of many people, many different circles.
It was not a monolithic society in which everybody talked about modern music or psychoanalysis.
—Ernst Gombrich, "An Autobiographical Sketch," in *The Essential Gombrich*, London, 1996, p. 21

With the acquisition in May 1970 of Klimt's *Hope I* from the Galleria Galatea in Turin for $120,000 US—a mere $128,400 Canadian in those proto-Galbraithian days—the National Gallery of Canada found itself the happy possessor of the most important and provocative work by the artist in North America.[1] Shielded, even from private view, once it entered the collection of Fritz Waerndorfer—who apparently purchased the work before the paint was dry, and in whose picture gallery the painting hung between 1903 and 1914, behind closed doors designed by Koloman Moser[2]—*Hope I* now publicly engaged visitors of all ages and tastes as an icon of Symbolism and Austrian Art Nouveau. Yet while the painting was the subject of an exemplary article by Johannes Dobai, published in the Gallery's scholarly *Bulletin* just one year after it entered the collection,[3] and has been reproduced countless times in monographs on Klimt and general works on *fin-de-siècle* Vienna, it has rarely been seen outside Ottawa, the fragility of the canvas and the delicacy of the artist's technique discouraging travel abroad. As a pilgrimage piece, *Hope I* amply repays a visit to the permanent collection of the National Gallery of Canada; thanks to the prompting and encouragement of the director, Pierre Théberge, its magnitude and stature in Klimt's oeuvre is for the first time fully addressed in a retrospective comprising nearly forty paintings and ninety works on paper.

That almost thirty years have elapsed before such an exhibition has been mounted—the first of its kind in North America—is perhaps explained by art-historical prejudice masquerading as orthodoxy (happily, no longer so firmly entrenched), which had consigned Viennese Symbolism and Art Nouveau to the margins of the modern movement. Klimt's training as a muralist and historical painter committed to state-sponsored public decoration; his desire to paint narrative and figurative cycles of the grandest moral themes; his failure to break with prevailing pictorial norms (recently characterized as a "substructure of specific naturalism")[4]—such resistance to the emergent languages of modern art did not endear Klimt to critics and art historians, even those who reassessed his achievement by situating it within a cultural context that looked neither to Paris nor, implicitly, to New York for validation. Klimt resisted the boldness and raw energy of nascent Expressionism and remained genially aloof from early experiments in abstraction, never wavering in his commitment to beauty: luxuriant, sensuous form defines both his figure painting and landscapes. This too may have been responsible for the modernist's unease and a residual, unstated antipathy: how to take altogether seriously an artist whose "insatiable eyes . . . saw only the beautiful in everything they contemplated."[5]

It would be absurd to suggest that Klimt's art is anything other than well-known, well-studied, and widely admired by a general public avid (in its youth at least!) for posters of his *femmes fatales* and blissful lovers. And in the past fifteen years, beginning with MOMA's groundbreaking exhibition *Vienna 1900: Art, Architecture and Design* (and its French counterpart, *Vienne, 1880–1938: l'apocalypse joyeuse*), there have been a series of ambitious reappraisals of Klimt's art in Zurich, Munich, Milan, and Vienna. An exhibition of his landscapes is currently planned for 2002, and with the projected opening of the Neue Galerie on Manhattan's "Museum Mile" in the autumn of 2001—a museum that will be devoted to all aspects of art and design in Austria and Germany between 1890 and 1940—Klimt's work may at last become the subject of focused investigation that will also make manifest the rich interplay between the fine and decorative arts in Vienna during the Secession and early modern period.

Klimt's paintings and drawings will surely benefit from greater exposure in North America through such

Opposite:
Hors catalogue
Girl with Blue Veil
c. 1902–03
Oil on canvas,
67 × 55 cm
Private collection
Novotny/Dobai 130

institutional initiatives, but it remains to be seen whether the artist's reputation among scholars and critics will improve accordingly. Disregard in those quarters is partially rooted in Klimt's unyielding attachment to figurative painting, and his lingering commitment to the academic system in which he had been schooled. As late as 1912 he praised the now forgotten Ferdinand Laufberger, his first teacher at the Kunstgewerbeschule (School of Applied Arts), as "the artist who had taught him the most in terms of his craft."[6] Despite the planar and spatial experimentation of Klimt's "golden period" paintings, and his flirtation with abstraction in the mosaic decoration for the Stoclets' dining room, his pictorial language remained pledged to the service of allegory and symbolism—modes distinctly out of fashion among more progressive painters by the first decade of the twentieth century. This may account for the surprisingly harsh assessments handed down by the historians who have done the most to rehabilitate Klimt. For Carl Schorske, Klimt's entry into the twentieth century is a significant falling off, as the artist retreats from the public to the private sphere. With the withdrawal of his University paintings, Klimt casts his lot with the Viennese *haut monde*, and the results—however sophisticated, however exquisite—cannot but be a diminution: "The painter of psychological frustration and metaphysical malaise became the painter of an upper-class life, beautiful, removed, and insulated from the common lot in a geometric house beautiful."[7] The conviction that narratives of frustration or malaise were remotely legitimate subjects for the modern painter informs Kirk Varnedoe's astringent appraisal of Klimt's most ambitious work. His style is undefined before 1897; the University paintings are "marginal" in every sense (both for the history of modern art and even within a critical assessment of Klimt's work); the *Beethoven Frieze* is marred by "sentimentality . . . and camp extravagance."[8]

Clearly, Klimt proves problematic as a representative of the avant-garde, for despite the terrible controversy over his ceiling paintings for the aula of the University of Vienna, he can in no sense be considered a *refusé*. As an immensely successful product of the recently established Kunstgewerbeschule, before he reached his thirtieth birthday Klimt had been awarded the Golden Order of Merit, was the first recipient of the Kaiserpreis (Imperial Prize), and had gained international recognition after his work appeared in the German section of the Universal Exposition held in Paris in 1889. In his twenties he was employed full-time on official commissions to decorate the ceilings and stairways of Imperial theatres and museums on the Ringstrasse. He was first nominated for a professorship in the School of Historical Painting in the Vienna Academy in 1893, and again in 1901 for a chair at the

Akademie der bildenden Künste (his nine-year-old sitter, Mäda Primavesi, always referred to Klimt as "Herr Professor").[9] Unlike the Impressionist exhibitions held in Paris a quarter century earlier, those mounted by the Secession (of which Klimt had been the inaugural president) between 1897 and 1905 to display contemporary art were both critical and commercial successes, and the organization itself enjoyed a measure of state support. The Imperial bureaucracy, far more supportive of Klimt and Hoffmann's efforts to bring modern European art to Vienna than, say, their Republican counterparts in Paris's Ministry of Fine Arts, also provided funding for paintings and drawings to enter public collections. The state's most extravagant outlay, but by no means an isolated occurrence, was the 25,000 crowns paid for Klimt's *Kiss* after its exhibition at the breakaway *Kunstschau Wien* of May–June 1908. Throughout his career, Klimt was also able to attach a network of sophisticated, committed, and indulgent patrons—mainly Jewish industrialists and assimilated upper middle-class Jews—who supported the cosmopolitan ambitions of both the Secession and the Wiener Werkstätte (the latter a drain on several stockholders' finances), and were eager to have their wives and daughters sit for an artist whose notoriously slow method of working and correspondingly high fees served only to increase demand.[10]

~

The present exhibition, which charts Klimt's painted and graphic oeuvre over some thirty-five years, concentrates more or less evenly on all periods of the artist's career: from Ringstrasse historicist, to Secession stylist, to the hard-to-categorize naturalist. Despite the manifold pleasures afforded by seeing Klimt's work in the context of contemporary design (from settees to sugar bowls), and the intellectual justification for such an approach, the National Gallery of Canada decided early on to show the artist's stylistic development independently of the achievements of the Secession and the Wiener Werkstätte. Klimt's extraordinary range and prodigious output as a draughtsman have not received the attention they deserve in North America, nor have the various phases of his pictorial language been systematically examined. His early work, with its affinities to pre-Raphaelitism and nineteenth-century Salon painting, often is disregarded; here, Klimt's production during the decade of the Künstlerkompanie assumes weightier significance as the foundation of his future development.

A more familiar trajectory emerges with the Symbolist paintings and drawings of the 1890s, followed by the golden period portraits and figure studies of Klimt's maturity. His most original contributions are sadly impossible to represent adequately in any exhibition. Klimt's three University paintings (1894–1903)—rejected by the profes-

sors, reclaimed by the artist, acquired by August Lederer, from whom they were expropriated by the Austrian state in 1938, only to be sent off to Schloss Immendorf for safekeeping (where they were destroyed by fire in the final days of World War II)—are known today only through black-and-white photographs, and can be evoked through a small selection of the multitudinous studies made in preparation. The *Beethoven Frieze* that was part of the Secession's full-dress homage to the Leipzig painter and sculptor Max Klinger was never intended to be on permanent display; it was preserved through the good offices of Schiele and Waerndorfer, entered the collections of Carl Reininghaus and August Lederer, and since 1985 has been installed in Olbrich's renovated Secession pavilion on the Karlsplatz. Like the University commission, its presence in any exhibition must be confined to a series of preparatory figure studies in black and white chalk.

Klimt's magisterial golden portraits are also poorly served by any exhibition outside of Vienna, since the surpassing effigies of Adele Bloch-Bauer and Fritza Riedler are too fragile to travel. Here the preparatory drawings, fascinating though they are, fail to do justice to the brilliance of Klimt's ornamentation and his innovative approach to this most fashionable of genres. Fortunately, Klimt's later work—the exuberantly brushed portraits and figure studies made after 1905, and the square-format landscapes that increasingly preoccupied him during his summers on the Attersee—can be more satisfactorily assembled. While not abundant (the entire corpus of paintings numbers less than 230 canvases) significant examples allow us to indicate the various modes in which the artist worked. We are particularly excited about the rediscovery of *Girl with Blue Veil* (see figure p. 12)—possibly the *Daphne* shown at the *Klimt Kollektive* in November 1903, and similar in style and morphology to *Hope I*. Its inclusion in the present exhibition allows us to follow Klimt's creative process in this critical year more closely than ever before.

"Out with squares; in with Naturalism!"[11] In the last decade of his life, a curious amalgam of influences—from El Greco to Matisse, from van Gogh to Congolese sculpture—now served to intensify Klimt's colour and liberate his brush. The flattened, geometric, neo-Byzantine style of the golden portraits gradually yielded to an enthusiastic acceptance of *la vie moderne*. Light-filled and roseate, his crystalline landscapes and celebratory allegories mark a dramatic shift of allegiances; having resisted its progressive tendencies for so long, Klimt embraces French modernism, albeit partially and selectively. The influence of Seurat and Matisse predominates: Neo-Impressionist technique was communicated by Seurat's epigones, particularly van Rysselberghe, while Matisse was glimpsed at the *Internationale Kunstschau* of 1909. Yet these develop-

ments occurred at the very moment when Cubism, to which Klimt seems to have been oblivious, once again reoriented the course of modern art.

The variousness of Klimt's style and its successive transformations should not obscure certain constancies, both technical and intellectual, that define the career as a whole: philosophical ambition, commitment to public art, and an obsessive erotic engagement with the female form. Klimt turned his world-weary cosmic vision, nourished by the writings of Schopenhauer, Wagner, but above all of Friedrich Nietzsche, to universal and elemental themes, with particular attention to the Apollonian/Dionysian dualities that were then thought to lie at the origins of all creative activity. Intellectually curious—his interests ranged from Archaic Greek vase painting to Schliemann's recent excavations at Mycenae[12]—Klimt was notoriously reticent about his working methods (as is born out in the unhelpful: "Whoever wishes to know something about me . . . should look at my pictures attentively and try from them to recognize what I am and what I intend").[13] While such erudition might be unexpected in a poorly schooled gold engraver's son from a lower middle-class suburb of Vienna—who at thirty-five was still struggling to learn French—we know from well-placed sources that Klimt was never without a copy of Goethe's *Faust* in his coat pocket, and could be found quoting from the Latin version of Sophocles' *Antigone*. The fervour and inventiveness with which Klimt approached his magisterial cycles charting the human condition from birth to death—grandiose and unfashionable as they soon became (and as they have long appeared to exponents of modernism)—are consistent with the formation of a history painter schooled in "the materialist foundations of a nineteenth-century art education."[14] By inclination and training, Klimt saw no reason to challenge the official value system that gave precedence to the decorating of public monuments (ironically, both of his mural series ended up in private hands), and created allegories and symbols well-suited to such a task. It is not surprising that well into the first decade of the twentieth century, Klimt still looked to Northern artists such as Hodler, Toorop, Minne, and Khnopff, who remained committed to allegory and narrative, the regnant genres in turn-of-the-century European art. He had far more interest in Rodin than in any of the Impressionists or Post-Impressionists (his first recorded comment on Manet and Cézanne—maddeningly terse—dates as late as October 1909); and it was only after the second showing of van Gogh's work in Vienna, at the Galerie Miethke in January 1906, that Klimt's landscapes took on something of the Dutchman's colour and expressive handling. Again in May 1908, in his manifesto to the *Kunstschau Wien*, Klimt reiterated his belief in a state-sponsored monumental art. The

contact between artist and public was best facilitated by "the carrying out of large-scale public commissions."[15]

Yet at the same time, Klimt, the public artist, explored a private, inner world, giving graphic and painted form to such personal preoccupations as angst and lassitude, but above all to sexual longing and its satisfaction. Erotic bliss, both utopian and degenerate, is the organizing principle of Klimt's *theatrum mundi*: a kingdom pleasured by subaqueous sirens, emaciated nymphs, and masturbating studio models. That the University paintings—Klimt's most sustained investigation of the human condition, and described as representing "actors in the service of endless procreation"[16]—were realized at the very time that Freud published his *Interpretation of Dreams* (1899) suggests a milieu uniquely attentive to the workings of the instinctual, sensual world. Freud was not yet on the faculty of the University of Vienna when the professors first expressed their collective dismay at Klimt's decorations; his appointment was confirmed only in March 1902. Just as there is no evidence that Klimt and his circle were aware of Freud's ideas at this time, so—from what is known of his conservative tastes—Freud seems not to have had the slightest interest in Klimt's art.[17] Ironically, it is by no means certain that the newly appointed Professor would have approved of a series of paintings that seem, in hindsight, to offer striking visual equivalents to the dream world and fantasy life that constituted the stock-in-trade of psychoanalysis.[18]

～

Klimt's art is paradoxical on many levels. He was an artist steeped in the classical and academic traditions, who explored the most intimate and troubling of themes with a directness, and at times brazenness, that still retain their capacity to shock. An obsessive draughtsman, whose preparatory studies might begin years before a commission came to be realized on canvas, he was the slowest of portraitists, willing to exhibit unfinished work, but increasingly reluctant to let patrons claim their property. Overbearing in his masculinity—Schnitzler remembered him at fifty as "not unlike a lively faun"[19]—his drawings record the most uninhibited of erotic fantasies, yet in his commissioned portraits he presented his female sitters as exemplars of self-confidence, strong temperament, and unshakeable presence of mind. These unexpected contradictions can only enrich our understanding of a figure whose prominence among the most original of modern artists, while widely—if grudgingly—acknowledged, still remains open to the most divergent assessments. It is hoped that our survey will succeed in evoking the richness and variety of Klimt's production, and offer North American viewers a glimpse into the unfamiliar—and at times unsettling—public and private realms that nurtured his distinctive vision.

Opposite:
Gustav Klimt and
Emilie Flöge in the
garden of his
Josefstädterstrasse
studio, c. 1905–06
Photograph by
Moriz Nähr
Austrian Archives /
Christian Brandstätter,
Vienna

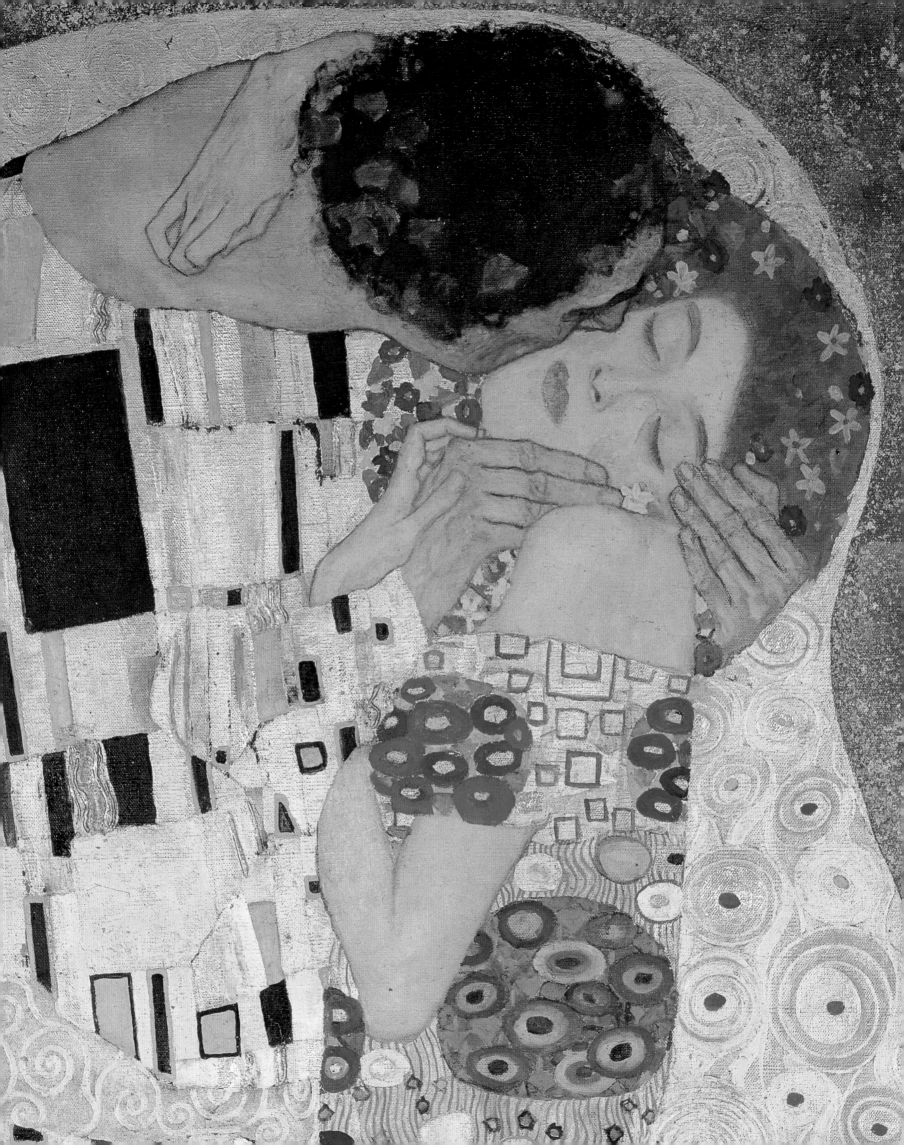

Between Modernism and Tradition:
The Importance of Klimt's Murals and Figure Paintings

PETER VERGO

Hanna Egger (1942–2000) in memoriam

Measured against the huge corpus of his several thousand known drawings, Klimt's output as a painter was not large. The standard oeuvre-catalogue by Fritz Novotny and Johannes Dobai documents just over two hundred works in oil which, averaged out over the whole of the artist's working life, comes to no more than five or six pictures per year. His method of painting was slow and laborious. He was given to retouching or even completely repainting canvases that were, in name at least, already finished. Or he would lay aside a picture that was half completed, resuming work on it only after an interval of months or sometimes years had elapsed. Given the fact that a not insignificant fraction of his oeuvre is known to have perished, the chances of uncovering an unknown painting, or of retrieving some lost work are, it has to be said, not high. For all of these reasons, any exhibition, any monograph or article devoted to his career will necessarily tend to revolve around the same limited number of paintings, some of which—especially *The Kiss* and other works of Klimt's "golden period"—have become so popular in recent years that by now they have been reproduced many dozens of times: in books, in articles, on calendars, even on tins of Viennese coffee.[1] It is difficult to decide which is more frustrating: to find oneself confronted by ever-growing numbers of illustrations of the same few golden paintings, of which no more than a handful survive (or indeed were ever painted), or by the same old poor-quality black-and-white photographs of pictures long since destroyed; for example, Klimt's celebrated but controversial canvases done for Vienna University,[2] or a work such as *Music II*, painted for the music-salon of Nikolaus von Dumba, one of his earliest Viennese patrons—paintings familiar to us only through inadequate reproductions.

Under these circumstances, it might appear somewhat perverse to have decided to concentrate in this essay upon just a few of the most important, and most popular, of Klimt's figure paintings, especially since, as a consequence, these works which have already been so often discussed and so frequently reproduced are, inevitably, illustrated once again here. It also seemed preferable to reiterate, even if only briefly, some well-known facts and a few frequently repeated anecdotes rather than send the reader, via the intermediary of footnotes, scurrying to ascertain the essentials of history and chronology from some other secondary source. But I have also tried to set these famous works against a somewhat broader background, and in particular to explore in more detail their intellectual context: a topic that has often been dismissed as potentially unrewarding, given Klimt's seemingly limited education and his notorious reluctance to say anything in the least illuminating either about himself or about his art.[3] I have also tried to shed some light on his working method, to explain why it seems to me appropriate to regard particular paintings, or more accurately *groups* of paintings, as occupying an especially important place within his work as a whole. I stress the phrase "groups of paintings," because an examination of Klimt's total oeuvre quickly reveals one significant characteristic of his figure compositions that affords a particular insight into not only his manner of proceeding but also his whole approach to his art. On closer scrutiny, we find that as a rule he seems not to have thought so much in terms of individual pictures, but instead tended to carry forward ideas and motifs from one work to another, sometimes continuing this process over a period of many years.[4] With respect to the motifs or compositional ideas on which they are based, particular paintings might be

I am greatly indebted to the staff of the Museum für angewandte Kunst, Vienna, especially the late Hofrat Dr Hanna Egger, Mag. Kathrin Pokorny-Nagel, and Peter Klinger, also to Dr Kathrin Dube and the staff of the Zentralinstitut für Kunstgeschichte, Munich, for their assistance in connection with this essay.

Opposite:
Detail of
The Kiss (fig. 13)

thought of as standing in relation to one another like links in a clearly envisaged chain of development; while certain "key" works occupy, as it were, a kind of nodal position inasmuch as they refer to or provide a summation of other groups of paintings related by theme or motif.

This manner of working was, as far as the early years of the twentieth century are concerned, characteristic not only of Klimt but of a number of other leading modernist painters. The Russian artist Wassily Kandinsky, for example, would use and re-use particular motifs over a considerable period, creating works that shared a given thematic content not merely with one another but also with other groups of paintings and drawings having at first sight no obvious resemblance as regards their subject or purpose. It is almost as if, given the decline in importance of traditional sources of patronage such as the aristocracy or the court, and the increasingly questionable significance of conventional subject matter in painting, artists began to see their works as primarily self-referential, depending largely upon a kind of private repertoire of subjects and motifs, linked with one another not externally but by a shared inner content. For Klimt, however, the traditional stuff of allegory and classical legend, of biblical narrative and amorous exploit, was not yet entirely outworn. By the early 1900s, such subjects were increasingly seen as part and parcel of the nineteenth century, of the Symbolist heritage; but for him, they could still have on occasion a profound intellectual and philosophical significance. As an introduction to the National Gallery of Canada's unique survey of Klimt's work, this essay sets out to explore that significance by analysing the nature of the subject matter he deployed in so many of his figure paintings, and to examine the tensions between these in many respects still traditional subjects and the highly idiosyncratic and increasingly innovative manner of working characteristic of his later career.

~

To scrutinize an artist's origins and upbringing in search of clues that might help to account for the twists and turns of his later development, or some of the more peculiar characteristics of his art, has become something resembling a commonplace of art-historical method. Yet in truth, there is little enough about Klimt's background or education that might foretell the modernist, the revolutionary, the butt of scandal that he was later to become. Like his brothers Ernst and Georg, Gustav Klimt was trained not at the Academy of Fine Arts in Vienna but at the Kunstgewerbeschule (School of Applied Arts), which offered in some respects a broader and more liberal education. His younger brother Georg embarked on a career as a metalworker; once established as an artist, Gustav was instrumental in steering a number of important commissions in Georg's direction, including that

for the decoration of the great bronze doors that adorned Vienna's Secession building. The later collaboration between the two brothers may have deepened Klimt's interest in the possibility of incorporating into his painting the techniques of decorative art, one of several preoccupations that came to dominate his years of maturity as an artist. Whether the education he received at the School of Applied Arts influenced his thinking about his own future career is impossible to say with confidence: not much that is revealing has survived from this early period by way of documents, letters, or reminiscences. What is certain is that, even before graduating from the School, he and his other brother Ernst teamed up with a fellow student, Franz Matsch, to form a kind of workshop or co-operative called the Künstlerkompanie (Artists' Company), which was remarkably successful in obtaining commissions for the decoration of public buildings.

This was a growth industry at the time, not just in Vienna but in many of the major provincial cities of the Danube Monarchy, such as Karlsbad or Reichenberg, where the late-nineteenth-century building boom meant that there existed any number of new opera houses and theatres and museums just waiting to be artistically decked out. Klimt and his associates spent the best part of a decade, from 1882 to 1891, on such projects, which included curtains and proscenium arches and ceiling frescoes.[5] The culmination of this highly productive period was marked by two prestigious undertakings in Vienna itself: the decoration of the Burgtheater (Imperial Court Theatre, 1886–88) and of the staircase of the Kunsthistorisches Museum (Art History Museum, 1890–91). In the latter instance, the historical and allegorical figures that Klimt supplied for the lunettes and spandrels above the main staircase can still be seen and enjoyed today: evidence of a precocious talent, and of his undoubted accomplishment in this particular field of artistic endeavour.[6]

Klimt never wrote anything of any significance about himself, or about his ambitions as an artist.[7] He was probably behind some of the statements published in the early issues of the Secession's magazine, *Ver Sacrum*, and may have been largely responsible for the published descriptions of his *Beethoven Frieze* of 1902 (see pp. 28ff), and of his other paintings shown in the Klimt retrospective at the Secession the following year. But he never attempted to formulate any proper artistic manifesto, nor did he describe, save in the vaguest terms, his own personality and outlook on the world.[8] His surviving letters and postcards are, moreover, largely unrevealing. Thus, we do not really know whether his preoccupation with monumental decorative art during the 1880s was part of a deliberate strategy, or whether he fell into this line of work more or less as a result of fortunate coincidence. In any case, how many people are sagacious enough to see their future lives

mapped out before them, and to know what will be important to them in years to come?

But whether by accident or design, Klimt soon began to enjoy a growing reputation as a decorative painter, together with the attendant financial rewards. By the 1890s, as Gerbert Frodl observes, his work in collaboration with the Künstlerkompanie had established his reputation as heir to Hans Makart's tradition.[9] In 1890, he was the first artist to win the newly established "Kaiserpreis" (Imperial Prize). The following year, he was accorded the "imperial approbation" of Emperor Franz Joseph himself on the occasion of the official opening of the recently completed Kunsthistorisches Museum, and the public unveiling of Klimt's frescoes.[10] These early successes were, as it turned out, to be of inestimable significance for his future career. On the one hand, the creation of monumental works, of cycles or thematically related groups of narrative compositions was significantly to influence his whole conception of his task as an artist, becoming a major preoccupation of his later years. On the other, this preoccupation provides a key to the understanding of his working methods, helping to illuminate the content and meaning of some of the most important of his subsequent figure paintings.

The attention Klimt gave to monumental decorative art marks him out as very much a child of his time. He had been born into an age in which the creation of cycles of narrative paintings was a well-defined strand of artistic endeavour, of some importance for an artist anxious to gain wider public recognition. But it was not just academic painters or officially sanctioned artists who devoted themselves to such tasks. Younger and more avant-garde painters, too, seem to have regarded it as entirely natural to create series or cycles of thematically related works, often overtly narrative or allegorical in intent. The Norwegian painter Edvard Munch, Klimt's almost exact contemporary, spent the greater part of his career painting and repainting the canvases that together constituted what he called his *Frieze of Life*, which, like much of Klimt's work, revolved around the traditional themes of love and death. Indeed, there are many points of resemblance between the two artists, although for the most part these are more likely to have been parallels or affinities rather than instances of direct influence—even allowing for the showing of important works by Munch at several of the later exhibitions of the Vienna Secession. Munch's *Frieze of Life* was not, however, intended for any particular location, the building it might most fittingly have decorated being, as the artist ruefully admitted, a "castle in the air." Klimt's monumental works, by comparison, were invariably conceived with a specific setting in mind, their content being determined to a large extent by the physical or architectural context for which they were painted. That content remained, nonetheless,

resolutely narrative or allegorical, or both, as was also the case with the majority of Munch's figure paintings.

Contemporary graphic art, too, could boast its narrative or allegorical cycles, drawing on a long tradition going back at least as far as Goya and Hogarth in the eighteenth century, of which we might single out Max Klinger's *Eine Liebe* of 1887 as a "modern" example. Klinger was a "corresponding member" of the Secession, and was greatly admired in Vienna at this time. Tangible evidence of that admiration was offered by the association's fourteenth exhibition (1902), conceived as an act of homage to the Leipzig artist and to his massive polychrome statue of Beethoven that formed the centrepiece of the show. It was for this exhibition that Klimt created his *Beethoven Frieze* (discussed below), the largest and in many respects most ambitious of all his decorative cycles. Klimt, however, despite the esteem in which he evidently held Klinger, seems never to have interested himself in making original prints, his graphic art consisting solely of drawings (including drawings for subsequently published emblems and vignettes), done for the most part in traditional media such as pencil, crayon, or black and coloured chalks.

His paintings, too, were essentially traditional in both subject and technique. Apart from his narrative and allegorical figure compositions, he concentrated almost exclusively on portraiture and landscape—in other words, on well-established genres of painting. He made no abstract experiments (with one possible exception),[11] no assemblages of "found" materials that might be compared with Picasso's relief-constructions of 1913–14. Klimt never flirted with mixed media (unless the *Beethoven Frieze*, with its somewhat peculiar combination of medium and support, or his occasional use of gold or of costume jewellery might arguably be considered as such). Nor did he attempt to liberate himself from the confines of painting in order to experiment with other vehicles of artistic expression such as poetry or drama, as did his younger compatriot Kokoschka. Rather, he seems to have shouldered willingly and without question the conventional tasks of painting, merely clothing its traditional content in modernist garb, just as in his portraiture he clothed his sitters in a dazzling array of ornamental, quasi-abstract patterns, while still representing their physiognomy and physical characteristics with the utmost naturalism. At various stages throughout his work, these two tendencies seem to exist side by side, in a sometimes uneasy juxtaposition, as if the conventional elements of narrative or of allegory, and of naturalistic depiction, were at odds with more abstract tendencies pulling his art more emphatically in the direction of the modern, the expression of psychological states by purely decorative means.

Nowhere is the tension between tradition and modernity in Klimt's work more clearly seen than in the paintings

he created for the ceiling of the aula, the great hall, of Vienna University. After initial hesitation, the commission for the decoration of the University ceiling had been awarded to Klimt and Franz Matsch jointly—no doubt on the strength of their earlier collaboration, for example, over the Burgtheater frescoes—and specified, in addition to sixteen smaller lunettes, four large paintings that were meant to apostrophize the four faculties of a traditional German university (Theology, Philosophy, Medicine, and Jurisprudence), plus an allegorical centrepiece representing the Victory of Light over Darkness.[12] The division of labour was, however, an uneven one: Matsch was to be responsible for the central painting and for that representing Theology, while Klimt undertook to depict the three remaining faculties—Philosophy, Medicine, and Jurisprudence. (Matsch later recalled that he and Klimt had "as usual" drawn lots over who was to execute which picture, but it is not certain how much credence should be attached to his reminiscences.)[13] As I pointed out in my book *Art in Vienna*, with this division the seeds of future disaster were sown, since even at this early date a growing divergence between the styles of the two artists was becoming obvious. At a joint sitting of the artistic commission of the University and the fine arts commission of the Ministry of Education that took place in May 1898, they were both forced to declare themselves ready "within the limits of artistic freedom" to undertake such alterations as might be necessary to ensure the stylistic unity of their respective contributions.[14] Klimt, however, finally became so discouraged by the public and critical hostility which greeted his work that, despite the fact that his three paintings for the University ceiling were actually approved by the Ministry in 1903, he repaid the advance of 30,000 crowns he had received for the pictures, declaring himself incapable of "bringing this task, which is already so far advanced, to completion as long as, under present circumstances, I am obliged to continue to regard it as a state commission."[15]

The subsequent history of the paintings and their tragic fate have been so often described that it seems unnecessary to rehearse the details here.[16] It is interesting, nonetheless, given the context of a prestigious official commission and an imposing public (or at least semi-public) location, to speculate at somewhat greater length as to the reasons that lay behind the hostility the pictures were to provoke, especially since these are intimately bound up with Klimt's development to maturity as an artist, and his conception of his own purpose as a figure painter. Several of his critics, Karl Kraus among them, seized on the stylistic discrepancy between the contributions of the two artists involved (a problem already highlighted by the authorities overseeing the commission); Kraus accused Klimt quite specifically of having "failed to accommodate himself" to Matsch's style.[17] This discrepancy was due in part to the increasingly marked changes that characterize Klimt's art during these last years of the nineteenth century, and which subsequent historians have tended to explain in terms of the ever wider range of foreign influences of which he was then becoming aware.

The early exhibitions of the Secession repeatedly featured the work of contemporary foreign artists, as part of a deliberate strategy for bringing art in Vienna into "more lively contact with the continuing development of art abroad."[18] Yet the first of these exhibitions did not take place until the spring of 1898, by which time the changes in Klimt's style had already begun to take effect. There were other exhibitions, of course, such as those of the Künstlerhausgenossenschaft which, apart from the so-called "Hagenbund," was the only other major exhibiting society in the Austrian capital. But prior to the founding of the Secession in April 1897, the complaint had always been that the showing of contemporary foreign art in Vienna had been poor or unrepresentative: little enough there, one might think, to stimulate Klimt's developing imagination. He himself travelled only sporadically, paying several visits to Italy, for example, where the Byzantine mosaics of Venice and Ravenna undoubtedly produced a profound impression on him. Apart from this, he made no more than occasional forays outside the borders of the then Austro-Hungarian empire. He also had only limited contact with foreign artists; significantly, when contributors from abroad were invited to submit work for the first exhibition of the Secession, it was the painter Josef Engelhart, rather than Klimt in his capacity as the first president of the newly formed association, who made the initial approaches.[19]

Travel and exhibitions were, however, not the only ways of keeping up to date with what was new and exciting in contemporary art from abroad. By the turn of the century, increasing numbers of lavishly illustrated art journals were freely accessible in the "well-stocked library" of the School of Applied Arts, Klimt's *alma mater*. Kokoschka, likewise a pupil at the school (albeit a generation or so later than Klimt), recalled how the library enabled students to "inform themselves about the latest developments in the fields of decorative art and of modern interior design which were then taking place in France, Holland, Belgium, Germany, and England. In increasingly provincial Vienna, the ideas championed by the School of Applied Arts were a subject of heated debate."[20] Nor was it only students who benefited: when Josef Hoffmann and Felician von Myrbach were planning the eighth Secession exhibition (autumn 1900), which focused on contemporary European applied art, they too plundered the library for illustrations of works by foreign designers such as Mackintosh and the artists of the "Glasgow School." It seems inconceivable

that Klimt, whose own personal library included a variety of well-illustrated art books, should not have exploited the same opportunities.[21]

If, as seems likely, it was indeed the illustrated periodicals of his day that played a significant role in widening his artistic horizons, then these go a considerable way in helping to account for the most obvious influences on his work of the period around 1900 in general, and the University paintings in particular. The parallels with Belgian Symbolism, and with the graphic art of Beardsley, have often been remarked. Both in his landscapes and in his figure paintings—for example the pale, luminous female face with staring eyes that arises from the lower depths of *Philosophy* (fig. 1), and which one critic identified as "Knowledge" (das Wissen)—one can detect a striking affinity with the paintings of Fernand Khnopff, whose work featured in the early exhibitions of the Secession. There are also similarities between Klimt's art and the elegant, attenuated marble figures of naked youths created by the Belgian sculptor George Minne. Fritz Waerndorfer, an important patron of the Secession and co-founder of the Wiener Werkstätte, who originally owned Klimt's once notorious *Hope I* (cat. 18) and was on friendly terms with the painter, was an enthusiastic collector of Minne's work.

Artists such as Khnopff and Minne are half neglected now, but there is no doubting the international esteem they, and modern Belgian art generally, enjoyed around the turn of the century.[22] One reviewer, writing in the influential periodical *Deutsche Kunst und Dekoration* about the Turin International Exhibition of Modern Decorative Art in 1902, went out of his way to situate the work of the designers represented there within the wider context of what was seen as Belgium's cultural rebirth: a process of artistic and intellectual renewal whose leading representatives included "Meunier, Khnopff und Minne, Verhaeren . . . and above all Maurice Maeterlinck."[23] English art, on the other hand, was kept before the eyes of the Continental public largely through the pages of the *Studio*, which enjoyed a wide circulation in Vienna at this time. Peter Altenberg's short essay "Der Freund," published in 1901 but probably written two or three years earlier, conjures up a vivid picture of a young Viennese lady—bourgeois, married, Anglophile—eagerly awaiting the 15th of each month because it was the day her copy of the *Studio* arrived from England; sitting in the deep armchair by the "soft light of the English standard lamp," she would slowly turn the pages, marvelling at "unworldly women by Burne-Jones, women who even barely stood on the ground with as much as the tips of their toes, at slender naked bodies in marble and various things in ivory and chased copper . . . ponds with lilies tall and straight as candles, naked virgins on horseback, flowers from Japan. . . ."[24] And Fritz Waerndorfer,

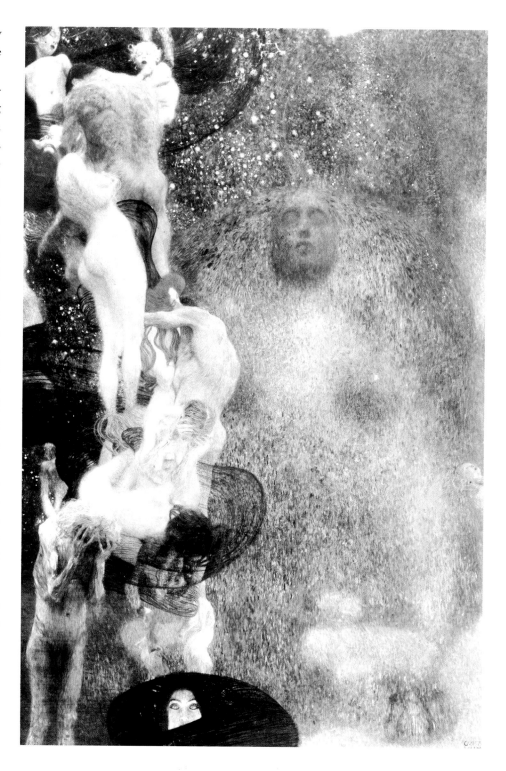

FIGURE 1
Philosophy 1899–1907
Destroyed by fire
in 1945

already mentioned as a friend of Klimt's, recalled how an Austrian friend with whom he had spent a good deal of time in England had his Viennese house furnished entirely out of Volume X of the *Studio*: "Page 10 fireplace, page 20 chest by Voisey [*sic*], etc."[25]

The undisguised erotic overtones of the passage by Altenberg quoted above, as well as the explicit subject matter of many of Beardsley's graphics, call to mind the significant thread of eroticism that runs through so much of Klimt's work of this period—allegedly another reason for the persistent and sometimes barbed criticism to which his art was exposed. His treatment of such themes recalls

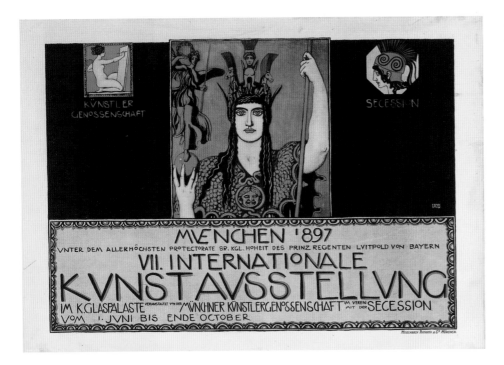

art—please a few. It is not good to please the many." But the real rebuff to his critics is to be found not in the Schiller quotation but in the mirror that Klimt places in the hand of the naked girl, which she holds up not to her own countenance but to that of the viewer, as if to deflect back on the artist's tormentors the accusation of obscenity. It is not just beauty, Klimt seems to be saying, that is in the eye of the beholder.

The increasingly marked eclecticism characteristic of his work of the period around 1900, the wide and disparate range of contemporary influences to which he responded, the jarring discrepancy between his manner of painting and the essentially conservative style of Matsch, and the erotic content of his art—all these have been advanced as reasons for the hostility provoked by Klimt's University paintings when they were first exhibited at the Secession, *Philosophy* in 1900, and *Medicine*, the second of the three large canvases for which he was responsible, in 1901 (fig. 3). As with so many frequently repeated assertions, there is an element of truth in all these opinions. Certainly, the naked female figure who occupies the upper left-hand area of *Medicine*, and who like her counterpart in *Nuda Veritas* seems to rejoice in the public display of her sexuality, thrusting herself forward before the viewer's gaze, was the object of a very public scandal. Questions were even asked in the Austrian Parliament, where the Minister of Education found himself obliged to defend the terms of the original commission; while representatives of the University demanded that if the figure in question had to be female, then it should be clothed, or if it was unavoidable that it be naked, then it should be a male figure instead.

However, the squabble over the provocative female nude was probably only a diversion. The University authorities who had been instrumental in commissioning the paintings in the first place must have been bitterly disappointed, not so much by stylistic incongruities, or the seemingly wilful glorification of female nudity, but by Klimt's whole attitude to the prescribed subject. Whereas the intention must surely have been to celebrate the achievements of human reason—science's unravelling of the mysteries of the natural realm, the conquest of morbidity and disease by medicine, the attainment of equality and justice through the rule of law—the message Klimt conveys through his paintings is, by contrast, one of unrelieved pessimism. In both *Philosophy* and *Medicine*, the most striking compositional element is the vertical chain of naked figures, which speaks so eloquently of human frailty and mortality: humankind caught in the inexorable grip of the endless cycle of birth, procreation, and death. Yet both the luminous female head symbolizing knowledge which, rising from depths, so vividly recalls the description of Erda, the fount of earthly wisdom, to be found in the directions

not only Beardsley, however, but also the erotically charged paintings of the Munich artist Franz von Stuck (another near contemporary). Stuck's fondness for classical and allegorical themes may have influenced Klimt's choice of subjects such as Pallas Athena (cat. 11), who likewise appears in the role of protrectress of the arts in a poster designed by Stuck for the Seventh International Art Exhibition in Munich in 1897 (fig. 2).

But Klimt was to far outpace Stuck in his depiction of erotic subjects, even though his on occasion relatively modest and conventional handling of such themes could still constitute a bone of contention. As early as 1898, with his design for the poster advertising the first exhibition of the Vienna Secession (cat. 63), he fell foul of the Viennese censor; in the second version of his design (cat. 64), he overprinted the genital area of the naked Theseus preparing to do battle with the Minotaur, with an entirely gratuitous (and barely opaque) tree trunk. Klimt's response, on this as on subsequent occasions, was both sardonic and unambiguous. In a clear gesture of defiance, and by way of a commentary on Viennese sexual mores, he soon returned fire with a full-frontal depiction of a nude, preternaturally elongated female figure, her proud display of ginger pubic hair striking a note of unrepentant naturalism we may find startling even today, entitled *Nuda Veritas* ("Naked Truth"), 1899 (cat. 12). The odd proportions of the figure are accentuated by the tall, narrow format of the painting (a device Klimt was to re-use on a number of occasions, most strikingly in his *Portrait of Emilie Flöge* of 1902, cat. 15), and by the decorative text-bearing panels at top and bottom: underneath, the title *Nuda Veritas* and the artist's signature; above, a quotation from Schiller, which translated reads: "If you cannot please everyone by your actions and your

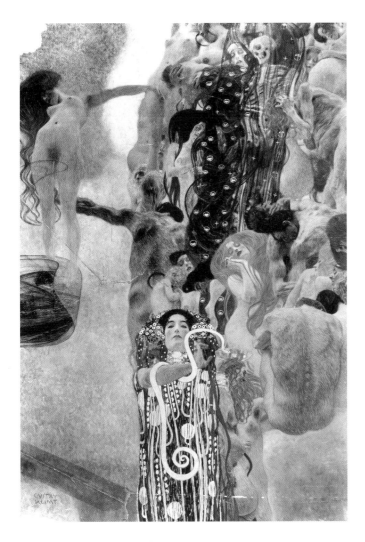

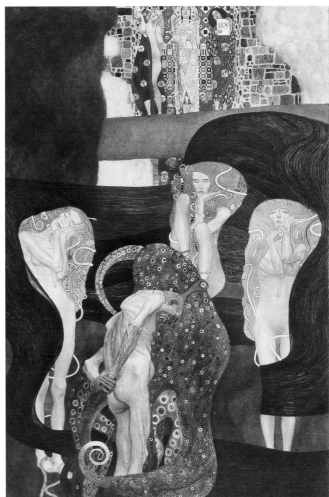

FIGURE 3
Medicine 1901–07
Destroyed by fire in 1945

FIGURE 4
Jurisprudence 1903–07
Destroyed by fire in 1945

for the staging of Wagner's opera *Siegfried*, and the stiff, hieratic figure of Hygeia, "miracle-working daughter of Aesculapius," seem incapable of illuminating the cosmic darkness that surrounds them. An insurmountable gulf separates them in each case from the chain of human misery behind. They do not even look at it. Their gaze is fixed firmly forward, out of the picture. It is directed at us, the audience. They cannot affect the events taking place elsewhere in the picture—any more than the diminutive figures of law, justice, and mercy can, which in *Jurisprudence* are placed at such a distance from the principal *dramatis personae* that they appear to inhabit an entirely different plane (fig. 4). The contrast—most especially in *Philosophy*—with the conventional "hall of fame" treatment of such a subject, of the kind typified by Raphael's *School of Athens*, could scarcely be more marked.[26]

What can have been in Klimt's mind when, in these canvases for Vienna University, he struck out in a direction that was so obviously contrary not just to the official taste of the time but to the spirit of the commission? The three paintings are clearly linked by a coherent, albeit negative (not to say downright gloomy) programme; but what, precisely, was that programme? I have suggested elsewhere that Klimt's thinking may have been influenced by the

essentially negative view of science held by both Nietzsche (interestingly, one hostile review specifically likened Klimt's *Philosophy* to Richard Strauss's Nietzschean tone-poem *Thus Spake Zarathustra*)[27] and, especially, Schopenhauer. In particular, it is Schopenhauer's notion of man's bondage to "the Will," that inescapable force that impels humankind from cradle to grave and which is at the same time the source of all our desires, and of all our grief, that seems to give the tone to this deeply pessimistic cycle of paintings.[28]

Just how well read in philosophy Klimt himself might have been remains, admittedly, open to question. Like so many artists, he deliberately laid a false trail, presenting an uncommunicative, sometimes even boorish face to the world, as if to say that intellectual or literary concerns were the last thing on his mind. On the other hand, he was a close friend of some of the foremost literary figures of his day—men such as Hermann Bahr and Peter Altenberg, who would never have suffered fools gladly. We know that he possessed an extensive library,[29] although only a few of the titles of the books it contained have been handed down to us. But from Alma Mahler, herself the daughter of a painter and stepdaughter of fellow Secessionist Carl Moll, who was on intimate terms with Klimt before the turn of the century, we know that he always carried a copy of

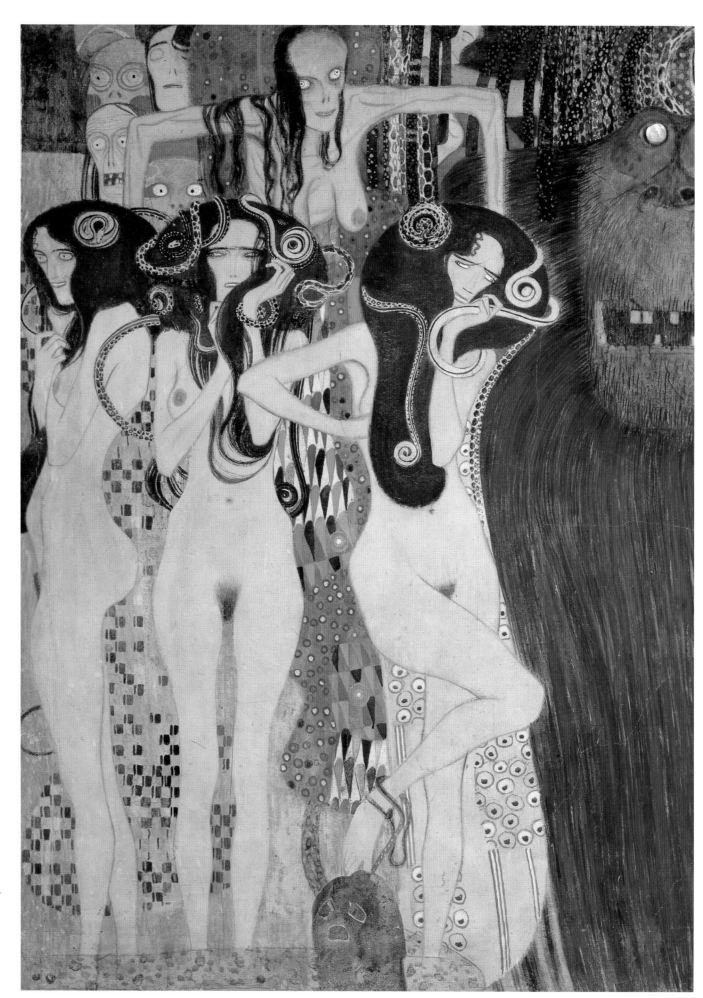

FIGURE 5
Detail of *Sickness, Mania,
and Death* above the
Three Gorgons
from the *Beethoven Frieze*
1902
Österreichische Galerie
Belvedere, Vienna

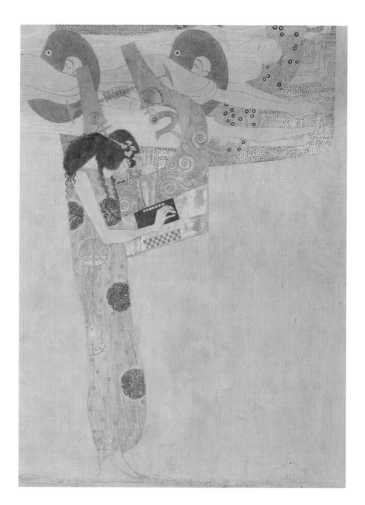

who had married Alma in 1901. Mahler, like other intellectuals in Vienna at this time, was profoundly affected by Nietzsche and by the philosophy of German idealism.[33] Although Mahler soon became close to several of the Secessionist artists, especially Alfred Roller whom he hired as head of design at the opera house as early as 1903, he remained personally somewhat distant from Klimt, perhaps because of the latter's earlier passion for Alma. There are, nonetheless, significant affinities between the works of painter and musician at this time. Mahler's *Second* and *Third Symphonies* both treat "cosmic" themes; listening to the gigantic opening movement of the *Third*, one can be in no doubt that one is embarking on a journey across a vast, imagined landscape that leads from the natural and human realm via Nietzsche's *Midnight Song* from *Zarathustra* ("All longing desires eternity . . .") to the angelic sphere, and ultimately to the divine.

The critics who pilloried the University paintings likewise scoffed at Klimt's cosmic ambitions; one writer likened

Goethe's *Faust* or Dante's *Divine Comedy* around in his coat pocket—scarcely the preferred reading of an ignoramus.[30] Nebehay and others, while by no means dismissing out of hand the notion that Klimt might have been affected by certain aspects of German idealist philosophy, have pointed out that he received no more than an elementary school education;[31] but as far as Schopenhauer or Nietzsche are concerned, we have to remind ourselves just how popular the works of these philosophers were during the years around the turn of the century, not least because both wrote in a vivid and accessible style that immediately appealed to a wider public—by contrast with, say, authors such as Hegel or Kierkegaard, whose writings must have appeared well-nigh impenetrable.

Perhaps the most compelling evidence for Klimt's wider intellectual and philosophical interests is to be found in the description of his *Beethoven Frieze* printed in the catalogue of the fourteenth Secession exhibition. From this it seems likely that Klimt was indeed familiar with Schopenhauer's ideas, if not in the original, then at least through the intermediary of Richard Wagner's essay on Beethoven (1870), which contains an elegant and lucid summary of the philosopher's views.[32] It is also possible that his intellectual horizons may have expanded still further as a result of his contacts with Gustav Mahler, the dynamic and difficult new director of the Vienna Opera,

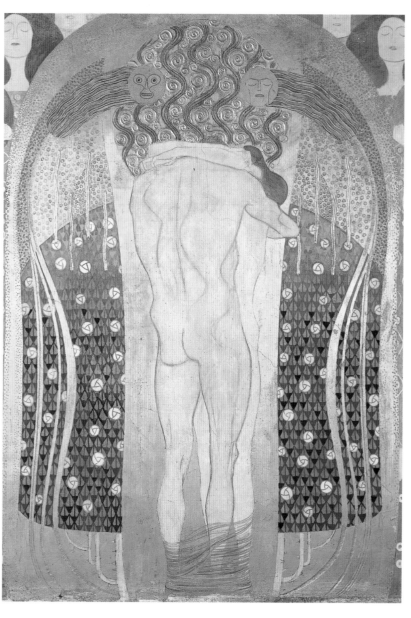

him to the central character in Zola's novel *L'Œuvre*, Claude Lantier, who "driven insane by failure, wants to unite the whole world and the whole of humanity in one picture."[34] And yet, as has so often been the case in the history of art, hostile criticism is here revealing of the artist's real intentions. For Klimt's subject was indeed the human condition, seen not in individual but in cosmic terms. This was abundantly clear to the art critic of the German periodical *Die Kunst für Alle*, for example, who wrote:

> The picture shows how humanity, regarded merely as part of the cosmos, is nothing more than a dull, unwilling mass which, in the eternal service of procreation, is driven hither and thither as if in a dream, from joy to sorrow, from the first stirrings of life to powerless collapse into the grave. . . . Apart from the frigid lucidity of knowledge, apart from that cosmic mystery which remains forever veiled, humanity engages in the struggle for joy and for experience, remaining however no more than a tool in nature's hands, exploited only for her immutable purpose, that of procreation.[35]

The Schopenhauerian allusions embedded in this highly perceptive account of Klimt's painting would have been clear even to the casual reader; but still more galling to the professors who protested vigorously against the prospect of displaying *Philosophy* in the University aula must have been phrases such as "frigid lucidity of knowledge," or "that cosmic mystery which remains forever veiled."[36] It is not difficult to picture to oneself their frustration when confronted

FIGURE 8

Max Klinger
Beethoven 1902
Museum der bildenden
Künste, Leipzig

with the spectacle of an artist, in the pay of the state, who had seemingly set himself the task not of glorifying science and the pursuit of knowledge, but of depicting in allegorical language their impotence, their irrelevance to the human condition. To make matters worse, Klimt's success in representing the inadequacy of philosophical method was evident not only to them but even to the critics. This, surely, must have been the final straw.[37]

~

Even good colour photographs of Klimt's University paintings are lacking. Poring over old black-and-white images and contemporary descriptions of these, arguably the most important of all his figural works, we may perhaps form at least some opinion as to the scope of his ambitions and the extent of his achievement. Yet the destruction of all three pictures means that we are hard put to imagine the effect that these huge and complex compositions might have produced, had we been able to see them in the original. Of his subsequent works, only two were conceived and executed on a comparable scale, utilizing a similarly complex programme, and these were again decorative cycles rather than individual pictures: his *Beethoven Frieze* of 1902 (fig. 5, 6, 7) and the mosaic friezes for the dining room of the Palais Stoclet in Brussels, designed and installed between 1905 and 1911. The Stoclet friezes were, however, created for a private setting, a domestic (albeit imposing) interior, and remain to this day only rarely accessible for public inspection.

That we are still able to see and enjoy the *Beethoven Frieze* is due largely to a fortunate combination of circumstances, since this, Klimt's next foray into the field of monumental decorative art after temporarily laying aside work on the University paintings, was not intended to be permanent. The six plaster panels that made up this enormous composition originally formed part of the setting for the Secession's fourteenth exhibition in the early summer of 1902. The whole exhibition, with contributions by nearly all the major Secessionist artists including Ferdinand Andri, Adolf Boehm, and Alfred Roller, was conceived as ephemeral, and the works it contained were to be destroyed afterwards, except for the centrepiece, Klinger's Beethoven statue (fig. 8). But from the outset, there were those such as the critic Ludwig Hevesi who demanded that Klimt's frieze, which in Josef Hoffmann's ingenious layout for the exhibition occupied the left-hand room of the building, adjacent to the entrance, should be preserved for posterity. In the event, the frieze was left in place until after the Klimt retrospective at the Secession (XVIII exhibition, 1903). Subsequently dismantled, it passed into private hands, survived World War II (unlike the University paintings, it was not transported to Schloss Immendorf for what was imagined to be safekeeping, but remained in

Vienna), and in 1972 was finally acquired by the Austrian State. After lengthy restoration, in 1985 this, Klimt's only essay in the medium of fresco painting proper,[38] was remounted in Vienna's Secession building, in a basement gallery that carefully replicated the proportions of the original setting.

In view of the mauling Klimt had received at the hands of the critics in 1900 and again in 1901, when *Philosophy* and *Medicine* were shown at the seventh and tenth exhibitions of the Secession respectively, it may appear to us extraordinary that he should have immediately embarked on yet another monumental project—albeit this time on home ground and with an altogether more congenial context and purpose. But while linked to these preceding canvases both intellectually and thematically, the *Beethoven Frieze* constitutes, in terms of its narrative programme, the other side of the coin. Its message is unmistakably optimistic, in contrast to the unrelieved pessimism of the University paintings. In simple terms, its subject, as described in the catalogue that accompanied the Secession exhibition, is mankind's struggle for happiness—a struggle undertaken by the resplendent figure of the knight in armour. After the knight has vanquished the "hostile powers"—among them the giant Typhon[39] and his three daughters, Sickness, Mania, and Death—it is the arts that lead suffering humanity, represented by the naked, kneeling figures whom we encounter early on in the cycle, into the kingdom of the ideal, "where alone we can find pure joy, pure happiness, pure love." The description printed in the catalogue ends with two brief quotations from Schiller's "Ode to Joy," the same text set to music by Beethoven in the final movement of his *"Choral" Symphony*: *"Freude, schöner Götterfunke." "Diesen Kuß der ganzen Welt."*[40]

Although this "programme" appears, on the face of it, relatively straightforward, the allusions and suggestions conjured up by the images that confront us as Klimt's narrative unfolds operate on a number of different levels. The figure of the knight in armour who challenges the hostile powers in order to relieve the plight of humanity surely calls to mind that of Lohengrin, who battles similarly against the forces of deceit and corruption for the sake of the hapless (and helpless) Elsa. Probably, this Wagnerian reference is quite deliberate, since there is other evidence to suggest that Klimt may have had Wagner in mind when framing his programme for the *Beethoven Frieze*. In the catalogue of the Klimt retrospective at the Secession in 1903, the final panel of the frieze, still *in situ* in the Secession building and therefore included in the exhibition, was identified not by the Schiller quotation cited above, but by the biblical *"Mein Reich ist nicht von dieser Welt"* (My Kingdom is not of this World). As has been pointed out elsewhere,[41] it seems likely that the choice of this quotation

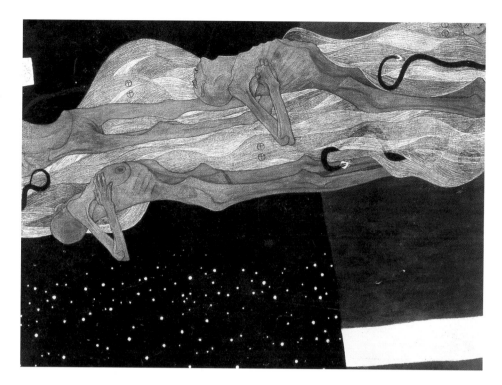

FIGURE 9
Procession of the Dead
1903
Destroyed by fire
in 1945

is by no means accidental. On the contrary, it recalls a particularly relevant passage of Wagner's 1870 essay on Beethoven in which the composer writes about the power of music to vanquish the materialism of contemporary life—a power which he compares to that of Christianity:

> Just as, under the world-civilization of the Romans, Christianity emerged, so too music now breaks forth from amidst the chaos of modern civilization. Both say to us "our Kingdom is not of this World." That means, we come from within, you from without; we derive from the essence of things, you merely from their appearance.[42]

This Beethoven essay is the text in which Wagner's profound admiration for Schopenhauer is most clearly manifested. That he is here merely elaborating upon Schopenhauer's view of music can be ascertained by reference to what was evidently the source of his inspiration, Book III of the philosopher's *World as Will and Idea* of 1818. In the concluding paragraphs of this part of his treatise which deals primarily with aesthetics, Schopenhauer writes *in extenso* about music's special capacity to reveal a kind of inner truth, on account of which he ranked it highest of all the arts, considering it to be ultimately different in kind from all other art forms. But he also thought that the arts in general could provide a kind of knowledge or understanding of the world that was different from, and in a sense superior to, that which could be obtained by rational or scientific means. Science, and deductive reasoning, were part and parcel of what he termed our normal, "Will-governed" process of explaining to ourselves the relationship between one object and another, and the nature of phenomena generally. In Schopenhauer's eyes, such "explanations" consisted of little more than referring effects to their causes; they could give no account of that deeper reality which, he

FIGURE 10
Vignette of *Music*
reproduced in
Ver Sacrum IV
(March 1901), page 214

thought, lay beyond the mere surface appearance of things. Art, by comparison, could lull us into a state of pure aesthetic contemplation in which we immerse ourselves in the contemplated object, losing in the process all consciousness of ourselves as individuals. Thereby released from the otherwise ceaseless promptings of the Will, and hence from the constraints imposed by our normal manner of perceiving or attending to things, we are able to recognize in any given phenomenon no longer the individual object but the Platonic Idea, that ideal form of which the individual manifestations that confront us in our everyday existence are merely imperfect copies. "The Platonic Ideas," wrote Schopenhauer, "are the true object of art."

Set against the backdrop of Schopenhauer's idealist philosophy, the more far-reaching implications embodied in Klimt's *Beethoven Frieze* become clear. The University paintings had indeed represented in allegorical form the limitations of rational enquiry. Neither philosophy nor medicine nor jurisprudence could hold out much hope of alleviating human suffering, and there was no "final panel"—nor was there ever intended to be—that might have offered some lightening of the darkness, some prospect of joy, or the cessation of grief. The programme of the *Beethoven Frieze* is, on the other hand, disarmingly optimistic. In contrast to the scathing interpretation of rationality proposed by the University paintings, the frieze celebrates the power not only of music but of the arts generally to ameliorate the human condition by liberating mankind from that misery, that endless, unfulfilled longing that proceeds from our otherwise inescapable bondage to the Will. Moreover, unlike the limited truths accessible to "the frigid lucidity of knowledge," the arts allowed us to apprehend, not the everyday phenomena that were the object of scientific enquiry, but what Schopenhauer calls the "innermost essence of the world." Thus it is the arts that lead humanity into the realm of "the Ideal" (a highly charged term in the context of Schopenhauer's philosophy)—rather than the knight in armour who, despite his valiant struggle with the "hostile powers," is described nonetheless as a merely "external" driving force. It is, surely, in this sense that the relevance of Wagner's otherwise puzzling remark "we come from within, you from without; we derive from the essence of things, you merely from their appearance" is to be understood.

~

The curious and in many ways profoundly moving programme that underlies the *Beethoven Frieze* would be sufficient in itself to assure this work a unique and central place within Klimt's oeuvre. But it also occupies a crucial position on account of the imagery and motifs that are here combined, so that the entire composition constitutes a kind of summing up of visual references to be found elsewhere,

spread throughout a surprisingly wide range of other works. The attenuated female forms that float above the heads of the all-too-human figures in the frieze, and which represent their "longings and desires," recall other "watery forms" in Klimt's independent figure paintings and drawings (compare for example *Moving Water* of 1898, cat. 10).[43] In their pronounced horizontality, however, they also resemble the likewise floating (but in this instance emaciated) bodies which, set against a "cosmic" void, appear in Klimt's now destroyed painting of the following year, *Procession of the Dead* (fig. 9).[44] The kneeling human figures, on the other hand, who represent the "sufferings of mankind" are, in their almost tangible frailty, clearly related to the pitiful human chain depicted in both *Philosophy* and *Medicine*—an explicit cross-reference that must have been wholly intentional. Similarly, the three alluring but sinister females who menace the gaunt figure of the accused in the third of the University paintings, *Jurisprudence*, recall the three daughters of Typhon who occupy the left-hand area of the narrow wall of the *Beethoven Frieze* (fig. 5). There are more literal "borrowings," too, for example the figure of *Poetry* (fig. 6), which is little more than a reworking of the lyre-playing female form that occurs as the subject of both the graphic vignette entitled simply *Music* (fig. 10), reproduced in *Ver Sacrum* in 1901,[45] and—with certain variations—of Klimt's somewhat earlier painting, *Music I*, of 1895 (fig. 11). And the knight in armour who undertakes the struggle for happiness makes a dramatic reappearance in a painting done the following year, *The Golden Knight* (or *Life Is a Struggle*, cat. 16), which is connected with the *Beethoven Frieze* not only by its subject but also by its title.

Even more significant, perhaps, in view of its widespread recurrence within Klimt's oeuvre is the motif of the embracing couple, which together with the choir of heavenly angels constitutes the subject of the final panel of the *Beethoven Frieze*. The theme of embrace, albeit depicted in a somewhat different form, can be traced back at least as far as Klimt's marvellously atmospheric evocation of *Love* of 1895 (cat. 8). Here, the man and woman who are so pointedly oblivious of our gaze are treated in more conventional fashion. The man holds, but does not yet enfold the woman. They maintain a certain distance. Above all, they are clothed. The type of clothing worn by the male and female protagonists is, moreover, that appropriate to each, which further emphasizes a certain distinction between them—their awareness of themselves as individuals, so to speak. In the *Beethoven Frieze*, not only is the embracing couple naked but the female figure is now scarcely visible behind the massive torso of the man (fig. 7). She has been almost literally devoured, swallowed up, her identity submerged in the all-consuming passion reflected in this most erotic of poses—just as, in Schopenhauerian terms, our conscious-

ness of ourselves is lost when we are absorbed in the contemplation of the arts. Klimt's treatment of the figures is here more than a little reminiscent of his sometimes quite explicit drawings of men and women making love—horizontally, that is—which perhaps helps to explain a certain feeling of weightlessness about the embracing couple in the *Beethoven Frieze*. (The heavenly angels behind are weightless, too: their feet do not even rest on the ground.) One almost feels that the two figures could easily be rotated through ninety degrees without undue damage to the coherence of the represented form, or to the logic of their anatomy.

Klimt's preoccupation with the theme of the embracing couple did not stop here, however. Although the two figures are once again reversed, his mosaics for the Stoclet dining room likewise culminate in the same all-consuming embrace (fig. 12). In this frieze, too, what we are shown is once again a progression: not from cradle to grave, as in *Philosophy*, nor from misery to happiness, as in the *Beethoven Frieze*, but from expectation to fulfilment. This time, the figures are clothed. Even so, there is something about the way in which the man's neck and shoulders are depicted that strongly suggests that they are naked beneath their garments, which are not painted naturalistically but rendered as an emphatically two-dimensional pattern of predominantly abstract ornamental forms. Throughout his career, Klimt had shown a lively interest in the methods and techniques of decorative art, even to the extent of designing a number of the frames for his paintings, and sometimes incorporating elements of "craft" such as the

FIGURE 11
Music I 1895
Bayerische
Staatsgemäldesammlungen,
Munich

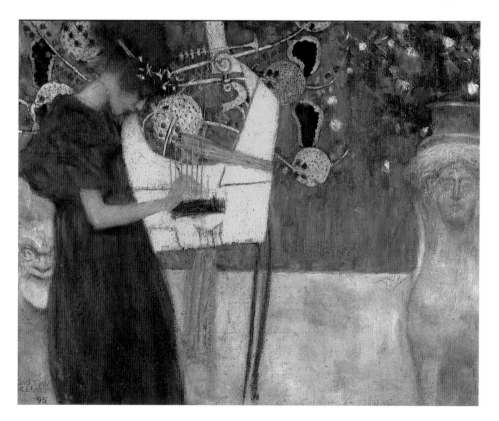

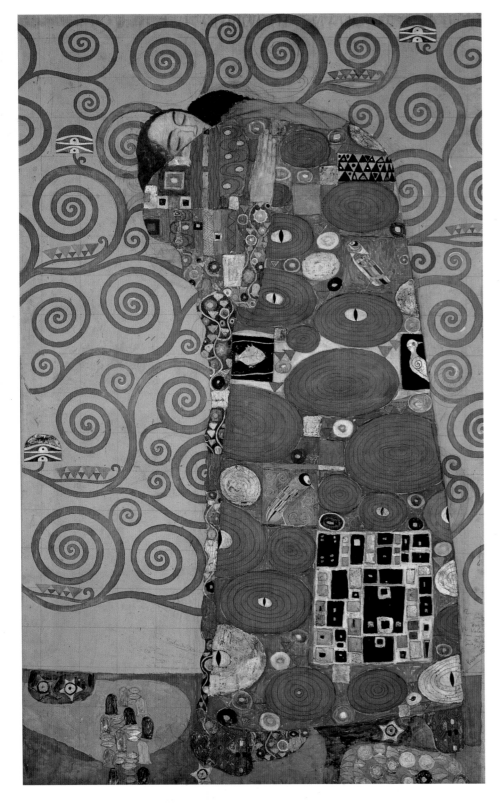

FIGURE 12

Cartoon for the Stoclet Frieze: Fulfilment 1908–10
Österreichisches Museum
für angewandte Kunst,
Vienna

use of gold or of inlay into his pictures. This tendency, and his delight in abstract pattern-making, often serves to make us aware of the surface of the painting, not as representation, nor as a window on the world, but as an object in its own right. In this respect his art may be regarded as distinctively modern, since historians have repeatedly singled out such insistence upon the surface qualities of the picture, and the emphasis upon the picture-as-object, as one of the distinguishing features of modernist painting

generally. But in the case of the Stoclet friezes, the mosaic technique in which they are executed not only emphasizes the physical reality of the play of abstract patterns; it also heightens the tension between, on the one hand, the still essentially conventional character of the represented subject and the naturalism with which the culminating figures—what little we are permitted to see of them—are depicted, and, on the other, the stylized abstraction of their ornamental garb.

Klimt's preoccupation with the theme of embrace reaches its apogee in his oil painting *The Kiss* of 1908 (fig. 13), yet another variation on the same compositional idea. There are, nonetheless, certain important differences, compared with its predecessors. As its title suggests, what we are shown here is for the first time something approaching a kiss, rather than merely an embrace as in the earlier variations upon this theme already cited. From these earlier versions, the overall conception and the treatment of the two figures are so familiar to us that we do not immediately notice the fact that the woman's pose is now quite different, since she is depicted kneeling. Our sense that the figures are probably naked under their garments persists, however, and is borne out by numerous drawings directly or indirectly associated with the genesis of the painting, in which Klimt repeatedly studied the forms and rhythms of naked, copulating figures.[46] In the final version of the painting, this erotic content is more discreetly handled, the intimacy of the relationship being not so much stated as implied, for example by the caul-like shape that appears to enfold both man and woman, embellished with a succession of loops and whorls which, despite our initial impression, have nothing to do with the pattern of the garments worn by either figure.

With the addition of this new compositional device Klimt's painting comes to resemble closely (if not in style, then in composition) Munch's depictions of the same subject (fig. 14): one of the core of motifs which, taken together, constituted the *Frieze of Life* referred to earlier. Munch's dream of exhibiting the *Frieze* in Vienna was, unfortunately, never realized,[47] and it appears that none of his oil versions of *The Kiss* was included when his work was shown at the Secession for the first time in 1901—nor again in 1904 at the association's nineteenth exhibition, which featured a powerful group of twenty paintings by the Norwegian artist.[48] However, Munch treated the theme of *The Kiss* not only in several oil versions but also in the form of a woodcut, which likewise existed in numerous states and versions. The Viennese Secessionists would have been well aware of Munch's reputation as a graphic artist, which was boosted still further by the appearance of Schiefler's catalogue of his prints, the first volume of which was published in 1907.[49]

Whether Klimt's use of such a similar compositional idea is an instance of direct influence, or borrowing, cannot be established with absolute certainty. He may have been affected by Munch's handling of the same subject, and for this reason may have deliberately incorporated the device of the caul-like shape that is so striking a feature of the composition, while at the same time giving it his own, distinctive, decorative treatment;[50] or he may have arrived at the same compositional idea quite independently. In favour of the former hypothesis is the fact that, as Nebehay notes, it would sometimes take Klimt a period of years to absorb a particular visual stimulus and rework it on his own terms.[51] Thus, a considerable interval between his discovery of Munch's art, which probably occurred as early as the turn of the century, and any visible trace of its influence upon his own painting would be entirely consistent with his development and working methods.

～

We have seen how Klimt's various treatments of the theme of embrace form part of a complex web of related motifs and compositional ideas, stretching across a wide range of works executed at various times and under different circumstances. On closer examination, this "cyclical" manner of working turns out to be characteristic not only of *The Kiss* and its relatives but of his figure paintings as a whole, among which there exist (or existed) only a relatively small number of totally independent compositions—independent in the sense that they are thematically unrelated to any of his other works. Even a painting such as *Pallas Athena* of 1898 (cat. 11), which might at first sight appear to fall into this category, is on closer inspection not really "free-standing" in the sense here discussed, since the same female head was given graphic treatment in the form of a vignette entitled *Ars* that appeared in the pages of *Ver Sacrum* (fig. 15);[52] while the tiny Nike-figure (the frontal, standing nude with outstretched arms, set against the gilded backdrop of the goddess's armoured breastplate) is clearly related to *Nuda Veritas*. A handful of other works, for example *Danae* (1903–07?)[53] or the two versions of his *Judith* (or *Salome*, 1901/1909), might perhaps be considered as standing apart from the rest of Klimt's oeuvre, having—at least at first sight—no direct or obvious relationship to his other figural compositions.

However, by far the greater number of his mature figure paintings have an overt or latent content that links them in one way or another to his monumental decorative works of the years around 1900: first and foremost the three University paintings, *Philosophy*, *Medicine*, and *Jurisprudence*, then the figural components of the *Beethoven Frieze* which, as already proposed, marks a further development of the same stock of ideas. The entangled human forms that inhabit both *Philosophy* and *Medicine* even find a distant echo

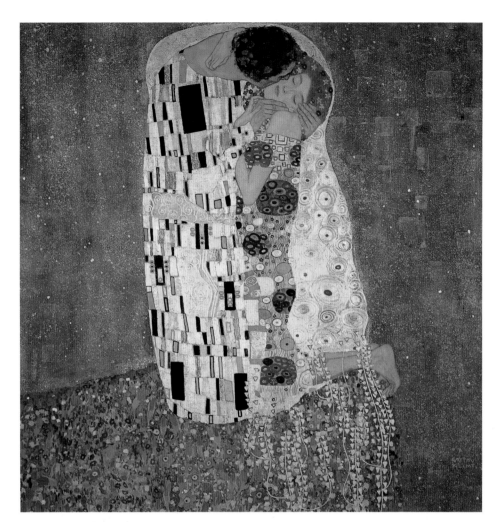

FIGURE 13
The Kiss 1908
Österreichische Galerie
Belvedere, Vienna

FIGURE 14
Edvard Munch
The Kiss 1897
Munch Museum, Oslo
© Munch Museum
(Andersen/de Jong) /
Munch Ellingsen
Group / SODART
(Montreal) 2001

FIGURE 15

Vignette of *Ars (Art)*
reproduced in
Ver Sacrum III
(1900), page 5

in a work such as *Water Serpents I* (fig. 16), despite its seemingly more "neutral" subject. This resemblance would at one time have been more striking than it now appears, since old photographs of the first state of the painting show that originally the female figures were far more emaciated, closer to the all-too-human flesh depicted in the University paintings than to the softer, almost ethereal forms which, in the reworked final version, now present themselves to our gaze.[54] There is also an evident similarity of figure and pose, rather than of subject or of theme, between the seemingly coquettish naked girl who, in *Goldfish* (fig. 17), takes evident delight in showing us her bottom, and the similarly positioned figure that occurs at lower right in the earlier versions of *Medicine*;[55] while the uppermost figure in *Goldfish* also conveys the impression that she might somehow have escaped from the same grief-stricken human chain, even though her facial features seem here to indicate a state of ecstatic self-oblivion.

Not only do individual figures and poses, examples of which have been cited above, occur and recur in different contexts and combinations across a wide range of other works; but also, both theme and import of the University paintings, and of the *Beethoven Frieze*, were to cast a remarkably long shadow over Klimt's subsequent oeuvre, giving the tone to later paintings. The sinister faces and menacing polyp that occur in the National Gallery of Canada's *Hope I* of 1903 (cat. 18) recall, of course, similar forms to be found both in *Jurisprudence* and in the "Hostile Powers" panel of the *Beethoven Frieze*, while the cycle of birth, procreation, and death represented in *Philosophy* is again invoked in the *Three Ages of Woman* of 1905 (fig. 18). The evident affinity between *Philosophy* and Klimt's *Procession of the Dead* of 1903 has been mentioned above. Equally obvious is the relationship with his later painting *Death and Life* (1908–11/1915, fig. 19),[56] which juxtaposes a skeleton holding a club with a chain of human figures resembling that found in both *Philosophy* and *Medicine*.

A similar complex of entangled, largely naked human forms constitutes the entire subject of another late work, *The Maiden* (also called *The Virgin* of 1912–13, now in Prague, fig. 20), leaving the viewer wondering whether the message of this picture should likewise be read as essentially pessimistic, despite its ostensibly different subject. Intriguingly, Klimt's last major figure painting, *The Bride* of 1917–18 (fig. 21), is so closely related to *The Maiden*, both in conception and as regards the reworking of individual motifs, that from a thematic point of view it might almost

FIGURE 16

Water Serpents I 1904–07
Österreichische Galerie
Belvedere, Vienna

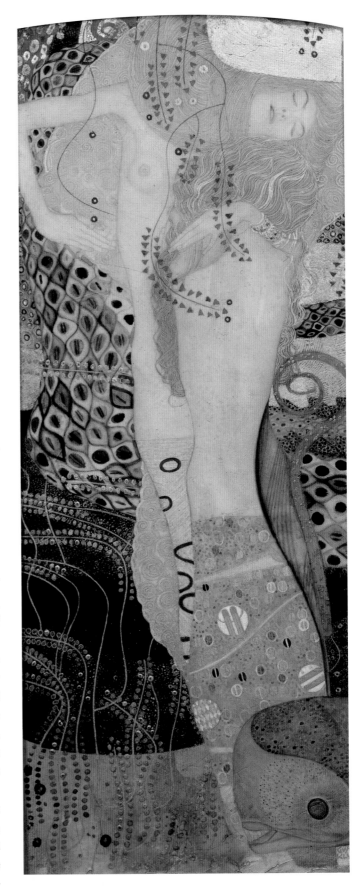

be regarded as a pendant to it, despite the different dimensions of the two pictures.[57] It is quite possible that, in working up his ideas for *The Bride*, Klimt may have turned for inspiration to drawings for *The Maiden* (see cat. 112–114) he had made up to five years earlier—as also apparently

happened in the case of *Danae*.[58] Such re-use of motifs
from earlier drawings, or significant lapse of time between
the exploration of compositional ideas in a group of draw-
ings and their ultimate realization in the form of a finished
painting, is also a frequently encountered characteristic of
Klimt's working method.[59]

A detailed study of the often complex relationship
between Klimt's paintings and his works on paper would
far exceed the scope of this essay, especially given the
prodigious quantities of his surviving drawings. Designs
seemingly flowed from his hand with a fluency and rapid-
ity that are bewildering when one thinks of his slow,
laborious, and often repetitive manner of painting in
oils. Sometimes, as in the case of his *Portrait of Adele Bloch-
Bauer I* (1907), historians have been able to identify up
to a hundred drawings for a single painting—drawings
(see cat. 82–84) in which Klimt would experiment over
and over again with different possibilities not only for the
composition as a whole but also for the pose of the figure
and even individual details of clothing and ornament. A
study of these drawings affords a valuable insight into
his method of working, highlighting, for example, his sur-
prisingly wasteful habit of exploring and developing but
also rejecting ideas that are sometimes worked up over a
long period in one or more series of related studies, elabo-
rated and adapted, refined and recast, only to be eventu-
ally discarded.

There also exist numerous fleeting sketches that
clearly were made just in order to capture a particular pose
or motif, or simply to keep his hand in. In certain instances,
even where an obvious relationship with a particular paint-
ing exists, it is difficult to believe that a given drawing
can ever seriously have been considered as an idea *for* a
painting—for example the studies of lovemaking couples
already referred to, which relate not only to *The Kiss* but
also (much earlier) to a painting such as *Philosophy*, and to
the chain of human figures there depicted.[60] Klimt was
already in enough trouble with this most public of com-
missions; surely, he can scarcely have contemplated repre-
senting the subject of sexual intercourse on a grand scale,
and in such explicit fashion, on a forty-five-foot-high ceil-
ing![61] Some of his most unashamedly erotic studies, on the
other hand, are so elaborate, and so highly finished, that
one might almost be tempted to think of them as presenta-
tion drawings—though for presentation to whom, or on
what occasion, is by no means clear. As already remarked,
what Freud once called "the misunderstood and much-
maligned erotic" runs as an important thread throughout
Klimt's work as a whole, evidently constituting for him a
constant source of inspiration—an inspiration reflected,
for example, in the extreme sophistication and delicacy
of his numerous representations of the theme of female

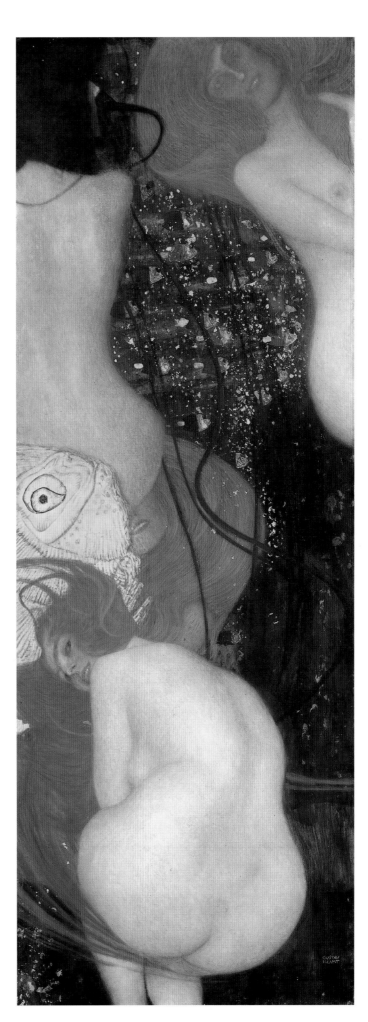

FIGURE 17
Goldfish (To my critics)
1901–02
Kunstmuseum Solothurn,
Switzerland,
Dübi-Müller-Stiftung

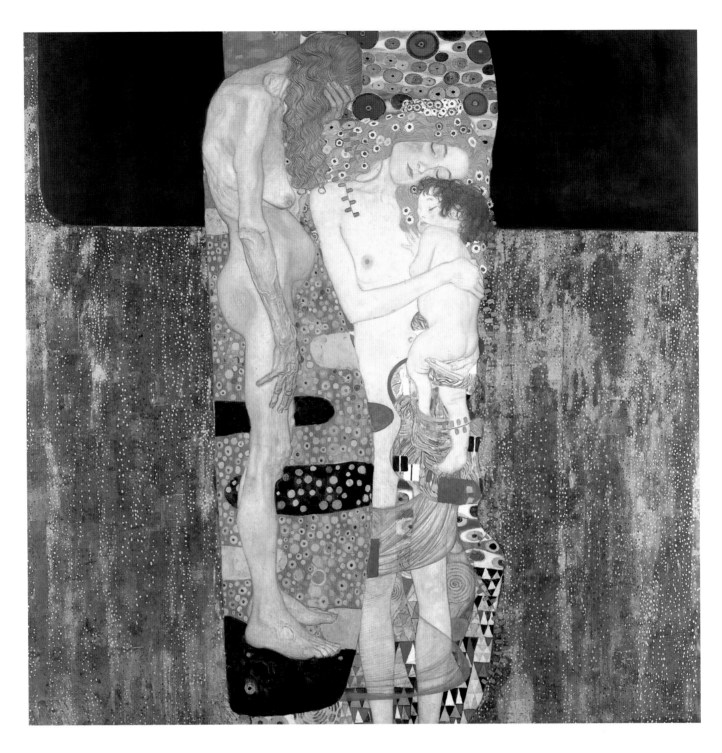

FIGURE 18
Three Ages of Woman
1905
Galleria Nazionale
d'Arte Moderna,
Rome

masturbation. Nor is it appropriate here to explore in detail questions raised by the chronology and accurate description of Klimt's drawings—tasks that still present formidable problems for the art historian.

These problems are only exacerbated by the artist's habit of experimenting with similar motifs or groups of motifs in drawings executed at quite different stages in his career. In many instances, only the apparent relationship with a securely identifiable painting enables one to assign a given drawing to a specific period or context within his oeuvre, rather than relying on stylistic criteria alone. Some drawings, however, bear no evident resemblance to any known composition; these, it has been suggested, are to be

thought of as studies for now unidentified paintings, rather than as independent sketches.[62] In other cases, the difficulty is of a rather different kind, since certain drawings appear to relate not just to one but to several paintings, done at different times and for different purposes. Curiously, this is true even of the portrait drawings, which one might have thought could be more easily arranged in some semblance of order. But for some of his portraits there exist literally dozens of drawings, utilizing every conceivable pose and format—sitting, standing, full-length, half-length, turned to the left, turned to the right. In some cases, it is difficult to rid oneself of the suspicion that a drawing which has been tentatively assigned to a particu-

lar group of studies might equally well relate to another, quite different portrait.

The same problem bedevils any accurate description not merely of those drawings apparently related to paintings such as *The Maiden* and *The Bride*, but also of numerous other works on paper that might be thought to occupy an intermediary position, summing up ideas and motifs already explored in earlier works while, at the same time, serving as preliminaries to others still to be created. As an example of this difficulty, one might cite a group of drawings iden-

tified by Strobl as related to Klimt's painting *Irrlichter* (*Will-o'-the-Wisps*, 1903, private collection), which the same author had previously associated with other studies for the *Beethoven Frieze*;[63] while another acknowledged connoisseur of Klimt's draughtsmanship considered at least one of the same drawings to be much earlier, identifying it as one of the preparatory studies for *Philosophy*.[64]

These uncertainties about the precise context within Klimt's oeuvre to which a particular drawing should be ascribed do not arise as a result of gaps in our knowledge,

FIGURE 19
Death and Life
1908–11/1915
Leopold Museum—
Privatstiftung, Vienna

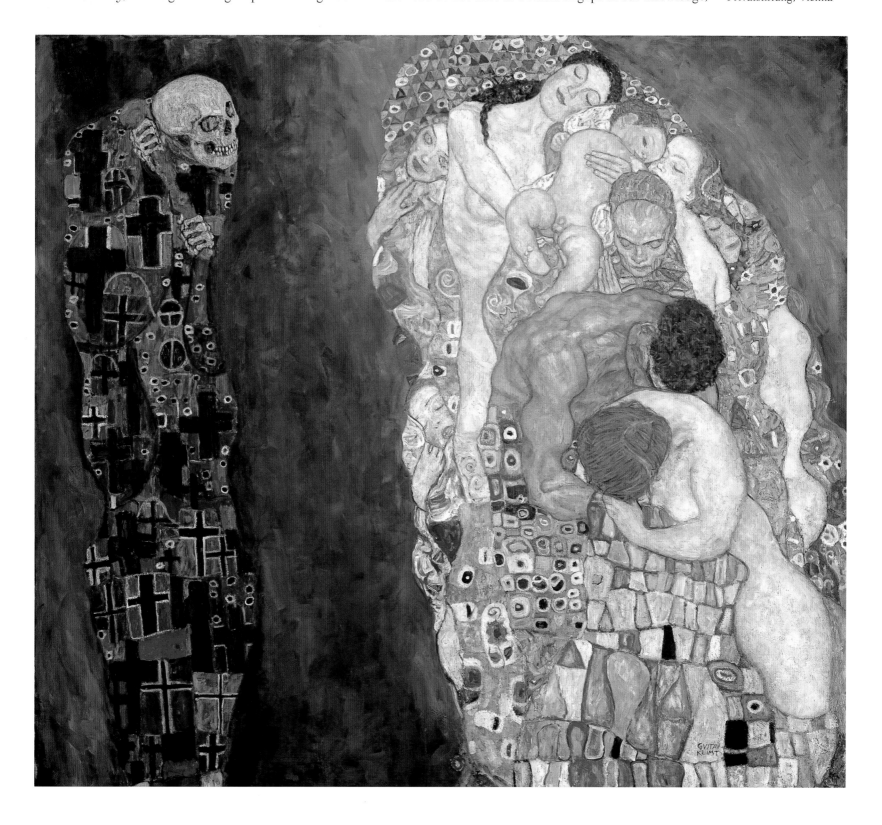

or of inadequate research—at least, not in most instances. Nor do they come about primarily as a consequence of a simple divergence of scholarly views. Rather, they have more to do with the very nature of the material, and with the oddities of Klimt's working method. It is as if, through his many hundreds, even thousands of figure drawings, the artist sought to keep constantly in mind an almost inconceivable number of motifs and poses, ready for a variety of possible uses. The fact that in these drawings the figures are, in the vast majority of cases, depicted naked has often been interpreted as evidence of his essentially academic training in life drawing and drawing from plaster casts, or of his preoccupation with classical models, or—more crudely—of his undoubted obsession with the domain of the erotic, and with the topic of (above all, female) sexual-

ity. But there is, I think, another possible explanation, which does not necessarily invalidate those already put forward, but which in a sense complements them.

The nude figures in Klimt's drawings are, quite literally, ready to be clothed in a manner appropriate to the role they are still waiting to be called upon to play in any given narrative—whether the scanty and insufficient covering of a shower of gold that falls between the thighs of an otherwise naked Danae, or the opaque but suggestive robes that conceal the embracing couple in *The Kiss*—figures which, as I have suggested earlier, are likewise surely naked beneath their garments. Perhaps one of the clearest instances of this phenomenon of figures "waiting to be used" (just as, we are told, his female models would hang about Klimt's studio for hours on end, not knowing whether or when

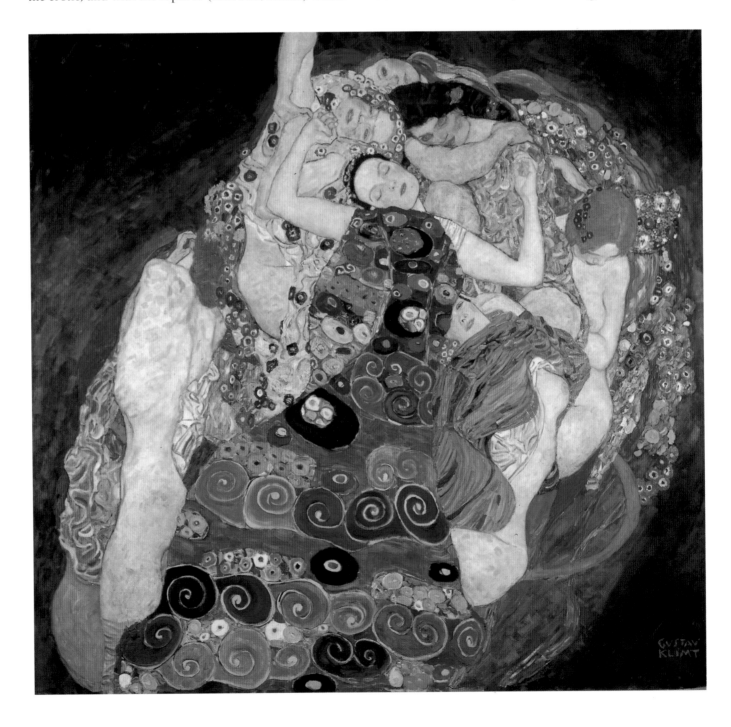

FIGURE 20
The Maiden 1912–13
National Gallery,
Prague

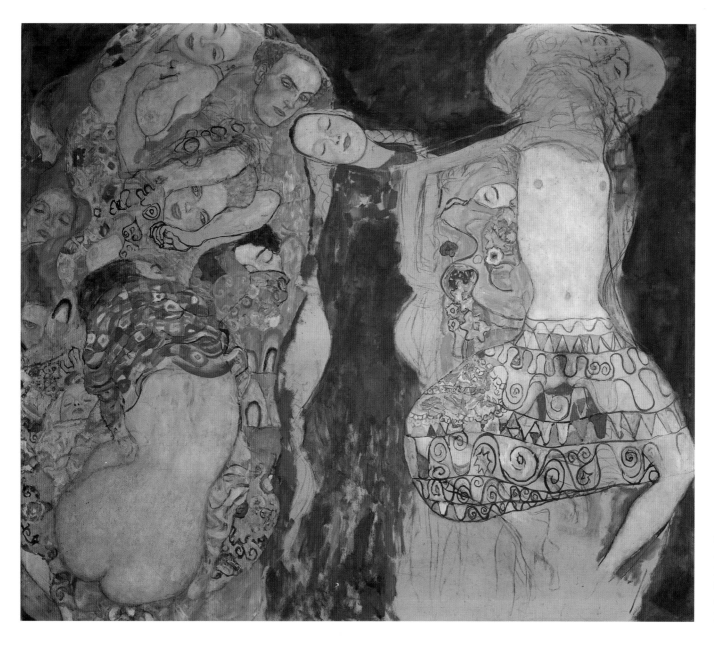

FIGURE 21
The Bride 1917–18
Private collection
On loan to the
Österreichische Galerie
Belvedere, Vienna

they would be required)[65] is a drawing dated by Strobl to the same period as *Medicine*, which appears to be related to other studies for the reclining female figure that occurs in the right-hand part of that composition, but which after a lapse of several years was eventually exploited as the basis for *Danae*.[66] Other examples of Klimt re-using earlier drawings that originally existed as figure studies in their own right before being "assigned" to any particular painting are legion.

More revealing still—in the most literal sense—is Klimt's last figure composition, *The Bride* of 1917–18 (fig. 21), left unfinished on the easel in his studio when he died in February 1918. Once again, it was evidently the nude model that served as his point of departure. But by comparison with his preparatory drawings, where the artist's handling of the naked figure is for the most part unremarkable, the working process here exposed is, by any standards, extraordinary. On the half-completed canvas,

the spreadeagled limbs of the female nude occupying the right-hand side of the composition are clearly visible beneath what are still only the beginnings of a decorated robe—yet another of Klimt's elaborate, patterned designs which, had he continued to work on it, would eventually have covered "a carefully detailed pubic area upon which the artist had leisurely begun to paint an overlay 'dress' of suggestive and symbolic ornamental shapes."[67] We might have suspected something of this habit of working, because of the existence of preparatory drawings for other pictures, where a figure that has remained naked until the very last stage in the presumed sequence of studies "suddenly" appears clothed in the final painting. This time, however, the process of gradual concealment to which *The Bride* testifies was never carried to completion. Too soon, the gaunt and bony figure of death whom Klimt had represented so often and in so many allegorical disguises came and took the brush from the master's hand.

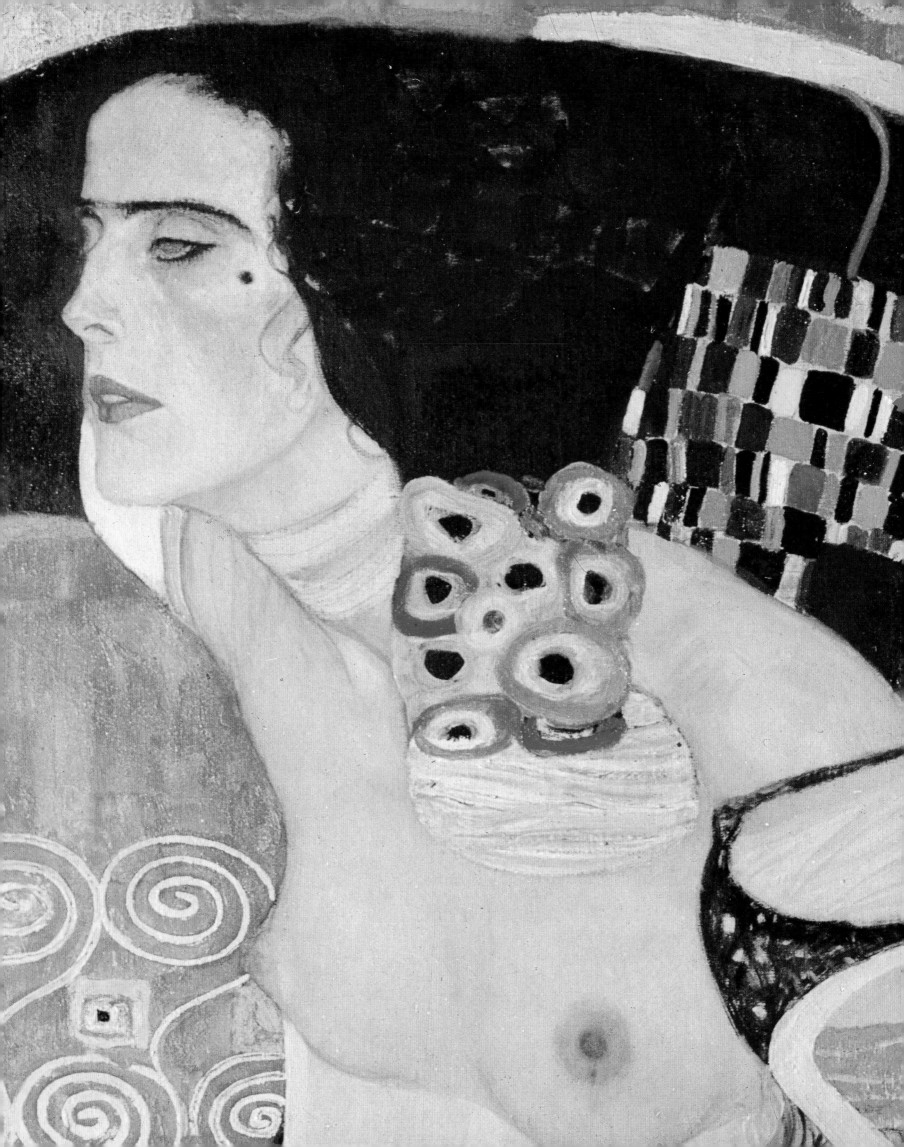

EMILY BRAUN

For Europeans, Klimt is an outsider. . . . It would be better not to compare him at all
to western ways. He is incomprehensible to the West, to the French and Germans,
and his art, for now, is rejected there. . . . He is conceivable only in Vienna, better
still in Budapest or Constantinople. His spirit is entirely Oriental. Eroticism
plays a dominant role in his art, and his taste for women is rather Turkish. . . .
He is inspired by the decorations of Persian vases and oriental carpets, and
especially delights in the gold and silver of his canvases.
—Anton Faistauer, *Neue Malerei in Österreich*, 1923

The culture of Habsburg Vienna has been described as one of paradoxes: nowhere is this more evident than in the critical fortunes of Gustav Klimt.[1] Today Klimt is admired among elite and mass audiences alike. His *Kiss* and other images of erotic bliss captured the popular imagination in the late 1960s, while at auction his works now command prices second only to Picasso and Matisse among twentieth-century artists. Yet for most of that same century Klimt's critical reputation lay dormant. His art was virtually unknown in North America until the Guggenheim Museum's *Gustav Klimt and Egon Schiele* exhibition in 1965; and although Klimt proved the focus of much of the Museum of Modern Art's 1986 *Vienna 1900*, the current exhibition at the National Gallery of Canada is, in fact, the first one-man museum show devoted to the artist on this side of the Atlantic. The rise of National Socialism in Germany and the aftermath of World War II, the postwar dominance of abstract over figurative art, the North American preference for things French, and lastly, Austria's strict cultural export laws—all have contributed to the belated reception of Klimt in Europe and America.[2]

This history of neglect stands in stark contrast to the sensational accolades and abuse heaped upon the artist during his lifetime in Vienna. The young Klimt rose to prominence as a talented architectural decorator. But his career experienced a meteoric rise on a wave of controversy, first as the leader of the youthful Secession movement in rebellion against the academic Künstlerhaus, and then over the now infamous rejection of the University murals commissioned by the Ministry of Culture. As was the case for many artists of the *fin-de-siècle* avant-garde, Klimt's reputation grew as much upon scandal as it did upon the quality of the work itself. Yet here another

paradox emerges: despite this notoriety at home and his ultimate recognition as "the greatest artist ever produced by the Imperial capital, or for that matter the entire Monarchy," Klimt drew little notice outside of Austria-Hungary and Germany.[3] Coming late on the heels of Symbolist developments elsewhere, and exhibiting abroad only sporadically, Klimt was barely considered by critics in France, and as a result, even less so in Britain, Belgium, and the Netherlands.[4]

When Klimt arrived on the scene at the Paris Universal Exposition of 1900, the French had come to terms with the extremes of Symbolist aesthetics and the social challenges posed by a modern culture of crises and "degeneration."[5] The unrelenting pessimism of Klimt's allegories was out of step with the progressive "organicism" represented by French Art Nouveau. More to the point, after a fleeting appearance at the Salon d'Automne of 1898, Klimt never again showed in any of the annual salons in the French capital, a fact that accounts for his conspicuous absence in the European art press during the first decade of the century. By contrast, foreigners such as Segantini, Previati, Hammershøi, Gallen-Kallela, Zorn, and the celebrated Spanish trio of Zuloaga, Rusiñol, and Sorolla enjoyed numerous notices and feature articles in the *Gazette des Beaux-Arts*, *L'Art et les Artistes*, and other mainstream art presses. Even personalities considered relatively obscure today—Frank Brangwyn, Josef Israels, Ivan Meštrović, and Oskar Zwintscher—not to mention Klimt's compatriot Hans Makart—received much more attention than he. One only has to look at Bénézit's *Dictionnaire critique et documentaire* to assess Klimt's critical reputation at the time, and how much values had changed by the end of the twentieth century: in the editions of 1913 and 1924 he merits only six lines, while

Opposite:
Detail of
Judith II (fig. 36)

41

FIGURE 22
Cesare Lombroso, c. 1900
Bildarchiv,
Österreichische
Nationalbibliothek,
Vienna

FIGURE 23
Installation view of
Klimt's paintings in
room 10 of the
1910 Venice Biennale
Archivio Storico delle
Arti Contemporanee,
la Biennale di Venezia

two columns of biography and stylistic analysis are devoted to the German Symbolist Max Klinger.[6]

Klimt's contemporary Felix Salten once asserted that "one can tell Klimt is a Viennese from the fact that he is honoured around the world and attacked only in Vienna."[7] True, Vienna had made a notable habit of maltreating its resident geniuses, among them Franz Schubert and Gustav Mahler. But while official rejection was still fresh in the minds of those mythologizing Klimt, the fact is that by 1908 the state had acquired two of his works, and the style of the early University murals had been superceded by his mature "golden manner." Moreover, the only official recognition Klimt ever received from the French was a medal at the 1900 Paris Exposition. The observation of another Klimt contemporary, the painter Anton Faistauer, rings truer: Klimt's career unfolded in Central and Eastern Europe and his insular exhibition history isolated him from the West. To this must be added the French bias in matters of art and race. At the turn of the century, the positivist method of interpreting style according to national, geographical, and racial characteristics was at its apogee. For Western European critics, Klimt's art inevitably represented a problem of identity—that of the Habsburg Empire itself, which consisted of a Germanic people presiding over a volatile mix of ethnic groups, languages, and religions, and which formed a gateway to the East that barely contained the threat of "otherness."

Austria-Hungary was a plurinational monarchy without unity, an empire colonized from within, a buffer between East and West, the offspring of Rome, Byzantium, and the Ottoman Turks. Not coincidentally, it produced some of the most significant theorists of both nationalism and difference, giving rise to modern fears of the dissolution of boundaries—be they social, sexual, psychological, or racial. Hans Kohn, the leading historian of nationalism, came from this "realm without a name," which was also the birthplace of both political anti-semitism and Zionism.[8] The term "homosexual" was coined by the Hungarian Károly Benkert in 1869, and came into common usage with Richard Krafft-Ebing's influential volume *Psychopathia Sexualis*, published in 1886 (and in English as *Sexual Deviancy* in 1892).[9] Fear of the New Woman found its most misogynist spokesman in Otto Weininger, whose notorious *Sex and Character* (1903) posited a biological essentialism that also aligned racial characteristics according to masculine and feminine traits. Lastly, Freud, perhaps Vienna's most famous resident, breached what was traditionally the most secure of boundaries—that between dream and reality. If, on the one hand, Austria brought to mind the fossilized monarchy of Franz Josef II, on the other, it heralded the disruptive forces of modernity: "sexual anarchy" and fanatical nationalism.

Also notorious was Max Nordau, author of *Degeneration* (*Entartung*, 1892), who hailed from an orthodox Jewish family in Budapest. Nordau transposed the mid-nineteenth-century criminal anthropology of Cesare Lombroso (fig. 22) into cultural criticism, positing a link between modern life and modern ills as made manifest in "sick" Naturalist and Decadent art. For Nordau as well as other scientific and cultural theorists steeped in social Darwinism, degeneration was equivalent to de-genderation, since most atavistic or primitive characteristics were perceived as feminine.[10] *Degeneration* was a best-seller across Europe and even with its detractors continued to influence the critical discourse of Symbolist painting and literature until the Great War. Nordau had cited Baudelaire as the primogenitor of European cultural decay, and his ideas had been fully absorbed by the French, particularly as part of the debate over the pathology of artistic genius. But for the French critics, steeped in a fear of German supremacy, Klimt's art mainly raised the issue of nation and race in Central and Eastern Europe: was his art Germanic, Slavic, Austrian, or Viennese, or a unique synthesis of all of these? And if Viennese, how did this cosmopolitan, supra-national identity represent the Empire at large?

The exception to the above history is Italy: for only in Italy did Klimt hold major exhibitions of his work, and only there did he enjoy a sustained critical following and purchases by state museums. And whereas French critics

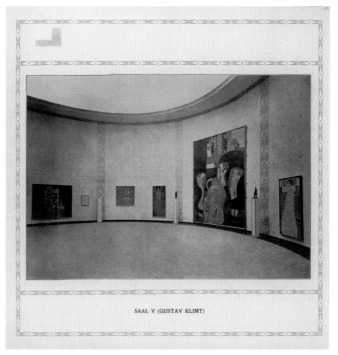

revealed their discomfort with—or lack of interest in—Austrian culture, the Italians were on intimate terms with it. Klimt first attracted minor notice at the Venice Biennale of 1899; his work and the illustrative style of *Ver Sacrum* then became known in Italian decorative art journals.[11] His major triumph abroad came at the Venice Biennale of 1910, where he was the subject of a stunning one-man exhibition with twenty-two works in a distinctive Secession-style installation by Eduard Josef Wimmer (fig. 23). The Klimt room proved a sensation again the following year in the Josef Hoffmann-designed Austrian pavilion at the *Esposizione internazionale* in Rome (fig. 24). Although Italian artists had been traditionally drawn to Munich or Paris for training, Klimt and the Secession provided the impetus for their own artistic splinter groups: the exhibitions of Ca' Pesaro in Venice (1908–1920), an organization for younger artists barred from the juried shows of the conservative Biennale; and the Rome Secession, founded in 1913 as an alternative to the stodgy Società Amatori e Cultori.[12] In 1914, Klimt returned the compliment by participating in the second exhibition of the Rome Secession (fig. 25), just a year before Italy entered the war against Austria and Germany.[13]

Aside from the impact of the sheer presence of his works, there are other reasons for Klimt's success south of the Alps. As in Austria, modernism came late to Italy, appearing in isolated pockets in a barely unified, strongly regionalist state. Symbolism in the visual arts emerged only in the 1890s, overlapping with Impressionist and Neo-Impressionist influences. Art Nouveau, or Liberty style as it was called, did not officially arrive until the *Esposizione internazionale degli arti decorative* in Turin in 1902.

Inaugurated in 1895, the Venice Biennale was the first venue to exhibit outside trends, but the artists chosen to officially represent their nations were of a conservative bent. For example, in 1910 Courbet and Renoir received their first Italian exhibitions; the former had died in 1877, and the latter was sixty-nine years old. It was only the following year that Ardengo Soffici penned the first article on Picasso and Braque, in the pages of *La Voce*.[14] In this context, Klimt's relatively late arrival heightened the critics' perception of his innovative style. At the same time, the predominance of the Decadent literary aesthetic in Italy—led by the giant figure of Gabriele D'Annunzio—had prepared the ground for a particular interpretation of Klimt's ornamental, oriental, and hence "feminine" art.

Furthermore, Italy was bound to Austria by geographical proximity and two centuries of cultural exchange, not to mention political enmity.[15] For the better part of the nineteenth century, Vienna ruled over Lombardy and the Veneto, and did its best to impede the Risorgimento by using its army to crush popular uprisings elsewhere on the peninsula. After unification in 1870, the new Italy normalized relationships with the Habsburg Monarchy, forming the Triple Alliance with Germany in 1882. Yet political tensions remained because of the irredentist movement, that is, the Italian claim to areas of the Trentino,

Dalmatia, and the Istrian peninsula, as well as the city of Trieste. In 1915, these disputed areas proved the bargaining chip for Italy's entry into World War I on the side of England and France, against her longstanding military allies.

Yet since the turn of the century, northern Italy looked to Austria for much of its contemporary culture, and was well versed in its music, literature, and Secession-style architecture. Essays on Schnitzler, Hofmannsthal, Weininger (who had particular currency in Italy), and Moravian and Bohemian artists, not to mention Balkan folk art, appeared in leading cultural journals of the day, with *La Voce* and *Emporium* at the forefront. The latter journal gave significant coverage to artists of the Habsburg Empire, including feature articles on Josef Mehoffer, Viktor Stretti, and Ivan Meštrović—a journalistic prize that eluded Klimt, despite his other Italian successes. The intimate relationship between Austria-Hungary and Italy, however, is best revealed by the city of Trieste, at that time Austrian-ruled but populated by an Italian majority whose writers—among them Italo Svevo and Umberto Saba—were distinctive products of a "Mitteleuropea" culture. The Trieste question was the subject of regular reports in *La Voce* by native sons Scipio Slataper and Giani Stuparich, among others. The conduit for Freud's influence in Italy before the Great War, Trieste was also the point of deportation for the majority of Italian Jews who died in the Holocaust. In short, though a Latin sister, Italy was closely bound to her Habsburg neighbour; so much so that in 1910, in the pages of *La Voce*, Giuseppe Prezzolini voiced the question facing his generation: "Austria or France?"[16]

The Italian literature on Klimt is worth probing, not only for its sheer depth but also for the perspective it provides on the artist's reputation as a whole. The critics who chose to write on Klimt include rank-and-file art journalists, but also the most important cultural critics of the time: Vittorio Pica, Ardengo Soffici, Ettore Cozzani, Enrico Thovez, Gino Damerini, and Emilio Cecchi. On the one hand, this body of criticism rehearses the history of the University paintings scandal and the chief points of contention: the abstruseness of his allegories and the pornographic depiction of the female nude. On the other, it gives objective distance—geographic and historical—in assessing Klimt's position in the wider European context of Symbolist aesthetics. In this context, Klimt's art was framed within pre-established notions of "art for art's sake," the decorative, and degeneration. Nor was his reception entirely favourable, but typically aroused "love or hate" reactions, in keeping with the sexualized themes of his art. Similar to the pendulum swings of notoriety and neglect that Klimt's work has endured over time, the critical discourse of the period is subject to extremes, marked by

devotion or obloquy, mania or phobia. In an age obsessed by neurotic illnesses, Klimt's critics treated his art in terms of pathology: the work of a madman or of a genius. Here, too, the Italian example is instructive, given the direct influence of Lombroso and Nordau on cultural criticism of the period. Lastly, in their detailed analyses of Klimt's ornamental style, the Italians addressed, with startling acuity, the main issue still surrounding Klimt: was he the last "artificial" *fin-de-siècle* artist or the first "genuine" modernist?

～

The initial notices of Klimt abroad appear in the context of large international exhibitions at the turn the century, where he was part of the Austro-Hungarian contingent, and competing—at a disadvantage—with other nations for attention. As an unknown artist presenting few works, he received only passing remarks, although some already singled him out among his Central and Eastern European peers. Foreign reviews of the newly founded Secession were rare, one example being a favourable article in *International Studio* of 1899 on the group's second show. Focusing on the applied arts, it skirted Klimt but did make a point of reproducing his *Portrait of Sonja Knips* (fig. 26)—the only early work to be widely featured in journals of the day. Observing Vienna's contemporary art world, the reviewer took pains to note that "Austria cannot be termed a nation properly speaking, but a conglomeration of different races— Germans, Hungarians, Slavs, Poles. This will account for a certain want of any distinct national feature . . . instead we have a number of separate individualities . . . each more or less developed in its own direction and influenced by local affinities."[17] While this attitude toward Austria-Hungary prevailed among foreign critics at the turn of the century, encouraged by the heterogeneity of artistic styles and ethnic identities, the rise of the Secession was seen as the first inkling of a distinct "Viennese" style.

The Venice Biennale of 1899 served as a prelude to the Universal Exposition in Paris the following year. Austrian and Hungarian artists formed a small group under the auspices of the Germans, predetermining critical perceptions. (Austria did not have a separate exhibition until the Biennale of 1907.) As Vittorio Pica put it, Latin artists had little to learn from the Germanic tendency to "morbid fantasy and caricature." Nevertheless, he did have hopes for the emerging Secession artists, whose decorative arts showed "a refined elegance and, above all, a delicate good taste that one searches for in vain in Germany." As to easel painting, Pica noted that it was too early, and the works too few, to determine whether the Secession would finally give rise to an "indigenous" art still lacking in Austria. And Pica, one of the first champions of French Decadent literature in Italy, praised Klimt's *Moving Water* of 1898 (cat. 10) in the sexualized aesthetic terms that would come to typify

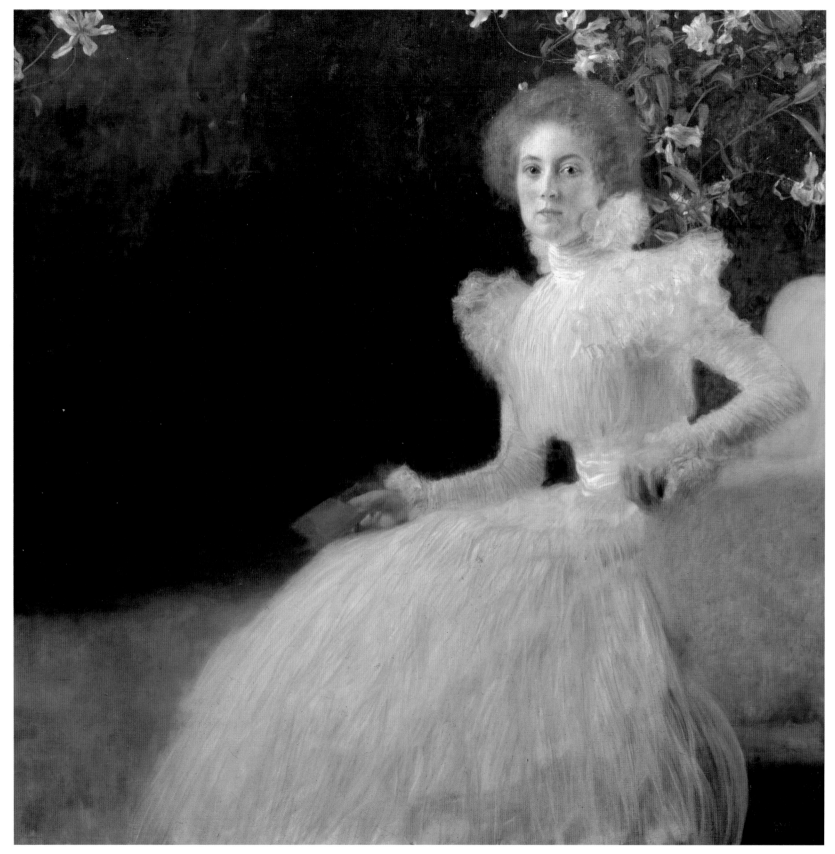

FIGURE 26
Portrait of Sonja Knips
1898
Österreichische Galerie
Belvedere, Vienna

his favourable appraisal abroad: "Exquisitely elegant and so pleasurable to the eye with its seductive, decorative grace."[18]

At the Paris Universal Exposition of 1900, Klimt received little press in the context of an empire given even shorter shrift by the European critics. Austria was represented by a neo-baroque pavilion, one of several historicist buildings along the Quai des Nations (fig. 27); and it promoted its state system of arts education with an impressive show of recent Jugendstil achievement in the decorative arts—both of which drew high praise from foreign critics, including Roger-Marx, the leading French arts and crafts proponent and cultural administrator.[19] Competition was stiffer and more direct, however, in the national exhibitions of painting and sculpture—the Exposition Décennale— assembled at the newly built Grand Palais. The latter also housed the much larger Exposition Centennale, a grand celebration of French painting of the previous century, which, as the organizers intended, left no doubt as to the host country's supremacy with brush and chisel.[20] While many French critics chastised this greedy and blatant self-promotion, they inevitably based their positive appraisal of foreign artists on the apparent influence of the French School. French cultural imperialism was in large part prompted by German military and industrial might, and occasioned considerable disdain for the artistic production of Central and Eastern Europe. To be sure, Germany and Austria-Hungary were also less advanced in modernist trends. After France, the most accolades were received by Belgium, Great Britain, the United States, and the Scandinavian countries. Although reviewers singled out the Austrian installation design (fig. 28)—matte-silver

wall coverings embellished with Jugendstil motifs and set within incised wood panels—the works themselves merited few, and mostly patronizing, comments.[21]

The Exposition Décennale served to highlight "the particular character of the art of each nation," providing the critics with a predetermined task. In the case of Austria-Hungary, reviewers uniformly bemoaned the hodgepodge of styles. The presentation of two conflicting schools—the "German influenced" academics and the younger modernists of the Secession—as well as the diverse regional components led to the perception of superficiality and dissonance. Here too, the depiction of peasants in traditional costume, a common image of national identity in exhibits ranging from Sweden to Italy, did little to foster the impression of unity in the Austro-Hungarian Empire. Léonce Bénédite, writing in the *Gazette des Beaux-Arts*, supplied the harshest appraisal: "Here we have a mix of all sources and schools that lacks conviction and produces a facile and dangerous dilettantism, for the most part without any great interest."[22] Yet important critics such as Arsène Alexandre and Julius Meier-Graefe heralded the advent of the Secession as a progressive force, invigorating "the pictorial empire of Hans Makart and Munkácsy."[23] And as the centre of innovation, Vienna imparted its characteristic "flowing elegance" and "abundant vitality," with an urbane refinement unique to the cosmopolitan imperial capital. Indeed, one lone critic, ideologically at odds with

the nationalism pervading the Exposition, hailed Viennese culture as a superior example of cultural unity within diversity:

> There is a particular artistic atmosphere in Vienna, the meeting point of so many races, where the blood of each runs through the life of the whole. Viennese art is like the Viennese: neither German nor French, nor Italian, nor Hungarian, but a bit like them all. Its originality and flavour derive from these different peoples, finding something of themselves in a totality which is not themselves. And discovering these shared affinities pleases all.[24]

Within this emerging Viennese modernism, however, no single artist was seen to carry the day: Klimt stood out largely because the scandal of the University commissions had preceded him. He exhibited three works—the controversial *Philosophy* (the first panel of the commission), *Pallas Athena* (cat. 11), and the *Portrait of Sonja Knips* (fig. 29). It was for all intents and purposes his major European debut, and reactions were mixed, especially over *Philosophy* (fig. 30). In many cases his name appeared in little more than a roll call (and was misspelled more than once). Prominent critics of the period, such as the Belgian Émile Verhaeren who also wrote for the *Mercure de France*, and Octave Mirbeau, never even considered Klimt—at the Exposition or at any other time. Within the Austrian section he also competed for attention with the Polish artist Josef Mehoffer (1869–1946), whose *Chanteuse* was an unqualified success. In a telling installation shot of the Austrian section, featured in one of the special publications devoted to the fair, Mehoffer's painting is seen at centre, with *Pallas Athena* off to the side, and *Philosophy* mostly cropped from view (fig. 31).

While foreign critics uniformly commended Klimt's *Sonja Knips* (dubbed the "Lady in Pink" for the apparent influence of Whistler's colour harmonies), they had to admit that the Viennese critics of *Philosophy* were somewhat justified. To paraphrase the most common complaints: it was hardly lucid as an allegory, badly drawn, and did nothing for Klimt's reputation as a colourist. Some agreed with Vienna that the murky space and anguished bodies obscured, rather than clarified, the human condition. Several made an unfavourable comparison of Klimt's effort as a decorator with that of the French painter Albert Besnard, whose murals decorated the Sorbonne's Faculty of Chemistry and the ceilings of the new Petit Palais. Although Besnard's allegories also emphasized the female body amidst swirling organic forms, his fluid, light-filled compositions and unquestioning faith in natural science provided a marked contrast to Klimt's dark refutation of progress.[25] Even Vittorio Pica, while lauding Klimt's decorative sense, found the content "abstruse." The least charitable voice was that of Rowland Strong of the *New York Times*, who in writing of Herr Klinst's [*sic*] picture echoed the objections of the Viennese professors, "frankly a failure,

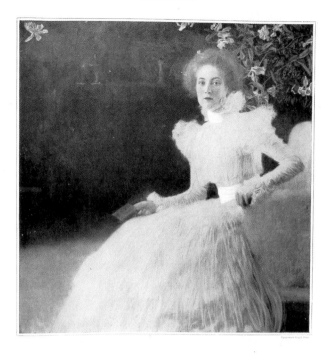

FIGARO ILLUSTRE

G. KLIMT. — PORTRAIT

FIGURE 29
Portrait of Sonja Knips reproduced in *Figaro Illustré*, October 1900

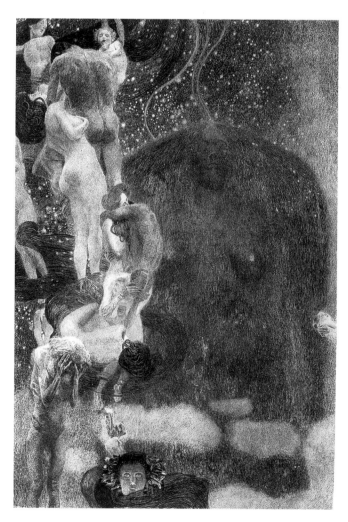

FIGURE 30
Philosophy (first state) 1899–1900, later overpainted Destroyed by fire in 1945

FIGURE 31
Installation view of
Austrian art at the
Paris Universal
Exposition 1900
with *Pallas Athena* and
Philosophy to the right
From Julius Meier-
Graefe *1900 Die
Weltausstellung in Paris*,
Paris and Leipzig, 1900

FIGURE 32
Cover design by Ivan
Meštrović for the
catalogue of the Serbian
Pavilion, *Esposizione
Internazionale*, Rome 1911

being hopelessly confused in design . . . *Philosophy* has little in common with this multi-coloured smoke of tears and passions whose clouds it should surely seek to dispel." By contrast, Arsène Alexandre found its "strangeness" compelling and profound, and the French judges were sufficiently impressed to award this newcomer the Grand Prix, one of twenty medals of honour at the Exposition.[26] As Meier-Graefe summed it up, "*Philosophy* raised a storm of indignation and enthusiasm in Vienna, and here in a neutral setting, one sees both points of view."[27]

It was Klimt's first and last exhibition in Paris during his lifetime. As late as 1907, one rare review in the French press devoted to a Klimt exhibition in Berlin continued to focus on the history of the University murals. Split between dream and reality, Klimt's work was seen to be strongest in the rendering of human anatomy and weakest in its "Barnum and Bailey" approach to sensationalist imagery.[28] Indeed, the combination of the pessimistic and the decorative was just too foreign for Western tastes. More to the point, Klimt's reception abroad was blocked by huge distances—cultural as well as geographic—manifested by consternation towards the Austro-Hungarian mosaic. "To tell the truth, in Austria, art, like politics, is widely dispersed as the result of contrasting nationalities—Germans, Czechs, Poles, Hungarians—and hence, one finds there a hostility among diverse tendencies—ancient, modern, and ultra-modern," wrote one observer in 1912.[29] The story of the Secession itself, fraught with internal

divisions and short-lived, did not simplify matters for outside chroniclers. In his milestone history of modern art based on the primacy of French Impressionism, Julius Meier-Graefe, himself the son of a Jewish industrialist from Bohemia, glossed over Austria and then favoured Kokoschka over Klimt. One must wait until 1928 for Henri Focillon's book on modernism to find a full and favourable paragraph on Klimt, but here, too, the Secession is viewed as a mere preamble to the more important influence of Cézanne on postwar Austrian art.[30]

The credit for the exceptional notices on Klimt in the French press before World War I must go to the Swiss-born critic William Ritter, who wrote as the Central and Eastern European correspondent for the *Gazette des Beaux-Arts*, *L'Art et Décoration*, and *L'Art et les Artistes* during the first decade of the century. He was also a regular contributor to *Emporium*. Ritter's interpretation of Klimt is found above all in his series of reviews for *L'Art et les Artistes* between 1908 and 1912, which forms a small but important body of writing undocumented in the Klimt literature.[31] An expert on Slavic art and music, he writes from the perspective of a non-Germanic "insider," and views Klimt along with Mahler as the unifying powers—the "Emperors" no less—of Austro-Hungarian culture. The heterogeneity that French critics denounced as a weakness, Ritter extols as a strength. His texts position the Secession, and Klimt's art in particular, as super-national forces that transcend longstanding conflicts by embodying characteristics of the Empire's diverse constituencies. Hence, for Ritter, the essence of Klimt's style cannot be understood without acknowledging the Slavic, Byzantine, and folkloric elements that emerge in a new synthesis out of the "Viennese melting-pot." Indeed, the modern Austrian style is the modern Viennese style—universal and cosmopolitan—as the ethnic variety of the Secession artists themselves attests. Ritter's ideological position echoed, intentionally or not, the official line of the liberal Ministry of Culture, which had earlier supported the Secession (and international modernism) in an effort to alleviate the political divisiveness of ascendant nationalisms.[32]

Klimt first comes to prominence in Ritter's review of the artist's one-man exhibit at the 1908 *Kunstschau* in Vienna, one of the pinnacles of his career. Ritter admits that for a long time Klimt's talent was questionable, but with this exhibition (in short, with his golden period) he emerges as "an unadulterated genius."[33] From a mere painter of architectural decor he has turned into a modern master, absorbing and surpassing all the international currents, from Neo-Impressionism to Symbolism, that emphasize the two-dimensionality of the picture plane. At the same time, Klimt's art is distinctly Viennese, because of its material preciosity and fascinating strangeness. For Ritter,

Klimt's "universality" is above all evident in his portraits of modern society women, "surrounded by golden grounds strewn with the eyes of peacocks' feathers," encrusted panels that blur the boundaries between art and ornament, East and West, modernism and archaism. Notably, Ritter never discusses allegorical content—the bane of many critics confronting Klimt's art—but focuses on style as an index of Austro-Hungarian identity and cultural politics: "That special model of Alexandrinism, produced here at the gateway of the Danube, with the junction of three or four races and religions, and dozens of nationalities."

Ritter acknowledges that after Klimt, other Austrian painters may appear merely "as ethnographic curiosities," but this would be to overlook the "reciprocal influences" that run between international modernism and indigenous styles, especially the "vital juices" of the Slavic schools. Currents from Impressionism to Symbolism have been absorbed in Prague, Cracow, and the farthest corners of the Empire; while Klimt and Mahler "would not have been possible but in an Empire where the Slavic element predominates." This mix is unparalleled elsewhere in Europe, as is the continuing vitality of the influence of regional art on the modern culture of the capital. Not surprisingly, Ritter observes, these factors have impeded an understanding of Klimt and Mahler, especially on the part of German and French critics. Splendour and synthesis form the "tradition of modern Vienna, a city which, let us not forget, is no longer German, but Slav, Italian, Israelite, as much as it is German." Between the lines of aesthetic discourse, Ritter makes the political argument against German

cultural hegemony, in favour of an invigorating ethnic diversity.

But the reality of national self-determination within the Austro-Hungarian Empire was otherwise, as is evident in Ritter's own coverage of the "Meštrović affair." The "two, very different sides of the Austrian situation," as he put it, were on view at the 1911 Rome exhibition: Klimt's triumphant display in the Austrian pavilion and the Croatian sculptor Ivan Meštrović's defiant decision to exhibit under the auspices of Serbia (fig. 32). The Dalmatian-born sculptor, known for his monumental figures rendered in a severe "Asiatic-Assyrian" style, had exhibited with the Secession and at the Salon d'Automne.[34] His patriotic subjects, with their allusions to the tyranny of foreign domination in the Balkans, had already aroused the irritation of Austro-Hungarian officials when exhibited in Vienna and Zagreb in 1910. Even more threatening was the figurative ensemble officially given to Serbia to display in an international context—sculptural fragments for an enormous temple commemorating the battle at Kosovo in 1389 (fig. 33, 34).[35] The mythic power of this historic event—the defeat of the Eastern Orthodox Kingdom of Serbia, and subsequent five-hundred-year dominion by the Muslim Ottoman Turks—has repeatedly served to incite nationalist ardour and religious hatred in the Balkans. Despite the recent Serb-Croatian conflict, at the turn of the century, the independence of Croatia from Austria-Hungary was linked to Serbia and a united "southern Slav" state.[36] Meštrović's decision to show with Serbia, notwithstanding Austria's last-ditch attempt to secure his work for its pavilion, was

FIGURE 35
Schloss Kammer on the Attersee II 1910
Private collection
Exhibited at the Venice Biennale 1910
and the *Esposizione Internazionale,*
Rome 1911

an outright political move. As the sculptor stated in his accompanying manifesto, quoted at length by Ritter: "Serb and Croat—these are two names for one and the same nation. But it is under the name of Serbia that it will win its independence and national freedom." Needless to say, one can imagine the effect these words had in Vienna and Budapest; according to Ritter, the Empire "must now find another sculptor to replace Meštrović," who along with "the two Gustavs, Mahler and Klimt" had formed the "glorious trinity of Austro-Hungarian art."[37]

Meštrović and the Serbian pavilion of 1911 also attracted a flurry of attention from Italian critics, who zealously embraced his insurgent nationalism, given Italy's own recent fight for independence from the Austrian yoke. For sheer volume of print, Meštrović easily rivalled Klimt, but as an artist, he could not compete with the "strange and impetuous personality" of his Viennese peer.[38] Klimt's shows in Venice and Rome were among his largest ever, affording critics a full survey of his development and his distinctive "manner of gold, silver, and mother-of-pearl."[39] Paeans to the religion of art and to Klimt's creative genius, the two installations were specially designed with white walls and abundant space and light, accentuating the pictorial intensity barely contained within the frames. The purity of the Secession-style interiors showed off his shimmering

compositions "like the setting of a ring designed for a special gem."[40] That Klimt's room at the Biennale fell between those of Josef Israels and Oskar Zwintscher only accentuated its dazzling impact. And in the 1911 national pavilion, all the other exhibits—including a tribute to Ferdinand Georg Waldmüller as the father of modern Austrian art—came across as "the mere pronaos of the temple to Klimt."[41]

Without any of the political subtext of the French criticism, the Italian reviews delve into the intricacies of Klimt's style; to use Pica's terms, one might well say that the critics were "seduced," and many responded with a prose that sought, by analogy, to reproduce Klimt's scintillating visual effects and ornamental richness. Revelling in its stylistic excess, critics alternatively heralded or disparaged his art as evidence of a gifted neurasthenic or raving madman, of health or decay. Klimt's work became the focus of debates on modernism itself, specifically the ideal of the decorative and its ability to alter mood and ambience. One of the central issues was the conflict between Klimt as an allegorist and Klimt as a pure painter, between the symbolic and the sensory, and serious critics were fiercely divided over the compatibility of the two. To be sure, the presence of *Jurisprudence* (fig. 4)—the third of the University panels—led to a renewed discussion of the scandal, but the Italian literature ultimately moved beyond anecdotal narrative to become among the most probing ever written on the artist.[42]

Critics pro and con analysed Klimt in the context of Decadence, a movement defined by an overemphasis on style and surface, on a surfeit of textual opacity and quotation. Inured to the prose and images of D'Annunzio (an immanently pictorial body of writing), they could immediately identify with Klimt's indulgence in exotic sources and enervating consumption of beauty, not to mention the languid female sexuality. Ettore Cozzani, editor of the Liberty-style journal *Eroica*, and promoter of the Italian Symbolists Adolfo De Carolis and Giulio Aristide Sartorio, provided the finest assessment of Klimt—"the orchid"—as a master of artifice. The artist's arbitrary stylizations may deform and abstract, but they ultimately serve to intensify our understanding of the essence of things. For Cozzani, Klimt belongs to the same aristocracy of the senses as Baudelaire and Oscar Wilde. Their "abnormal vision" creates an "art of exception" and demands a similar over-refined sensibility on the part of the viewer. Barely concealing his contempt with mocking humour, Cozzani comments on those younger artists averse to Klimt's sumptuous domain: "For them, this is the garden of sin, where temptations grow and the satanic *fleurs du mal* bloom in a thousand perverse forms!"[43]

Cozzani, Pica, and others extolled Klimt as "the greatest decorative painter of our time," for his "intense optical

sensations and refined cerebral impressions" designed specifically to mesmerize the viewer.[44] Yet his "audacious fantasy" was easily parodied by those who had no patience with the profusion of "checks, arabesques, volutes, curlicues, stripes, tendrils, all encrusted, inlaid, and embedded in a most absurd way."[45] Viewed by his detractors as sensationalist rather than serious, Klimt's pictorial effects were likened to carnivals, kaleidoscopes, and fireworks. His landscapes were the most derided (fig. 35)—often as pavement or tapestry posing as painting. Their cropped views, mottled gradations, and seemingly infinite brushstrokes gave rise to a "disorienting" blur in more than one viewer. "I find them indecipherable and tenaciously so," wrote Mario Pilo, "but someone more patient and believing perhaps would be able to recognize *The Park*, *Orchard*, *Roses under Trees*, *The Pond*, or *Blooming Meadow* [cat. 27, 21?, 20, 28, 22?], which for me continue to look like a crazy dance of multi-coloured paper or fabric samples, jettisoned by the handful, pell-mell, out the window."[46] To such incomprehension Cozzani retorted that there is "no other vision, no other technique that so emphasizes the dimension of the picture plane"—in short, a defence of modernist abstraction. So calibrated was Klimt's deforming vision, so sure his mastery of "pure form" and the "purely decorative," that to change the measure of the canvas by but a few centimetres, Cozzani asserted, would be to destroy the whole effect.

"Illogical," "disorienting," "vague," and "besmeared"—the disparaging adjectives commonly used to describe Klimt's style were equated with symptoms of a psychic disorder; this was nothing less than the rhetoric of sickness or degeneracy. Klimt's gloomy outlook and insatiably ornate surfaces, his coiled serpentine lines and palpitating strokes all conformed to Nordau's definition of the *fin-de-siècle* malaise—the decay of the brain and nervous system from the overstimulation of modern industrial society. Among other "visual derangements," writes Nordau, the hysteric or neurasthenic painter "perceives the phenomena of nature to be trembling, restless, devoid of firm outline"—characteristics applied verbatim to Klimt's landscapes.[47] Drawing from Lombroso's theories on the atavistic physiognomies of criminal types, Nordau argues that cultural degeneracy has similarly resulted from regressive evolutionary development. Modernism, that is, aestheticism, runs against human progress. For Nordau, cultural norms are based on the clear, the practical, the disciplined, the moral—all stereotypically masculine qualities. Accusations against Klimt of being artificial and perverse similarly follow Nordau's stereotype of the decadent artist as "morbid deviation" from an original, healthy type.

Was Klimt a gifted visionary or simply a madman who was unable to see straight? As Gino Damerini explained in his laudatory article on Klimt: "The function of artistic genius is to create outside the pre-established confines and so expand the realm of the senses, the mind, and consciousness."[48] Here, considerations of the artist revolved around the relationship between genius and mental illness, a common concern of Symbolist aesthetics. Lombroso intimately connected the two pathological conditions: genius and madness were both abnormal, but potentially inspiring, since they unleashed the imaginative faculties in excessive, irrational ways. While Nordau considered such delirium "unhealthy" in the cultural realm, the Symbolists emphasized the superior, quasi-divine status of the "mad genius" as a positive rather than debilitating force.[49] Hence, for Italian critics, Klimt played the role of the "savage who is not devoid of brilliance," and was even diagnosed by one as "*genialoide* and *mattoide* in equal measure."[50] But for the more sceptical, his colours were derided as a "crazy mix," his designs dismissed as "worms" of a diseased Art Nouveau.[51]

For Symbolist advocates, the "expressive nervousness" and "keen vibrations" of Klimt's art were signs of its essential modernity, a modernity to be embraced, not rejected as Nordau had. One favourable critic—Leandro Ozzòla—asserted that Klimt's style continued the venerable tradition of the gothic, which was now fraught with the qualities of "modern hysteria, which is perhaps more acute in Vienna than in any other European capital." Klimt's brilliant depiction of "modern neurosis" appeared in the smallest of details, such as the quivering "movements of nostrils and lips."[52] In Damerini's view, the artist's research into the "restless modern spirit" came to the fore in his images of women, in "the feminine psyche that dominates our time with its flighty inconstancy and elegant, silky pleasures." The "vibrant creature" depicted in *Judith II* (fig. 36), for example, "exhibits all the exacerbated excitability of our frenetic and corrupt civilization."[53] True to form, the Italian critics interpreted Klimt's depiction of the female sex and psyche along the lines of well-established *fin-de-siècle* stereotypes: either the "archaic" mother, symbolizing the wholeness of experience unalienated by modern life, or the femme fatale, whose threatening sexuality pointed to the disintegration of social hierarchies. In both cases, the feminine was characterized by inchoate impulses and biological needs that ran counter to instrumental reason and progress.[54] "Like a beautiful woman," Damerini concluded, "the art of Klimt enchants."

Klimt was a self-declared painter of women; not only his subject but also the style of his art was immersed in the feminine, in the surrender to artifice and the primal forces of nature. Ornament proved the most threatening aspect of Klimt's art, for it captivated the viewer with a Byzantine complexity of design. Critics describe how Klimt encased the female visage in golden grounds, creating a

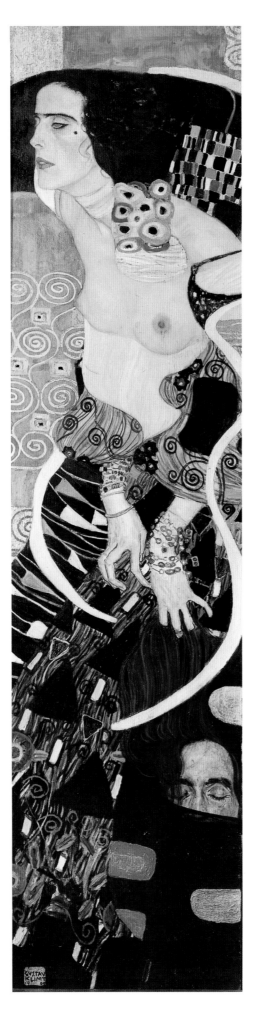

FIGURE 36
Judith II 1909
Galleria Internazionale d'Arte
Moderna—Ca' Pesaro, Venice
Exhibited at the Venice
Biennale 1910

"dream-world" where time stops and incidentals of the outside world are shunned. The stark contrast between abstract patterns and realistically depicted facial features heightened the sense of intimate contact with the female subject, while the suggestive layers of adornment increased the visual allure.[55] Between the lines, one reads how ornament, as inherently feminine, both beguiles and enervates. In linking ornament to the constellation of female sexuality, the atavistic, and the degenerate, Italian critics echoed the charge laid down by Adolf Loos in a famous indictment of Klimt and the Secession style: "All art is erotic. The first ornament that was born, the cross, was of erotic origin. . . . But the man of our times who from an inner compulsion smears walls with erotic symbols is a criminal or a degenerate. . . . Just as ornament is no longer organically linked with our culture, so it is also no longer an expression of our culture."[56]

While discussions of Klimt as a Decadent painter, with their degenerate subtext, fall into the historical confines of the *fin-de-siècle*, a more serious criticism levelled against the artist still has currency today: the conflict between his luxuriant manner—with its emphasis on surface and sheen—and the intended profundity of his allegories, particularly *Death and Life* (fig. 19), *Three Ages of Woman* (fig. 18), and *Hope II* (cat. 24). Several key Italian critics took Klimt to task for what they considered to be his rhetorical sham—an "inflated" style that actually masked the lack of serious content, or parodied it through excess. Ardengo Soffici, for one, the champion of French modernism, dismissed the portentousness of Klimt's art with masterful sarcasm:

> Imagine yourselves at a carnival in a mortuary chamber. Inside the biers covered with fake flowers lie the cadavers of rickety babies, maidens dead of starvation, bald and wrinkled old women, and the swollen, putrid green bodies of the drowned. All around rockets trail, fireworks explode, pinwheels swirl, and out fly paper streamers of all colours, amidst shooting stars of silver, yellow, azure, red, and white. . . . As everyone can see, we are dealing with philosophical art as it is done in the metaphysical German lands, and I would not know how to trust my own judgements, being only a simple painter with modest views. No sir! When the universe appears before me with such faces, when being and not being are painted and drawn this way, and the absolute is depicted in the style of Art Nouveau, I tip my hat, take a deep bow, and I'm on my way.[57]

The most probing condemnation of Klimt, however, came from the pen of Emilio Cecchi, in his essay "The Eye of the Dove."[58] He begins with a poetic fantasy of the world seen through the innocent eye of a bird, one that does not recognize things per se, but only vibrating geometric splendour and radiant light refracted in an endless dance of colour. This infinite array of zoological and biological ornament, or what Cecchi terms "the cabalistic signs of

nature," similarly captures the imagination of children looking through a kaleidoscope, or grown-up "barbarians" gazing at the art of Klimt. The Viennese artist is at his best when capturing the scintillating colours of a butterfly's wing or the glint of precious stones, but his pretensions interfere. Klimt considers himself a philosopher—unfortunately so—since works like *Jurisprudence* are "puerile literary conceptions, not worthy of discussion." The leering Furies and grimacing skulls that pop out from overly florid bowers reveal themselves as hollow figures composed of cardboard and coloured wax. Cecchi finds Klimt guilty of not knowing himself as an artist, which results in a "mendacious contrast" between "the sullen, scorn-filled sockets of Death and the ingenuous eye of the dove." Despite Klimt's ambitions, what remains is the "baseness of an art that wants to be painting and is nothing but mosaic and stained glass; that aspires to be an immense lyric and falls back upon embroidery; and that aims at evoking the grandest themes—Death, Remorse, Love—only as a pretext to expound the most mediocre."[59]

By contrast, those seeking to redeem Klimt insisted that the actual meaning of his pictures lay embedded in the decorative elements. Damerini, for example, hailed Klimt as a genuinely "pessimistic thinker," who imparted his ideas not through narrative but through the riveting power of expressive form, line, and colour. Those who find his work "abstruse" miss the point. There is nothing difficult to understand about his symbols, which, like the figures in *Three Ages of Woman*, are "obvious, even banal." Instead, the true content emerges from the engulfing black and gold grounds, multi-coloured aureoles and tangled lines that "create a vague, ineffable mood, whose sense cannot be grasped, and in which our destinies unfold." Therefore, Klimt's work is not concerned with "symbolism or allegory to be examined, clarified, and interpreted," but just the opposite: finding meaning in the ineffable. Immersed in Klimt's uncertain spaces and inscrutable designs, the viewer "submits to an indefinable atmosphere" that nonetheless defines "the psychological torment of contemporary consciousness."[60]

Whether his work was extolled or ridiculed, Klimt's reputation in Italy was brief and intense, like the burning trajectory of a shooting star described in his pictures. He exhibited one last time in Italy at the Rome Secession (with the *Portrait of Mäda Primavesi*, cat. 30), whose artistic rebellion he helped to inspire; but in 1914, he no longer appeared quite as radical next to the likes of Matisse and the Fauves (fig. 37). Already in 1910, five young artists known as the Futurists issued their first manifestos with a violent assault on Decadent aesthetics. At the very moment of Klimt's apotheosis at the Biennale, they bombarded the public with 800,000 leaflets dropped from the bell tower of

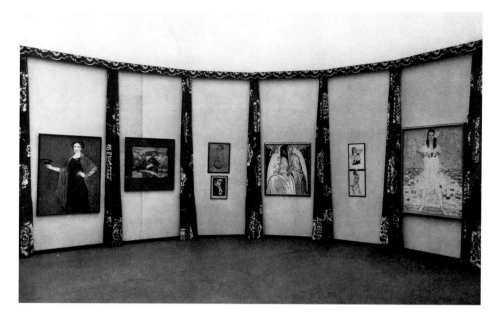

FIGURE 37
Installation view of work by the Österreichischer Künstlerbund at the second Rome Secession 1914 with *Portrait of Mäda Primavesi* to the right From *Die Kunst*, vol. 34 (1915–16), page 305

the Piazza San Marco, denouncing "passéiste" Venice as "a jewelled bathtub for cosmopolitan courtesans."[61] And although Umberto Boccioni and his cohorts had once admired Klimt, they now reviled him and the Secessionists as augurs of a "false modernity," as peddlers of a merely "illustrative style." The Futurists admitted to the errors of their youthful days, when they had looked for inspiration to Munich and Vienna rather than Paris. As Boccioni recalled: "In Italy, fifteen or twenty years ago, Lenbach was more famous than Manet, Hans Thoma more than Pissarro, Liebermann more than Renoir, Max Klinger more than Gauguin, Josef Sattler more than Degas, etc., and we didn't even speak of Cézanne. Lastly, we considered the Austrian Klimt—with his marketable pastiche of the Byzantine, the Japanese, and the gypsy-like—to be an aristocratic innovator of style."[62]

For the Futurists, Klimt's art inevitably represented a dual threat—Austria and the feminine. Promoters of Latin culture and bellicose irredentists, the Futurists agitated for Italy's entry into World War I alongside the Triple Entente, not the Alliance. With their typical mix of hyperbole and ardent nationalism, they derided Austro-Hungarian and German culture as "pedantic," "bigoted," and "barbaric." Moreover, they were bent on a cleansing purge of Symbolism, of its introverted, ornamental style. In their view, a new, more virile Italy required an art that was similarly masculine and resolute. Proclaiming their "scorn for women," the Futurists banished female sexuality and biological destiny from their canvases—subjects at the heart of Klimt's artistic project—replacing them with a fantasy of male auto-genesis and a steely eroticism. Phobia of the female body was overcome by mania for the machine.[63] The Futurist battle against Klimt and the decorative, like that waged by Loos and the Austrian naysayers, was a battle over the gender of modernity itself.

JANE KALLIR

Gustav Klimt is often hailed as the greatest Art Nouveau painter in all of Europe.[1] One might even say that he was the *only* great Art Nouveau painter, for Art Nouveau was a movement focused largely on the applied arts. Klimt, however, while maintaining a primary commitment to the realm of conventional "high" art, melded the decorative innovations of Art Nouveau craftsmen with the Symbolist tendencies exemplified by contemporary painters. At a time when the boundaries between art and craft were being challenged, yet nonetheless remained very much intact, Klimt was one of the few artists who was equally inventive in both areas. He created grand allegorical canvases in the old manner, as well as posters, illustrations, and elaborate applied wall decorations according to the new style. Whether one believes, as did Klimt and his colleagues at the Secession and later at the Wiener Werkstätte, that this merging of high and low served to elevate craft, or whether one feels, as did the polemical architect Adolf Loos, that it debased art, is a matter of personal opinion. What seems clear from our perspective, some one hundred years after the fact, is that Klimt was uniquely suited to assimilating the conflicting aesthetic demands of his particular time and place.

Setting the Stage: Training and Early Career
Klimt himself personified a strange combination of "high" and "low" elements. Given the heights to which he would rise in the Viennese art world, his beginnings were hardly auspicious. The son of a poor Bohemian goldsmith, Klimt grew up with his brothers, Ernst and Georg, and sisters, Klara, Hermine, and Johanna, in the tenements of what is today Vienna's fourteenth district. (A fourth sister, Anna, died at the age of five, when Gustav was twelve.) By the time Gustav reached adolescence, his family's always precarious financial situation had worsened, and it was clear that he and his two younger brothers would have to support the others. Gustav, whose artistic talent was already evident, therefore applied not to the prestigious Academy

of Fine Arts, where the leading artists and architects taught and studied, but to the more commercially oriented Kunstgewerbeschule (School of Applied Arts).

When Klimt entered the Kunstgewerbeschule in 1876, he was fourteen and the school itself only eight years old. The Kunstgewerbeschule had been founded as an adjunct to the Österreichisches Museum für Kunst und Industrie (Austrian Museum for Art and Industry) in order to bolster Austria's competitive position in the newly industrialized international economy. It was felt that industrialization had undermined the apprenticeship system that previously constituted the basis of a craftsman's education. The Kunstgewerbeschule prepared its students either to design for industry or to teach. Klimt's plan was to become a drawing instructor.[2]

However, the Kunstgewerbeschule was no ordinary vocational school. Rudolf von Eitelberger, who as director of the Museum für Kunst und Industrie was instrumental in establishing the school, believed that crafts could not and should not be separated from the "high" arts of painting, sculpture, and architecture. "The crafts are nothing other than the application of these three art forms to the requirements of daily life," he proclaimed.[3] Accordingly, the Kunstgewerbeschule was divided into departments of architecture, figural drawing and painting, decorative drawing and painting, and sculpture. Eitelberger was an avid admirer of English innovations in industrial design — his museum *cum* school was in fact modelled on London's South Kensington School and Museum, today the Victoria and Albert — and his ideas about the integration of the "high" and "low" arts had precedents in the British Arts and Crafts Movement and among the French and Belgian Symbolists. The desire to grant equality to all art forms and to unite them in a comprehensive Gesamtkunstwerk (total art work) would become one of the central tenets of international Art Nouveau.[4]

After Gustav Klimt had completed the introductory coursework at the Kunstgewerbeschule and stood ready to

Opposite:
Detail of
*Cartoon for the Stoclet Frieze:
Expectation* (fig. 53)

take the qualifying exam to become a teacher, no less a personage than Eitelberger intervened and decreed that he instead enter the department of figural drawing and painting, then headed by Ferdinand Laufberger. The normal programme of study at the Kunstgewerbeschule comprised two to three years, or perhaps a little longer if the preparatory curriculum was counted.[5] Klimt, however, remained there an astonishing seven years. Following Laufberger's death in 1881, he enrolled for an additional two years with Laufberger's successor, Julius Victor Berger.

One reason for Klimt's extended tenure at the Kunstgewerbeschule was undoubtedly that it afforded invaluable professional contacts, and in fact, Klimt began earning a living as an artist years before he left the school. As early as 1879, he started collaborating with his younger brother Ernst (who had entered the Kunstgewerbeschule two years after Gustav) and another fellow student, Franz Matsch. The trio eventually established a formal workshop, which they dubbed the "Künstlerkompanie der Gebrüder Klimt und Matsch" (Artists' Company of the Klimt Brothers and Matsch). The school put a separate studio at the group's disposal and paid them a stipend of twenty gulden each per month.

At the time, the Austrian government, bolstered by a protracted economic boom, was sponsoring new public works all over the Empire. This building programme — crowned by an arc of grand edifices along Vienna's central Ringstrasse — generated a wealth of commissions for artists. Through the Kunstgewerbeschule, the Künstlerkompanie

gained entrée into that lucrative realm. It was probably Laufberger who introduced the young painters to the renowned architectural firm of Fellner and Helmer, which hired them to design curtains and murals for a number of provincial theatres.[6] Later, through their teacher Berger, the trio grew closer to the studio of Hans Makart, Vienna's reigning art star. A favourite of the Imperial court, Makart was not only a sought-after society portraitist, but also a popular sensation whose monumental canvases drew thousands of viewers, and who was frequently called upon to create elaborate wall decorations for the new Ringstrasse buildings. Shortly before Makart's death in 1884, the Künstlerkompanie was invited to help complete one of his last, unfinished projects: the murals for the quarters of the Empress Elisabeth at the Hermesvilla in the Lainzer Tiergarten.[7]

The Hermesvilla murals proved decisive for the Künstlerkompanie. Not only was this their first significant Imperial commission, but it brought them to the attention of the Emperor's favourite architect, Karl von Hasenauer, who was responsible for the Künstlerkompanie's first major Viennese assignment, a cycle of paintings for the new Burgtheater (fig. 38). Klimt received the Emperor's Golden Order of Merit for his contributions to this project in 1888; and a second prestigious commission in the Imperial capital followed soon thereafter. In 1890 the Künstlerkompanie was asked to complete the staircase decorations for the Kunsthistorisches Museum, another of Makart's unfinished assignments (fig. 39). In scarcely ten

FIGURE 38
Shakespeare's Theatre
1886–88
Ceiling painting in
the southern stairwell
of the Burgtheater,
Vienna

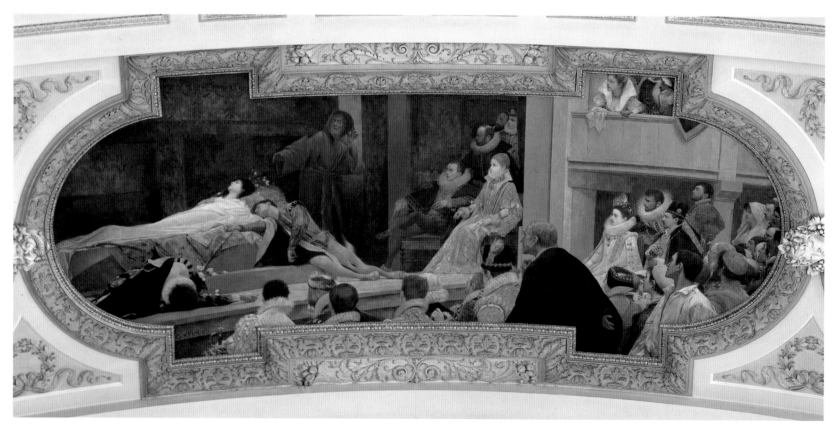

years, the Künstlerkompanie had made it from the provinces to the Ringstrasse. Blessed with Imperial patronage and, symbolically, with the mantle of the revered Makart, the members of the Künstlerkompanie seemed poised to become the darlings of the Austrian establishment.

As it transpired, this honour was accorded to only one of the three: Franz Matsch, who developed a sizable following among the aristocracy and was himself ennobled in 1912. By this time, Ernst Klimt was long dead, and Gustav's career had taken a very different turn. Stunned by Ernst's death from pericarditis in 1892, Gustav entered a period of artistic withdrawal that strained his relationship with Franz more or less to the breaking point. With the Künstlerkompanie in shambles, Klimt nevertheless agreed in 1893 to share one final assignment with Matsch, a series of murals for the University of Vienna.

The University project decisively confirmed Klimt's break with the conventional scene represented by Matsch and the Künstlerkompanie. The commission entailed the production of a series of canvases depicting various of the university faculties, which were to be installed on the ceiling of the school's auditorium. Working independently from Matsch on his three given subjects, *Philosophy, Medicine,* and *Jurisprudence* (fig. 1, 3, 4), Klimt produced a group of images that precipitated a scandal unlike anything ever before experienced in the staid Imperial capital. University professors and art critics alike were befuddled by the paintings' absence of mollifying historical or literary references, and appalled by the nudity, and in some cases blatant ugliness, of the figures. After enduring years of protracted protests, Klimt finally renounced the commission in 1905.

Klimt's changing allegiances were further evidenced by his roles in the founding of the Vienna Secession in March 1897 and the Wiener Werkstätte in May 1903. Though both organizations encompassed a variety of stylistic viewpoints, they were united in their opposition to the historicism that had dominated the work of Hans Makart and his Ringstrasse-era contemporaries. Rather than aping past styles, the emerging Viennese avant-garde sought to create a new, modern art. After breaking with their predecessor, the Künstlerhaus (Artists' House), the artists of the Secession built their own exhibition hall, to which they brought work by foreign modernists, heretofore unknown and unseen in Vienna. The psychological allegories painted by such Symbolists as Edvard Munch, Jan Toorop, and Fernand Khnopff had a dramatic influence on Klimt. Also key to the development of the Viennese avant-garde was the Secession's attempt to integrate the fine and applied arts. This approach found its ultimate flowering in the Wiener Werkstätte, a design collective established by the designers Josef Hoffmann and Koloman Moser, and the financier Fritz Waerndorfer.

The Legacy of the Ringstrasse Period

In the context of his later career, Klimt's collaboration with the Künstlerkompanie may seem anomalous, but these early years were in many respects paradigmatic for the artist. Conceptually, this period offered a promise of cooperation, patronage, and mutual goodwill which, though repeatedly broken, never lost its seductive allure. The exceptional kindness that Klimt later bestowed upon his colleagues, particularly those who were just starting out, mirrored the support he received at the outset from his partners, teachers, and better-established professional colleagues. Though permanently embittered by the University scandal, Klimt remained committed to the ideal of official patronage. He was still mourning its loss as late as 1908 when, on the occasion of a survey of contemporary art called the *Kunstschau* (Art Show), he characterized such exhibitions as a second-rate alternative to public commissions.[8] The goal of the Secession and the Wiener Werkstätte was to provide a forum in which artists could create, unhampered by the banality of official taste and supported by a cadre of like-minded patrons. In joining forces with these organizations, Klimt had not so much altered his way of working as found more hospitable venues for the expression of his ideals.

Stylistically, too, Klimt's years with the Künstlerkompanie presaged aspects of his subsequent work. Historicism was so furiously denounced by the ideologues

FIGURE 39
Egyptian Art I 1890–91
Girl with Horus and
Thot in the background
Spandrel painting in
the staircase of the
Kunsthistorisches
Museum, Vienna

of the *fin-de-siècle* avant-garde that the connections between the Ringstrasse period and Austrian Art Nouveau have until recently been largely ignored.[9] In fact, throughout Europe, Art Nouveau artists and artisans did not so much abandon historical styles as sever them from their original historical contexts.[10] The past thus became a grab bag of motifs from which artists could pick and choose at whim, recombining disparate images much as postmodern artists today mine art-historical and popular iconography, with similarly disconcerting results. It was the ad hoc nature of the Art Nouveau artist's use of historical sources that made the new art an art "for its age" (to paraphrase the Secession's famous motto), and it was the dismembering of the original context that the general public found so disrespectful and alienating.

Historicism influenced Klimt's mature work in several key ways. Through his early training he had become extremely adept at assimilating historical material, and his

FIGURE 40
Rudolf von Alt
Makart's Studio 1855
Historisches Museum
der Stadt Wien, Vienna

FIGURE 41
Stoclet Frieze 1909–11
As installed in the dining
room of the Palais Stoclet,
Brussels

Opposite:
FIGURE 42
Portrait of Fritza Riedler
1906
Österreichische Galerie
Belvedere, Vienna

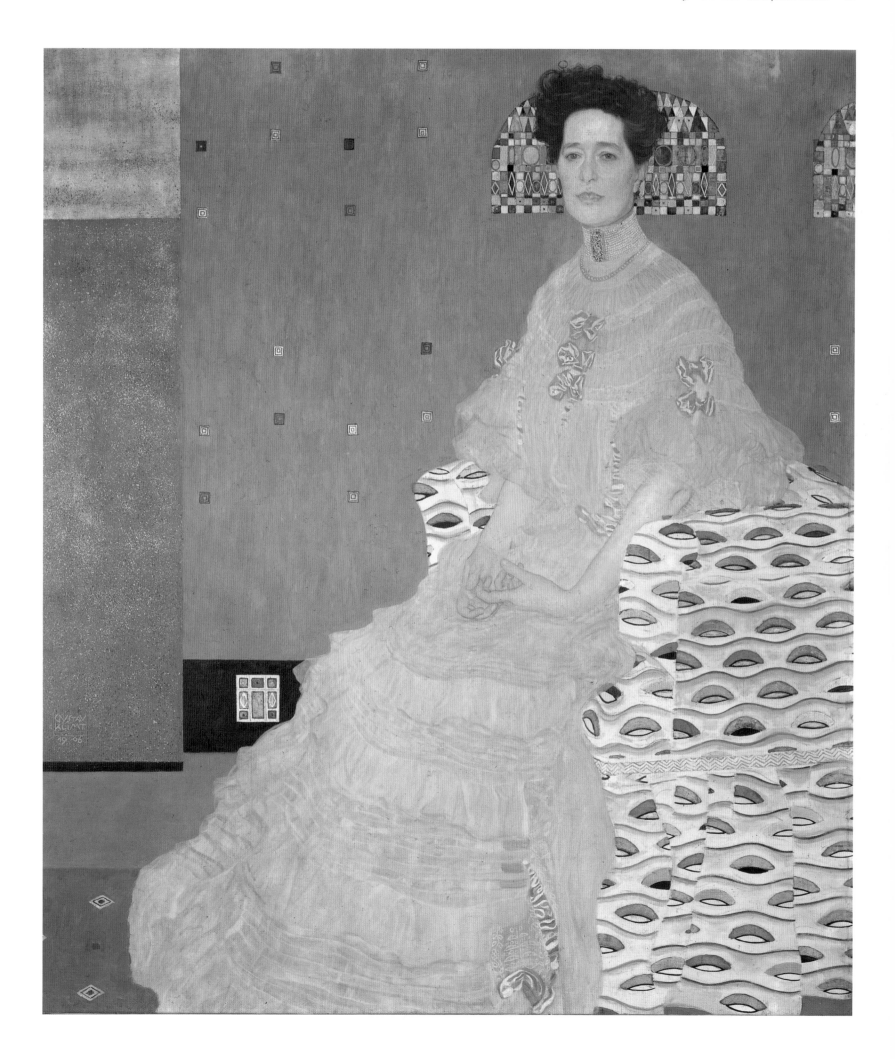

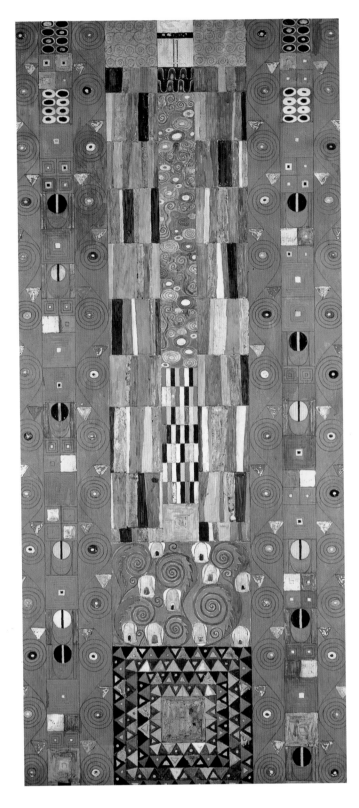

his less illustrious contemporaries, offered a decisive model for Klimt in the manner in which it combined painting with architecture.

The Gesamtkunstwerk may have reached its apogee in the *fin-de-siècle* Art Nouveau era, but the origins of the concept can be traced back to the turn of the prior century. The revival of classical fresco technique and the reunification of painting with architecture were among the ideals espoused by the Romantic movement, which sought to reinvest art with the spiritual integrity ascribed to Medieval and Renaissance churches. Although the Romantics were not initially well received in Austria, in the second half of the nineteenth century their vision of a monumental fresco revival found a belated, albeit secular, incarnation in the Ringstrasse building programme.

Not only was the Künstlerkompanie's erstwhile role model, Hans Makart, the undisputed master of the Ringstrasse mural, he was also a quintessential "lifestyle" artist in a manner that strangely anticipated the dictates of the Wiener Werkstätte. There were Makart hats and Makart bouquets and, for an added touch of theatricality, a massive "Festival Parade" orchestrated by Makart in 1879 on the occasion of the Emperor's twenty-fifth wedding anniversary. Long before the Wiener Werkstätte was founded, Makart breezed easily from the "high" arts to the "low." One has only to look at Rudolf von Alt's famous watercolour of Makart's studio (fig. 40) to get the impression of an all-encompassing environment that is in its own way as oppressive as Josef Hoffmann's Gesamtkunstwerk interiors (fig. 41). Whereas the German composer Richard Wagner saw opera—with its unique combination of musical, literary, dramatic, and visual arts—as the ultimate Gesamtkunstwerk, the Austrians would remove the concept from the stage and bring it into the home.

Implicit in the Austrian Gesamtkunstwerk was a blurring of the boundaries between art and life. Klimt, during his years as a muralist-for-hire, learned through practical experience to deal with the aesthetic problems posed by this mandate. The architectural settings in which he worked were real, yet their forms were abstract; his paintings, on the other hand, were only pictures, yet they had a realistic appearance. The attempt to resolve this paradox, to reconcile reality and illusion, lies at the heart of all Klimt's subsequent work. It is one of the reasons he was so well-suited to collaborations within the realm of the applied arts.

Klimt was acutely aware not only of the distinction between a picture and its setting but of the inherent tension, within the picture, between the three-dimensional figure and its two-dimensional ground. His earliest independent commission, a series of drawings for *Allegorien und Embleme* (*Allegories and Emblems*; published by Martin Gerlach

later compositions are interspersed with elements drawn from such disparate sources as the Imperial armour collection, antique statuary, Greek vases, Byzantine mosaics, Japanese prints, and Chinese screens. Another legacy that Klimt retained from historicism was a reverence for allegory, though like his Symbolist predecessors he tried to reach beyond stale iconographic traditions to present universalized statements about the human condition. And, last but not least, historicism, as practised by Makart and

between 1882 and 1885), already shows a characteristic preoccupation with framing and abstract form (cat. 2, 37, 39). Sometimes Klimt placed extra emphasis on his frames (on occasion designed by himself or his brother Georg, see cat. 4 and 11); thereby accentuating the boundary between the artificial image and its environment. On the other hand, Klimt might incorporate into the image itself geometric forms echoing the frame or architectural surround, thus minimizing the aesthetic distance between the two (cat. 5 and 8). Recognizing that a blank canvas is an essentially artificial device, Klimt, in his mature compositions, preserved the integrity of the picture plane by filling his backgrounds with two-dimensional geometric or painterly ornaments. The faces and flesh of his human subjects, however, remained realistically rounded and shaded (fig. 42).

Klimt was never entirely able to eliminate the innate conflict between figure and ground. He came closest, perhaps, in his landscapes, because these subjects could most readily and completely be reduced to abstract form (cat. 14, 17, 20–23, 27, 28, 32, and 33). However, just as Klimt could never revert to the sham of illusionistic verisimilitude, he could not embrace full abstraction. His one purely abstract work—the rear panel for the dining room of the Palais Stoclet (fig. 43)—invites comparison with the relief that Hoffmann designed for the Secession's Beethoven exhibition (fig. 44). Both were, so to speak, accidental works of abstract art, their aesthetic conviction undermined by their obvious function as applied wall decoration. Klimt's figural works, on the other hand, teetered precariously between realism and abstraction. While making concessions to the representational mandate of "high" art, the artist simultaneously flirted with the geometric formal devices that at the time were the province of the "low."

Art and Craft: Embracing the Gesamtkunstwerk

Gustav Klimt's affinity with the applied arts manifested itself in innumerable ways throughout his life and art. His background as a goldsmith's son and his training at the Kunstgewerbeschule oriented him to the crafts early on. By the 1890s, Klimt's destiny had become intertwined with the family of Hermann August Flöge, an artisan originally from Hanover who had made good in the Austrian capital as a manufacturer of meerschaum pipes. Klimt's brother Ernst married Helene Flöge in 1891, and soon thereafter, Gustav began a long-term liaison with Helene's sister Emilie. In 1904, Helene, Emilie, and their older sibling Pauline opened the fashion salon Schwestern Flöge, an enterprise with which Klimt was intimately connected. Not only did Gustav design dresses for Emilie (fig. 45),[11] but it is likely that her collection of folk textiles influenced the colourful abstract patterns in his paintings.[12] Klimt's multi-faceted skills as a designer made him an ideal propa-

FIGURE 44
Josef Hoffmann
*Sculpted Wall Relief
Designed for the Secession's
Beethoven Exhibition* 1902

gandist for the Secession. He created advertising posters for its exhibitions (cat. 62–64), illustrations for the house organ *Ver Sacrum* (cat. 60 and 61), and it has been said that he even contributed to Josef Maria Olbrich's concept for the Secession's building (fig. 46).

At the Secession, Klimt associated less with his fellow painters than with the faction that came to be known as the "Stylists": those, like Josef Hoffmann and Koloman Moser, whose primary interest was the applied arts and who were firmly committed to the concept of the Gesamtkunstwerk. The idea of the Secession as a temple to art (again harking back to the Romantics in a way now quasi-spiritual, now quasi-secular) manifested itself in specialized installations intended to coordinate the architectural setting with the works on display. Whereas Klimt had once been compelled to conform to the dictates of Ringstrasse architecture, henceforth he and the architects would willingly engage in collaboration. The communal labours of the defunct Künstlerkompanie would be superseded by a new community of artists and artisans.

The fact that the Secession included architects and artisans as well as fine artists, and on occasion exhibited crafts, constituted a highly unusual mingling of the "high" and the "low."[13] Granted, there were precedents for this in Vienna—not only in the aforementioned curriculum of the Kunstgewerbeschule, but before that, in the combined fine-art and crafts orientation of the Biedermeier style that dominated Austrian culture during the early to mid-nineteenth century. Nevertheless, the marriage of "high" and "low" within the Secession did not prove an altogether happy one. Friction soon developed between the Stylists and the "Naturalists," as the opponents to Klimt's clique came to be called.

The conflict between the Naturalists and the Stylists involved both aesthetics and money. Led by the painter Josef Engelhart, the Naturalists favoured a far more traditional approach to painting. While they did not object to customized exhibition installations, or even to the applied

FIGURE 45
Emilie Flöge in a
"Concert Dress"
designed by
Gustav Klimt, 1907
Photograph by
Gustav Klimt

FIGURE 46
*Design for the Secession
Building* 1897
Historisches Museum der
Stadt Wien, Vienna

he complied with its objective to aestheticize every aspect of daily life, not just as a collaborator but as a customer. Both his studio and the Flöge fashion salon were designed by Josef Hoffmann. Klimt purchased Werkstätte jewellery as gifts for Emilie, wrote to her on Werkstätte postcards, and framed his paintings in slender black Hoffmann frames. With a comprehensive repertoire of such utilitarian objects, the Wiener Werkstätte completed and celebrated the domestication of the Gesamtkunstwerk. And a stage in Klimt's development was likewise completed through his association with Hoffmann and company.

Art and Architecture: Creating the Gesamtkunstwerk

As a commissioned muralist, Klimt had initially produced paintings for vast public spaces and been dependent on public patronage. The founding of the Secession, however, freed Klimt from the conservatism of official taste, for the private collectors who supported the Secession had far more progressive sensibilities than did Hapsburg bureaucrats. Nevertheless, the Secession was still a public building, its potential and intended audience the broad mass of citizens whose tastes the Secessionists hoped to educate and elevate. Although the Wiener Werkstätte assimilated the Secession's educational mission, it soon became evident that only the well-to-do could afford the Werkstätte's standards of taste, workmanship, and materials. A Wiener Werkstätte handkerchief, at 9.2 crowns, cost as much as a trained tailor earned in one week,[14] and by 1916, a Klimt portrait commanded the huge sum of 20,000 crowns![15] As a result, not just the source of his revenue but his audience became a largely private one.

The three stages of Klimt's career are, as it happens, conveniently illustrated by his three most important architectural commissions: the University paintings (fig. 1, 3, 4), the *Beethoven Frieze* (fig. 5–7), and the *Stoclet Frieze* (fig. 12, 43), designed, respectively, for the Austrian Ministry of Education, the Secession, and the Wiener Werkstätte. Even the materials selected for these three projects are suggestive of the artist's shift in values. The University pictures were painted, conventionally, in oil on canvas. The *Beethoven Frieze* was essentially a *fresco secco* (casein on dry plaster) augmented with gold and inlaid stones, while the *Stoclet Frieze* was a true mosaic, executed by the workshop of Leopold Forstner after large cartoons on paper by Klimt.

The University paintings were Klimt's last official commission, and their style was very different from that of the comparatively bland allegories that had accounted for his prior success in that realm. As allegories go, the artist's depictions of the three faculties, *Philosophy*, *Medicine*, and *Jurisprudence*, are admittedly somewhat obscure. The paintings contain few of the historical or literary references that traditionally served as guideposts for interpreting such

arts per se, they drew the line at the full merger of craft and art advocated by proponents of the Gesamtkunstwerk. Furthermore, the Naturalists resented the broadened economic base that the Wiener Werkstätte afforded their rivals. And Engelhart's group felt that the Stylists' association, through Secession artist Carl Moll, with the commercial Galerie Miethke constituted an unacceptable conflict of interest. This caused the so-called "Klimt-Gruppe" to sever its ties with the Secession in 1905.

After the Secession split, Klimt's sole significant organizational affiliation was with the Wiener Werkstätte; and

lofty themes. Klimt's interpretations are instead personal, and in each case extraordinarily pessimistic. Humankind is depicted as a mass of suffering bodies whose plight cannot be ameliorated by the mortal disciplines taught by any of the faculties in question. No wonder university professors were up in arms in opposition to these images!

The argument that the University paintings, in addition to being disturbingly sexual, were inappropriate for the purpose is to some extent supported by the compositions themselves. Stylistically, Klimt's work was no longer compatible with that of his collaborator and former partner, Franz Matsch. And only Klimt's first canvas, *Philosophy*, made some concession to the fact that the works were intended to be mounted on the ceiling. *Medicine* and *Jurisprudence* were clearly best viewed head on, and indeed it is possible that Klimt already knew, after the uproar that greeted *Philosophy* upon its first public showing in 1900, that none of these works would ever be installed on the University's ceiling. *Jurisprudence*, the last of the cycle, was substantially reworked after Klimt gave up the commission in 1905.

Even if the University debacle had not effectively ended Klimt's career as a public muralist, the era of official patronage was fast winding down. Faced with embattled nationalities and social classes as well as the incipient fragmentation of its Empire, the Austrian regime had little incentive to support the arts, much less to back a scandal-prone painter.[16] The implicit alliance between artists and the Imperial court, which had been manifested not only along the Ringstrasse but also at the progressive Museum für Kunst und Industrie and the Kunstgewerbeschule,[17] was being undermined by the more egalitarian demands of parliamentary democracy. Whatever their personal politics, Klimt and his cohorts at the Secession were no fans of artistic democracy. Rather, they favoured a sort of benign cultural despotism, in which a talented elite would gently but firmly take the public in hand and lead them down the road to good taste.

The *Beethoven Frieze* was Klimt's ode to the artist as persecuted redeemer, just as the Beethoven exhibition (which housed the frieze) was the Secession's most comprehensive realization of the Gesamtkunstwerk as art temple. The 1902 exhibition was intended to enshrine the German artist Max Klinger's sculpture of Beethoven, who himself personified a kind of ideal artist-saint (fig. 47). The installation was designed by Josef Hoffmann and included, in addition to Klinger's statue and Klimt's frieze, art by various other members of the Secession. The approach differed from that of all prior Secession exhibitions in that the design of the space, rather than accommodating pre-existing art works, in most cases preceded their creation. With the exception of the Klinger, the paintings and sculpture

were intended to "conform to the concept of the room." As noted in the catalogue, "The idea is to subordinate the parts of the conception to the whole through prescribed relationships and narrowly defined boundaries."[18]

The Beethoven exhibition included murals by a number of artists, but for the most part these did not breach the parameters of beautiful (albeit elaborate) wall decoration. Klimt's frieze, on the other hand, managed both to meet the decorative requirements of the assignment and to deliver a statement of compelling artistic complexity and profundity.[19] It is significant that the Expressionist artist Egon Schiele considered this to be Klimt's greatest work.[20] Although the abrasiveness of Schiele's approach was diametrically opposed to the sumptuousness of Klimt's style, both artists believed that the purpose of art was to explore the essence of human existence. In its allegorical orientation, as well as in its hodgepodge of classical borrowings, the *Beethoven Frieze* kept faith with the University paintings and all the historicist works that had preceded them.

Lest the viewer be in doubt as to the *Beethoven Frieze*'s meaning (as were the professors when confronted with the University cycle), the exhibition catalogue provided a programmatic explanation. The work occupied three walls of its own oblong room, and the three panels were meant to be "read" in sequence. The first panel (fig. 48) juxtaposes *The Longing for Happiness* with *The Sufferings of Weak Mankind*, and concludes with a plea to a literal "knight in shining armour" (said to resemble the controversial composer and director of the Vienna Opera, Gustav Mahler). The second panel, occupying the short end wall, depicts *The Forces of Evil* (fig. 49), including "Disease, Madness, Death, Desire and Lewdness, Licentiousness, and Nagging Care." In the final long panel, all ends well: "The longing for happiness

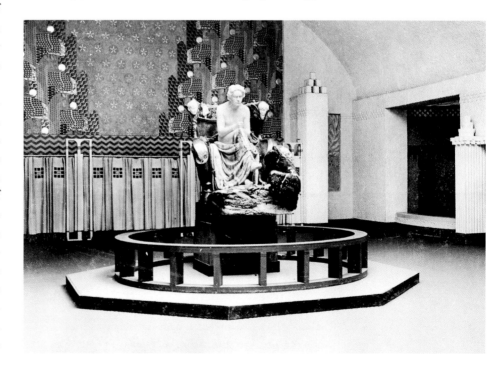

FIGURE 47
View of the central room designed by Josef Hoffmann, Beethoven exhibition, Vienna Secession, 1902 featuring Max Klinger's sculpture

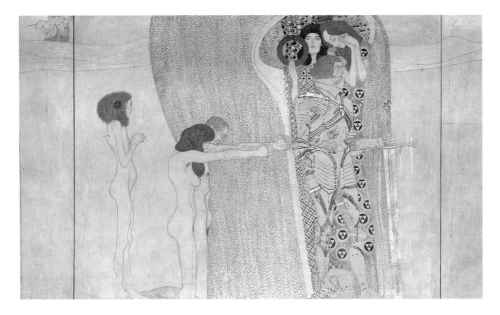

finds appeasement in Poetry." A chorus of angels rejoices, and humankind is saved by the concluding "Kiss for the Whole World" (fig. 50),[21] illustrating a verse from the German poet Friedrich Schiller's "Ode to Joy," set to music by Beethoven in his Ninth Symphony.

Yet, despite the ambitious allegorical content of the *Beethoven Frieze*, Klimt took great pains to subordinate the form of his composition to the architectural requirements of the assignment. Recalling the raised frieze that the Scottish designer Charles Rennie Mackintosh had created for the Secession's eighth exhibition (fig. 51), Klimt's mural ran along the top of the walls, above eye level (fig. 52). The porosity of the plaster surface caused the casein pigment to sink into the ground, so that the painting almost literally became one with the wall. The stylized flatness of the figures further accentuated this effect. On the other hand, the genuine jewels and gold insets seemed to sit above the plaster surface, their palpable bulk both echoing and contrasting with the duller painted ornamentation. It is almost as though Klimt were deliberately teasing his audience, asking them to discern what was real and what was not. Klimt's double-edged approach to illusion and reality was perhaps never more effectively deployed than in this allegory about art and life, in which form and content were perfectly matched.

If Klimt's enshrinement of the artist-hero was intended as a response to the University scandal, then at its peak, the *Beethoven Frieze* certainly did not win him converts from among the already disaffected conservatives. As with the University canvases, the public's main objections revolved around the blatant sexuality of some of the female figures and the perceived ugliness of others. "Klimt has once again produced a work of art that calls for a doctor and two keepers," wrote one typical critic. "His frescoes would fit well in a [psychiatric] institute. . . . The representation of

'Lewdness' on the back wall is the last word in obscenity. And to think that this is Klimt's path to Beethoven!"[22]

Unlike the younger artists of the Expressionist generation, such as Schiele and, in particular, Oskar Kokoschka, who deliberately scandalized the public, Klimt was an unwitting "Bürgerschreck" (scourge of the bourgeoisie).[23] He did not mean to offend, and the continuing controversy surrounding his work wounded him to the core. His unhappiness was exacerbated by the Secession split, which demonstrated that the "Klimt-Gruppe" could not even count on support from their fellow artists. However, the Wiener Werkstätte promised to address and redress these issues. Here at last would be created a true "Künstlergemeinschaft" (artistic community), an entity that would unite like-minded artists and patrons, and exclude all the rest. Private patronage would guarantee artistic freedom, though it would largely confine the artists' reach to the private sphere.

Vienna's *fin-de-siècle* avant-garde depended on direct relationships with patrons, because Austria had not yet developed a viable network of commercial galleries to mediate between artists and the larger public. The overlap between Klimt's key patrons and those of the Wiener Werkstätte was virtually total. These included two of the organization's principal backers, Fritz Waerndorfer and Otto Primavesi, as well as the collectors Friederike Maria Beer, Sonja Knips, August and Serena Lederer, Karl Wittgenstein, and the Zuckerkandl family. That Klimt's patrons decorated their homes according to Wiener Werkstätte precepts facilitated the assimilation of the artist's paintings into the all-encompassing lifestyle that was, after all, the goal of the Gesamtkunstwerk.

Klimt's *Stoclet Frieze* reflected perfectly, in form, content, and circumstances, the retreat of the Austrian avant-garde into the private sphere. Still smarting from the earlier attacks on his work, Klimt did not even allow the mural to be publicly exhibited in Vienna. Those in the know—presumably comprising only friendly parties—could visit the frieze at the mosaic workshop of Leopold Forstner before it was shipped to its intended site, the Brussels mansion of the industrialist Adolphe Stoclet. Here Klimt's frieze would virtually disappear from view.[24]

Whereas the Beethoven exhibition had been the Secession's most complete realization of the Gesamtkunstwerk as art temple, the Palais Stoclet was the Wiener Werkstätte's most successful interpretation of the Gesamtkunstwerk as domestic environment. In Adolphe Stoclet, Josef Hoffmann found a client who was both willing and financially able to conform to the architect's every dictate, and he proceeded to mastermind a totally coordinated environment. Between 1905 and 1911, an enormous team of Werkstätte artists and artisans created everything from carpets to coffee spoons. Not a single aspect of the wall ornamentation,

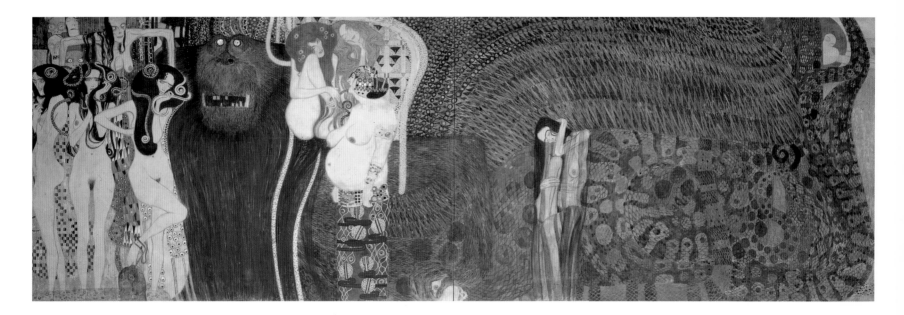

furnishings, or fixtures escaped Hoffmann's attention. It is even said that the Werkstätte established its fashion department because Mme. Stoclet's clothing clashed with the mansion's interior.[25]

Klimt had bowed to Hoffmann's architectural conception when designing the *Beethoven Frieze*, but the creations of both the painter and the architect had been subordinated to the higher goal of "Art." By comparison, Klimt's *Stoclet Frieze* was destined for the dining room of a Belgian mansion, which had no more lofty purpose than the comfort of its owner and his guests. If the *Stoclet Frieze* was not exactly upstaged by the dining room's ancillary accoutrements (which naturally were more numerous than had been the case with the Beethoven installation), it nevertheless blended harmoniously with the interior decor. The mosaic stones and tiles were conceptually of a piece with Hoffmann's marble walls. The *Stoclet Frieze* was clearly part of the decorative reality of the room it inhabited, rather than evoking the parallel world of artistic illusion that had given depth to Klimt's allegorical visions.

The *Stoclet Frieze* had an allegorical programme, but it was far simpler than that of the *Beethoven Frieze*. The composition centres on two vignettes, *Expectation* (fig. 53) and *Fulfilment* (fig. 12; the latter reprising the *Kiss for the Whole World*, fig. 50, which had, in the meantime, also been essayed in what is today Klimt's most famous canvas, *The Kiss*, fig. 13). *Expectation* and *Fulfilment* are entwined in the *Tree of Life*, whose spiralling golden branches give decorative unity to the whole. The dark and ugly forces of the *Beethoven Frieze* are wholly absent here. *Expectation* gives way to *Fulfilment* with nary a struggle. Nothing untoward disturbs the Stoclet family's dinner guests.

The bland form and content of the *Stoclet Frieze*, together with its complete reliance on materials more often associated with the "low" than with the "high" arts, would

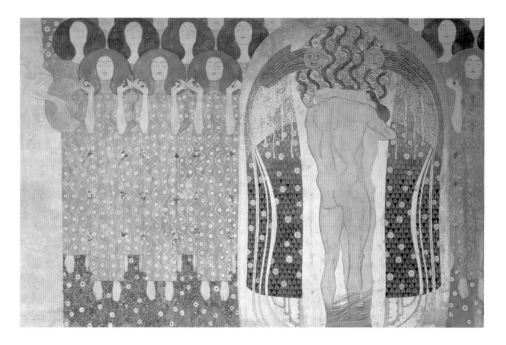

seem to substantiate Adolf Loos's complaints against the Wiener Werkstätte. In his view, the Gesamtkunstwerk concept granted neither art nor craft its proper place. "The work of art," Loos wrote, "wants to shake people out of their comfortableness. The house must serve comfort."[26] Klimt himself had trouble with the dining-room commission, presumably because his tempera and metallic leaf designs had to anticipate and make concessions to the much harsher medium of mosaic. "Stoclet is growing like an abscess on my neck," he wrote Emilie Flöge in July 1910.[27] After finally completing the full-scale cartoons (which, in frustration, he let Emilie touch up), Klimt worked closely with Forstner's workshop on the interpretation of his designs. In the end, Klimt was not entirely satisfied with the result. Offered another similar commission by the Werkstätte, he turned it down. The *Stoclet Frieze* was the artist's final large-scale mural.

FIGURE 49
The Hostile Powers
from the *Beethoven Frieze* 1902
with *Nagging Care*
at right
The Secession, Vienna

FIGURE 50
Detail of the *Beethoven Frieze* 1902
with *The Chorus of Angels*
(left) and *A Kiss for the Whole World*
The Secession, Vienna

FIGURE 51
Charles Rennie
Mackintosh
*Room Designed for the
Eighth Secession
Exhibition* 1900

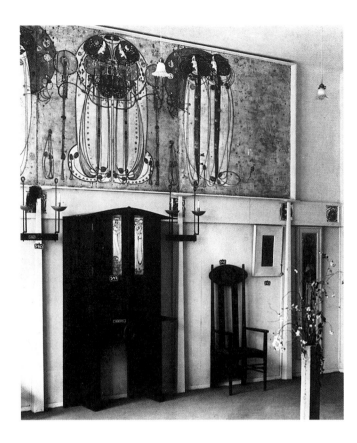

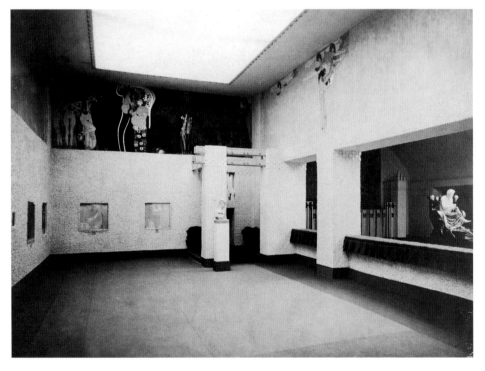

FIGURE 52
Beethoven Frieze
as originally installed
at the Vienna
Secession in 1902
The Secession,
Vienna

Conclusion: On the Road to Modernism

Seen as a group, the University paintings, *Beethoven Frieze*, and *Stoclet Frieze* illustrate the potential and perils of the Gesamtkunstwerk. Of the three commissions, the *Beethoven Frieze* is probably the most successful. The University paintings take too little account of their architectural setting, the *Stoclet Frieze*, arguably, too much. The Beethoven frescoes, on the other hand, achieve just the right balance between art and architecture—proving that it is, indeed,

possible to create an art work that is fully one with its space, yet nevertheless as complex, profound, and moving as any conventional easel painting.

The *Beethoven Frieze* may, to some extent, be seen as a forerunner of the installation art that would flourish toward the end of the twentieth century. Like these later works of art, the Beethoven installation was clearly intended as an aesthetic experience; it did not pretend to serve a utilitarian function. Whether or not Klimt consciously rejected the Gesamtkunstwerk model put forth by the Wiener Werkstätte after completing the Stoclet commission, there must be some significance to the fact that thereafter he retreated to the more conventional world of paint and canvas. Implicitly, the artist's subsequent paintings acknowledge the fact that art, to be art, must occupy its own separate realm, apart from the everyday and the practical.

Klimt's later paintings, however, continued to be informed by his earlier architectural sensibilities: the need to balance two-dimensional considerations against three-dimensional ones. Gradually, he developed a more painterly approach. His portrait subjects were now placed against backdrops of lush flowers and impastoed swirls (cat. 30 and 31), instead of the flat geometric planes of former years. Nevertheless, the contrast between realistically rendered flesh and a more abstract, ornamental surround remained as pronounced as before.

Negotiating trade-offs between illusion and reality was, in a sense, the fine-art equivalent of the form-versus-function dichotomy that was played out in the *fin-de-siècle* Gesamtkunstwerk. Just as Klimt tried to balance the illusionistic space suggested by his paintings against the geometric solidity of their architectural settings, applied artists endeavoured to balance their love of beautiful objects against the need for those objects to serve a utilitarian purpose. To the extent that they created new forms derived from the objects' function, *fin-de-siècle* Viennese artisans can be deemed to have succeeded; but to the extent that form eventually overwhelmed function, the Wiener Werkstätte ended up merely substituting a new style of superficial ornamentation for the old, historicist one.

Whereas the applied-art incarnation of the Gesamtkunstwerk ultimately proved as problematical as Loos had predicted, its fine-art counterpart would supply Klimt with endless inspiration. Instinctively resisting the push to produce interior decoration, he was able to focus on the core conflict between illusion and reality. The fact that he could never resolve this conflict in his work was not a weakness, but rather the source of the artist's enduring strength. It is, finally, Klimt's duality—his effective bridging of the moribund world of academic realism and the coming world of abstraction—that accounts for his greatness.

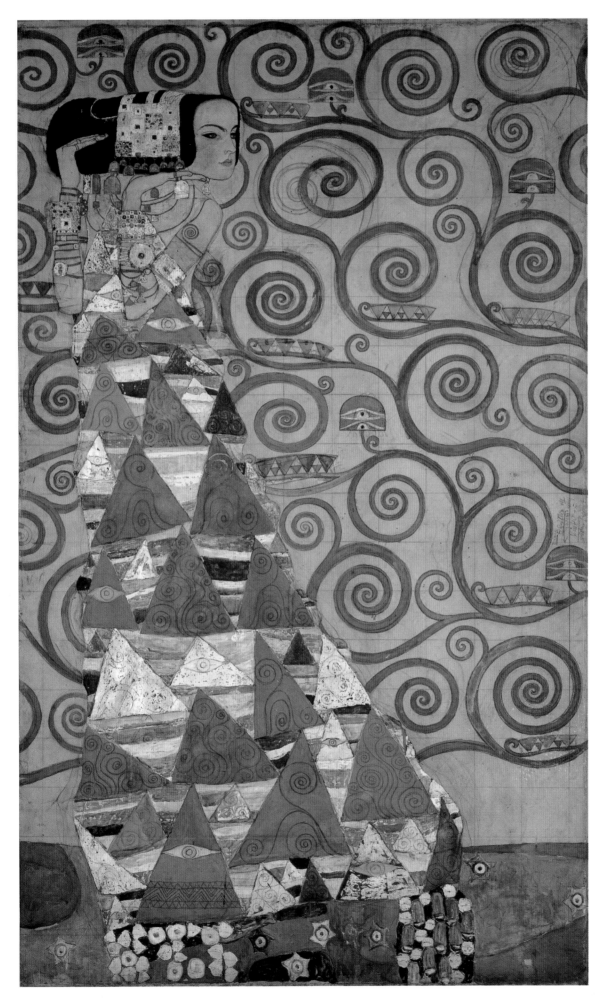

FIGURE 53
*Cartoon for the Stoclet Frieze:
Expectation* 1905–11
Österreichisches Museum
für angewandte Kunst,
Vienna

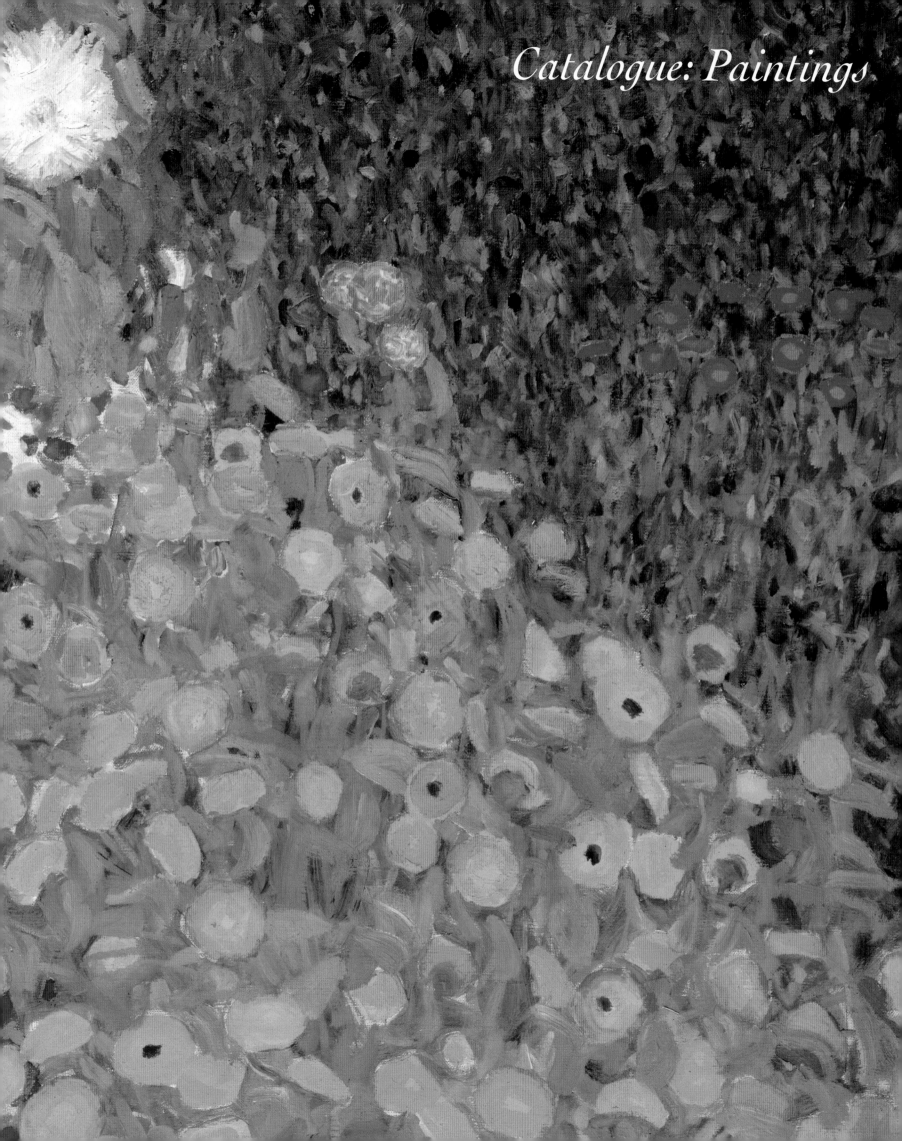

Fable 1883
Oil on canvas, 84.5 × 117 cm
Historisches Museum der Stadt Wien, Vienna
Novotny/Dobai 18

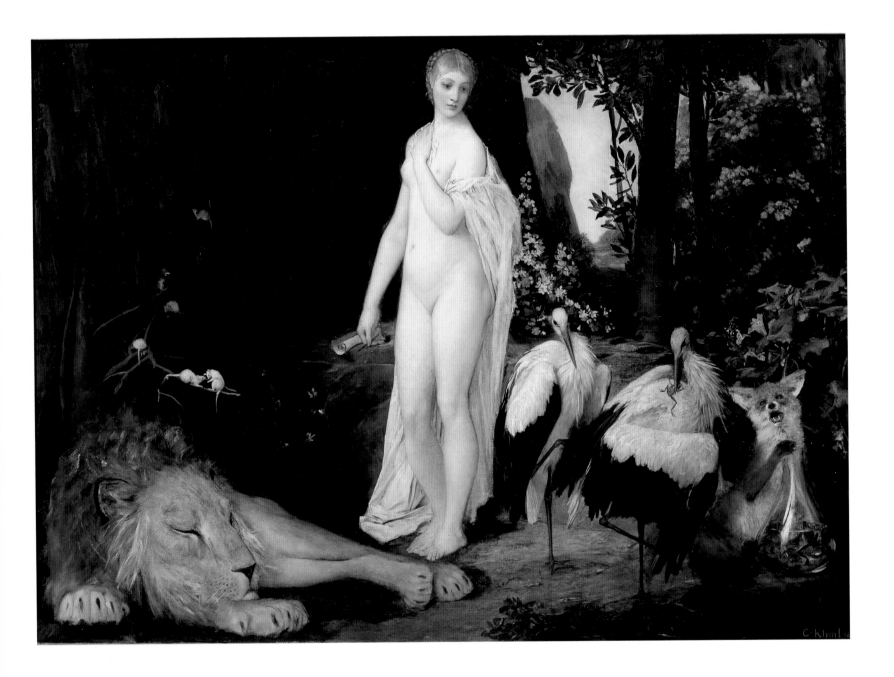

With her pale complexion, scant drapery, and formal pose, Klimt's muse of poetry is a sensual beauty worthy of the leading Viennese academic painter of the time, Hans Makart (1840–1884) (fig. 54). A luminous imaginary landscape of tall rocky cliffs and a deep valley can be glimpsed through the opening between rock and bushes. Within a sheltered retreat, the muse is surrounded by the traditional subjects of Aesop's fables. At the left, the opening lines of the "Lion and the Mouse" are illustrated, in which a sleeping lion catches a mouse creeping over his face and is about to eat it when the mouse claims that one day he would be able to repay the lion for sparing his life.[1] Illustrated at right are the final lines of the famous fable of retribution, "The Fox and the Stork" (fig. 55). In this tale, a scheming fox gets his due after he serves a hungry stork her dinner on a flat dish. The stork in turn serves the fox dinner in an urn with a long, narrow neck, from which he is unable to obtain a morsel.[2] Klimt demonstrates himself to be an "animalier" in every respect, achieving an extraordinary veracity in the soft, downy feathers of the birds, the bristling coat of the angry fox, and the muscular hide of the sleeping lion—also seen in his *Realms of Nature* (cat. 37).

Fable was reproduced as plate no. 75a in the series of *Allegorien und Embleme* published by Gerlach and Schenk of Vienna between 1882 and 1885.[3] For the series, German and Austrian artists were commissioned to provide modern interpretations of allegories that drew their subjects "from human life, from nature, heaven and earth, time and eternity, vegetation, animal life, seasons, days and months, ranks and guilds of men, passions, virtues, and vices."[4]

While many of the 130 illustrations were by lesser known artists, some names, such as Klimt's, would later be recognized as important Symbolists. The Munich artist Franz von Stuck (1863–1928), for example, contributed *Destiny* (no. 105), *Diligence* (no. 108), and *Vanity* (no. 129), among many others; Max Klinger (1857–1920) prepared drawings for *Republic and Monarchy* (no. 97) and *Anarchy and Despotism* (no. 98). In addition to *Fable*, Klimt contributed

Youth (no. 8), *The Times of Day* (no. 26), *The Realms of Nature* (no. 39 and cat. 37), *Opera* (no. 64a), *Fairy Tale* (no. 74 and cat. 39), and *Idyll* (no. 75 and cat. 2), all of which were exhibited at the Vienna City Hall in 1901 as part of the Gerlach and Schenk collection, and acquired the same year by the Historisches Museum der Stadt Wien.[5]

Klimt began his work for the series while training as a painter of decorative murals at the Kunstgewerbeschule (School of Applied Arts), a "design reform" institution modelled after the South Kensington School in London, whose primary purpose was to raise artistic standards in products for manufacture and export. Klimt's professor of painting at the Kunstgewerbeschule, Julius Victor Berger (1850–1902), also contributed to the series, as did his fellow students Franz Matsch (1861–1942) and brother Ernst Klimt (1864–1892), with whom he would collaborate on decorating commissions as part of the Künstlerkompanie (Artists' Company). Franz von Stuck emerged from the same milieu, having attended the Kunstgewerbeschule in Munich from 1878 to 1881.[6]

FIGURE 55
Jean-Baptiste Oudry, *The Fox and the Stork*, plate 2 of Jean de La Fontaine's *Fables*, Paris, 1755–59

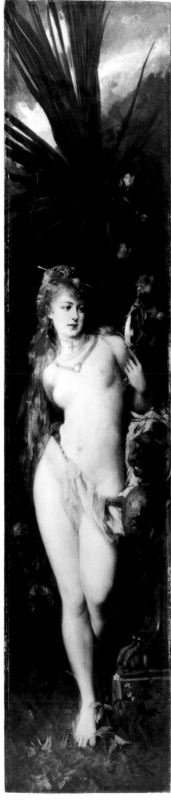

FIGURE 54
Hans Makart, *The Five Senses: Vision*, 1872–79
Österreichische Galerie Belvedere, Vienna

Idyll 1884
Oil on canvas, 49.5 × 73.5 cm
Historisches Museum der Stadt Wien, Vienna
Novotny/Dobai 19

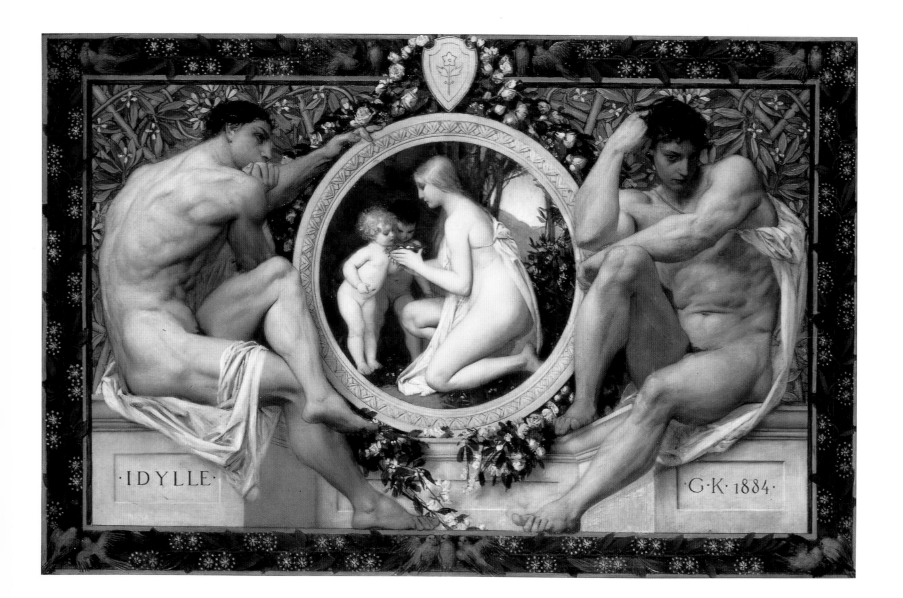

Painted a year after *Fable* for inclusion in the *Allegorien und Embleme* series as plate 75, *Idyll*'s architectural setting and "picture-within-a-picture" composition reflect Klimt's current preoccupation with the decoration of theatre and palace ceilings, in which paintings were fitted into an existing ornamental framework.[1] The brooding visages and athletic forms of the two shepherds emulate Michelangelo's nude male youths who represent the "anima razionale" on the ceiling of the Sistine Chapel in Rome (fig. 56), a format that also informs Franz von Stuck's *Coat of Arms of the Goldsmith's Art*, c. 1884 (fig. 57), another contribution to *Allegorien und Embleme*.[2] As Andrew Wilton has pointed out, the stylized patterning of the decorative background and border of *Idyll* strongly suggest Klimt's awareness of English Pre-Raphaelite painting, especially the work of Edward Burne-Jones.[3]

Idyll is divided into three distinct spatial settings, each with its own particular significance. The outer frame contains pairs of birds and flowers on long stalks whose leaves spill out of their confines. Within this frame are two male nudes holding a tondo, or circular painting, garlanded with white roses. They sit on a shallow marble bench backed with a stylized flowering vine on a trellis. Within the tondo is a bucolic landscape in which a muse—the model from *Fable*, her hair now unbraided and loose—reveals to two inquisitive children a nest containing eggs, a thematic link with the birds that inhabit the frame.

"The pairing of birds is an idyll," wrote Emerson, in defining the genre of pastoral life and loves which, like the fable, originated with the ancients.[4] That Klimt sought to conjure a golden age, populated with shepherds and rustic tribes, and familiar from descriptions of Arcadia, is confirmed by introductory remarks about *Idyll* written by Dr. Albert Ilg, the director of the art historical collections of the Imperial family of Vienna:

> The poetic form of "The Idyll" is sprung forth from the real or dreamt life of plain folk, with the simple task of depicting their quiet happiness. The artist evokes the Bucolica of Theocritus and Virgil in painting a sound, strong pastoral people enjoying an enviable peace, whose experiences of life take place on the stage of unspoiled Nature.[5]

Ilg praised Klimt's *Fable* and *Idyll* for their shared positive outlook ("Weltanschauung"). He saw these qualities as essential to a healthy approach to social life, as well as a corrective to Satire and Wit, the subjects of the illustrations provided by Max Klinger that followed *Fable* and *Idyll* in *Allegorien und Embleme* (no. 76), which belonged, according to Ilg, to an "over-cultivated state."[6] Yet the expression on the faces of Klimt's shepherds suggests that not all is harmonious in this pastoral paradise. One senses here a foretelling of Klimt's future Symbolist pessimism, in the contrast of innocent life in nature with the pensive air of the shepherds who sit unhappily bound to their task, just as the birds surrounding them spread their wings but have no place to fly.

Both technical manual and collector's item, *Allegorien und Embleme* provides insight into artistic patronage in Habsburg Vienna in the 1880s, and helps situate the origins of Klimt's continuing interest in allegory. Also published by Gerlach and Schenk in a concurrent English edition in 1882, the set of allegorical plates was widely admired. The international scope of the success of *Allegorien und Embleme* is suggested by the appearance of *Idyll* and *Realms of Nature* (cat. 37) in William Walton's *Chefs-d'œuvre de l'exposition universelle de Paris*, 1889, establishing these works as Klimt's first public exposure outside of Austria.[7]

FIGURE 56
Michelangelo, *Two Youths Holding the Medallion of the "Death of Joram,"* c. 1510, Sistine Chapel
From D. Anderson's *Roma*, vol. 80 (1904), plate 3743

FIGURE 57
Franz von Stuck, *Coat of Arms of the Goldsmith's Art*
From *Allegorien und Embleme*, 1882–85, vol. 2, no. 54a

Auditorium of the Old Burgtheater 1888
Gouache on paper, 82 × 92 cm
Historisches Museum der Stadt Wien, Vienna
Novotny/Dobai 44
Strobl 191

Located on the northern perimeter of the Hofburg, Vienna's Imperial palace complex, the Burgtheater had been founded as a court theatre by Empress Maria Theresia in the mid-eighteenth century.[1] This painting was commissioned for the Historisches Museum der Stadt Wien only months before the Burgtheater's demolition to make way for the monumental facade of the Michaelertrakt.[2] Klimt and Franz Matsch, his colleague in the Künstlerkompanie decorating partnership, had already begun work on murals to embellish the new Burgtheater on the Ringstrasse, and were further charged with documenting the view toward the auditorium and stage (fig. 58) of the old building.[3]

Originally built on the site of an indoor court for playing ball attached to the palace, the old Burgtheater's interior was a baroque shell renovated to suit mid-nineteenth-century taste.[4] The theatre's intimate scale provided it with exceptional acoustics but had long been inadequate to accommodate its expanding audience.[5] In 1884, it would be described as "neither remarkable by comfort, nor by elegance. The [auditorium], which is a great deal too small, can hardly contain the half of the spectators who should like to enter."[6]

By taking a low vantage point from the right, just level with the stage, Klimt opens up the space and presents a sweeping view of the balcony that ends with the draped Imperial box to the far left. Here stands Archduke Carl Ludwig, brother of Emperor Franz Josef, with his third wife, the Archduchess Maria Theresia of Braganza.[7] The audience represents a veritable "Who's Who" of high-ranking Viennese society of the time, including more than a hundred individual portraits "of distinguished and familiar personalities."[8] The Emperor's mistress, the actress Katharina Schratt, is seated on the aisle, third row back, and opposite her, the pioneering surgeon Theodor Billroth, a friend of composer Johannes Brahms, whose familiar white beard is almost lost from view among the throng.[9] Klimt's younger brother Ernst, smartly dressed in a starched collar and trimmed beard, takes his seat in the middle of the second row on the left, perhaps the location of Klimt's own "Permanenzkarte"—the season tickets he obtained while involved with the Burgtheater commission.

Commissioned to be as "authentic and correct as possible," Klimt took great care with the accuracy of the auditorium architecture, going so far as to make precise measurements of the interior and floor plan that delayed the completion of the work.[10] The realism of the various miniature portraits suggests that Klimt may have resorted to photography for his busier models (such as Billroth), and it is known that he used photography for poses in the murals of the new Burgtheater.[11] However, such precise recording of the audience is in contrast to the spontaneity and originality of many of the poses, a result of Klimt's study of an actual performance with his sketchbook in hand. The resulting series of quickly drawn studies of spectators was executed with rapid pencil strokes, conveying an immediacy of expression usually associated with Impressionism (fig. 59). Around the upper rows of balconies, some theatre-goers study the crowd through opera glasses while others lean over the rail, content with more casual observation. In addition to portraits, Klimt included a number of anonymous women holding fans and wearing evening veils over their heads, who proceed unescorted down the centre and outer aisles to the most desirable seats; above the Imperial box, another removes her veil, seemingly indifferent to the bustle of activity around her.

The preparation of the Burgtheater views by Klimt and Franz Matsch created a minor sensation in Vienna. Matsch recalled an unending stream of models passing through the doors of their studio, but, as not all could be included, "there were many intrigues, and many tears flowed from more or less beautiful eyes."[12] In his discussion of Klimt's *Philosophy*, Carl Schorske shows the artist "to be a child of theatrical culture,"[13] and the Burgtheater's central role in nurturing this culture was described by the novelist Stefan Zweig: "For the Austrian [it was] more than a stage upon which actors enacted parts; it was the microcosm that mirrored the macrocosm, the brightly coloured reflection in which the city saw itself, the only true *cortigiano* [courtier] of good taste."[14] After the final performance in the old Burgtheater, on 12 October 1888—Goethe's *Iphigenie auf Tauris*—Zweig relates that "the curtain had hardly fallen when everybody leapt upon the stage, to bring home at least a

splinter as a relic of the boards which the beloved artists had trod."[15] It is not surprising, therefore, that following the exhibition in March 1890 of the *Auditorium of the Old Burgtheater* at the Künstlerhaus, on 25 April Klimt was awarded the highly coveted "Kaiserpreis," the Emperor's Prize of 400 ducats (approximately $10,000 today), an honour reserved for "the promotion of patriotic artistic works," and one that acknowledged Klimt as Austria's leading painter.[16]

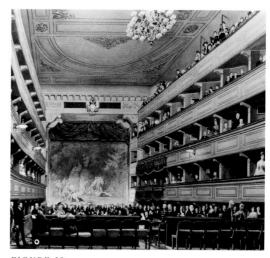

FIGURE 58

Franz Matsch, *Auditorium of the Old Burgtheater*, 1888
Historisches Museum der Stadt Wien, Vienna

FIGURE 59

Four Studies of Women, 1888. Yale University Art Gallery, New Haven, Connecticut, Gift of John Goelet

Portrait of Josef Pembaur 1890
Oil on canvas, 69 × 55 cm
Tiroler Landesmuseum Ferdinandeum, Innsbruck, Austria
Novotny/Dobai 58

This painting of Josef Pembaur (1848–1923), the noted Innsbruck music teacher, composer, and conductor, is one of the few male portraits ever undertaken by the artist.[1] According to Klimt's partner in the Künstlerkompanie, Franz Matsch, the portrait originally hung in the Löwenbräu Tavern in Vienna.[2] Here, every Thursday, admirers of the composer met as the "Pembaur-Gesellschaft"—their devotion to new ideas in music equivalent to the love of literary innovation that inspired the "Jung Wien" (Young Vienna) group of writers who gathered around Hermann Bahr in the 1890s.

Appropriate to the painting's function as a tribute, the composer is shown with a golden lyre, the attribute of Apollo, the god of Music. On the frame to the right, Apollo himself stands on a column copied faithfully from an Archaic Greek black-figure vase painting, except for the colouring and a band of piano keys encircling it.[3] Beside the column, the dolphins jumping from the sea are an allusion to Apollo's sanctuary at Delphi, mentioned in Homer's *Hymn to Apollo*.[4] On the frame to the left is a further reference to the cult of Apollo, in the form of a tripod, above which burning incense drifts up to a star-filled sky. References to Pembaur Society meetings appear on the lower portion of the frame, where an emblem containing the letters "G" and "S" below a spade have been identified as the trademark of the Munich brewery "Spatenbräu."[5] The Archaic Greek heads beside it undoubtedly represent the loyal members of the society.

At the time the portrait was painted, Pembaur held the position of director of the Innsbruck Music Society (Musikverein), and was a highly accomplished composer of pieces for male choirs and religious songs noted for their "genuine piety" and "unity of style."[6] Born in Innsbruck to a senior municipal official, Pembaur studied music at the Conservatory in Vienna with Anton Bruckner, and choir music and solo voice in Munich from 1871 to 1874,[7] under two ardent Wagnerians: Franz Wüllner, who conducted the first performances of Wagner's *Das Rheingold* (1869) and *Die Walküre* (1870), and Julius Hey, who undertook the reform of singing instruction to emphasize German nationalism, as part of a plan initiated by Richard Wagner.[8]

Pembaur's interest in vocal music led to his involvement in preparations for a monument to the twelfth-century German Minnesinger (singer of courtly love) Walther von der Vogelweide, erected in 1889 at Bolzano, Italy, which was then part of Austria and the region of Vogelweide's birth.[9] It was on the occasion of the monument's unveiling that the Viennese actor Georg Reimers, a friend of Franz Matsch, delivered a speech in honour of Pembaur, which prompted the idea of a Pembaur Society.[10] In addition to Klimt, Matsch, and Reimers (who owned Pembaur's portrait until his death), members of Vienna's Pembaur Society included actors Friedrich Kastel, Max Devrient, and Ernst Hartmann, and singers Theodor Reichmann and Hermann Winckelmann.[11] In March 1887, the two singers had taken part in a gala performance held in Vienna as a fundraiser for the monument, with the opening chorus to Wagner's *Die Meistersinger* included on the programme.[12]

Despite Pembaur's three years of training with Wagner's disciples in Munich, his vocal arrangements and musical scores are recognized today as following in the late Romantic tradition of Robert Schumann.[13] Wagner's influence can be detected, however, in Pembaur's published music theory. Believing that "music was tonal architecture," Pembaur emphasized the artistic potential of choral music and championed a greater creative freedom in composition.[14] In an address delivered to the "Ambrosius Verein" (Ambrosius Society) of Vienna in 1891, and published under the title *Über das Dirigieren (On Conducting)* in 1892, he wrote: "Every musical idea possesses its own musical form; one no longer composes according to a predetermined set of rules; rather, a composition will accord with the essence and the content of one's emotions as portrayed in characteristic motifs and phrases."[15] For Pembaur, choral music was an elevated art form that had nothing to do with simple entertainments such as operettas, drinking songs, and dance pieces, and he advised directors of choral societies to view the "earnest nurturing of music" as their primary concern and to pursue the "artistic ideal" in their work: "Its absolute musical significance aside, all vocal music should be understood, in its essence, as an illustration of the poetic."[16]

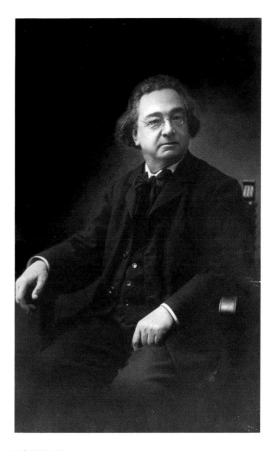

FIGURE 60

Josef Pembaur, c. 1900. Bildarchiv, Österreichische Nationalbibliothek, Vienna

Pembaur directed the Innsbruck Music Society for forty-four years, from 1874 until his retirement in 1918.[17] A photograph taken about ten years after Klimt's portrait (fig. 60) shows Pembaur to be a little fleshier around the jowls, his dark hair now flecked with grey, but still wearing the same rimless spectacles and black silk lavallière tie seen in the portrait. If the Burgtheater gouache placed Klimt among Vienna's theatre-going society, his portrait of Pembaur widens this cultural milieu to include the musical sphere and anticipates his friendship with the composer and conductor Gustav Mahler. Klimt's association of Pembaur with Apollo looks forward to his allegorical pantheon of cultural heroes derived from Greek art and the Middle Ages, including *Pallas Athena*, *Nuda Veritas*, and the *Golden Knight* of the *Beethoven Frieze*, who all signified the struggle of the Arts against outmoded clichés, and the striving of artists to be of their time.

Two Girls with an Oleander c. 1890–92
Oil on canvas, 55 × 128.5 cm
Wadsworth Atheneum, Hartford, Connecticut
The Ella Gallup Sumner and Mary Catlin Sumner Collection Fund
Novotny/Dobai 59

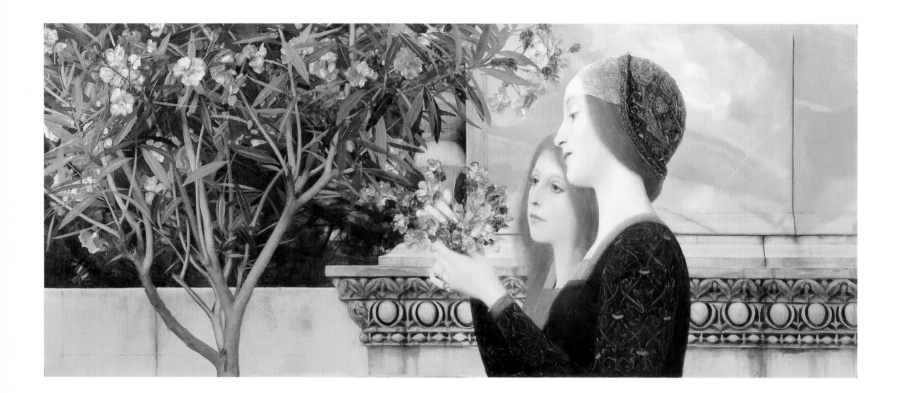

It is not known what prompted Klimt to paint this unusual early work, nor to whom it first belonged.[1] Klimt rarely executed easel paintings in a horizontal format, and the severe cropping of the scene renders the setting ambiguous—only the upper torsos of the girls, the truncated marble column behind, and the lower limbs of the oleander tree are visible. Yet the painting is anchored as an independent composition with a central focal point that falls upon a delicate pair of hands, whose ringed fingers arrange freshly picked oleander blossoms.

With its appeal to the antiquarian world of the senses, *Two Girls with an Oleander* draws on the great vogue for paintings of classical Greece and Rome by Sir Lawrence Alma-Tadema (1836–1912).[2] Running like a leitmotif through the oeuvre of Alma-Tadema are contemporary young British women in antique robes admiring luxuriant tropical flowers, as seen for example in *The Oleander*, 1882 (private collection), or in *Unconscious Rivals*, 1893 (Bristol City Museum and Art Gallery) with its brilliant red azalea tree.[3] Alma-Tadema's paintings invite the observer to inhabit an historical dream world of untroubled luxury and pleasure; this is also the ambience of *Two Girls with an Oleander*.

With its academic style, historical subject matter, and placement of figures against a shallow architectural background, *Two Girls with an Oleander* is closely related to the representations of Italian Renaissance art that Klimt executed at this time for the spandrels and lunettes above the staircase of Vienna's recently completed Kunsthistorisches Museum (Art History Museum); and, indeed, the artist drew upon the Museum's collections for this painting.[4] The serene demeanour of the model holding the oleander blossoms is based on the features of the subject in *Isabella of Aragon* (fig. 61), a marble bust by Francesco Laurana (1430–1502) inventoried as part of the Imperial family's collection in the seventeenth century.[5] Even the coloration of Klimt's model seems derived from Laurana's bust, the only known example of the sculptor's work to retain the original polychrome surface. Isabella's neck and face have a pale, flesh-like glow, the lips a reddish-brown tone, and the hair an auburn colour—all qualities applicable to Klimt's model.[6]

Further references to the Italian Renaissance in *Two Girls with an Oleander* can be seen in the visible fragments of costume and architecture.

The richly embroidered sleeves of the dress of the foreground figure, the crespinette that holds her hair, as well as the red tunic worn by her companion are compatible with a style of clothing worn in fifteenth-century Italy. The oleander tree was considered the "favourite flower of the Levantine mid-summer," and the ovolo moulding at the base of the marble column also appears in Klimt's two spandrel paintings of the Florentine Quattrocento.[7]

Two Girls with an Oleander is usually placed in that period prior to Klimt's awakening to the explorations of the psyche by Symbolist artists around the turn of the century. But the painting's reference to Laurana suggests that Klimt was already aware of the sculptor's international following among a generation of Symbolist artists.[8] For example, the cool indifference and melancholy tone expressed by the subjects of Laurana's busts attracted the Belgian artist Fernand Khnopff in the 1890s. Khnopff pays homage to the Italian sculptor in *The Offering*, 1891 (fig. 62) and *Through the Ages*, 1894 (created for *The Studio*), in which a studio model embraces a Laurana bust in a representation of what must be contemporary longing for the perfections of an ideal past.[9] With its horizontal format and shallow, architecturally enclosed space, *The Offering* is especially suggestive of *Two Girls with an Oleander*.[10] The affinity between Khnopff and Klimt was noted by the Viennese critic Hermann Bahr in his review of the second Secession exhi-

bition of November–December 1898: "[Klimt] shares with Khnopff that elegance of the soul that would rather not be understood at all than decide to speak out and cause discord."[11] With its oblique historical references, *Two Girls with an Oleander* possesses something of that hushed esotericism so readily associated with Khnopff's meditations on material existence.

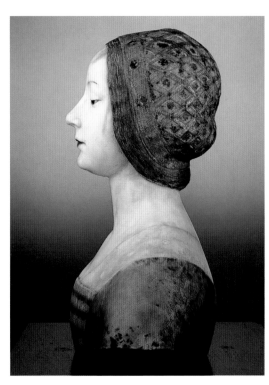

FIGURE 61
Francesco Laurana, *Isabella of Aragon*, c. 1488
Kunsthistorisches Museum, Vienna

FIGURE 62
Fernand Khnopff, *The Offering*, 1891. Anonymous extended loan to The Museum of Modern Art, New York

Portrait of a Woman (Frau Heymann?) c. 1894
Oil on cardboard, 39 × 23 cm
Historisches Museum der Stadt Wien, Vienna
Novotny/Dobai 65

If decorative painting was Klimt's principal occupation in the late 1880s and 1890s, after the success of his *Auditorium of the Old Burgtheater* he became a recognized portrait painter. The identity of the sitter in this portrait has remained uncertain since its acquisition by the Historisches Museum der Stadt Wien in 1937 from Dr. August Heymann, a noted collector of art and of books relating to the history of Vienna.[1] It has been proposed by a former director of the Museum that the sitter is in fact the wife of Dr. Heymann.[2] While the woman in Klimt's portrait is the right age to be Heymann's wife, Helene Junkermann, born in Vienna on 23 November 1872, the two were only married on 19 July 1904, ten years after the dating of this painting.[3]

The brown eyes of Klimt's model gaze out at the viewer with a steady self-assurance and purposefulness worthy of François Clouet's *Portrait of Elisabeth of Austria*, 1571 (fig. 63). Her full cheeks and fleshy chin suggest a life of contentment and luxury, enjoyed in what Stefan Zweig would describe as Vienna's "Golden Age of Security" prior to World War I.[4] Despite her comfortable life, there is a reserved stylishness and an exploration of psyche about this portrait that sets it apart from the earlier *Portrait of Clothilde Beer*, 1880 (fig. 64), painted by her cousin Hans Makart, Vienna's most popular society portraitist. The putative Frau Heymann wears a jewelled choker and drop-pearl earrings that do not distract from the quiet intent of her bearing; the dark velour of her clothing and the grey gauze of her collar complement the reddish-brown tone of her curly hair and the ruddy colour of the inlaid woodwork or wall covering behind.

In contrast to the protuberant moulding of a classical design seen behind Clothilde Beer, the schematic floral surface decoration of the background of *Portrait of a Woman (Frau Heymann?)* reflects an interest in seeking more arcane sources for decorative motifs. The straight-stemmed floral design could well have been drawn from Art Nouveau or Arts and Crafts sources. As Heymann also owned a copy of the deluxe "Gründerausgabe" (founder's edition) of the Secession journal *Ver Sacrum* published in 1898 and 1899, this modest portrait can be seen to look forward to the Secession movement of 1897 and the enlightened patronage that made it possible.[5]

FIGURE 63

François Clouet, *Portrait of Elisabeth of Austria*, 1571
Bibliothèque nationale, Paris

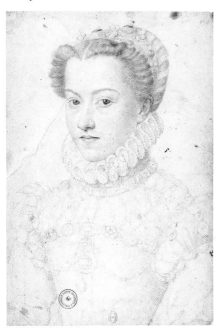

FIGURE 64

Hans Makart, *Portrait of Clothilde Beer*, c. 1880
Österreichische Galerie Belvedere, Vienna

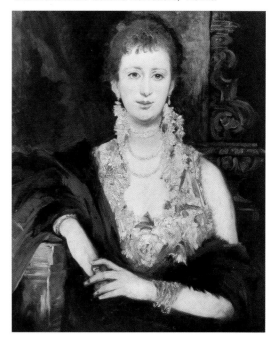

Portrait of Josef Lewinsky 1895
Oil on canvas, 60 × 44 cm
Österreichische Galerie Belvedere, Vienna
Novotny/Dobai 67

The circumstances of Klimt's commission to paint the official portrait of Josef Lewinsky (1835–1907) are unusual to say the least. It was not Lewinsky who approached Klimt, but rather it was the artist who initially proposed the idea to this celebrated actor of the Viennese stage in a letter of 19 May 1894:

> Honourable Sir. The Society for Reproductive Art is publishing a large work on Vienna's theatres, and first and foremost about the old Burgtheater; I believe that your Honour has already been advised to this effect through his Excellency Baron von Wieser. I have been commissioned to paint one of the actors of the old Burgtheater, and specifically in a role that alters the appearance of the artist in question as little as possible. I have taken the liberty of electing to paint a portrait of your Honour and would now kindly request word as to where and when I might be privileged to speak with your Honour on this matter.[1]

This relatively small painting took over a year to complete, which suggests that Klimt may not have received Lewinsky's entire cooperation. In June and July 1895, Klimt would again write Lewinsky requesting a further sitting, explaining that he required only an hour or two of the actor's time.[2]

Since his debut at the Burgtheater in 1858 at the age of twenty-two, Lewinsky had been closely identified with the character of Carlos in Goethe's tragedy *Clavigo*.[3] Indeed, Klimt's portrayal of Lewinsky in this role at age sixty seems at odds with the play's theme of youthful love and ambition. Written in 1774, *Clavigo* was inspired by events that had taken place in Madrid a decade earlier, which had been recorded by Pierre Augustin Caron de Beaumarchais in *Fragment de mon voyage d'Espagne* (they involved an affair between the author's sister, Marie Louise Caron, and the Spanish Royal Archivist, José Clavijo y Fajardo).[4] In Goethe's dramatization, Marie dies from shock after Clavigo abruptly cancels their planned marriage; Beaumarchais takes Clavigo's life to avenge his sister's honour—though the actual Clavijo was merely dismissed from his post for ungentlemanly conduct and lived until 1806. The character of Carlos—who appears as Clavigo's worldly friend, but is really his unscrupulous alter ego—is Goethe's own dramatic embellishment of the story. In the noted "persuasion scene" in Act IV, Carlos eloquently emboldens the Archivist by stoking his ambitions and suggesting that his betrothed may be a liability to his prospects.[5]

Goethe is recorded as remarking: "In Carlos, I wanted to allow purely worldly intellect, combined with true friendship, to counteract passion, affection and external pressures."[6] Contemporary critics immediately recognized the actor's skill at conveying Carlos's duplicity: "Mr. Lewinsky presents us with a man whose features bear the deep traces of passions now extinguished and overcome; it is a cold, dead face, old before its time, in which there is nothing left save a bitter contempt for mankind."[7]

Like *Allegory of Love* (cat. 8), also of 1895, this portrait has a tripartite division, with lighter side panels that contrast with the shadowy stage on which the actor stands in a pose that recalls Manet's *Tragic Actor*, 1865–66 (fig. 66). On the right panel Klimt depicts Melpomene, the muse of Tragedy, in traditional Greek dress, holding an eerily lifelike mask. The artist would use a variation on this scheme in *Tragedy*, 1897 (cat. 50), and again for the female muses of theatre in *Thalia and Melpomene*, 1899 (cat. 57). According to Lisa Florman, the side panels can further be interpreted as references to the Dionysian and Apollonian origins of Greek tragedy outlined by Nietzsche in *The Birth of Tragedy* (1872).[8] The incense-burning tripod in the right panel, seen earlier on the frame of *Portrait of Josef Pembaur* (cat. 4), is an attribute of Apollo, while the tendrils of grape vine on the left are associated with Dionysus, the god of Wine. To Florman's analysis one can add that a bearded mask, consistent with ancient Greek Dionysian imagery, hovers at the top edge of the right panel, and that a spray of laurel, another attribute of Apollo, lies veiled by mists beneath the vine on the left. Each side panel, therefore, affirms Nietzsche's dual explanation of tragedy.

In 1902, the portrait was acquired from the Society for Reproductive Art by the Moderne Galerie (now the Österreichische Galerie Belvedere), in consideration of a grant from the state, but it was subsequently little discussed in the Klimt literature and only exhibited in 1928, after the artist's death.[9] As one of his rare portraits of men, the painting may not have been typical of Klimt, but with its mood-setting presentation and freely interpreted references to theatrical tradition, it anticipates his more provocative Symbolist style seen in full bloom in the Secession and *Ver Sacrum* a few years later.

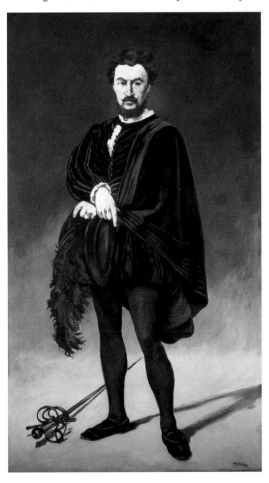

Allegory of Love 1895
Oil on canvas, 60 × 44 cm
Historisches Museum der Stadt Wien, Vienna
Novotny/Dobai 68

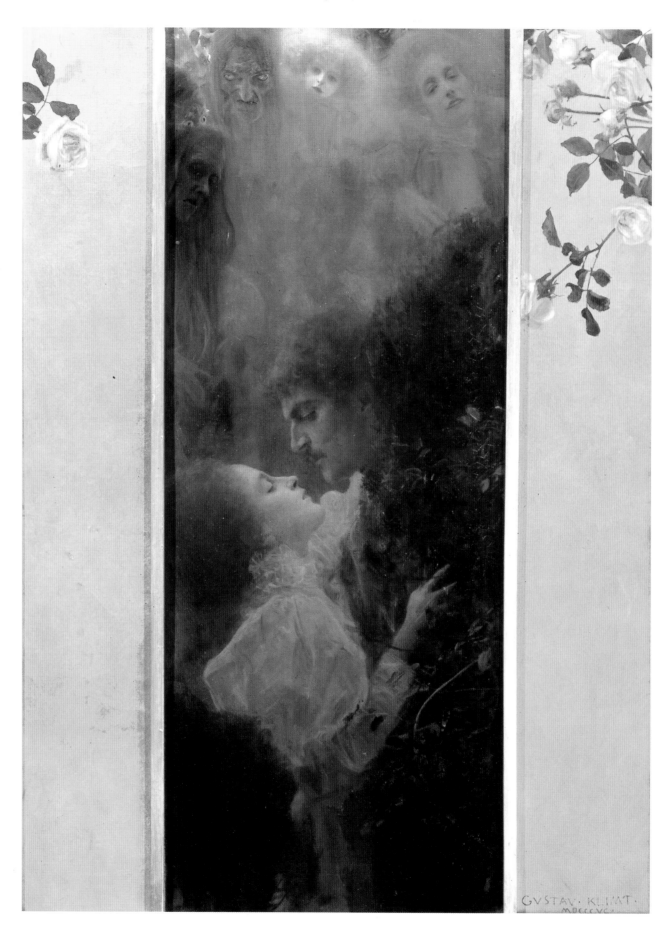

In 1895, Klimt was again invited to contribute to a new series of Martin Gerlach's allegories, beginning with this work.[1] No less than ten artists would prepare illustrations on the same topic, though as a finished painting Klimt's *Love* stands out as an ambitious, and by far the most complex, undertaking of the theme. With its unusual tripartite design, *Love* is the first of Klimt's paintings to incorporate gold as part of the picture plane. Each of these side panels is painted with a spray of roses, the universal symbol of romantic involvement and a motif that Klimt would return to, for example in the *Beethoven Frieze* of 1902 as a background to the *Kiss for the Whole World*.

In the foreword to this new series, Gerlach wrote: "First I chose the theme that exudes joy and life: love, song, music and dance. Later the inexhaustible florid sphere of the arts and sciences and the happy cycle of the seasons with the cheerful sports would be added to this."[2] Despite the simplicity of Gerlach's text, Klimt profited from the commission of *Love* to step beyond the boundaries of traditional allegory into the veiled realm of the psyche, with a brooding commentary on agonizing "desire." This most basic of human instincts was being explored elsewhere in Vienna during the 1890s, in plays by Arthur Schnitzler and in the cure of hysteria through hypnotism by Sigmund Freud.[3]

Today, it is *The Kiss*, 1908 (fig. 13) that has established Klimt as the ultimate Romantic Symbolist and made his name synonymous with the subject of "love." But in the 1890s, this honour still belonged solely to the French sculptor Auguste Rodin, whose well-known work *The Kiss* (fig. 67) created a sensation following its first public appearance in 1887.[4] Klimt's *Love*, however, offers another interpretation of the theme and differs significantly in mood. Klimt chooses not to illustrate that primordial moment of the couple's romantic fulfilment, but rather, the charged instant of expectancy before the lips touch. Where Rodin's *Kiss* presents love as universal salvation, Klimt associates doubt and foreboding with physical desire, and its ever-present nemeses of old age, disease, and death.

These "symbols of love's pleasures and love's pains," as Max Eisler would describe them in 1920, appear as disembodied visages rising from a crepuscular mist, and introduce the pessimistic themes that Klimt would return to in his later allegorical paintings.[5] From the upper left, an aged woman with long strands of unkempt hair gazes vacantly down upon the couple, a frankly disturbing and admonishing image. Above her, a pair of crazed eyes suggests madness, while a skull

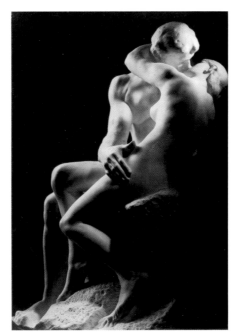

FIGURE 67

Auguste Rodin, *The Kiss*, 1888–89. Musée Rodin, Paris
Marble after the plaster exhibited in Brussels, 1887

representing death is partially concealed behind the face of a snarling old woman with distended and wandering eyes (fig. 68).[6]

With the appearance, above the couple, of a child with a halo of frizzy hair (fig. 69) and the lilting head of a beautiful young woman in the prime of life, Klimt's *Love* has often been interpreted as his earliest treatment of the "ages of woman" theme.[7] Yet if this were correct, how can we account for

the inclusion of figures representing death and disease, and why the single male face between the youthful females, with his round and angry eyes? And how are we to interpret the contrast between the soft light that falls directly upon the passive face of the swooning woman and the malevolent shadow that shrouds her earnest lover? A gold ring gleams on her right middle finger, as she grasps her lover's amorphous form emerging from behind a tall garden hedge—from dark nature itself. Fiancé, husband, or amorous fantasy, he seems somehow associated with the sinister dream world of old age, death, and disease, hovering above. In *Love*, Klimt draws into doubt the very foundations of contemporary Viennese society, the virtue of its young women, and the honourable intentions of its bourgeois men. As Stefan Zweig put it, "the air was full of erotic infection, and a girl of good family had to live in a completely sterilized atmosphere, from the day of her birth until the day when she left the altar on her husband's arm."[8]

"When the work of interpretation has been completed, we perceive that a dream is the fulfilment of a wish," wrote Sigmund Freud in the *Interpretation of Dreams* of 1899.[9] With its allusions to the illuminated subconscious, Klimt's *Love* anticipates Freud's revolutionary conclusion about the modern mind, and the fear of its unwelcome revelations. Klimt's allegory of *Love* suggests the lesson that, just as the rose has thorns, passion is fraught with uncertainty.

FIGURE 68

Study of an Old Man for "Love," 1895. Graphische
Sammlung Albertina, Vienna

FIGURE 69

Study of a Child for "Love," 1895. Graphische
Sammlung Albertina, Vienna

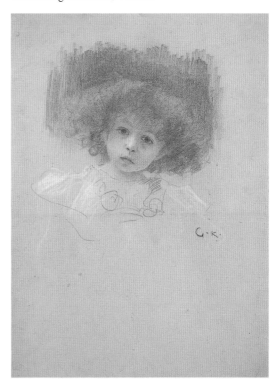

Portrait of a Lady 1897–98
Pastel on heavy brown wove paper, 51.2 × 27.7 cm
Allen Memorial Art Museum, Oberlin, Ohio
R.T. Miller Fund, 1958
Novotny/Dobai 82
Strobl 392

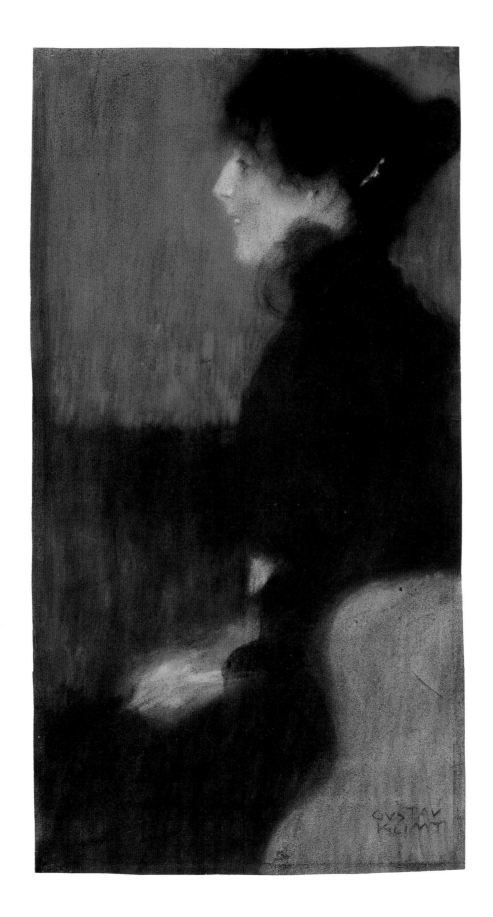

Portrait of a Lady is one of the few examples of Klimt's work in pastel, and belongs to a series of drawings of women in profile created between 1896 and 1898 (Strobl 386–96), all characterized by a fluid blending of figure and ground and a dim ambient light, evoking a mood of melancholic withdrawal. This work has been identified as one of the two pastels that Klimt sent to the first Secession exhibition, which opened in March 1898, where they inspired art critic Ludwig Hevesi to remark: "Completely masterful are some portrait studies by Klimt, rendered with a strangely beautiful light."[1]

The atmospheric treatment, in which light is manipulated to create an intimate, emotive setting, was also a characteristic of the work of such Symbolist artists as Eugène Carrière and Fernand Khnopff—both of whom participated in the first Secession exhibition.[2] Yet the strict profile position of the model in *Portrait of a Woman* also recalls James McNeill Whistler's well-known portrait of his mother, *Arrangement in Grey and Black*, 1867 (Musée d'Orsay, Paris); it is a pose that Whistler would return to in the lithograph *The Sisters* almost thirty years later (fig. 70).[3]

Hevesi referred to "portrait studies," but the identity of the sitter of *Portrait of a Lady* remains unknown. The sitter's features are related to Klimt's profile *Portrait of Melanie Cambras*, c. 1897–98 (private collection), though the model's large eyes and raven hair gathered behind also evoke Serena Lederer, whose portrait Klimt painted in a very Whistlerian manner in 1899 (fig. 95). According to Egon Schiele, Serena was Klimt's student during the early years of the Secession, the period of the Oberlin pastel.[4]

Coincident with *Portrait of a Lady*'s appearance at the first Secession was its publication in *Ver Sacrum* in March 1898—an issue devoted to Klimt's illustration and design work. Indeed, in its striking tonal contrasts, and in the planar, cropped presentation of the figure, as well as in the flowing curve of dress and armchair, the pastel reflects contemporary Art Nouveau and Jugendstil graphic styles that were a regular feature of *Ver Sacrum*. Lost in that reproduction, however, are the textural subtleties that Klimt was able to achieve through the use of pastel: the way a layer of navy blue crayon applied over the dress adds depth, or the hairpin's reflection of light, or the soft curls that fall over the model's forehead.

In 1903, *Portrait of a Lady* was shown in Klimt's Secession retrospective, hung in room seven (fig. 71) between *Pine Forest I* and *Pine Forest II* (cat. 14).[5] No owner was identified, and it may have sold on the opening day of the exhibition, suggesting that it had remained in Klimt's personal possession since 1898.[6] As Jane Kallir has pointed out recently in her engaging history of the Galerie St. Etienne, after emigrating to New York in 1939, her grandfather, the art dealer Otto Kallir, showed *Portrait of a Lady* in the *Saved from Europe* exhibition he mounted during the summer of 1940, together with *Pear Tree* (cat. 17) and *The Park* (cat. 27).[7] At the time, Klimt was not well known in the United States, and nineteen years would pass before his first one-man show at the Galerie St. Etienne in 1959. The Allen Memorial Art Museum was early to recognize the artist's importance, acquiring *Portrait of a Lady* in 1958. This followed *Pear Tree*'s

entry into the collection of Harvard University's Fogg Art Museum in 1956, a gift of Otto Kallir, and the 1957 purchase of *The Park* by New York's Museum of Modern Art.

FIGURE 70

James McNeill Whistler, *The Sisters*, 1894–95. The Art Institute of Chicago, Bequest of Bryan Lathrop, 1917

FIGURE 71

View of the *Klimt Kollektive* exhibition at the Secession, 1903, with *Portrait of a Lady* at centre. Bildarchiv, Österreichische Nationalbibliothek, Vienna

Moving Water 1898
Oil on canvas, 53 × 66 cm
Private collection
Courtesy Galerie St. Etienne, New York
Novotny/Dobai 94

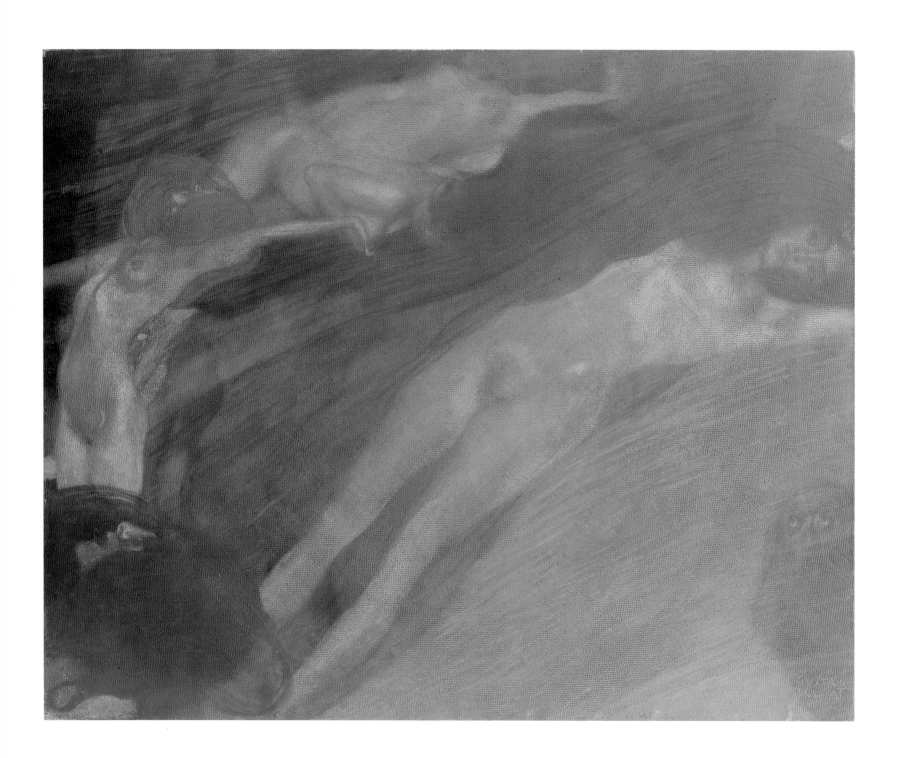

In *Moving Water*, five female nudes appear to be swept along underwater as half-conscious spirits of the depths. A mildewy film of green and blue clings to their slim, pale bodies, while long, billowing tresses surge in the current's flow. These strange aquatic beings would be the first appearance of Klimt's ubiquitous "Schwebenden" (floating women). With her outstretched arm, the floating figure would reappear most notably as part of the great chain of humanity in *Medicine*, the second of Klimt's University paintings, exhibited at the Vienna Secession in March 1901. He would again use a series of floating female nudes to represent the Arts in the finale of the *Beethoven Frieze*.

When shown for the first time at the second Secession exhibition in November–December 1898, *Moving Water* was eloquently described by art critic Ludwig Hevesi: "Bright waves and white bodies seem to dissolve into one another, a fleeting dream-image created by a playful mind, caught by a Sunday's child. . . . Such fantasies flow from a venerable primordial urge of the human race; pantheism will never die."[1] Creatures that spring forth from the elements were a common subject among Symbolist artists. That the female water-elf, nymph, or Nixie had a long history in German folklore is evident from the fairy tales collected by the brothers Grimm in the early 1800s.[2] Later in the century, the water nymph took on an additional significance in the exploration of female sexuality.[3] It was this aspect that had a particular appeal for Klimt, and *Moving Water* introduces the theme that would preoccupy him in various incarnations for the next decade.[4]

As Jost Hermand has suggested, the prevalence of the water nymph in German art at the turn of the century was part of a reaction against industrialization and the "soullessness" of modern society.[5] As a "Naturwesen" (Creature of Nature), she became a favourite motif of Jugendstil artists intent on demonstrating the falseness of the corsetted world of big city fashion. In Vienna, the image of the "Naturwesen" evoked the spirit of youth and springtime that was key to the Secession's task of artistic renewal. As a woodsy relative of the water nymph, she appeared in Josef Engelhart's *A Summer Day* (fig. 72)[6]; and was featured frequently in the illustrations of the Secession journal *Ver Sacrum*, including Klimt's own *Fischblut* ("Fish Blood"), published in March 1898, which translates *Moving Water* into clear graphic forms (fig. 73).[7]

The German tradition of the water nymph was most prominently revived in Richard Wagner's opera *Das Rheingold*, first performed in Munich in 1869. The powerful opening scene, in which three Rhinemaidens swirl about on the murky bed of the river, reflects the *Gesamtkunstwerk*, the synthesis of sound and vision in a music drama. Appointed as music director of the Vienna Opera in 1897, Gustav Mahler staged *Das Rheingold* in December 1899, as part of his project to produce the unabridged opera cycle of *Der Ring des Nibelungen*. Mahler's future wife, Alma Schindler, who eventually owned *Moving Water*, attended this performance and recorded her impressions of the opening scene: "Forty-two bars with an unchanging harmonic basis—a fine idea. And the water, the rise and fall, the whoosh and roar. In my mind's eye I could see and hear the water."[8] The tragic cycle of the *Rheingold* operas is set in motion when the dwarfish Nibelung, Alberich, seizes the gold guarded by the Rhinemaidens and flees. The green-eyed ogler in the bottom right of Klimt's *Moving Water* has just the sinister presence to be identified as Wagner's Alberich. But rather than directly illustrating Wagner's opera, it might be argued that *Moving Water* sheds the historical baggage of *Das Rheingold* while retaining its dithyrambic mood, primal eroticism, and rushing sense of movement.

The female figures of *Moving Water* have a particularly slim body type that first emerges in Klimt's studies for the painting (fig. 74)—a protruding pelvis and rib cage, provocatively red hair and lips, long and slender legs, which would be Klimt's legacy to Viennese Expressionism. The turn-of-the-century sexologist Otto Weininger would find in the Secessionist taste for "tall, lanky women with flat chests and narrow hips" the negative influence of the English Pre-Raphaelite movement and (following the Oscar Wilde scandal) clear evidence of the rampant increase of homosexuality.[9] The Viennese poet Peter Altenberg, however, would endow Klimt's nudes with a more sympathetic spiritual significance: "The naked bodies of all these women, ascetic-lean-*tender-delicate*, the fingers, the hands, the arms, the legs of these Fairest Ones, almost *delivered* from the desolate, evil Matter which only *weighs down* the spirit and the soul. Fantastic naturalism of the modern most genuine ideal of beauty."[10] But if Klimt found in recent English art a precedent for his slender androgynous forms, he also derived inspiration from the

Dutch Symbolist Jan Toorop or the Belgian sculptor George Minne in transforming the floating woman into a sensual allegorical form of infinite suffering.[11]

FIGURE 72

Josef Engelhart, *A Summer Day*, 1897. Private collection
Exhibited at the second Secession, November 1898

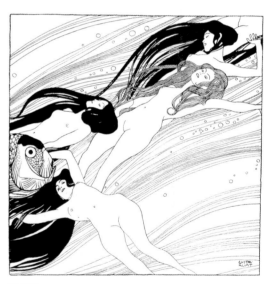

FIGURE 73

Fish Blood, reproduced in *Ver Sacrum* I (March 1898), page 6

FIGURE 74

Study for Moving Water, c. 1898. Neue Galerie am Landesmuseum Joanneum, Graz

Pallas Athena 1898
Oil on canvas, 75 × 75 cm
Historisches Museum der Stadt Wien, Vienna
Novotny/Dobai 93

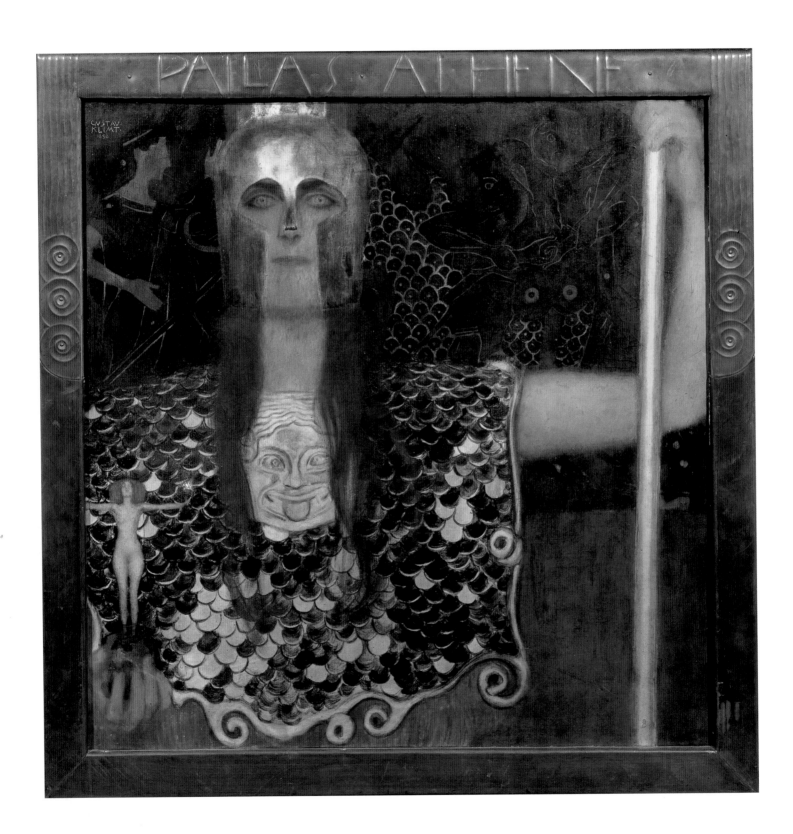

When *Pallas Athena* was first exhibited at the second Secession exhibition in November 1898, it immediately gained notoriety.[1] Art critic Ludwig Hevesi observed: "The public is accustomed to Athenas which one can clearly see are painted marble statues."[2] The goddess had become familiar to the Viennese public with her appearance in two monumental sculpture programmes planned for the Ringstrasse. In her role as patroness of the arts, a colossal Athena was installed on the cupola of the new Kunsthistorisches Museum, built to house the Imperial art collection (fig. 75). The museum was only opened in October 1891 after a long period of construction and interior decoration, which included Klimt's first painting of Pallas Athena for one of the spandrels in the staircase.[3] As protector of the "polis" (city/state), Pallas Athena was again placed before the Austrian Parliament Buildings in 1902.[4]

In his painting, Klimt merges the dual aspects of Pallas Athena's authority—over politics and culture. "Pallas" refers to her role as the warrior goddess fighting for just causes, then in peacetime instructing mankind in wisdom and the arts.[5] In place of the traditional statue of Nike, the winged victory, stands the sensual bearer of the mirror of modern man, a figure that Klimt

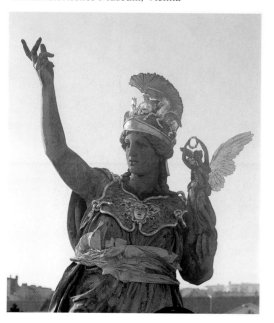

would return to the next year in life-size format for his *Nuda Veritas* (cat. 12). The struggle with the Secession's adversaries is alluded to in the background, where an Ancient Greek depiction of Hercules wrestling with the merman Triton can be seen. Marian Bisanz-Prakken was the first to identify the scene as copied directly from an Attic-style black-figure hydria, or water jar, of sixth century B.C. (fig. 76).[6] Klimt remained true to the original, except to transform the red background colours to a muted olive green.[7]

As Hevesi warned: "This is no statue taken from the Earth, nor a woman painted from real life, it is an apparition, the materialization of a state of mind of creative defiance and sovereign artistic desire. . . . [She is] an Athena of today, the Athena of her time, her place and her maker."[8] Provocatively, Klimt depicts the classical Greek goddess with long strands of red hair that fall untidily from her helmet. Light gleams from her helmet and armour, though her face remains inexplicably concealed in a cool blue shadow. In her determined and icy stare one sees the glacial attraction of Fernand Khnopff's drawings of inscrutable femmes fatales.[9]

Pallas Athena had previously played a symbolic role for the advent of Modernism in Henri Fantin-Latour's *An Atelier in the Batignolles*, 1870 (fig. 77), where she stands on a table near the group of writers and painters who gathered around Édouard Manet. In choosing Pallas Athena as the guardian of the Vienna Secession, Klimt draws upon the immediate precedent of Munich Secession artist Franz von Stuck,

whose poster design for the *VII Internationale Kunstausstellung* of 1897 includes an image of the goddess with the same rigid frontality and cropping of the upper body to accommodate a square format (fig. 2).[10] Stuck's *Pallas Athena* follows closely her traditional representation as the Ancient Greek goddess of peace and prosperity. In concealing Athena's face with her helmet, Klimt readies her for combat, transforming her into a more suitable champion of Secession ideology.[11] Klimt is also a libertine in placing an Archaic-style Medusa head on Pallas Athena's aegis, its tongue extended in ridicule of all those not won over to the Secession cause.

In March 1898, Klimt had called upon the goddess to preside over the struggle of Theseus and the Minotaur on the poster of the first Secession exhibition (cat. 64). In returning to Pallas Athena for the second Secession show, Klimt re-emphasized that the movement was not merely isolated dissent, but a further example of the recurrent theme of man's struggle to overcome ignorance and intransigence. Indeed, the aggressive stance of Klimt's Pallas Athena echoed the fighting words that appeared in the first issue of *Ver Sacrum*, in January 1898: "We wish to declare war on sterile routine, rigid Byzantinism, and on all lack of taste, and we count upon the energetic support of all those who understand that art is a high cultural mission and who recognize it as one of the great educative tasks of a civilized nation."[12]

Nuda Veritas 1899
Oil on canvas, 252 × 56.2 cm
Österreichisches Theatermuseum, Vienna
Novotny/Dobai 102

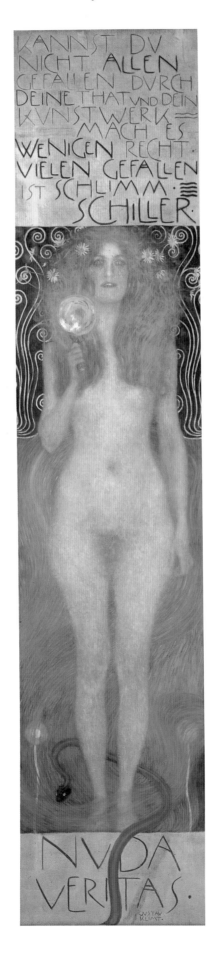

The redheaded female nude first seen standing with outstretched arms in the right hand of Pallas Athena (cat. 11) at the second Secession exhibition in November 1898 reappeared in a life-size incarnation when *Nuda Veritas* (*Naked Truth*) was shown at the fourth Secession in March 1899. Indeed, the work is a pendant to *Pallas Athena* in the way it manifests Secessionist ideals; as Carl Schorske has written, *Nuda Veritas* represents "a crucial turning point in the emergence of a new culture from an old."[1] With her abundant hair adorned with long-stem daisies, direct gaze, slim body, and unidealized features, the model of *Nuda Veritas* personifies a living contemporary art, distinct from the "clothed" falsehood of academic historicism—an apt metaphor to complement the Secession's motto, "To every age its art and to art its freedom."[2] Above her head, Klimt has included Friedrich Schiller's dictum, "If you cannot please everyone by your actions and your art—please a few. It is not good to please the many," thus boldly proclaiming the provocative nature of the Secessionist enterprise.[3]

Klimt based the composition of *Nuda Veritas* on his drawing of the same subject, first published in *Ver Sacrum* in March 1898 (cat. 60).[4] Known from Antiquity, Truth, as Fritz Saxl has shown, was frequently depicted as the daughter of Time, "Veritas filia Temporis."[5] Klimt makes allusion to Truth's release from captivity by winged Time in his calendar drawing *January* (fig. 78), published in *Ver Sacrum* in January 1901, where figures representing the New Year and the Old, but resembling *Nuda Veritas* and *Envy* (cat. 61), are supported on the Snake Ring (Uroboros), an attribute of Time.

As Hansjörg Krug has pointed out, Veritas ("Wahrheit" in German) was the subject of two plates in volume one of *Allegorien und Embleme* (1882–85) (fig. 79), to which Klimt contributed (cat. 37 and 39).[6] Returning to the theme to illustrate the artist's elite role in society, Klimt creates a more confrontational figure and "Egyptianizes"

Calendar Page "January," reproduced in *Ver Sacrum* IV (January 1901), page 2

the model in a hieratic pose that would lead Hevesi to characterize her as a "Secessionist Isis" when the painting was first exhibited in March 1899.[7] Echoing her representation in *Allegorien und Embleme*, Klimt has Veritas holding a mirror, implying that a reflection can never be false. The two flowers growing at her feet can be related to the biblical passage: "Truth shall spring out of the earth (Psalms 85:11)." Hevesi is again helpful in identifying the flowers as dandelions and suggesting a link with Eugène Grasset's well-known bookplate design, *La Semeuse* (*The Sower*), that appeared on the cover of the *Nouveau Larousse illustré* in 1897, in which dandelion seeds are carried away on the breeze—a Symbolist representation of the spread of new ideas.[8]

The snake entwining the calves of Veritas can be read both as a reference to the allegorical figure of Time and to sexuality. In contrast to its depiction in *January*, the snake is here endowed with an animated presence: it appears to have pulled away the transparent blue veil that falls to the ground behind the standing figure, in accordance with the adage that Time will reveal Truth. In Symbolist circles, however, the snake also represented temptation or vice, as in Franz von Stuck's painting *Sin*, 1897 (Museum Villa Stuck, Munich), exhibited at the first Secession.[9] And while the model of *Nuda Veritas* may not conform to the academic ideal of beauty, her "realist" presentation and brazen nakedness are clearly erotic, and it would be typical of Klimt's fusion of traditional and Symbolist iconography for the snake to also allude to *Nuda Veritas* as the new Eve.

The first owner of *Nuda Veritas* was the writer Hermann Bahr (1863–1934), a leader of the "Jung Wien" (Young Vienna) movement of ambitious writers who gathered at the Café Griensteidl in the 1890s.[10] In January 1890, Bahr wrote, in an article on modernity, words that could serve as a precept for the Secession movement: "We have but one law, and that is the truth as perceived by each of us."[11] On the Secession's founding in 1897, Bahr became its leading spokesperson, writing in *Ver Sacrum*: "I would like to have a table that harmonizes with my Liechtenstein garden and with my Kahlenberg, a table that is as Viennese as the garden and the mountain, and not only my table but also my lamp and my chair."[12] In October 1900, Bahr made the first of four payments of 1,000 crowns for *Nuda Veritas*, installing the painting in the study of his recently completed villa in the Vienna suburb of Ober Sankt Veit (fig. 80).[13] After the scandal over Klimt's University paintings erupted, Bahr became his ardent defender, publishing two compilations of writings and criticism on the artist, *Speech on Klimt* (1901) and *Against Klimt* (1903).

As its owner, Bahr made only one known comment on *Nuda Veritas*. In his 1922 foreword

to a book on Klimt's drawings, he would downplay the painting's Secessionist message, preferring to dwell on its beauty as a work of art: "It has no need of words, for it shows us what bliss there is in seeing; it affirms the eye's elemental experience—that moment of revelation connecting seer and seen—in an experience so powerful that we forget to inquire into its meaning and value."[14] *Nuda Veritas* was donated in 1954 to the theatre collection of the Nationalbibliothek in Vienna from the estate of Bahr's wife, Anna Bahr-Mildenburg, a well-known opera singer.

Alfred Miessner, *Truth and Falsehood*. From *Allegorien und Embleme*, 1882–85, vol. 1, no. 114

Hermann Bahr standing before *Nuda Veritas* in the study of his villa in Ober Sankt Veit, early 1900s Österreichisches Theatermuseum, Vienna

Cows in a Stable 1899
Oil on canvas, 75 × 76.5 cm
Neue Galerie der Stadt Linz, Austria
Novotny/Dobai 114

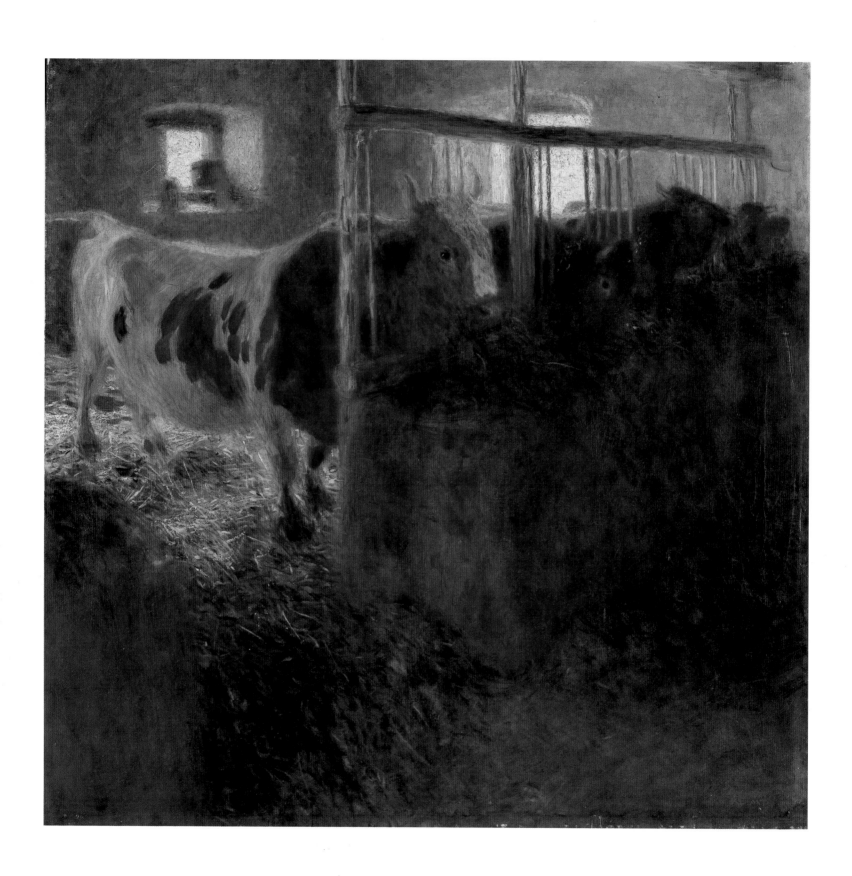

Among the earliest of Klimt's square landscape formats, *Cows in a Stable* has been convincingly reassigned by Alfred Weidinger from 1900–01 to 1899, because of its similarity in size, at 75 by 75 centimetres, and Impressionist handling to *Secluded Pond* (Leopold Collection, Vienna), a subject securely identified as the region near Golling, which Klimt is known to have visited that summer.[1] As his landscape painting activity increased over the first years of the new century, so too did the size of his canvas. During the summer of 1900, while vacationing at the Brauhof Litzlberg, the artist painted five 80-by-80-centimetre canvases, returning to the stable theme with *The Black Bull* (fig. 81).[2] By 1901 Klimt had increased the size of his square canvas formats to 90 and 100 centimetres.[3]

When *The Black Bull* was exhibited as part of the artist's 1903 retrospective, the critic Felix Salten was moved by its profoundly peaceful atmosphere, and he recognized Klimt's landscapes generally as having a soothing and contemplative appeal: "There is another, completely different kind of Klimt picture. Not tempestuous, not enigmatic, not sumptuous . . . the waves of a mountain lake, glittering in the sun . . . and a stable, all engulfed in deep semi-darkness."[4]

Cows in a Stable evokes the same meditative mood as *The Black Bull* in its balance of light and dark, and disciplined geometrical organization. A masonry trough runs diagonally from the upper right, where four cows feed through bars of primitive timber construction. At the centre of the painting, the trough meets the solid frame of a large cow, who has paused in feeding to observe an intruder. A striking visual contrast is established between the shadowy interior of the stable where the artist stands and the warm yellow sunlight streaming through the window and doorway behind the cattle, which rakes over the hay scattered on the floor and imbues the light brown hide and head of the cow with a soft golden glow. It is as though Klimt sees man the artificer as remaining in obscurity while the innocent beast occupies the privileged position of the animal world.

Klimt had previously been attracted to mythical human-animal hybrids such as the Minotaur—whose struggle with Theseus he represented on the poster for the first Secession exhibition of March 1898 (cat. 64)—or the ghostly Sphinx that presides over the University painting *Philosophy* (fig. 1). Yet here, in the shadows of the stable, Klimt the consummate city dweller implies something of the mysterious bond between man and beast, depicting a common farm animal with the sculptural monumentality of an Ancient Egyptian cult object. Even at this early date, Klimt appears to have been informed about Egyptian mythology, specifically referencing the veneration of bulls and cows as fertility symbols and as incarnations of the gods (fig. 82).[5] The critic Hermann Bahr would write of the artist in 1901: "Incapable of touching anything without immediately . . . lifting it onto a spiritual level and giving it a soul, [Klimt] is what may be called an idealist."[6] *Cows in a Stable* demonstrates that even while on vacation in the country, Klimt maintained an aesthetic dialogue with his surroundings, seeking in the seemingly mundane a means to convey transcendent Symbolist metaphors.

FIGURE 81
The Black Bull, 1900–01. Private collection

FIGURE 82
The Bull Apis from the Serapeum at Saqqara, Egyptian, 30th Dynasty. Musée du Louvre, Paris

Pine Forest II 1901
Oil on canvas, 91.5 × 89 cm
Private collection
Courtesy Galerie St. Etienne, New York
Novotny/Dobai 121

Johannes Dobai's catalogue raisonné of Klimt's work includes fifty-five landscapes, some forty percent of the entire output of paintings in the last two decades of his life.[1] Landscape would not have been part of Klimt's Kunstgewerbeschule training as a painter of decorative murals of historical and mythological subjects. Not surprisingly, therefore, the artist's first landscapes coincide with his embrace of Modernism and the Secession's founding in 1897, and show how swiftly he claimed the genre as his own.

As the first decade of the twentieth century progressed and the scandal surrounding Klimt's University paintings distanced him further from lucrative government commissions, landscape painting came to play an increasing role in his production, in answer to his immediate need for cash. For Klimt remained the primary financial support of his aging mother and a sister, following the death in 1892 of Klimt's father, Ernst. When his brother, Ernst junior, died the same year, he was left with a further responsibility as guardian to his niece, Helene Klimt.[2]

A mossy ground cover opens onto the centre of this cool forest, allowing the viewer the most meagre of spatial references. No path is visible, as if one dare not pass further into the murky, impenetrable depths. Out of the trees' seeming randomness emerges the soaring grandeur of Nature's order, "like columns in a church," in the words of Ludwig Hevesi.[3] A twilight stillness descends over *Pine Forest II*, where only the faintest glimmer of blue sky is allowed through the dense forest ceiling, and a distant yellow haze is just discernible through the trees to the far left.

From the time of his earliest landscapes, Klimt painted outdoors, "sur le motif," to accurately capture atmospheric effects. Intrigued with unusual weather conditions, he was known to work at his easel unperturbed by the physical discomfort of pouring rain.[4] Like the Impressionists before him, Klimt often returned to a landscape setting, which resulted in a series of paintings of the same subject with variations in the point of view. *Pine Forest I* (private collection)

was also painted during the summer of 1901; and it, too, presents a dense screen of tall tree trunks.[5] This approach governed Klimt's future landscape enterprise, for example *Beech Forest I*, c. 1902 (fig. 83), *Beech Forest II*, c. 1903 (location unknown), and *Birch Forest*, 1903 (Österreichische Galerie Belvedere, Vienna).[6]

The view of a dark forest interior of rigidly vertical tree trunks is a subject that particularly appealed to northern Symbolist landscape painters, and examples appear in the work of Ferdinand Hodler, Piet Mondrian, Fernand Khnopff and, most strikingly, in that of Prince Eugen of Sweden (fig. 84), to whom Klimt would be compared by German art critic Richard Muther in 1901.[7] The potent, emotionally charged atmosphere of these landscapes is related to the tradition of the "mood landscape," or "Stimmungslandschaft"—a sensibility that would dominate Klimt's early views of nature, but one soon to be transformed by his discovery of Pointillism.[8]

Pine Forest I and *Pine Forest II* would be among a number of "Nadelwaldmotiven" (coniferous forest subjects) by various artists exhibited at the thirteenth Secession in February–March 1902. Ludwig Hevesi found Klimt's work to be the most delicate and poetically engaging:

> In one of his two woodland pictures, merely a dark copse at first glance, one espies the sunlit air softly breaking through. In one spot is a very narrow, uneven breach, like a crack in a door, it too shifting and darkened again and again. Through this crack streams the whole of the day-bright landscape beyond the wood: below, the sunny yellow of the grassy hillside, then the joyful tones of the hills, and above, the blue cast of the sky. One senses the construct of a whole bright world behind the dark woods. Klimt is, after all, the master at leaving the viewer to divine what lies beyond his landscape.[9]

Described by the critic for *The Studio* as the "Bohemian woods," depicted here is the southern perimeter of this forest range along the northwestern shores of the Attersee, a lake near Salzburg in Upper Austria, where Klimt vacationed with the Flöge family at the Brauhof Litzlberg.[10]

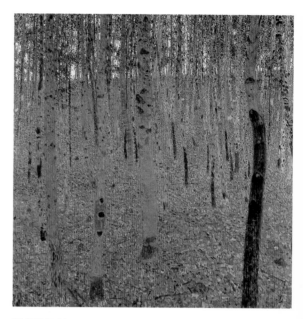

FIGURE 83
Beech Forest I, c. 1902. Staatliche Kunstsammlungen, Gemäldegalerie Neue Meister, Dresden

FIGURE 84
Prince Eugen, *The Forest*, 1892. Göteborgs Konstmuseum, Göteborg, Sweden

Portrait of Emilie Flöge 1902
Oil on canvas, 181 × 84 cm
Historisches Museum der Stadt Wien, Vienna
Novotny/Dobai 126

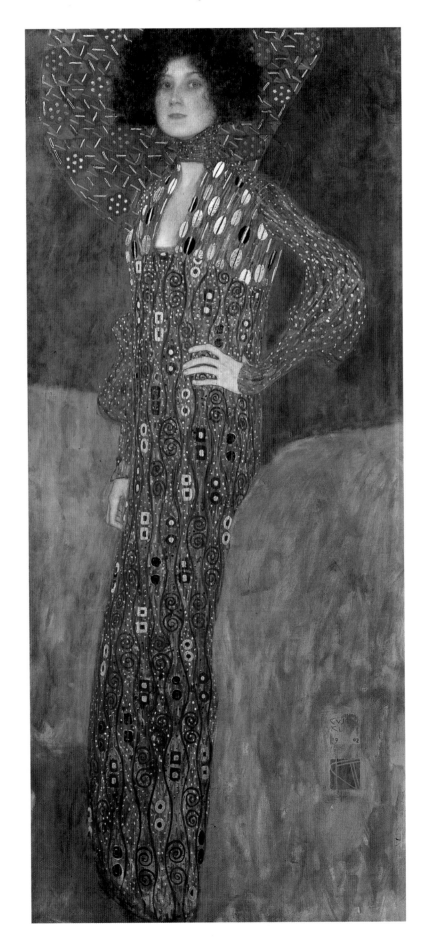

In the intent gaze of the twenty-eight-year-old Emilie Louise Flöge (1874–1952), Klimt conveys an indomitable personality who would become the impetus behind the successful Vienna couturier firm of Schwestern Flöge from 1904 until 1938. A former employee recalled the aggravation of many late nights and the exacting demands of dressmaking projects.[1] Even in later life, Emilie remained remarkable for "an admirable profile, a delicate nose, tiny mouth, and wonderful blue eyes," qualities Klimt lovingly reproduces here with almost photographic precision.[2] Long, slender fingers rest on her hip; her hair is bohemian in its dark abundance, falling in loose curls about her face. Her slim figure appears to pass through inchoate matter of brown and grey-blue, save for the patterned fan that silhouettes her head and shoulders—Klimt's first introduction of the ornamented backgrounds that would become so familiar in his later portraits.

While today Klimt's *Portrait of Emilie Flöge* has come to define the quintessence of Viennese beauty, at the turn of the century it was seen as an example of provocative modernity. In 1903, the critic Ludwig Hevesi was impressed by the way the portrait reflected a "blue-coloured world of majolica and mosaic." It was one of a group of portraits of women at the *Klimt Kollektive* exhibition that year, which Hevesi felt ushered in a new era of stylization for the Viennese "Damenbildnis" (ladies' portrait).[3] Yet it is a modernity at the crossroads of east and west, past and present. In contrast to the substantiality of Emilie's face and hands, her torso and legs are concealed beneath the patterned dress fabric, as though preserved for eternity like a mummified Egyptian Fayyum portrait (fig. 86). The textile design, which almost certainly existed only in Klimt's mind, is drawn from such disparate sources as Japanese stencilling and Byzantine mosaics.[4] The loose-fitting style of Emilie's dress was one advocated by the Dress Reform Movement (fig. 87, 88).[5] Klimt's interest in clothing reform is closely related to the Secession's call for creative involvement in all aspects of the decorative arts.[6] In March 1901, the Belgian architect Henry Van de Velde (1863–1957), an advocate of the Arts and Crafts Movement, gave a lecture on dress reform in Vienna.[7]

The relationship between Gustav Klimt and Emilie Flöge began after 1891, when his brother Ernst married Emilie's sister Helene. The nature of their liaison is still a matter of debate—whether sexual (Emilie is said to be the female model for *The Kiss*) or platonic, as family and friends insisted.[8] It is a question that may never be resolved, despite a formidable correspondence from Gustav to Emilie between 1898 and 1917, consisting of some 400 postcards that reflect a close and constant companionship.[9] Klimt sent these cards much as one uses e-mail today: on

FIGURE 85
Emilie Flöge in a dress made with fabric designed by Kolo Moser, c. 1908. Photo by Madame d'Ora. Museum für Kunst und Gewerbe, Hamburg

10 July 1909 alone he sent eight of them, describing the weather and preparations for his holiday at the Attersee.[10] One looks in vain for some romantic or erotic sentiment in these terse one-line messages, such as that of 6 July 1899: "Dear Emilie! I have for this evening two tickets for the Raimundtheater [to see Ibsen's *Ghosts*]. I expect you at quarter to 8 at the theatre."[11]

Klimt rarely mentions a letter from Emilie, and none have been brought to light, though her affection for the artist is unquestionable. Following Klimt's death in 1918, she maintained a locked room at Schwestern Flöge, where she kept Klimt's easel, painting smocks, and hundreds of his drawings.[12] Their unconventional relationship baffled even their contemporaries, who saw it as one of stoic self-denial: "For many years [Klimt] was tied to a woman by close bonds of friendship, but here again he was unable to say 'yes' . . . Klimt did not dare to take on the responsibility of happiness, and the woman whom he loved for so many years was rewarded only with the right to care for him at the painful moment of his death."[13] Not saying 'yes' to one woman appears to have left Klimt free to pursue whomever he pleased. During his years as Emilie's companion, he is said to have fathered no fewer than fourteen children.[14] In 1898 he developed an infatuation for

FIGURE 86
Portrait mummy in the Theodor Graf Collection, Vienna. From Georg Ebers, *The Hellenic Portraits from the Fayyum at present in the Collection of Herr Graf*, New York, 1893

the nineteen-year-old Alma Schindler, the future wife of the composer Gustav Mahler, which was quickly suppressed by her stepfather, Carl Moll. At the Secession that November, Alma first encountered her principal rival for Klimt's affections: "Later they pointed out his [Klimt's] sisters-in-law to me. They're in all his pictures. One of them—the younger—is unique. Strange eyes. Experienced, sad, floating."[15]

It is with the same allure that Emilie appears in photographs taken by Klimt, most likely in the summer of 1906, wearing Reform dress designs.[16] But this would be the last occasion on which Klimt used her as a model. In July 1908, the portrait of Emilie was purchased for the collection of the Historisches Museum der Stadt Wien. On 6 July, Klimt informed Emilie of the acquisition while she was vacationing at the Villa Oleander on the Attersee: "Today you are 'sold off' or 'cashed in'—I got a telling-off from Mother yesterday. [She] is indignant and has ordered me to produce a new PORTRAIT as quickly as possible."[17] Despite the abundant opportunity to do so, it would appear that Klimt never fulfilled his mother's request.

FIGURE 87
Emilie in the Salon of Schwestern Flöge, 1910 Photo by Madame d'Ora. Austrian Archives / Christian Brandstätter, Vienna

FIGURE 88
Emilie in a dress said to be designed by Klimt, c. 1908. Photo by Madame d'Ora. Bildarchiv, Österreichische Nationalbibliothek, Vienna

The Golden Knight 1903
(also known as *Life Is a Struggle*)
Oil, tempera, and gold on canvas, 103.5 × 103.7 cm
Aichi Prefectural Museum of Art, Nagoya, Japan
Novotny/Dobai 132

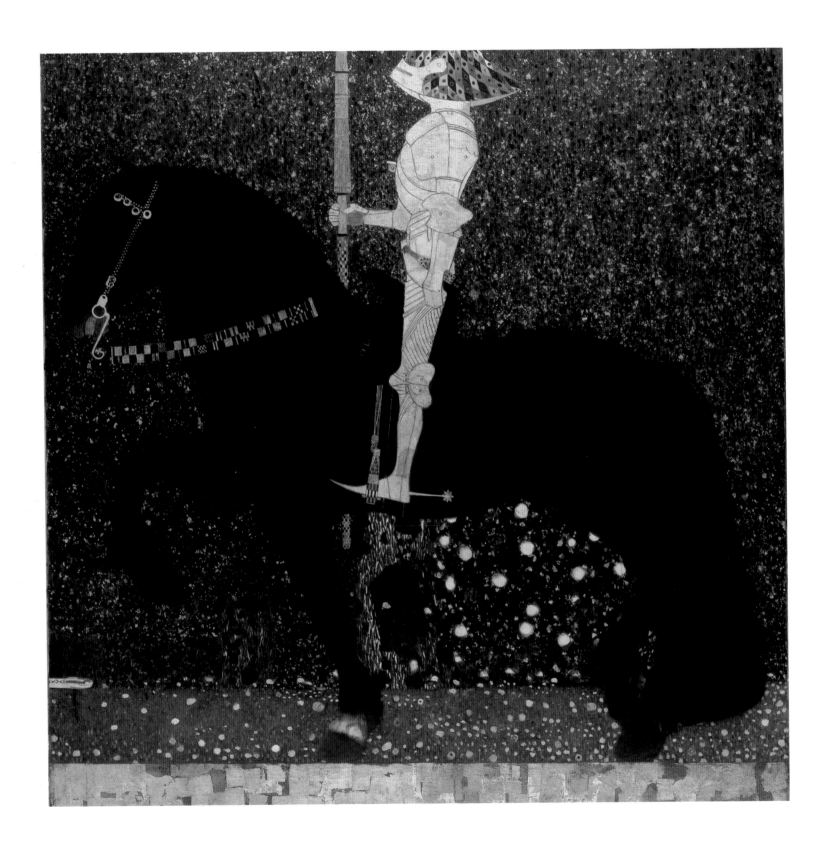

With *The Golden Knight*, Klimt draws upon the traditional iconography of medieval chivalry, but presents the subject with the cool detachment of a modern observer. A knight in golden armour, visor drawn, lance at the ready, is mounted on a tall steed with a mane of deep chestnut brown. As the horse raises its hoof above a path of golden brick, it is unclear whether the knight has paused momentarily on his solitary campaign or is the guardian of this lush garden setting—scattered with blue, yellow, and red wild flowers and a hedge of white roses. Shown in profile, the knight is bolt upright in the saddle before a dense curtain of green foliage woven with shimmering gold. This is the enclosed garden of sacred ideals, the *hortus conclusus*, through which there can be only one true path, and where space itself seems to occupy a single plane.

The subject of the mounted knight in profile brings to mind Albrecht Dürer's well-known engraving *Knight, Death, and the Devil* (fig. 89), where dire threats to mortal existence are clearly visible but seem powerless to inflict any harm. Klimt's idyllic garden contains a more potent danger, as the head of a large yellow serpent enters the scene along the path at the lower left, undetected by the proud knight, and ready to strike at his horse's vulnerable underbelly.

When first exhibited at the Secession's Klimt retrospective in November 1903, the painting was given the title *Life Is a Struggle*, suggesting it was intended to be a reprise of the *Beethoven Frieze*'s theme of mankind's struggle for happiness, seen at the Secession the previous year.[1] In the *Beethoven Frieze*, the knight is designated as the "external driving power," who—together with "Pity" and "Ambition"—moves weak humanity to seek earthly fulfilment;[2] he wears a suit of armour that was copied from one that belonged to the Archduke Siegmund of Tyrol in the fifteenth century (fig. 90). The Golden Knight's armour is of the same period.

In its disciplined planarity, *Golden Knight* shares the fresco-like character of the *Frieze*, but differs in two important aspects: it shows the knight mounted and combat-ready, and facing, in place of the giant, apelike Typhon, a less conspicuous adversary of more ambiguous intentions. In the form of St. George, the mounted knight enjoyed a great vogue among Symbolist artists in the 1890s, who adopted the dragon slayer as both a defender of the arts and conqueror of tyranny. Walter Crane's *St. George Slaying the Dragon of Materialism* (now lost) was reproduced in *Die Kunst für Alle* (1896), and it may have encouraged the young Russian artist Wassily Kandinsky (1866–1944) to pursue the subject in a series of works on the theme of St. George, following his arrival in Munich that year. Kandinsky's interest in the mounted knight would yield the defining motif for the *Blaue Reiter Almanach* in 1911.[3]

By 1905 *The Golden Knight* would be in the collection of the Austrian industrial magnate Karl W. Wittgenstein (1847–1913), a founding member of the Secession in 1898, who had provided a substantial sum for the construction of the Secession building.[4] Wittgenstein, a reputed innovator in business, eventually owned a total of five paintings by Klimt, and in 1905 commissioned the artist to paint a portrait of his daughter, Margaret Stonborough-Wittgenstein (Neue Pinakothek, Bayerische Staatsgemäldesammlungen, Munich).[5] Upon his death, Wittgenstein was recognized as a far-sighted supporter of a younger generation of artists: "He saw life and one's labours and endeavours as a struggle and so, in art, too, there was nothing more appealing to him than a clash of artistic energies."[6]

Among Klimt's patrons, Wittgenstein was rivalled in wealth and breadth of vision only by Fritz Waerndorfer (1868–1939), whose support of the Wiener Werkstätte drove him into bankruptcy, and Adolphe Stoclet (1871–1949), the Belgian banker who commissioned the Wiener Werkstätte to build and furnish his Brussels home between 1905 and 1911.[7] The beautiful mosaic frieze that Klimt designed for the dining room of the Palais Stoclet included, near the entrance, a panel made of enamel, mother-of-pearl, and ornamental gold, which the artist referred to as his "knight" after a visit to Brussels in May 1914[8] (see cat. 107 for working drawings). Like his golden counterpart, Klimt's Stoclet knight presides over a garden landscape inhabited on one side by *Expectation* (as a dancer), and on the other by *Fulfilment* (a couple embracing), each set among the spiralling branches of the *Tree of Life* (fig. 100). There has never been an adequate explanation for the inclusion of a knight in the context of the Stoclet mosaic's romantic theme.[9] Whether by coincidence or intention, Klimt's return to the knight theme acknowledges the major role of patrons of contemporary art and design such as Stoclet, Waerndorfer, and Wittgenstein, who literally represented the "external powers," sharing the ideals of the Secession and the Wiener Werkstätte and enabling their realization on a monumental scale.

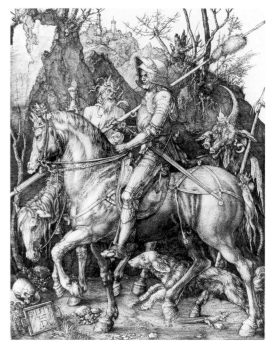

FIGURE 89

Albrecht Dürer, *Knight, Death, and the Devil*, 1513
National Gallery of Canada, Ottawa

FIGURE 90

Suit of Armour, c. 1485, made by Lorenz Helmschmied for Archduke Siegmund of Tyrol. Kunsthistorisches Museum, Vienna

Pear Tree 1903
Oil and casein on canvas, 101 × 101 cm
Busch-Reisinger Museum, Harvard University Art Museums, Cambridge, Massachusetts
Gift of Otto Kallir
Novotny/Dobai 134

"Klimt's landscapes should be in an exhibition on Mars or Neptune; on our globe things still look somewhat different, thank God."[1] So wrote an irate critic of the seventeen landscapes exhibited at the Secession's Klimt retrospective of 1903, including *Pear Tree*, completed in the months prior to the show's opening. One can easily imagine how *Pear Tree* might have provoked such a remark from a conservative critic. Fully one third of the canvas is occupied by a single plane of broken brushstrokes, a hybrid of Impressionist and Pointillist techniques, woven tapestrylike across the surface—a speckled web of bright yellows, reds, and pinks, beneath a hazy veil of blue.

However, the viewing angle of *Pear Tree* is unlike any Impressionist or Neo-Impressionist examples. A strict containment of space and iconic focus on a single foreground tree disclose Klimt's Symbolist proclivities, as well as his ongoing exploration of near/far and large/small contrasts.[2] A profusion of tree branches meshes together to create a canopy of densely applied dots of colour, while the distant view is limited to the hedge of deep mauve that borders the orchard. In the upper corners of the canvas, a cloud-covered blue sky is just visible.

Such unusual cropping resulted from the use of the square viewfinder with which Klimt scouted the countryside around the Attersee for landscape subjects, a device mentioned in a letter to Marie (Mizzi) Zimmermann in early August 1903, in response to her enquiry about how he spent his days: "I did no work during the first days of my stay here, I did what I had intended to do. I lazed, looked through a few books, studied Japanese art, and in the early morning, during the day, and in the evening, I went about with my "finder" ["Sücher"], that's a piece of cardboard with a hole cut into it, looking for landscapes to paint, but I found nothing."[3]

Given the dating of *Pear Tree* to 1903, therefore, it must have been begun in August, in the more productive period following his letter. Presumably, it was well under way before Klimt returned to Vienna on 7 September, where it was finished in the studio before appearing in his November retrospective.[4] On this occasion, art critic Ludwig Hevesi would be more appreciative of the provocative landscape style of Klimt's *Pear Tree*, writing rapturously of its colour effects:

> The bright points of colour are from a known source. He uses them with special emphasis in *Pear Tree*. Here, he covers the whole surface with bright masses, so teeming and pleasing to the eye in appearance. . . . Every Divisionist has his own manner, but Klimt avoids any kind of prescription, always managing to seek his own independent way.[5]

Hevesi's "known source" was, of course, Pointillism, or Divisionism—a Neo-Impressionist style much in vogue among the Vienna Secession in the early years of the twentieth century.[6] Of importance in introducing the style to Vienna were the Secession exhibitions of the Belgian Theo van Rysselberghe (1862–1926) in January 1899, and Paul Signac (1863–1935), a leading French proponent of Pointillism in March 1900, which included *The Dutch Mill at Edam*, 1898 (fig. 91).[7] The Pointillists advocated the use of pure colour: "The enemy of all painting is grey!

FIGURE 91
Paul Signac, *The Mill at Edam*, 1898. Private collection
Exhibited at the Vienna Secession in March 1900

Ban all earthy colours!" wrote Signac in *D'Eugène Delacroix au Néo-Impressionnisme* in 1899.[8] With its vibrant, subjective interpretation of colour and shadowless view through the trees, *Pear Tree* closely adheres to Signac's rhetorical programme for painting.

Klimt's receptiveness to new ideas—and their gradual emergence in his own work—is exemplified by the landscapes from the first years of the new century. As early as 1901, as evident in *Orchard* (private collection), Klimt had begun painting with a tentative Pointillist technique; a technique that Hevesi would later describe as "Forellentupfen" ("trout stippling").[9] After his trip to see the Byzantine mosaics at Ravenna in May 1903, a further change in style occurred—of which *Pear Tree* is an example— toward a mosaiclike application of "pure" colour and the elimination of shadow.

Hope I 1903
Oil on canvas, 189.2 × 67 cm
National Gallery of Canada, Ottawa
Novotny/Dobai 129

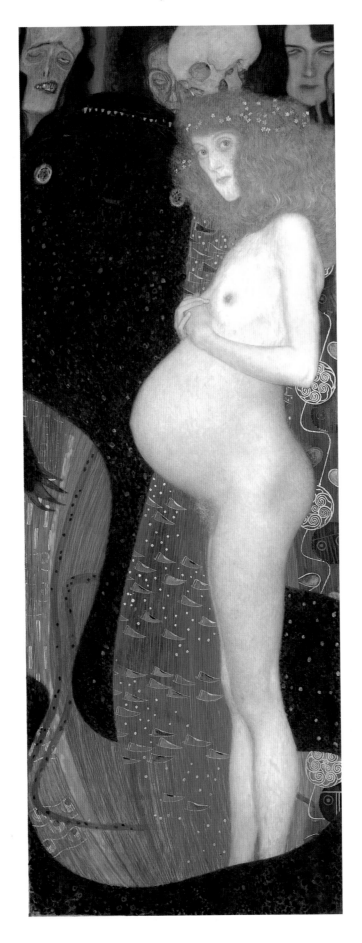

From the time that Klimt began work on the ceiling paintings for the University of Vienna in 1893, he would relentlessly test accepted views of the most profound questions concerning the origins of life, knowledge, and morality. While nineteenth-century science insisted on rational explanations for all biological phenomena, Klimt could only see enduring mystery and assert the authority of the artist to unravel life's truths in dreamlike allegory. While the word "hope" connotes virtue in an allegorical sense, in German it can also mean to be pregnant ("in guter Hoffnung").[1]

In its forthright portrayal of pregnancy, *Hope I* singles out a motif first introduced as part of the entwined tangle of bodies in the painting *Medicine* (fig. 3), exhibited in March 1901. In preliminary sketches published by Alice Strobl, it appears that Klimt initially thought of *Hope I* as a couple contemplating their good fortune, the man standing with his arm protectively around the shoulders of his pregnant mate (fig. 92).[2] In the final painting, however, the artist replaced the woman's male companion with the skeletal visage of death wearing a long, diaphanous, blue cape, embroidered with a pattern of toothlike motifs. Encircling the model and death is the massive tail of a dark and scaly sea monster, a serpentine variation of the "Hostile Power," represented by Typhon in Klimt's *Beethoven Frieze* of April 1902 (fig. 5–7). Beside Typhon stand the three evil Gorgons, one of whose seditious features reappear in the upper right of *Hope I*, now wearing a long cape richly ornamented with gold arabesque. In the background beside this Gorgon figure are two further grotesque heads also derived from the *Beethoven Frieze*, where they represent "Sickness" and "Madness" (fig. 5).[3]

The addition of these funereal faces only heightens the unsettling nature of the woman's brazen nakedness and her steady, unashamed gaze. Such an image flagrantly contravened standards of propriety in turn-of-the-century Vienna, and continues to disturb us at the beginning of the twenty-first century. Interviewed in his studio in 1903 while preparing *Hope I* for inclusion in his first Secession retrospective, Klimt would remark of the painting: "Everything is ugly: she is, and what she sees—only within her is there beauty growing, hope. And her eyes say that."[4] Klimt's intention to exhibit *Hope I* threatened to provoke a further public scandal, and a few weeks before the opening he was persuaded by the Minister of Culture, Baron von Hartel, to withdraw the work, lest the three University paintings, *Philosophy*, *Medicine*, and *Jurisprudence*, should be refused by the Ministry.[5] (A compromise proposed by the Secession on 21 October, whereby the offensive nudity would be concealed, leaving "only a fragment" of the painting visible, had been flatly rejected by the artist.)[6] Two years after the incident, Klimt told art critic Berta Zuckerkandl, "I withdrew it because I did not want to cause any embarrassment to the Secession, but I myself would have defended my work."[7] Even as it hung in the private home of Klimt's devoted patron Fritz Waerndorfer, *Hope I* remained hidden behind the closed doors of a specially made frame, "to keep away profane eyes."[8]

The 1903 interview just mentioned throws further light on Klimt's anxiety about the reception of *Hope I*. Apparently, when the painting was almost finished, the artist had a change of heart about the background, which had originally been planned as a landscape. According to the account: "[*Hope*] is finished except for a few details, but will not be part of the exhibition: he [Klimt] wants to repaint the background once more. Originally, he had painted in a landscape; now it looks like a patterned carpet, and from it characteristic heads will emerge, to clarify the concept."[9]

This change in approach, from one of positive fulfilment to one that recapitulates the theme of life's struggle in the face of disease and death, as found in *Medicine* and the *Beethoven Frieze*, may have been inspired by Klimt's own painful experience of fatherhood. On 22 June 1902, his longtime model Marie Zimmermann bore him a second son, Otto, who died on 11 September, before his fourth month.[10]

If *Hope I* stood in one respect for freedom of expression, it also resonated with a spiritual calm. The art critic Ludwig Hevesi first noted this aspect following a visit to the Waerndorfer home in 1905:

> The young woman walks along in the holiness of her condition, threatened on all sides by appalling grimaces, by grotesque and lascivious demons of life . . . but these threats do not frighten her. She walks unperturbed along the path of terror, pure and made invulnerable by the "hope" entrusted to her womb.[11]

When the painting was exhibited for the first time in Vienna at the second *Kunstschau* of 1909, critic Franz Servaes would comment, "Some people claim to find it cynical, whereas I get the impression there is an aura of sanctity about it."[12] But, Arthur Roessler proved the most insightful of Klimt's contemporaries when he described *Hope I* as the "High Priestess" of modern man: "In her naked womb lies the future. She is the keeper of coming generations, creator of a new humanity, enabler of a sort of immortality." His passage suggests that *Hope I* represents the procreator of the Nietzschean "Übermensch," described by the philosopher as the prophet and seer who fears no evil or suffering—an aspect of pregnancy that is also reflected in the German painter Otto Dix's cosmic *Pregnant Woman*, 1919 (fig. 93).[13]

Portrait of Hermine Gallia 1903–04
Oil on canvas, 170.5 × 96.5 cm
The National Gallery, London
Novotny/Dobai 138

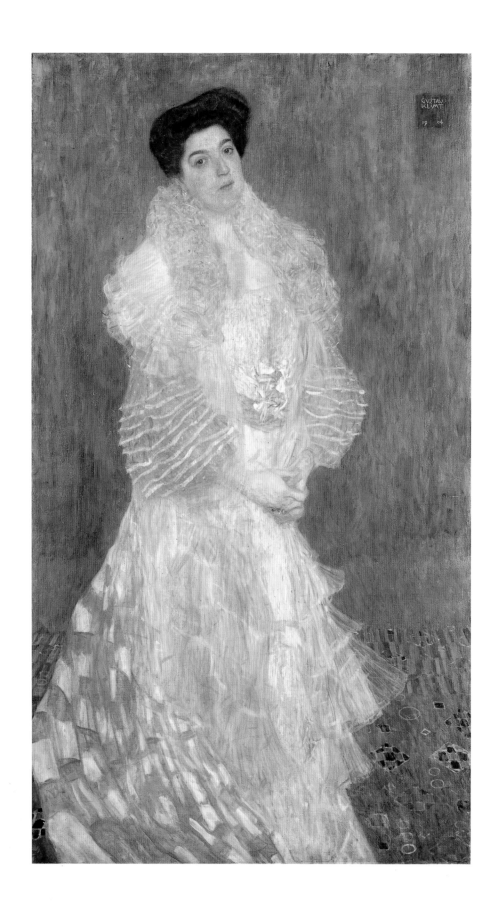

Dressed in an elegant and loose-fitting gown of translucent white fabric, accented by a pink waistband, pearl earrings, and jewelled pendant, Hermine Gallia (1870–1936) floats with the most wistful of expressions above a carpet of geometrical Viennese *Moderne* design. A sense of weightlessness is further suggested by the dissolution of her body beneath the textures of her garments: over her dress she wears a white boa and a *ball-entrée* with gathered shoulders that falls like a transparent scarf down her front. Klimt made over forty studies for the picture, quickly drawn in ever-changing poses, as if Hermine had walked around the studio while he sketched (fig. 94).[1] This preoccupation with the moving figure and the sway of the drapery contributes to the final painting's animated presence.

The world Hermine Gallia occupies in this portrait is wholly one of modernist taste, even more so than that depicted in the earlier *Portrait of Serena Lederer*, 1899 (fig. 95), for which Klimt was paid 35,000 crowns.[2] Here, Klimt seamlessly merges the contoured outline of Japanese prints of geishas with the soft white harmonies of society portraits by James McNeill Whistler.[3] The serpentine rhythm of the pose also reveals the influence of Art Nouveau, where the lyrical tilt of Hermine's head and the curve of her feather boa are mirrored in the swell of her sleeves and clasped hands, then counterbalanced by the voluminous sweep of the dress's gossamer train.

Such daring costume, together with her distinguished coiffure and the intelligence with which Klimt endows her gaze, places Hermine's portrait frankly at odds with her plain, understated appearance in a photograph from the same period (fig. 96).[4] This startling metamorphosis suggests the wide psychological distance between

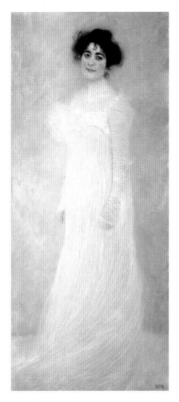

the glamorized public personas of Viennese socialites at the turn of the century and their more demure private world (fig. 97). This *Portrait of Hermine Gallia* well serves Hermann Bahr's contention that Klimt's portraits of women revealed the sitters' "innermost nature . . . at the finest moment of their whole existence."[5]

Indeed, the Gallias were the most unlikely patrons of modern art. Hermine was born in Freudenthal in Western Silesia (now part of the Czech Republic) on 14 June 1870, to a Jewish brewery owner, Nathan Hamburger.[6] In 1893 she married her uncle, Moriz Gallia (1858–1918), who was twelve years her senior; he had emigrated to Vienna from Bisenz in the Habsburg crown land of Moravia. At the time, Gallia made a comfortable living in Vienna as director of the Auer Gaslight Factory, a position he acquired as a result of his brother Adolf's successful defense of Baron von Auer's gaslight patent.[7] By 1900–01, the couple had four children and were part of the Klimt circle, possibly through the interest in music Hermine shared with Alma Schindler.[8] This relationship blossomed over the next decade, through the portrait and in a growing collection of paintings by Alma's stepfather, Secession founder Carl Moll, who may have brokered the commission with Klimt, as well as the purchase of his landscape *Beech Forest II*, c. 1903.[9] The couple also amassed a significant collection of Wiener Werkstätte silver and ceramic, much of which is now in the National Gallery of Victoria in Melbourne, Australia, where the Gallia children emigrated after the death of their mother in 1936.[10]

In 1913, Moriz Gallia commissioned the architect Josef Hoffmann to design and furnish the principal rooms of his new five-storey apartment building at 13 Wohllebengasse, in Vienna's fashionable fourth district.[11] The Gallias' commitment to supporting modern design in Vienna extended to another Hoffmann project: they became shareholders in the financial revival of the Wiener Werkstätte in March 1914, after it had been liquidated by bankruptcy earlier that year.[12] It is a reflection of the close relationship between cultural patronage and upward mobility in Vienna at this time that in 1912 Moriz and Hermine Gallia shed their Jewish heritage and converted to Catholicism, a common practice among Jews seeking to remove all barriers to their assimilation into society.[13] World War I would appear to have taken its toll on the family business, however, for when he died on 16 August 1918 at the age of fifty-nine, Moriz owned a company that manufactured vinegar for the military, which Hermine continued to manage after his death.[14]

Roses under Trees 1904
Oil on canvas, 110 × 110 cm
Musée d'Orsay, Paris
Novotny/Dobai 147

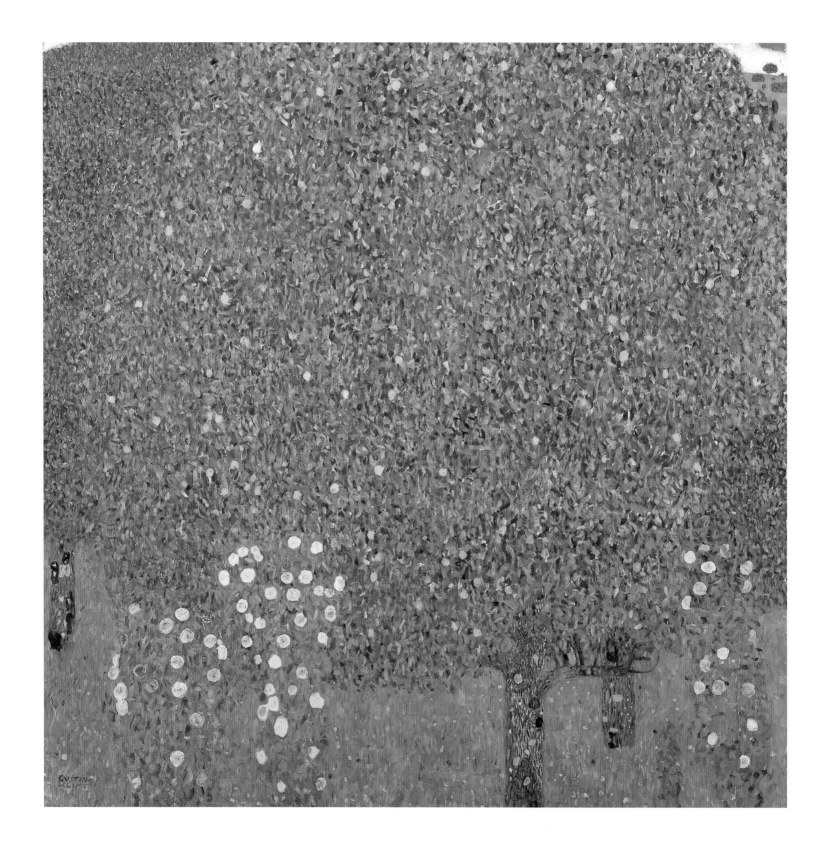

oses under Trees, painted the summer after *Pear Tree* (cat. 17), is another lush scene set in an orchard of fruit trees and rendered in Klimt's eclectic Pointillist technique of tightly-knit hatches of graduated size.[1] In this painting, however, volumetric drawing and perspective rendering are kept to a minimum. The use of a square viewfinder has again allowed Klimt to control carefully the field of vision and to all but eliminate the middle ground and distance. Now a single fruit tree is isolated from the rest of the orchard, save for three tall rosebushes with remarkably upright anthropomorphic stature. The tree's circular mass of leaves and fruit reaches to the very edges of the canvas like a panel of mosaic tessera. One can follow the way the composition emerged from Klimt's disciplined observation of the scene in a rare surviving landscape sketch—a few rapid strokes of the pencil in square format showing the rosebushes in a slightly different position from that of the final painting (fig. 98).[2]

While the tree's foliage remains flecked with shades of blue and mauve, there is greater variation in tone and value of green than in *Pear Tree*. This raises the question of how Klimt was able to render such intense outdoor colours without the slightest suggestion of shadow or source of light.[3] Klimt uses a varying density of brushstrokes to construct fragmentary details of foliage around the perimeter of the fruit tree. To the left is the crown of a tree of a darker green leaf. Above this tree, in the very upper-left corner, lies yet another zone of more closely packed dots of darker mauve and pinkish reds, corresponding to a glimpse of blue sky and cloud curving away in the upper-right corner. Together, these two zones can be interpreted as the inclusion of some distant rising slope in the region of the Attersee.

Writing of Klimt in 1901, the Viennese critic Hermann Bahr seems to have anticipated the artist's choice of theme and explained his approach to landscape: "The rosebush means something very specific in the outer world; philosophically, it "represents an idea in the world." This "idea" is also present in the inner world; there is something in the soul that is a rosebush."[4] As Bahr suggests, Klimt treated landscape in the Schopenhauerian tradition, where individual will is subsumed in the all-absorbing contemplation of the "treeness" of the tree, and where natural objects relinquish their specific identity to become essential "ideas."[5] Certainly, there were nineteenth-century precedents that Klimt could draw upon for idealized represen-

FIGURE 98
Landscape Study, c. 1903, from a sketchbook formerly owned by Sonja Knips, page 55. Österreichische Galerie Belvedere, Vienna

tations of trees. Compare, for example, the German Romantics' obsession with immanent nature in Carl Blechen's *Young Oak Tree*, c. 1830 (National Gallery of Canada), or Caspar David Friedrich's *Raven Tree*, c. 1822 (fig. 99). More contemporaneously, stylized trees and orchards had become a recurrent decorative motif of the English Arts and Crafts Movement.[6]

The rose and fruit tree had first appeared in Klimt's work as emblems of summer's timeless pleasures in the allegorical drawing *June* of 1896 (cat. 47). Here, the Muse of Summer is flanked by two caryatid figures, one standing against a vertical band of stylized rosebush, the other against a fruit tree. In their outstretched arms they bear a branch of each plant, crossed one over the other before the round globe of the sun.

FIGURE 100
Cartoons for the Stoclet Frieze: Tree of Life, 1905–09 Österreichisches Museum für angewandte Kunst

From 1905 until 1911, Klimt was occupied with the design for the frieze in the dining room of the Palais Stoclet in Brussels, where he again returns to the symbolic landscape motif of the rosebush, now paired with the fertile *Tree of Life* (fig. 100).[7]

When *Roses under Trees* was first exhibited at the *Kunstschau* of 1908 with a group of landscapes produced since Klimt's 1903 retrospective, the poet Peter Altenberg would recognize their sensual nature, if not their formal innovations:

Are you a real, honest friend of nature? Then drink in these paintings with your eyes: cottage garden, beech wood, roses, sunflowers, poppies! The landscape is treated as you treat a woman: it has been raised to its own romantic pinnacle, it comes into its own, it is transfigured and made visible to the sceptic's joyless eyes! Gustav Klimt, a strange mixture of primitive strength and historical romanticism. Let the trophy be yours![8]

Painted while Klimt was vacationing at the Brauhof Litzlberg on the Attersee, *Roses under Trees* has a meditative quality, yet also reflects a joyful and exuberant experience of summer, an experience that he shared with his companion Emilie Flöge.

FIGURE 99
Caspar David Friedrich, *Raven Tree*, c. 1822 Musée du Louvre, Paris

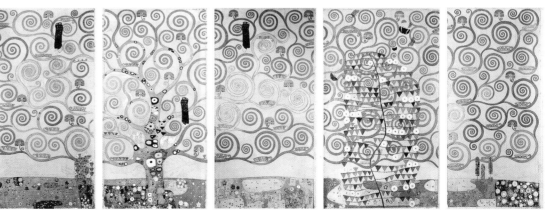

21

Orchard c. 1905–06
Oil on canvas, 98.7 × 99.4 cm
The Carnegie Museum of Art, Pittsburgh, Pennsylvania
Patrons Art Fund, 1960
Novotny/Dobai 164

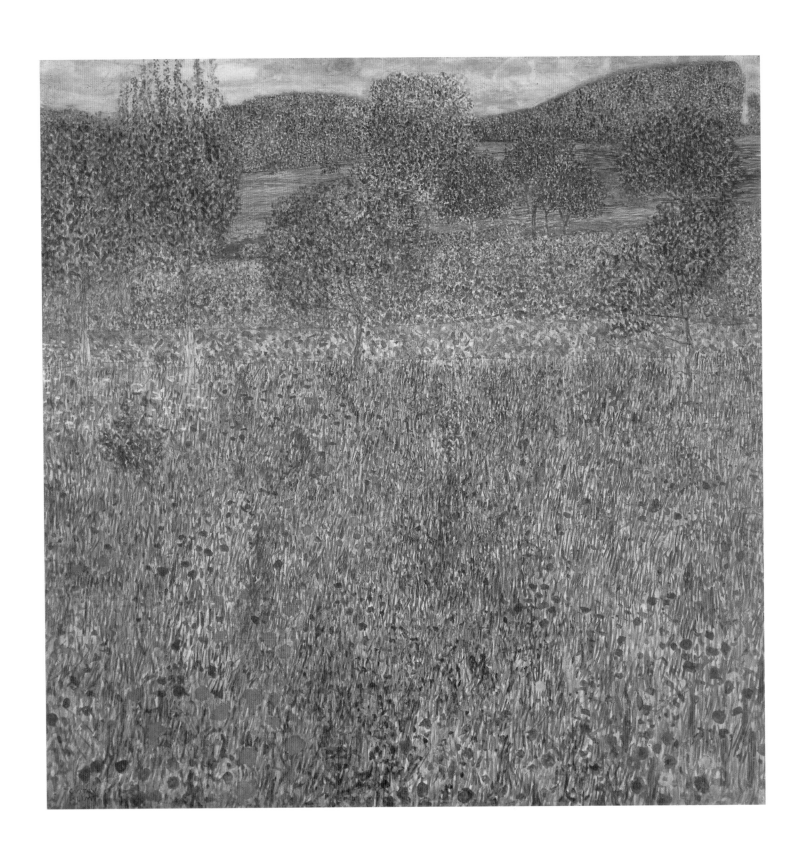

Once again, Klimt returns to set up his easel in an orchard with scattered fruit trees, but now we see beyond its borders to a grassy field and the forested hills around the Attersee. In rendering the deep vista, Klimt creates a veritable collage of layered textures, reserving the Pointillist style for the treetops and the distant hill. A grey and cloudy sky hangs over the scene, which explains why shadow and contrasting light are absent. And while the decorative planarity of previous landscapes has been relaxed in *Orchard*, the foreground remains predominant. Klimt's rendering of long grasses, interspersed with random clusters of red, blue, yellow, and white wildflowers, is considerably looser in handling and more energetic in style, suggesting the influence of Vincent van Gogh, whose work had been included in the Secession's "Development of Impressionism" exhibition in January–February 1903.[1]

Running horizontally through the orchard in the upper middle of the canvas is a band of lighter green, painted with less densely applied brushwork and lined with small fruit trees, suggesting a footpath. It adds yet another ribbon of texture to the scene and is a rare instance in Klimt's landscape work where underdrawing is clearly visible. This is possibly the same path on which he was photographed in 1907, walking in formal summer whites with Emilie Flöge, in a broadbrimmed hat, and two unidentified companions, near the Brauhof Litzlberg (fig. 101).[2] The photograph, too, shows several small fruit trees and the familiar rolling topography of the Attersee.

If Symbolist allegories and portraits of women formed the basis of Klimt's artistic reputation in Vienna, in contrast, his landscapes remain free of any figural encumbrance.[3] The Swiss Symbolist Ferdinand Hodler was of the opinion that the "presumed mobility" of figures disturbed the "motionless character" of the landscape subject, nevertheless, he later posed figures in landscape settings.[4] In Klimt's body of work, however, there is a strict division between the allegorical figure paintings, with their often disturbing messages, and the meditative calm of the landscapes. Genre and allegory subjects hung side by side in Klimt's exhibitions, and the originality he brought to both demonstrates the broad range of his talents.

Painted during the summer months at the Attersee, Klimt's landscapes have been referred to as his "vacation work."[5] Far from Vienna, in the heart of the Salzkammergut region of Upper Austria with the Flöge family, Klimt was liberated from the expense and distraction of models, as well as the vexing problems posed by the figure in modernist allegory and portrait painting (a problem he studied exhaustively in thousands of drawings). At the Attersee, Klimt was able to combine painting with his much-loved boating exercise, a pastime he was photographed enjoying while wearing a painter's smock (fig. 102). He explained this complex routine of mixing work and leisure at the Attersee in a letter to Marie Zimmermann from about August 1902:

> You ask for a sort of timetable—how the day goes by—well, that's very simple and quite regular. Early in the morning, mostly about 6 o'clock, sometimes earlier, sometimes later, I get up—if the weather's good, I go into the nearby wood—I'm painting a small beech wood there (in the sun), dotted with a few evergreens, that'll take me to 8 o'clock, then comes breakfast, then a swim in the lake, carefully of course—then I paint again a little, perhaps a view of the lake by sunlight, or if the weather's dull, a landscape from my window—sometimes I drop this morning painting and study my Japanese books in the open air. Then comes midday, after lunch I sleep a little or read, and before or after tea another swim, not always but mostly. After tea I'm painting again—a big poplar at dusk with a storm brewing—or else, instead of this evening painting, a game of skittles in the neighbouring village—but that is seldom—then comes dusk—supper—and early bed and the next day early to rise. Every now and then I fit a bit of rowing into the day's programme, in order to limber up . . . my work keeps me busy in all types of weather, and that is a good thing.[6]

Garden Landscape (Blooming Meadow) c. 1906
Oil on canvas, 110 × 110 cm
Private collection, New York
Novotny/Dobai 148

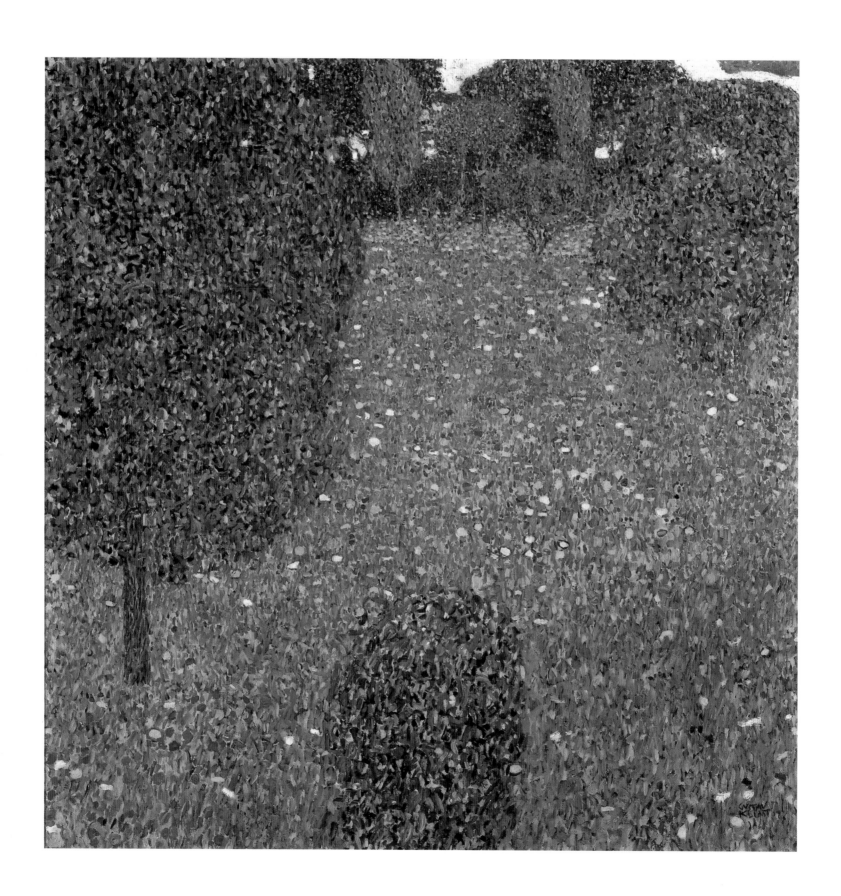

With their rounded crowns and evident yellow fruit, the trees of *Garden Landscape* could almost be part of the same orchard setting as *Roses under Trees* (cat. 20), but now Klimt's emphasis is on the brilliant, multi-coloured floral growth spread over a meadow that is undisturbed by any human presence. Here, Klimt shows a much deeper view into the orchard than in any of the earlier landscapes included in this exhibition; yet the composition remains as rigidly planar as *Roses under Trees*. There is a remarkably undifferentiated lighting throughout, save for the cooler forms of the trees that float against the pale meadow and narrow strip of blue sky. According to Alfred Weidinger, the high horizon and exaggerated foreground depth result from Klimt having tilted his square viewfinder forward.[1] Klimt may have been encouraged by his study of Japanese art to seek unusual perspectives to address the near/far problem of landscape painting.[2]

In addition to this interest in *Japonisme*, contemporaries discerned in Klimt's landscapes a strong architectural sensibility, derived from his preference for decorative "Stylism," as well as his close collaboration with architect Josef Hoffmann.[3] On the occasion of Klimt's fiftieth birthday in 1912, immediately following completion of the Palais Stoclet frieze, critic Hugo Haberfeld had this to say about the landscapes:

> One can clearly retrace the way the space of the picture sequentially becomes the surface of the picture. The landscapes, until now dreamlike reflections of a lyrical feeling for nature, mainly orchards, beech forests, young birches, quiet ponds, receive a firm architectural structure; in cleverly chosen frames, painted with Pointillist technique whose colour dots have the brilliance of jewels, they no longer capture just the mood, but the optical poetry of a motif which, although drawn from nature, has been totally detached from nature and placed under the conditions of a specific form.[4]

If *Garden Landscape* reflects this "optical poetry," it is an impression filtered through the Pointillist calm of a Georges Seurat, yet as exuberant in its celebration of wildflowers as the paintings of Vincent van Gogh. Klimt always

sought out studios with large gardens. In a photograph by Moriz Nähr from about 1910 (fig. 103), he can be seen admiring the bountiful garden of his studio at 21 Josefstädterstrasse. From 1914 on, his last studio in Hietzing, in Vienna's thirteenth district, featured a flower garden much admired by the artist Egon Schiele (1890–1918), which Klimt replanted every year.[5] The joy Klimt derived from his garden is suggested in a letter to Emilie Flöge, written in the spring of 1916: "Blazing sunshine and it's beautiful beyond belief. Crocuses bloom in the garden, the ground resembles a sky studded with stars! And the mind lightens and courage and strength [return]."[6] After Klimt's death, Arthur Roessler would evoke the beauty of that garden in Hietzing: "[Klimt's studio] is framed by a remnant of that rural Vienna which Adalbert Stifter described so intimately in his little book *Feldblumen* [Wildflowers]: a side street in Hietzing as quiet as a village."[7]

Klimt's *Garden Landscape, Orchard* (cat. 21), and *Poppy Field*, 1907 (Österreichische Galerie Belvedere, Vienna) share the foreshortened point of view of van Gogh's landscapes and an interest in the random colour effects of wildflowers (fig. 104). As noted, it was through the Secession that the Dutch artist's paintings were first exhibited publicly in Vienna. In January 1903, a large survey of Impressionist painting opened that included five van Goghs, one of which, *The Plain at Auvers-sur-Oise*, 1890, was purchased from the exhibition and donated to the new Moderne Galerie).[8] Three years later, in January 1906, an exhibition of forty-five van Goghs opened at the Galerie Miethke; this progressive commercial gallery directed by Carl Moll also handled Klimt's paintings.[9]

While Klimt's allegorical paintings remain a genre distinct from his landscapes, inevitably, when Klimt treats the theme of love, the setting is a flower garden. Examples include the Stoclet Frieze and, of course, the masterpiece of Klimt's "Golden Period," *The Kiss*, 1908 (fig. 13), where the grassy carpet of bright flowers on which the lovers kneel could well have been transposed from *Garden Landscape*. In seeing *The Kiss* for the

first time at the 1908 *Kunstschau*, Ludwig Hevesi was struck by the way the couple were "wading through flowers, as when a floral stream surges from the earth near Homer on Mount Ida, when Hera is once again embracing her old Zeus."[10] Indeed, in *Garden Landscape*, myriad red, blue, orange, and white flowers seem to float down the surface of the canvas in a wide stream of cascading colour.

FIGURE 103

Gustav Klimt in the garden of his Josefstädterstrasse studio, c. 1910. Photograph by Moriz Nähr. Austrian Archives / Christian Brandstätter, Vienna

FIGURE 104

Vincent van Gogh, *Long Grass with Butterflies*, 1890 The National Gallery, London

Farm Garden 1907
Oil on canvas, 110 × 110 cm
Private collection
Novotny/Dobai 144

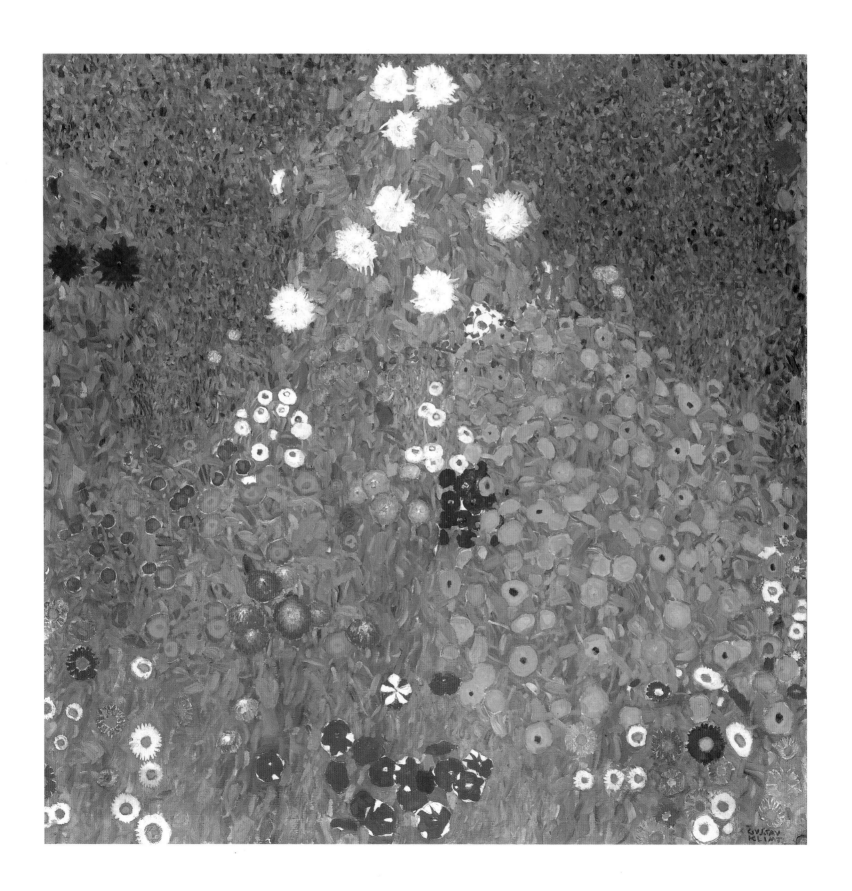

In *Farm Garden*, Klimt's Pointillist landscape style has yielded to a more fluid brushstroke to capture this colourful floral melee—described by Johannes Dobai as a "firework display of summer."[1] As in Klimt's earlier landscapes, the spatial setting of *Farm Garden* is ambiguous, the lighting undifferentiated and absent of contrasts. The influence of van Gogh's garden paintings is apparent in the downward viewing angle and immersion in floral beauty for its own sake. The pyramidal surge of blossoms conveys the patterned quality of graphic design. The flowers share the same wild blend of colour and form as the ceramic tile entrance of the Cabaret Fledermaus in Vienna, which opened in October 1907, and anticipate a favourite Pop Art motif of the 1960s (fig. 105).[2]

Rather than a "flower power" fantasy, *Farm Garden* is inspired by the delightfully fantastic in nature, made perplexing by Klimt's novel tendency to exclude the peripheral field of vision. At first glance, these floral "fireworks" appear to fall into a single impenetrable plane, yet Klimt never entirely relinquishes reality in favour of abstract stylization. The most minimal of perspectival references allow the painting to be read in three dimensions. In the right foreground, for example, the orange poppy blossoms that sit pressed against the surface of the canvas noticeably diminish in size as they curve upward. To the left, red zinnias, mixed in a natural bouquet with purple and white daisies, draw the eye further along the length of the flowerbed. A cluster of smaller red flowers behind and to the right of the poppies also appears to curve up and into space. Crowning this floral pyramid are fleshy white dahlias, rising vertically before a dense, leafy hedge.

When Klimt's farm garden paintings were exhibited together for the first time at the 1908 *Kunstschau*, their fresh vision of nature elicited much praise from critics. Josef August Lux, writing in *Deutsche Kunst und Dekoration*, sensed a mystical quality about the Klimt room, almost a

FIGURE 105

Andy Warhol, *Flowers*, 1966. The Menil Collection, Houston, Texas. © SODRAC (Montreal) 2001

religious sense. Of the garden pictures he noted: "The flower meadows are even more beautiful since Klimt has painted them; the artist gives us an eye with which to see the radiant glory of their colours. We never learn to seize nature in her magical beauty other than through art, which always renews her appearance."[3] For Karl Kuzmany of *Die Kunst*, the garden pictures proved Klimt to be a master landscape painter, in perfect harmony with nature:

> What catches the eye is Klimt's most recent predilection for meadow flowers and whatever plants are cultivated in farmers' gardens. He now enjoys blending these strongly coloured cup- and starlike blossoms with the areas meant to be ornamental, but he has also painted them for their own sakes, as they grew, rampant in lush estival glory. These very "cuttings from nature" are evidence that Klimt is always in search of the most intimate contact with nature, that he has never lost it.[4]

That rustic country gardens were as much a part of Klimt's experience at the Attersee as sprawling fruit orchards can be seen in the photograph he took of Emilie Flöge standing in the gar-

den of the Brauhof Litzlberg, modelling a dress of his own design (fig. 106).[5] Such casually planted gardens were the very opposite of the ordered aesthetic that architect Josef Hoffmann imposed on the grounds of the Palais Stoclet, or that the planner Hermann Muthesius recommended in his influential book *Das Englische Haus* of 1904–05.[6] Rather, the motif of the farm garden that Klimt painted here, as well as in *Peasant Garden with Sunflowers*, c. 1906 (Österreichische Galerie Belvedere, Vienna), and *The Sunflower*, c. 1906–07 (private collection), can be seen as the landscape equivalent of Klimt's interest in the simple pleasures of country life, of finding the "regularity within irregularity."[7]

FIGURE 106

Emilie Flöge modelling a "Summer Dress," 1906 Photograph by Gustav Klimt. Reproduced in *Deutsche Kunst und Dekoration* (October 1906–March 1907)

Hope II 1907–08
Oil, gold, and platinum on canvas, 110.5 × 110.5 cm
The Museum of Modern Art, New York
Mr. and Mrs. Ronald S. Lauder and Helen Acheson Funds, and Serge Sabarsky
Novotny/Dobai 155

Klimt's return to the theme of the pregnant nude, first treated in the University painting *Medicine*, 1901, and once more in *Hope I*, 1903 (cat. 18), attests to its enduring appeal among his allegorical subjects.[1] The composition of *Hope II* again centres on a pregnant woman who stands in profile, but her swollen belly is now concealed from public view by a crimson robe decorated with golden ellipses. As in *Hope I*, the figure of Death is present at the woman's side, though in a less dominant position. Three praying female figures rise from below, recalling the flowing tangle of unconscious human forms in *Medicine*, but here neatly compressed into an ornamental column against a nebulous background of silver and gold.

Hope II was first exhibited with a small number of paintings in the Klimt room of the second *Kunstschau* of 1909. There, too, was the controversial *Hope I*, making its first appearance before the Vienna public since it had been withdrawn under threat of scandal from Klimt's 1903 retrospective; it had, however, remained the talk of "all the coffee houses and Five o'Clocks."[2] Although the two *Hope* paintings ostensibly represent the same subject, they offer a remarkable contrast in mood and symbolic content. *Hope II* is less inspired by Wagnerian storytelling or Nietzschean heroics than by a subjective exploration of the mythology of regeneration. Significantly, during Klimt's lifetime, the painting bore the title *Vision*, a transcendent state suggested by the figure's bowed head and raised hand.[3] Where the eyes of the protagonist in *Hope I* glare defiantly at the viewer, those of her counterpart in *Hope II* are closed and sunken, her cheeks pale and thin, her lips tightly pursed.[4]

The solemnity of the painting derives in part from Klimt's then current interest in Egyptian art. M.E. Warlick has thoroughly discussed the Egyptian references in Klimt's design for the Stoclet Frieze, on which he was occupied from 1905 until 1911.[5] As Alice Strobl has pointed out, the curving outline of the pregnant woman in *Hope II* resembles the corpulent figure of Sebek-em-sauf, a high-ranking official in Ancient Egypt, shown wearing an ankle-length kilt in a sculpture that Klimt may have seen in Vienna's Kunsthistorisches Museum (fig. 107).[6] Furthermore, the upraised hands of the figures

Statue of Sebek-em-sauf, Egyptian, 13th Dynasty, c. 1700 B.C. Kunsthistorisches Museum, Vienna

below the subject can be interpreted as the Egyptian gesture of veneration. For the blonde figure partially draped by the robe, whose left hand reaches behind the model's slim calves, this gesture has assumed the gravity of a protective embrace, possibly a representation of "Ka," the symbol of an individual's divine life force.[7]

Hope II still had not been sold when it was exhibited in Prague in 1914.[8] In the Josefstädterstrasse studio Klimt used until that year, the painting was photographed in a custom frame, most likely designed by Eduard Josef Wimmer of the Wiener Werkstätte (fig. 108).[9] The photograph reveals that Klimt made later changes to the canvas, as was his habit with paintings that remained in his studio for long periods.[10] The subject's head and shoulders can be seen to have been set against a light-coloured halo, underscoring the sacredness of her condition. In the final version, this halo was reduced to a curved band intended to be filled with a floral wreath, begun below the model's chin and similar to that around the head of Death. A second swath of darker colour falls behind the figure like a veil, but this, too, was subsequently painted over. A further change was made to the position of the red-haired praying figure at the lower right: she

bows toward the shoulders of her neighbour. This lends a greater rhythm to the figures and recalls Ferdinand Hodler's use of repeated poses.[11]

The change in Death's status, from dominant companion in *Hope I* to subordinate in *Hope II*, must reflect a shift in Klimt's interpretation of life under the most adverse of circumstances. The painting holds the same troubling message as Klimt's *Mother and Children* of 1909–10 (private collection), and looks forward to his late allegorical work *Death and Life*, 1908–15 (Leopold Collection, Vienna). It is the universal truth of death's co-existence with life that returns as a theme in *Hope II*, now expressed with the authority of Ancient Egypt.

View of Klimt's studio at 21 Josefstädterstrasse, Vienna, c. 1910–14. Bildarchiv, Österreichische Nationalbibliothek, Vienna

Detail of figure 108

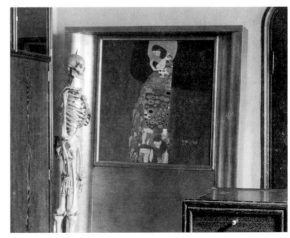

Pale Face 1907–08
Oil on canvas, 80 × 40 cm
Private collection
Novotny/Dobai 156

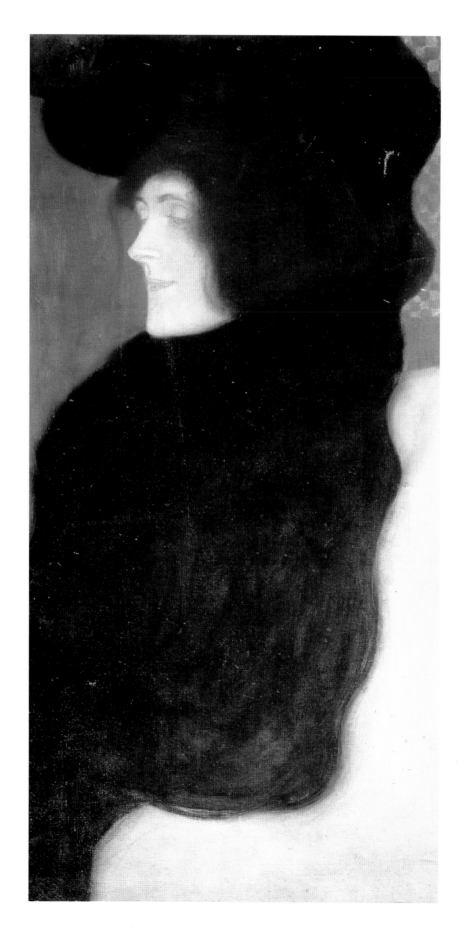

Just as the French Impressionists had turned to the Parisian "beau monde" as a source of allegory for the passing seasons (fig. 109), Klimt would find in fashionable Vienna a relationship between the ephemeral secular world and the timeless realm of art. With *Pale Face*, the influence of French modernism is also apparent in the way that Klimt has integrated the figure into a geometrically patterned background, accented with blue and red, that recalls the decorative settings of Édouard Vuillard.[1]

The model's appearance suggests that the Viennese lady of fashion preferred cool detachment to appealing charm, anaemic pallor to a rosy flush, anticipating the impassive *Neue Sachlichkeit* vamps painted by Otto Dix a decade and a half later. The deep black of her overcoat, boa, and hat are in pronounced contrast to her fair skin tone; and the light upholstery fabric of her chair, defined simply with a thin layer of white pigment over primer, further resonates with her complexion. Thick dark brown hair brushed closely about her cheeks and forehead squarely frames her distinctly Klimtian features—a long, straight nose, firm jaw, and petite mouth. With his unerring gift for observation, the artist includes a lock of hair falling loose over her brow, adding to the indifference of her downward gaze and slightly parted lips.

In assigning a date of 1907–08, Johannes Dobai placed the painting at the beginning of group of fashion subjects including *The Sisters* (private collection) and *Portrait of a Woman in Red and Black* (fig. 110), both exhibited at the *Kunstschau* of 1908, and which share *Pale Face's* vertical format and Secession-style decor.[2] However, as Alice Strobl suggested, in her seated profile pose *Pale Face* resembles the earlier Secessionist pastel *Portrait of a Lady* of 1897–98 (cat. 9), and may date to some years prior to 1907.[3] Differences in handling also support an

Édouard Manet, *Autumn: Study of Méry Laurent*, 1882
Musée des beaux-arts de Nancy

earlier dating for *Pale Face*. While *Pale Face's* light features have been achieved through the exposure of the canvas primer, those of *Woman with a Hat and Feather Boa* (cat. 26) have been made exaggeratedly so through an application of layers of white pigment.

The work under discussion was known to have been exhibited at the Berlin Secession of 1911 with the title *Pale Face*.[4] An earlier dating may in fact resolve the problem of a second *Pale Face* (*Bleiches Gesicht*), shown at the 1903 Klimt retrospective and now thought to be lost.[5] In the sales records of the Galerie Miethke, the Vienna commercial gallery that handled Klimt's work, Alice Strobl notes the sale in September 1905 of

a painting titled *Bleiches Gesicht* to Heinrich Böhler, who owned several Klimts including *Pond at Schloss Kammer* (cat. 28).[6] It seems plausible, therefore, that the current work first appeared in 1903, perhaps in a more generic conception, and that a commonality of dress between its model and those of *The Sisters* and *Woman in Red and Black* might be explained by a later reworking of the canvas by Klimt—to update its "contemporaneity," as fashions changed.

Portrait of a Woman in Red and Black, 1907–08. Private collection, Courtesy of Galerie Welz, Salzburg

26

Woman with a Hat and Feather Boa 1909
Oil on canvas, 69 × 55.8 cm
Private collection
Novotny/Dobai 161

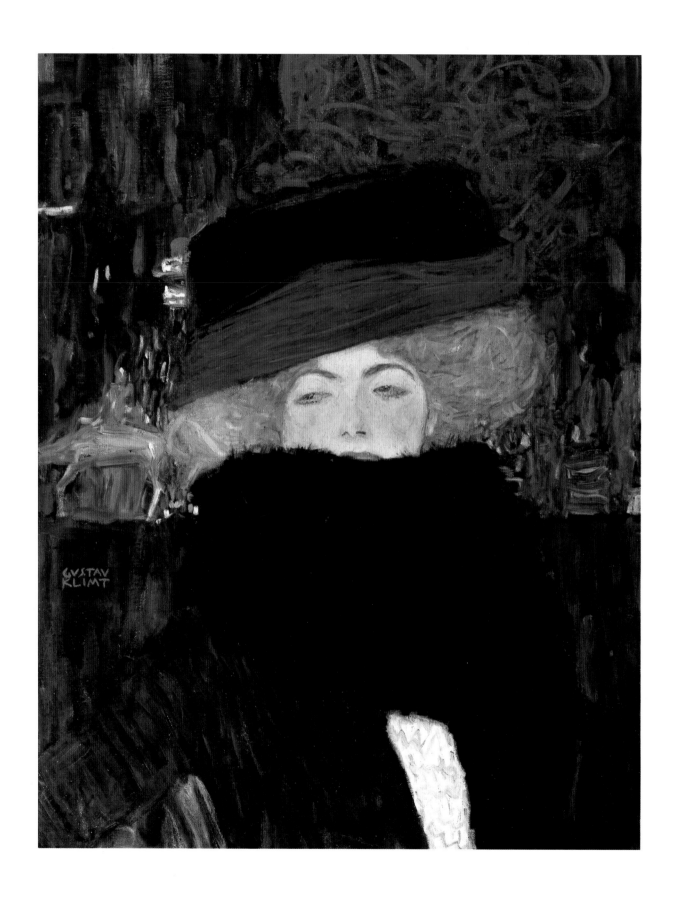

Fashion played as central a role in Klimt's vision of modernity as did Symbolist allegory or Jugendstil decorative motif.[1] The sitters for his portraits usually wear provocative dresses that distinguish them as belonging to Klimt's circle of admirers and as supporters of the Viennese avant-garde. Emilie Flöge, Klimt's companion, ran a thriving art fashion house and modelled the artist's own loose-fitting Dress Reform designs (see cat. 15).[2] Clothing and textiles were included among the artistically designed products of the Wiener Werkstätte from 1905.[3] The link between fashion and modernity first emerges in Klimt's work in the late 1890s, coincident with the founding of the Secession and its journal *Ver Sacrum*, which reproduced a number of his drawings of stylishly dressed women (see cat. 9).[4]

For Klimt, the line between fashionable reality and allegorical fantasy remained a fine one. For example, the foreground figure of Hygeia in *Medicine* (fig. 3) wears a jewelled choker and ornamented robe inspired by Jugendstil and Art Nouveau. And beneath the urban-chic winter wear of the model in *Woman with a Hat and Feather Boa* lurks the femme fatale—a biblical Judith dressed for an evening stroll along Vienna's Kärntnerstrasse.[5]

Between 1907 and 1909, Klimt painted five canvases with modish women in dark winter clothing, including *Pale Face* (cat. 25), *The Sisters* (private collection), and *Woman in Red and Black* (fig. 110); the last two were placed to either side of *The Kiss* in Koloman Moser's design for the Klimt room of the first *Kunstschau* of 1908 (fig. 186). Another, *Lady with Roses on Her Hat*, was presented at the 1909 *Kunstschau*.[6]

A recent cleaning of *Woman with a Hat and Feather Boa* has renewed the painting's vibrant coloration and allowed a fuller reading of its rich detail.[7] Now one can clearly see the ruffle of a white blouse between the lapels of a dark green jacket, and how deftly Klimt has outlined the eyes and brows of the model with a blue pigment. Most palpably revealed by the removal of old

Winter hat designed by Rudolf Kriser. Photo by Madame d'Ora, 1910. Austrian Archives / Christian Brandstätter, Vienna

varnish is the model's pale, sallow skin, and the light red flush over her cheeks. The deep black feather boa is wrapped high above the chin, leaving visible only a thin red line of lipstick. A mass of thick orange curls supports a broad crowned hat of black velvet, hemmed with a raised veil of intense cobalt blue. The same material has been transformed into a billowing plume that disappears off the edge of the upper picture plane. That Klimt drew his inspiration from the Viennese fashion world is suggested by Madame d'Ora's photograph of a winter hat designed by the painter Rudolf Kriser (fig. 111).[8]

In the tilt of the hat, the sidelong drift of half-closed eyes, and the raised elbow, there is a spontaneity to the pose that suggests movement, a momentary turn to her right. Rather than the imaginary decorative setting of so many of Klimt's portraits and figure paintings, the background of *Woman with a Hat and Feather Boa* is a dark interior, with a collection of oriental figurines arranged

on a shelf behind the model. Perhaps Klimt sketched the details of his own ebony display cabinet designed by Josef Hoffmann, which can be seen filled with Asian artefacts in a studio photograph taken after he moved to Hietzing in 1914 (fig. 196).[9] Figures in red lacquer stand on the shelf at the right, and Erhard Stöbe has suggested that the brass statue on the left is *Lao-tse Riding a Buffalo* (fig. 112), the aged founder of Taoist philosophy being carried off to paradise.[10] During his stay in Paris in October 1909, Klimt wrote enthusiastically of the Asian collections of the Musée Guimet.[11] The visit would stimulate his interest in Asian art and mark a transition from the mosaiclike Egyptian or Jugendstil influenced backgrounds of his earlier portraits, to the Asian and Korean inspired motifs that appear in later works such as *Portrait of Baroness Elisabeth Bachofen-Echt*, c. 1914 (private collection), or *Portrait of Friederike Maria Beer*, 1916 (fig. 199).

Lao-tse Riding a Buffalo, Chinese, Qing Dynasty Musée des arts asiatiques—Guimet, Paris

The Park 1909–10
Oil on canvas, 110.5 × 110.5 cm
The Museum of Modern Art, New York
Gertrude A. Mellon Fund, 1957
Novotny/Dobai 165

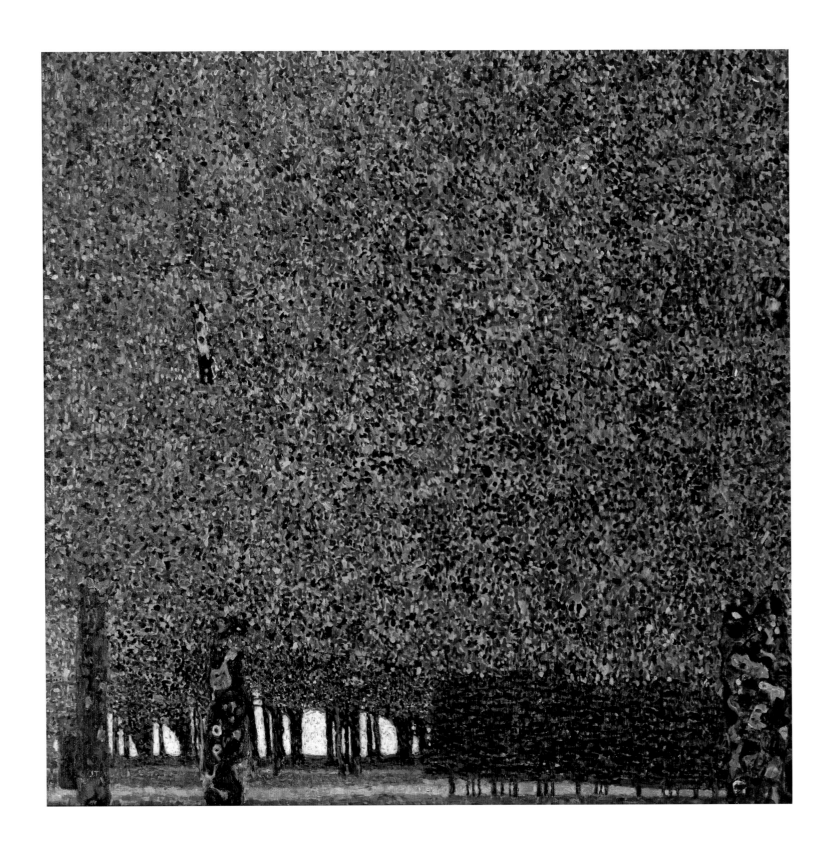

Unlike many of Klimt's undated landscapes, *The Park* can be securely placed between the second *Kunstschau* in the summer of 1909—where Klimt exhibited only two landscapes[1]—and its first appearance in the Klimt room at the ninth Venice Biennale from April to October 1910 (fig. 23). Here the artist forsakes his familiar orchard setting to capture the natural beauty of a stand of trees in the grounds of Schloss Kammer on the Attersee; the castle's architectural features appear in Klimt's paintings from 1908.[2] The curtain of cascading leaves that dominates the canvas recalls the background of *Golden Knight* (cat. 16), but in *The Park* the mosaic patterning of greens, yellows, and blues has become the primary visual interest and takes on a vibrating life of its own.

This planar, undifferentiated mass of colour comprises the foliage of at least three separate trees, anchored in the immediate foreground by their vertical trunks. A single branch continues upward on the middle left, piercing the surface like a thick thread through Pointillist fabric. The dense growth of the park is interrupted only in the lower left by a bright aperture; perhaps a view through the trees to the surface of the Attersee. At lower right, a darker rectangle of small evergreens provides textural contrast and a sense of the scale of the surrounding trees. It is only in his treatment of the ground cover that Klimt varies the lighting conditions, with a narrow horizontal band of yellow indicating a break in the trees into which the sun has penetrated.

In its balance of horizontal and vertical, and the compartmentalization of elements into near/far, small/large contrasts, *The Park* anticipates Piet Mondrian's use of orthogonal line in his abstract paintings and his arrangement of colour into discrete rectilinear areas of canvas (fig. 113).[3] Such abstracting tendencies in Klimt's landscapes did

FIGURE 113

Piet Mondrian, *Composition*, 1929. Solomon R. Guggenheim Museum, New York, Gift, Estate of Katherine S. Dreier, 1953. © Beeldrecht / SODART (Montreal) 2001

not go unnoticed by his contemporaries, who saw them as a consequence of his collaboration with the architect Josef Hoffmann.

Berta Zuckerkandl, commemorating Klimt on his fiftieth birthday in 1912, attributed the unusual visual tension in his landscapes to an ongoing struggle between naturalism and style—the very conflict that had precipitated the 1905 split between the "pure painters" of the Secession and the artists of the "Klimt-Gruppe," with their emphasis on architecture and design:[4]

> Never before has Klimt created more fiery, surging, fresh reflections of existence than in the marvellous landscapes of this very last creative period.... They are the outcome of that tenacious inner battle between Naturalism and Style. They are the first results of an equilibrium showing supreme maturity, balancing the dichotomy which

we would have to call the tragic conflict in this evolution towards mastery.[5]

If *The Park* looks forward to abstraction in its reduction of nature to fundamental formal relationships of geometry and colour, it also draws retrospectively from the very origins of landscape painting in the tradition of the Danube School. The source of *The Park*'s rich and expansive foliage has been linked by one scholar to the pantheistic visions of Albrecht Altdorfer, as evident in *St. George and the Dragon*, 1510 (Alte Pinakothek, Munich).[6] However, a more recent precedent for Klimt's *Park* might be seen in the closely observed landscapes of watercolourist Rudolf von Alt (1812–1905): in his *The Spa Park in Teplitz*, c. 1875 (fig. 114), branches fill the canvas and extend beyond its edges.[7]

FIGURE 114

Rudolf von Alt, *The Spa Park in Teplitz*, c. 1875 Graphische Sammlung Albertina, Vienna

Pond at Schloss Kammer on the Attersee 1909–10
Oil on canvas, 110 × 110 cm
Private collection
Novotny/Dobai 167

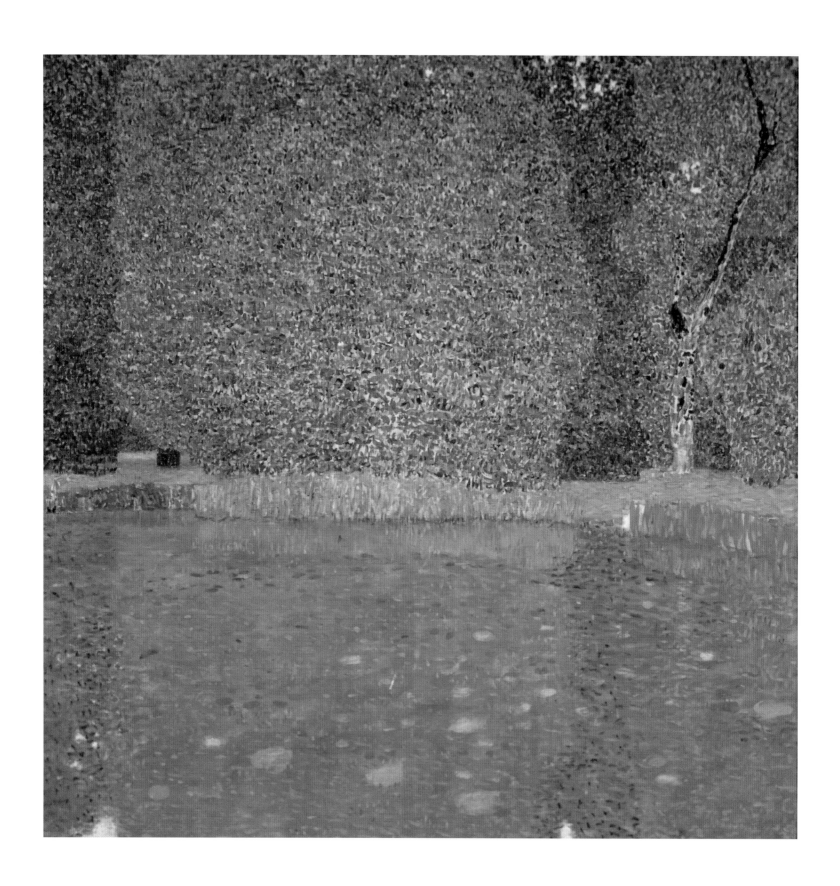

Like *The Park* (cat. 27), this landscape presents a view of the wooded grounds of Schloss Kammer, and depicts a similar dense foliage, composed of interwoven hues of green and blue suffused with warm yellow tones, above a trim lawn. Perspectival depth can be read across the calm surface of the lily pond to a reeded shoreline, as well as in the cooler blues of the trees further away from shore. And *Pond* shares *Park*'s impenetrability—not only in the near absence of sky and limited breadth of vision that restricts the park to a few bushy trees, but also in the way this closure is mirrored by its reflection in the water. A bit of blue sky, just visible at upper right, is reflected as two small triangles of light along the bottom edge of the canvas. Based on this relationship of style and subject, *Pond at Schloss Kammer* may be dated with *Park* to the summer of 1909, and certainly before both canvases appeared at the Venice Biennale in April 1910.

With its viewing angle suspended above the water's surface and its sense of airless tranquillity, *Pond at Schloss Kammer* shows the lingering influence of such Symbolist landscapes as Fernand Khnopff's *Still Water*, c. 1895 (fig. 115), a work exhibited at the first Secession in March 1898 and reproduced in *Ver Sacrum* the following December.[1] Both artists achieve an emotional response to the landscape without recourse to the supernatural or the allegorical.[2] Yet Klimt refrains from imposing on his view the mood of twilight gloom that pervades Khnopff's painting; rather, *Pond* remains undisturbed by any strong variations in light or the intrusion of shadow. Klimt also departs from Khnopff's example in his use of a square format and in his robust Pointillist technique, which renders the material

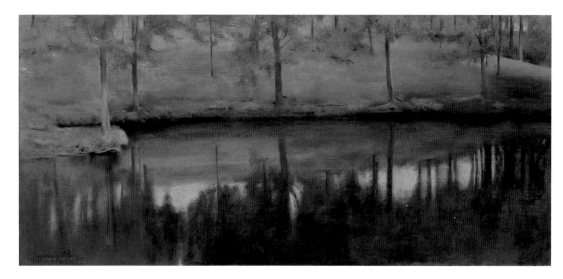

FIGURE 115

Fernand Khnopff, *Still Water*, c. 1895. Österreichische Galerie Belvedere, Vienna

form of the trees while allowing them to dissolve before the eye into plumes of shimmering colour.

The strong showing of landscapes at the *Kunstschau* exhibitions of 1908 and 1909 moved critic Franz Servaes to declare:

> Klimt stands virtually alone in rendering to such sublime and resonating effect Nature's lavish abundance, or an atmosphere laden with unease and disquiet, or the heavenly serenity of idealistic dreams, often with lines of exhilarating simplicity and unpretentiousness, in colours at times alight, as luminous as the very stars themselves.[3]

From 1908 until 1912, the years Klimt vacationed at the Villa Oleander, he would depict the nearby Schloss Kammer and its grounds in seven canvases, each from a different vantage point.[4] The series stands as a panoramic testimonial to the fortresslike walls of the castle, which in 1872 became part of a luxury convalescent hotel a few hundred metres away.[5] In 1898, a

tourist guide to the region described the appeal of the place:

> Many people needing to recover seek out the little paradise of Kammer, to reinvigorate themselves. Genuinely miraculous cures are effected here with very simple and natural means. . . . Avenues, magnificent parks and gardens near the castle, a grouping of beautifully constructed villas belonging to it—Villa Oleander, Seevilla, Waldhütte, and Russvilla . . . numerous walks winding through the nearby hills: these are all things uplifting to one's heart and a balm to one's health.[6]

With the Schloss Kammer landscape series, Klimt was able transform his immediate surroundings into a subject with latent Symbolist resonance. Though absent of figures, his scenes of summer on the Attersee evoke a sensuous vision of nature's delights, even as they bear an unsettling hermetic quality.

Ria Munk on Her Deathbed 1912
Oil on canvas, 50 × 50.5 cm
Richard Nagy, Dover Street Gallery, London
Novotny/Dobai 170

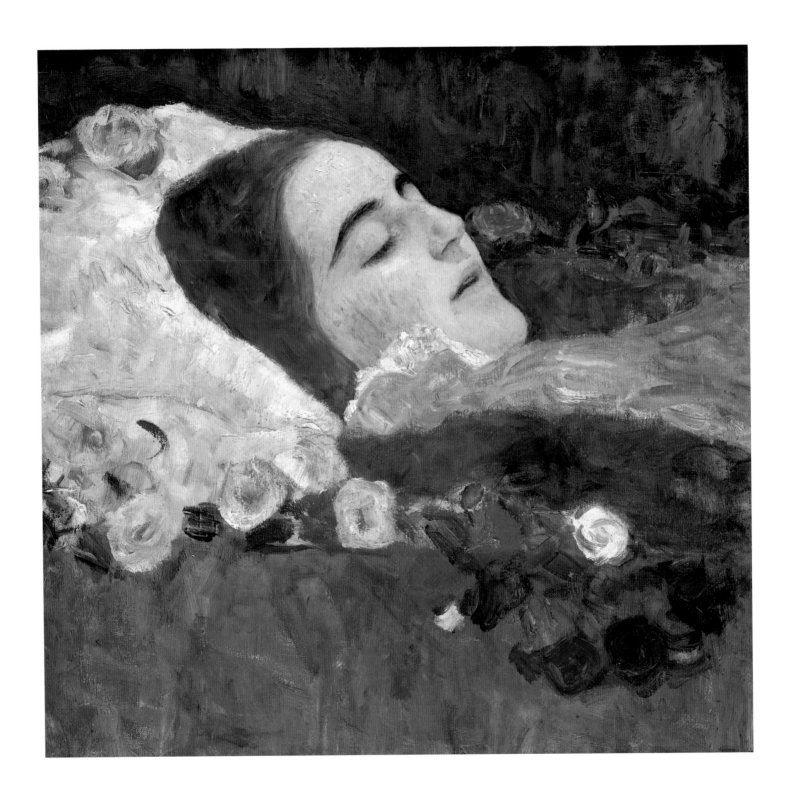

In lifeless repose, the twenty-four-year-old Maria (Ria) Munk (6 November 1887–28 December 1911) lies like a Pre-Raphaelite *Ophelia* among red and white flowers, her long auburn hair flowing down over her shoulders and arms.[1] Even in the pallor of death, Ria's youthful beauty is undeniable. Klimt has taken care to portray her fine features with a faithful realism, while hastily sketching in details of the bed and mauve-coloured shroud. The overhead light that aids his work casts a visible shadow under Ria's nose, yet the background of the canvas remains in obscurity, painted in a deep blue, the colour representing death and the afterlife in Klimt's work.[2]

The commission for this portrait most likely came to Klimt through Ria's aunt, Serena Lederer, a long-time student of the artist's and the subject of his portrait of 1899 (fig. 95).[3] Serena's son Erich was the first to identify the subject of this portrait as his cousin, the daughter of Aranka Pulitzer Munk and the wealthy Viennese businessman Alexander Munk.[4] Serena and Aranka were daughters of Charlotte Pulitzer (c. 1838–1920), a member of the well-known newspaper family, whose portrait Klimt would paint in 1915.[5] The family's long acquaintance with Klimt dates to at least 1888, when Aranka and Alexander Munk were portrayed in their box seats in the *Auditorium of the Old Burgtheater* (cat. 3), next to Serena and the Pulitzer family.[6]

Tragically, Maria Munk took her own life just before New Year's Eve 1911, shooting herself in a moment of despair after a falling out with her lover, the writer Hans Heinz Ewers (1871–1944).[7] In *fin-de-siècle* Vienna, suicide had become an all too common method of escape for those who had reached an impasse in matters of love or honour. The most celebrated instance was the double suicide in 1889 of Crown Prince Rudolf, the only son of Emperor Franz Josef, and his lover, Baroness Maria Vetsera, in the Imperial hunting lodge at Mayerling, which ended any hope of a direct succession. Of the seven siblings of Viennese philosopher Ludwig Wittgenstein, son of Klimt's patron Karl Wittgenstein, three were lost to suicide.[8] By 1910, suicide had become such an intractable problem that the Vienna Psychoanalytic Society

FIGURE 116
Old Man on His Deathbed (Hermann Flöge?), c. 1897
Österreichische Galerie Belvedere, Vienna

held a symposium to openly examine the phenomenon.[9] The meeting was chaired by Sigmund Freud, who agreed with the opinion of the speaker, David Oppenheim, that suicide results when "the life instinct is overwhelmed by the libido."[10]

The death mask and the deathbed portrait had become fashionable in the nineteenth century as a means to preserve the last memory of the deceased (fig. 116).[11] Stefan Zweig wrote of the social ritual of death in *fin-de-siècle* Vienna: "Even funerals found enthusiastic audiences and it was the ambition of every true Viennese to have a "lovely corpse," with a majestic procession and many followers; even his death converted the genuine Viennese into a spectacle for others."[12] With his Symbolist vision, Klimt transforms this potentially morbid subject into one of significant visual sensuality. As Marian Bisanz-Prakken has noted, the artist's considerable number of deathbed portraits attempt to "express the unbridgeable distance between physical proximity and spiritual inaccessability."[13] Klimt's sensualization of death is evident in Ria Munk's ethereal attractiveness, flowing tresses, and the strong colours he chooses. It is an approach to the subject that had emerged in the artist's work as early as 1885 in the softly modelled features of the dead Juliet (cat. 40), and again in the moving drawing of his son Otto, swathed in a white shroud, shortly after his death on 11 September 1902.[14]

It was evidently the desire of Ria's family that her memory be preserved in Klimt's acclaimed pantheon of Viennese *Frauenbilder*.[15]

This deathbed image would be followed by two posthumous full-lengths, the first begun in 1913, when Klimt wrote to Emilie Flöge of the difficulties he was encountering in completing it.[16] The second full-length of Ria, dressed in a patterned robe or kimono against a background of bright floral design (fig. 117), was begun about 1917, but remained unfinished at the time of the artist's death in 1918. The sure gaze and sanguine smile he adoringly gives Ria in this portrait, which was undoubtedly painted after photographs, are conveyed with a spontaneity that suggests Klimt drew upon his recollections of a personal friendship.

FIGURE 117
Portrait of Ria Munk III, 1917–18. Neue Galerie der Stadt Linz, Wolfgang-Gurlitt-Museum, Linz

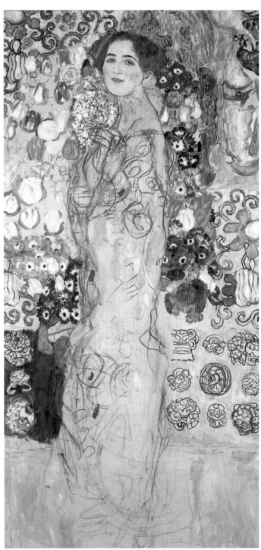

Portrait of Mäda Primavesi 1913
Oil on canvas, 149.9 × 110.5 cm
The Metropolitan Museum of Art, New York
Gift of Andre and Clara Mertens in memory of her mother, Jenny Pulitzer Steiner, 1964
Novotny/Dobai 179

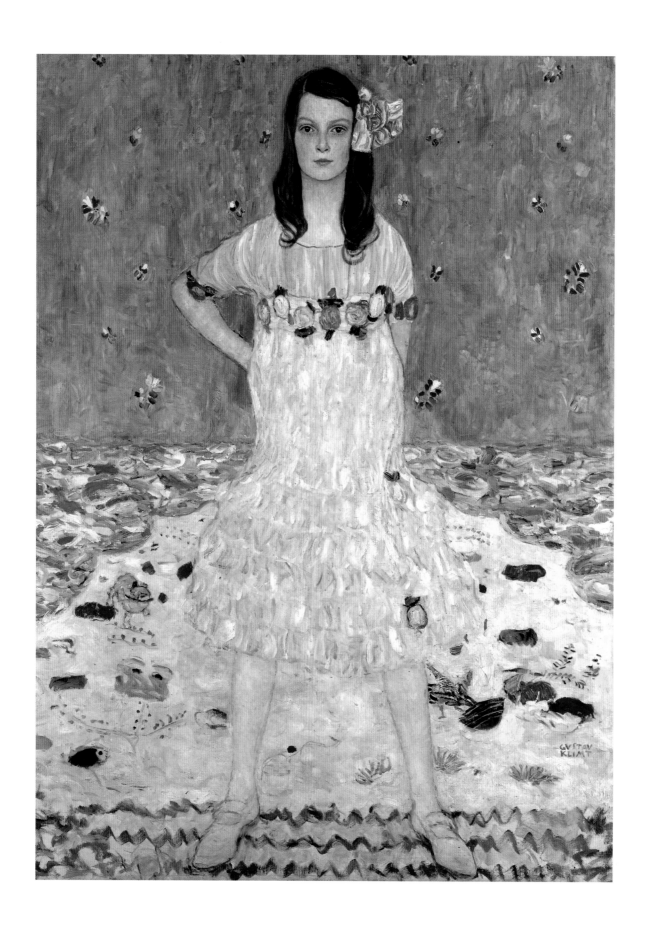

Mäda Gertrude Primavesi (fig. 118–120) was born on 22 December 1903 in Olmütz, Moravia (now Olomouc, Czech Republic), centre of the banking empire owned by her father, Otto Primavesi (1868–1926); she died 25 May 2000.[1] In this full-length portrait, Klimt portrays Mäda as an unusually precocious nine year old who fills the canvas from top to bottom, posed as far forward as possible in the fictional space she occupies. Her unwavering gaze and unsmiling expression are the opposite of the shy vulnerability familiar from paintings of children by Whistler or Renoir, but rather evoke the self-possession of a *Pallas Athena* (cat. 11). Mäda's youth is apparent only in her slender figure, floppy blue hair ribbon, and short iridescent white dress that reveals more leg than any grown woman would dare show in Vienna at the time. Her hands are hidden from view, as if they too might disclose some clue to her age.

This, Klimt's only commissioned portrait of a child, required a patron of some courage to support such an unconventional example of the genre.[2] The painting shares the bold originality of Klimt's other *Frauenbilder*, and one must look to portraits by the Norwegian Symbolist Edvard Munch to find an equally probing investigation of a child's personality. Mäda's stance, with feet apart and hand propped on hip in a gesture of bored resignation, invites comparison with Munch's *Four Sons of Dr. Max Linde*, 1903 (fig. 121), a painting that Klimt had occasion to view, along with other works by Munch, at the nineteenth exhibition of the Vienna Secession (22 January to 6 March 1904).[3]

FIGURE 118

Mäda Primavesi, c. 1907. Private collection

Klimt first mentions a visit to his studio by Mäda's mother, Eugenia Primavesi (cat. 31), in February 1912.[4] Later that year, he began a number of studies of Mäda in a patterned pinafore dress: some show her sitting, others standing, facing to the left or right in a three-quarter pose with her weight on one leg (cat. 110). A second set of studies (fig. 122) indicates that Klimt had fixed upon Mäda's taut frontal pose, but still sought an appropriate canvas size and background geometry. In February 1914, Mäda's portrait was exhibited for the first time at the second Rome Secession (fig. 25). Klimt borrowed it again for the Berlin Secession of 1916, and also for the Austrian art exhibition held in Stockholm in September 1917.[5]

FIGURE 119

The children of Otto and Eugenia Primavesi, c. 1908 From left: Otto, Mäda, Melitta, and Lola Private collection

FIGURE 120

The Primavesi family, c. 1909. From left: Melitta, unidentified, Mäda, Eugenia, Otto, and another unidentified guest. Private collection

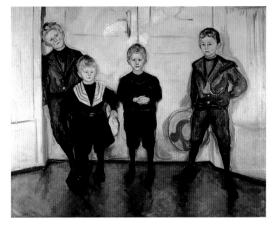

FIGURE 121

Edvard Munch, *Four Sons of Dr. Max Linde*, 1903 Behnhaus—Museum für Kunst und Kulturgeschichte, Lübeck

FIGURE 122

Studies for the Portrait of Mäda Primavesi, c. 1913 Private collection

The background blends fantasy landscape with Wiener Werkstätte inspired interior to create a horizontal balance to the strong vertical line of Mäda's pose. The canvas is divided between the soft mauve hues of a wall accented with floral sprigs and a carpet of unusual semi-circular design that arcs behind Mäda, repeating her triangular stance and the flare of her skirt. This half circle is inhabited by the serendipitous world of a child's daydreams. To the bottom right can be seen tufts of grass and two birds: one has its beak in a shell, the other, with red and blue plumage, sits calmly. To the left, a blue and yellow fish, which recalls Klimt's signet design, is watched stealthily by a small dog—possibly the girl's favourite bulldog.[6] Mäda herself stands on three undulating blue lines resembling ripples along a shoreline. At the carpet's edges is a flat surface of pink and green, like a pond of water lilies. In this most innovative of portrait compositions, the balance is not only geometrical but also psychological, as the playfulness of background details contrasts with the lack of sentimentality in Mäda's pose and expression.

Portrait of Eugenia Primavesi 1913
Oil on canvas, 140 × 85 cm
Toyota Municipal Museum of Art, Toyota, Japan
Novotny/Dobai 187

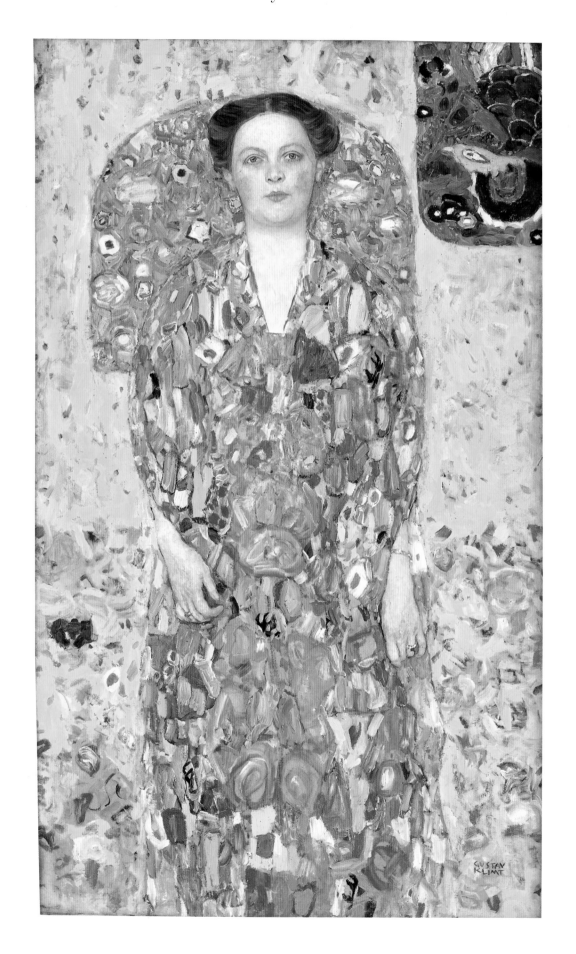

With her plump cheeks and bemused gaze, Eugenia Primavesi (1874–1963) seems the least likely of femmes fatales (fig. 123–126), yet she was one of the few women who genuinely intimidated Klimt. Eugenia was a commanding presence, not only because of her irascible nature but also due to the vast wealth of her banker husband, Otto.[1] When informed that she planned to visit his studio in February 1912, likely so he could begin studies for her daughter's portrait (cat. 30), Klimt wrote Emilie Flöge: "Frau Primavesi is coming today—I'm curious!—now I can't paint."[2]

An actress before her marriage in 1895 (fig. 123), Eugenia was known for hosting flamboyant parties at the Primavesi country estate in Winkelsdorf, near Olmütz, for which guests were required to dress in costume (fig. 127).[3] These lavish events were also attended by Josef Hoffmann, the architect of the country house

FIGURE 125
Anton Hanak, *Bust of Eugenia Primavesi*, 1905
Private collection

FIGURE 126
Eugenia Primavesi, c. 1910. Private collection

FIGURE 123
Eugenia Butschek, later Primavesi, as Gretchen in Goethe's *Faust*, early 1890s. Private collection

FIGURE 124
Eugenia at about the time of her marriage, c. 1895
Private collection

built in 1913–14.[4] In December 1915, Klimt complained of a cold and tiring three-hour wagon ride to Winkelsdorf from the train station and of overly generous servings of Bohemian cuisine: "Huge meal of boiled beef with horseradish—apple and cabbage strudel—probably Bratwurst in the evening—tomorrow black pudding and liver sausage—madness!"[5]

Thanks to documentation published by Alice Strobl, we know that Eugenia Primavesi's portrait was under way by 7 February 1913, when she wrote to a mutual friend, the Czech sculptor Anton Hanak (1875–1934; see fig. 125), that she would be returning to Klimt's studio on 18 February for a second sitting.[6] On 28 June 1913, two weeks after Eugenia's thirty-ninth birthday, Otto Primavesi paid Klimt 15,000 crowns for her portrait and Mäda's (cat. 30).[7] Given that in 1908 Klimt had been paid 12,000 crowns by the City of Vienna for the *Portrait of Emilie Flöge* (cat. 15), this sum for two portraits seems rather low.[8] Indeed, the hasty brushwork and lack of finish in the background and Eugenia's robe, compared with that of her daughter, suggests that Klimt may have been obliged to end work on this portrait quickly.

Eugenia wears a kimono-like robe in multicoloured pastel shades, possibly acquired from the Wiener Werkstätte fashion shops.[9] While Klimt's bravura execution renders the pattern indecipherable, one can discern a symmetry in the design along either side of the robe's centre line. An unusual background colour of intense yellow has been has been applied over a floral design of pink, blue, and green, obscuring this pattern in the upper half of the painting. The careful rendering of Eugenia's hands suggests they were as important to Klimt in conveying the personality of the sitter as the facial expression

or gaze. During the sitting for her portrait of 1916 (fig. 199), Friederike Maria Beer recalled: "Klimt would take my hand and just stand there, holding it, studying it, turning it over without speaking—so long it made me feel eerie."[10]

Klimt's portrait of Eugenia would mark the beginning of a new phase in the Primavesis' lives. In March 1914, Otto Primavesi became the principal shareholder of the revived Wiener Werkstätte, following the company's recent bankruptcy and Fritz Waerndorfer's flight to America; in 1915 he would become its commercial director.[11] In May 1914, the Primavesis accompanied Klimt and Hoffmann on a visit to the Palais Stoclet in Brussels, where they were swept away by its beauty.[12]

FIGURE 127
Costume party at the Villa Primavesi, 1916. Klimt's robe is made with "Forest Idyll" fabric designed by Carl Otto Czeschka. Österreichisches Museum für angewandte Kunst, Vienna

Garden Landscape with Hilltop 1916
Oil on canvas, 110 × 110 cm
Kunsthaus Zug, Switzerland
Deposit of Foundation Collection Kamm
Novotny/Dobai 216

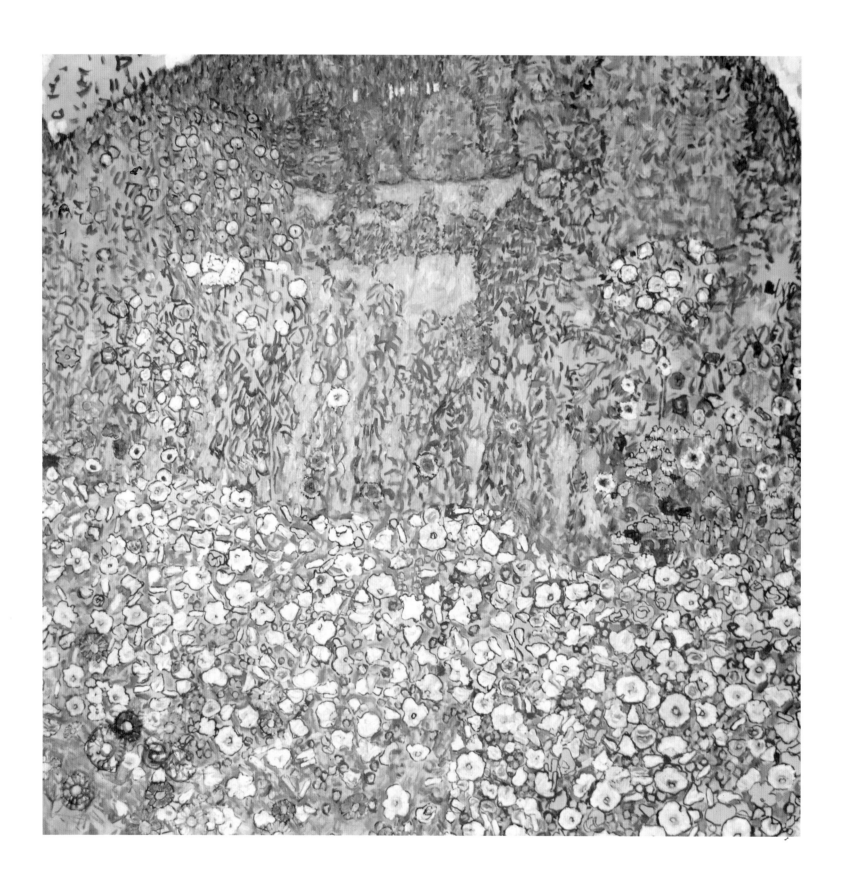

The steeply sloping terrain depicted here could be a view toward the Höllengebirge, a mountain range immediately to the east of Weissenbach am Attersee, where Klimt vacationed from 1914 to 1916. In its unfinished condition, *Garden Landscape with Hilltop* is a good example of Klimt's procedure for painting landscapes during his summers at the Attersee, and it reveals that he was initially attracted by the subject's contrasts of scale and engaging visual patterning. In painting out-of-doors, Klimt did not prepare preliminary oil sketches for later enlargement, but rather outlined the scene's principal motifs directly onto the final canvas with the tip of his brush, and then defined the colour relationships with pigments from his paintbox.[1] Once he had charted the essentials of colour, texture, and geometry, Klimt might leave interstices of bare canvas to be finished in his studio in the fall.

In the four to six weeks that Klimt spent at the Attersee, he usually managed to begin five or six canvases. His letter to Marie (Mizzi) Zimmermann in August 1902, a few years after he began landscape painting, confirms that he soon established a routine for work: "Mizzi, I know better than anyone that painting is very, very difficult, I had to work very hard in the country and I'm bringing five paintings back that are nearly finished, but I'm not quite satisfied with them, and must hope for better results next year. God willing!"[2] Areas of canvas in *Garden Landscape with Hilltop* remain only lightly sketched in green pigment with the brush tip, suggesting that the painting sat uncompleted in Klimt's studio until his death.

Yet even in this state, the work clearly signals a departure from the artist's earlier landscape style, for he seems to have abandoned his disciplined, architectonic ordering of elements. Not only does the composition seem more abstract than in previous landscapes, but the perspective is unusually distorted. A pink-and-white floral mosaic slants up to the left; at centre, tall stands of dahlias sway to the right—even the hilltop has a forward roll in its asymmetrical cropping. A lone fruit tree, top-heavy with golden apples or pears, tentatively frames the scene to the left, while interspersed clusters of yellow and purple daisies and a white rosebush serve the same function to the right.

The wide skirt of blossoms that occupies the foreground is a compositional device that Klimt had used for *Forester's House at Weissenbach* of about 1914 (fig. 128). However, in comparison with the earlier work, the flowers of *Garden Landscape with Hilltop* are much more profuse and depicted from an even closer viewing position. Thus, a near/far contrast is established between the bright, lyrical patterning of the blossoms and the distant, somewhat sombre view through the trees that crown the hilltop.

In the last year of his life, Klimt's postcards to Emilie Flöge, usually filled with mundane comments about the weather and travel, became the outlet for a growing anxiety about his art and his health. It is evident that when Klimt returned to Vienna in early August 1917, he was suffering from a depression brought on by the gloomy course of the war. He writes, "I'm still wandering around like a lost sheep. It seems that my urge to

FIGURE 128
Forester's House at Weissenbach, c. 1914
Österreichische Galerie Belvedere, Vienna

work which was weak anyway has been reduced even further;" and a few days later, while organizing his selection for the exhibition of Austrian art in Stockholm: "I still feel miserable about my art! I am doubly sick about the other paintings."[3] Lacking the consummation of the finishing touch, *Garden Landscape with Hilltop* might bring to mind the anxious, unresolved character of the late work of Titian, Degas, or Picasso. Nevertheless, the painting is a rhapsodic ode to the country flower garden, one of Klimt's consuming passions. It is apparent that, had Klimt lived to finish the painting, it would have been the harbinger of a new direction in his work—towards a more restless and sensual idealization of nature.

Forest Slope in Unterach on the Attersee 1917
Oil on canvas, 110 × 110 cm
Private collection
Novotny/Dobai 218

With its sweeping vista through a screen of evergreens across the soft blue of the Attersee, *Forest Slope in Unterach* is unlike any earlier landscape in the exhibition, which are characterized by enclosed, compressed perspectives and the absence of human habitation. Here, the inclusion of buildings and Alpine scenery conjures up the storied appeal of the Salzkammergut region.[1] Yet in the striking contrast of scales—between diminutive architecture and towering slope, unrelieved by open sky—lingers a sense of foreboding, of man's vulnerability before the looming brow of nature.

Unterach lies on the southwestern shore of the Attersee, across the lake from Weissenbach where Klimt vacationed from 1914 to 1916. Johannes Dobai's dating of this work to 1917, the last active year of the artist's career, is problematic. In 1917 he is only recorded in the Salzkammergut at the end of July—in Bad Gastein, near Salzburg, where he had been taking the cure each summer since 1912.[2] In the second week of August 1917, he wrote Emilie Flöge of his return to Vienna from Bad Gastein, and by 16 August was on his way to meet her in Mayrhofen.[3] If Klimt did sojourn at the Attersee that year, it was either in June, early July, or at the end of August; and it would have been briefer than his usual uninterrupted stay through July and August to work steadily at his painting.

The resort town of Unterach numbered about 1,000 inhabitants during Klimt's lifetime, and was known for its sylvan setting amid Spanish chestnut trees.[4] In Klimt's view, pale-

FIGURE 129
Houses in Unterach on the Attersee, c. 1916
Österreichische Galerie Belvedere, Vienna

coloured boathouses punctuate the shoreline, while a linked pattern of Alpine dwellings occupies the lower slope of the Höllerberg. These same houses appear greatly magnified in *Houses in Unterach on the Attersee* (fig. 129), which was possibly executed with the aid of a telescope at the same time as *Forest Slope in Unterach*.[5]

With their ordered structure and interlocking forms, Klimt's Unterach paintings recall Cézanne's many views of Mont-Sainte-Victoire and the surrounding farmhouses.[6] In their stillness and inspiration found in nature's underlying patterns, one might compare the landscapes of Canadian painter David Milne (1882–1953) to this image. Milne's *Boston Corners* (fig. 130),

for example, shares with *Forest Slope* a measured division of the composition into a foreground occupied by stylized trees, a middle ground of closely grouped houses, and a steeply rising background affording vertical closure.

For Peter Altenberg, the loneliness of Klimt's small towns brought to mind the nineteenth-century Romantic literary tradition that placed man at the mercy of nature: "Your small towns by the lake look as if they were taken from Victor Hugo's tragically profound novels, haunted and abandoned, and at the same time, *fantastic / naturalistic*."[7] To Altenberg, Klimt's late landscapes remained Symbolist in nature, drawn with precision from the surroundings of his summer vacation world, but suggesting the interiorized realm of the intellect and imagination.

FIGURE 130
David Milne, *Boston Corners*, 1917–18. National Gallery of Canada, Ottawa

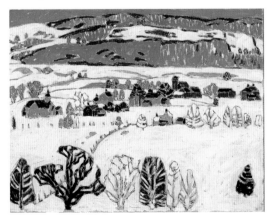

Baby 1917
Oil on canvas, 110 × 110 cm
National Gallery of Art, Washington, D.C.
Gift of Otto and Franciska Kallir with the help of the Carol and Edwin Gaines Fullinwider Fund
Novotny/Dobai 221

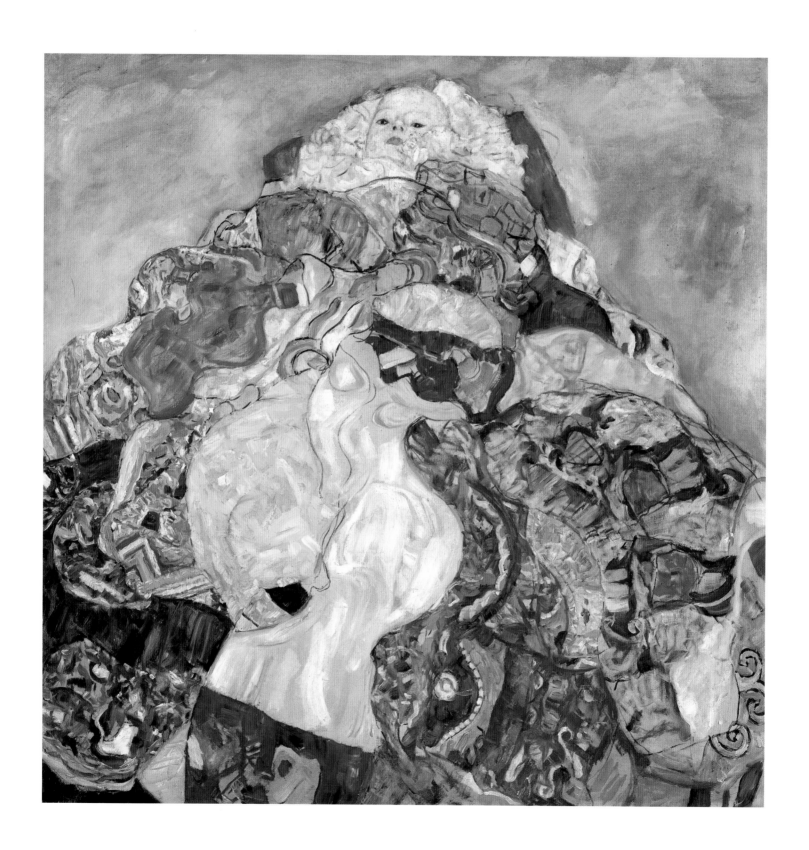

The sleeping infant often featured in Klimt's allegorical representations. As childhood innocence in *Three Ages of Woman*, 1905 (fig. 18), for example, and in *Death and Life*, 1908–15 (fig. 19), where it forms part of the coil of humanity opposite the menacing figure of Thanatos. In the late, unfinished painting *The Bride*, 1917–18 (Österreichische Galerie Belvedere, Vienna), the baby belongs to a young woman's dream of joyous fulfilment.

In Klimt's *Baby*, however, the single figure resists an obvious allegorical interpretation, yet the introduction of a note of ambiguity absolves this portrayal of a child of all convention or sentiment. The artist uses the compositional device of a triangle within a square, seen also in *Farm Garden* (cat. 23), placing the baby's head at the apex of a mountain of jumbled cloth, like some pagan idol. However, the viewer looks *down* upon the infant lying amid a Léger-like cluster of interlocking forms (fig. 131) that envelops its body. The colourful jumble of floral and geometric patterns suggests that Klimt emptied his wardrobe of Japanese kimonos, and for good measure threw in a few items from Emilie Flöge's collection of Moravian and Slovak textiles.[1]

If Klimt's previous depictions of sleeping children could prompt Peter Altenberg to describe them as the "essence of sweet, noble helplessness,"[2] this image is of the ever-wakeful baby, peering warily at the artist from its swaddling, with clenched right hand raised and remarkable red lips. It is the opposite condition of the subject of Nagasawa Rosetsu's *Sleeping Chinese Boy* (fig. 132), and an intermediary state between the active and passive portrayals in Egon Schiele's *Mother with Two Children* (fig. 133).[3]

The visible swirl of the green line with which Klimt initially outlined his forms, the ample areas of exposed canvas, and the raspy trails of hastily applied pigment, all attest to swiftness of execution. Indeed, the conception and completion of *Baby* took place in a matter of days in August 1917, while Klimt was in Vienna preparing his entry for the exhibition of

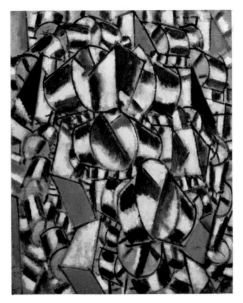

FIGURE 132

Nagasawa Rosetsu, *Sleeping Chinese Boy*, 18th century Museum of the Imperial Collections, Tokyo

Austrian art that would open in Stockholm the next month.[4] On his return from Bad Gastein after 30 July, Klimt must immediately have begun studies (fig. 134) for the painting, for he wrote Emilie Flöge on 11 August about starting the "Kinderbild."[5] The next day he was ready to apply colour to the canvas, and on 13 August reported that it was half complete and should be finished the same day.[6] Klimt went to join Emilie

in the Austrian Tyrol on 16 August, but he nonetheless managed to ship *Baby*, the paint scarcely dry, along with thirteen paintings and twenty drawings to Sweden before his departure (see fig. 202).[7] While certain paintings, such as *Death and Life*, were reworked over the years they remained in Klimt's studio, *Baby* stands as an example of how assuredly and rapidly he could paint when pressed, and of just how little the distinction between finished and unfinished canvas mattered to him.[8]

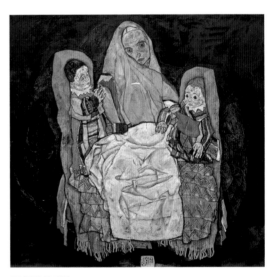

FIGURE 133

Egon Schiele, *Mother with Two Children*, 1915–17 Österreichische Galerie Belvedere, Vienna

FIGURE 134

Infant Dressed in a Baptismal Gown, c. 1917 Leopold Museum—Privatstiftung, Vienna

Portrait of Johanna Staude 1917–18
Oil on canvas, 70 × 50 cm
Österreichische Galerie Belvedere, Vienna
Novotny/Dobai 211

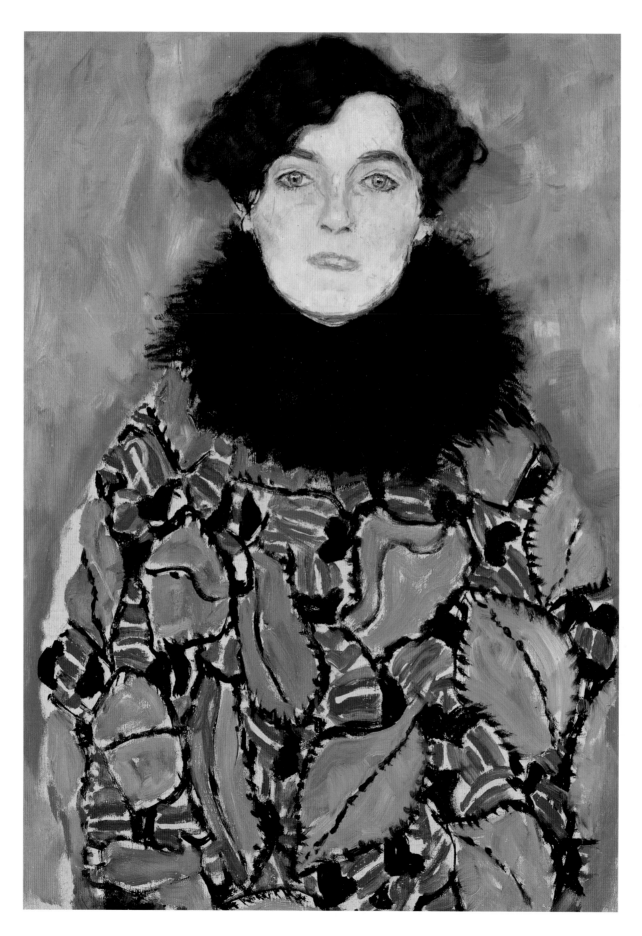

When interviewed in the 1960s, Johanna Staude (16 February 1883–2 July 1967) claimed that she worked as a model for both Klimt and Egon Schiele, though the paintings she posed for were not recorded.[1] The wide curve of Johanna's jaw, her high cheekbones and dark brown hair, however, are features shared with Klimt's *Lady with a Fan*, 1917–18 (fig. 135). (Also, she may have posed nude in a study for *The Friends*, 1916–17.)[2] Here, as a portrait subject, Johanna Staude no longer plays the fictional role of a studio model. Rather, in the uncertain look in her grey-green eyes, slightly tilted head and parted lips, one senses a note of melancholy, perhaps even a resignation to the bleak prospects of wartime Vienna. Her wavy hair is trimmed at an angle above the earlobe and brushed to one side, and while not glamorous, shows her to be aware of the current vogue for shorter hairstyles.

The daring Wiener Werkstätte blouse she wears further identifies her as a disciple of Modernism. The luminous turquoise of Martha Alber's "Blätter" ("Leaves") fabric design of about 1910–11 (fig. 136) boldly contrasts with the background of vivid mandarin orange against which Klimt places Johanna.[3] A black feather collar accents her jawline and sustains a symmetry with her sloping shoulders. Klimt has modified Alber's design only slightly, adding a magenta highlight to enhance the colour contrasts. The lighter areas between the leaves are actually unpainted canvas, yet they faithfully follow the colour scheme of the original design.

It is not known why Klimt chose to paint the portrait of Johanna Staude, to single her out for posterity from among the many models he used at this time. According to Johanna's own account, Klimt left the portrait deliberately

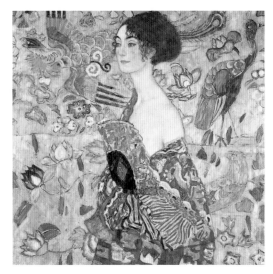

unfinished so that he could be assured she would return to his studio, but his death on 6 February 1918 ended that possibility.[4] Klimt took an interest in the lives of his models, and had previously intervened on behalf of one aspiring actress hoping to enter the Vienna theatre world.[5] He may have introduced Johanna Staude to the poet Peter Altenberg (1859–1919), one of Klimt's closest friends and admirers. Both men were invited to join the "Kunsthalle" group of writers, artists, and musicians outlined by Egon Schiele in a letter of March 1917.[6] Staude is named by Altenberg as one of three "modern saints" who cared for him during the last year of his life: "The *divorced* Frau Johanna Staude, as housekeeper she oversees the bustling war kitchen."[7] In addition to this portrait, Staude owned a drawing Klimt had done of her, inscribed by Altenberg on 21 February 1918

with an eloquent eulogy evoking the beauty of Klimt's landscape painting.[8]

It is evident that at the time Johanna was model to Klimt and housekeeper to Altenberg, she was regarded with a status above that of "hired help," perhaps even as acolyte of Klimt and his circle, and one who gladly accepted payment in kind. She only emerged from obscurity in 1963 when the Österreichische Galerie Belvedere acquired her portrait.[9] The ambivalence of her place in Klimt's life is compounded by her professional listing in the 1963 Vienna City Directory as "Painter," although she left no trace of activity in this field.[10] Such a declaration points to Johanna Staude's aspirations in life, yet also, apparently, to her own limitations.

Portrait of a Woman 1917–18
Oil on canvas, 67 × 56 cm
Neue Galerie der Stadt Linz, Austria
Novotny/Dobai 212

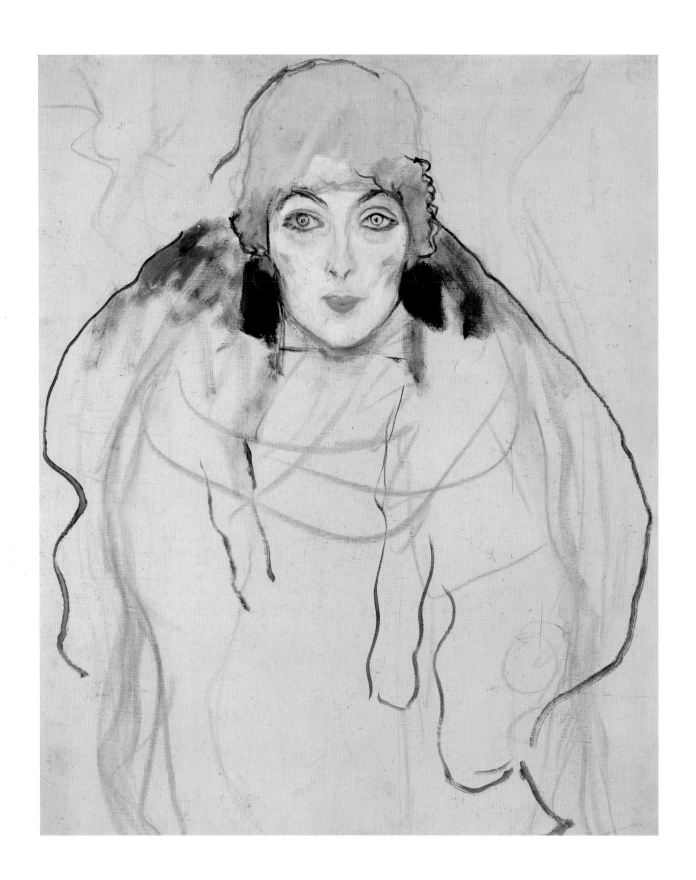

Klimt's premature death in February 1918 ended his work on this image; and yet it remains one of his most striking portrayals of women.[1] The ghostly blue skin tint and the intense gaze of pale yellow irises under arched brows give a disturbing Expressionist exaggeration to her features, which share the wide-eyed frontality of Egon Schiele's *Portrait of the Painter Paris von Gütersloh* (fig. 137). Initially, Klimt uses the brush like a pencil or crayon on paper, freely sketching the broad outlines of the figure on canvas before turning in more detail to the facial features. Blonde curls appear under the line of a cloche hat, and awkwardly applied rouge highlights the lips and cheekbones. Both the waxen complexion of the model and the fluidity of the brushwork, with dark lines trailing off across bare canvas, recall Toulouse-Lautrec's 1890s portraits of cabaret personalities (fig. 138). A line of blue pentimento above the woman's upper lip reveals that even at this early stage of painting Klimt made changes, bringing the position of the lips forward.

It is not known whom the *Portrait of a Woman* represents. Edith Krebs has proposed that this may be a study for the *Portrait of Amalie Zuckerkandl* (fig. 139), although the features and hair colour of the two women are quite different.[2] Alternatively, Alice Strobl has posited that the painting may be related to a commission for a portrait of Suzanne Stoclet, the wife of the

Belgian banker.[3] From Brussels in May 1914, Klimt wrote of having prepared twenty studies, undoubtedly for a portrait, during the course of a ten-day visit with the Stoclet family.[4] However, he was unhappy with the results, and it is presumed he never began the portrait. Given the more than three-year gap between his Brussels visit and *Portrait of a Woman*, and the lack of a photograph of Suzanne Stoclet, Strobl's suggestion is intriguing, but speculative. Nevertheless, she has identified at least eight studies for this painting of a woman wearing a fur stole, hat, and long dress, including a drawing of the model seated (fig. 140).[5]

If *Portrait of a Woman* portrayed a particular individual, however, the sitter laid no claim to the work when it became part of the artist's estate in 1918.[6] Like many of the paintings begun in the last year of Klimt's life, for example *The Bride* (fig. 21) or *Lady with a Fan* (fig. 135), the Linz *Portrait of a Woman* is unfinished, yet appreciated as an autonomous work of art today. In his recent discussion of Cézanne's unfinished paintings, Albrecht Schröder has argued that such works, also known as the "non finito," should be considered conceptually complete.[7] Certainly, it is easier to accept this notion with the benefit of twentieth-century hindsight; but even in the nineteenth century, the non-completion of pictures or the production of fragmentary ideas was common in the work of Auguste

Rodin or Toulouse-Lautrec. Indeed, *Portrait of a Woman* is sufficiently realized to reflect a move by Klimt toward expressive freedom in his late portrait painting, perhaps influenced by the younger artist Egon Schiele, who in March 1917 enlisted Klimt in his "Kunsthalle" group.[8]

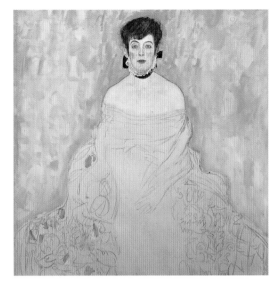

FIGURE 139
Portrait of Amalie Zuckerkandl, 1917–18. Österreichische Galerie Belvedere, Vienna

FIGURE 140
Study for Portrait of a Woman, 1917–18. Private collection

FIGURE 137
Egon Schiele, *The Painter Paris von Gütersloh*, 1918
The Minneapolis Institute of Arts, Gift of the
P.D. McMillan Land Company

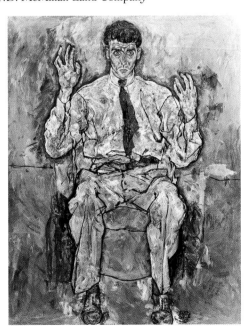

FIGURE 138
Henri de Toulouse-Lautrec, *May Milton*, 1895
The Art Institute of Chicago, Bequest of
Kate L. Brewster

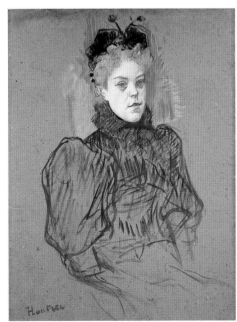

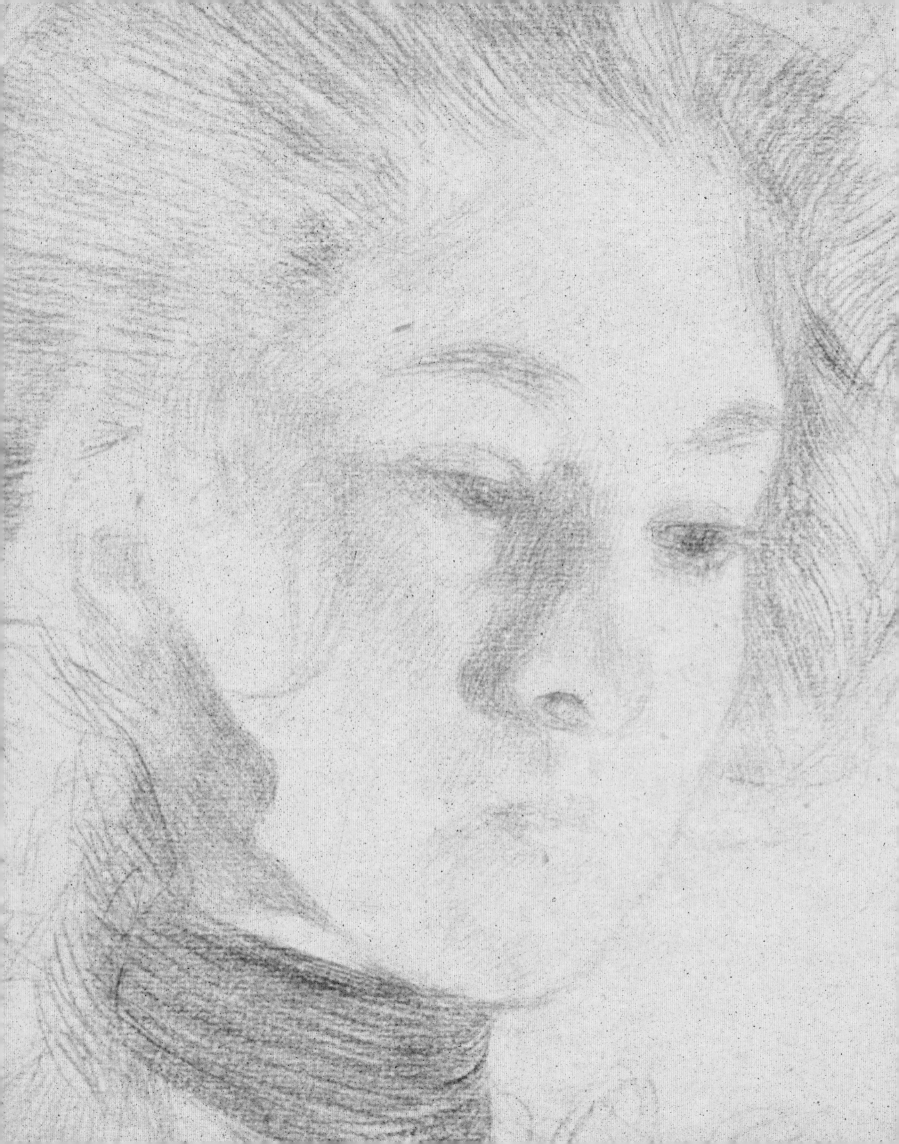

MARIAN BISANZ-PRAKKEN

Gustav Klimt's drawings occupy a place all their own, both in Austria and in the realm of international modernism around 1900, and many value them even more highly than they do his paintings. The works selected for the present exhibition provide ample opportunity for exploring what it is that makes these drawings distinctive. The ninety drawings span the time frame from the beginning of the artist's career to the final year of his life; they represent the various stylistic phases of his development, while also illustrating his broad spectrum of techniques in many fields of application. As well, the works on paper demonstrate splendidly that regardless of the far-reaching changes his style underwent in the course of one of the most turbulent periods in Austrian artistic and cultural history, Klimt invariably remained true to himself. He was open to current developments, grappled with new trends, and met the challenge of working out what was right for him. Thus he preserved his identity to the last: an early drawing done in the context of decorations for the Burgtheater, for instance, is just as much a "Klimt" as is a late study for *The Bride*.

Klimt himself said little about his conception of art, and equally little about his working method. Drawing and painting were intimate and private matters for him, something he did not share even with his models or the society ladies he portrayed. Working in seclusion, the artist only occasionally received friends, acquaintances, or clients in his studio. The reports we have of him are colourful and varied, and often blur the boundary between fantasy and reality. To illustrate the point, describing Klimt in the act of producing his drawings, critic Franz Servaes wrote:

> Here he was, surrounded by enigmatic naked women who, as he stood silently before his easel, would stroll up and down in his workshop, stretch and laze about, casting their radiance on the daylight hours—ever ready to obediently hold a pose at a

nod from the master, as soon as he espied some posture, some movement that appealed to his aesthetic sense which he wanted to record in a quick sketch.[1]

This all-too-winsome image of the sometimes dreamy, sometimes passionate artist at work, driven by spontaneous momentary impressions, is countered by a likely more credible version of the situation handed down to us by painter and Klimt friend Carl Moll: "There were several models available to him every day; if he wasn't using them to continue working on pictures, he would draw nude studies, invariably related to these pictures."[2] The four-volume catalogue raisonné of Gustav Klimt's drawings published by Alice Strobl between 1980 and 1989 impressively substantiates the fact that most of Klimt's surviving figure studies were indeed linked—some closely, others loosely—with his painting projects.[3] Here, for the first time, emerges the overall portrait of an artist who worked consistently and earnestly on his subjects. To corroborate this very important documentation, several sources affirm that both of Klimt's studio complexes had a lounge for the models, as well as a workroom where the artist was able to devote all his attention to the study of figures seen either individually or in combination.[4]

Just how many drawings Klimt produced is still uncertain. Alice Strobl's catalogue of his oeuvre runs to 3741, but the total is actually larger, given the instances of work numbers to which the letter "a" has been appended. The quantity of drawings that has meanwhile come to light is growing slowly but surely; having been asked to continue tabulating the Klimt drawings, I have become aware of some two hundred new works to date. However, if it is true that Klimt drew for many hours each day, "like a virtuoso practising scales," in the words of Berta Zuckerkandl,[5] the quantity of drawings of which we are currently aware must be only a fraction of his total production. Arthur Roessler,

Opposite:
Detail of
Study for "Schubert at the Piano" (cat. 52 recto)

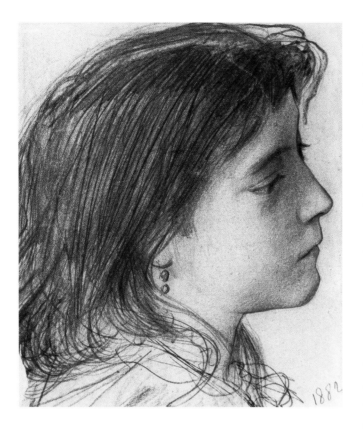

FIGURE 141
*Portrait Study of
Klimt's Sister Johanna
Used for "The Realms
of Nature"* 1882
Private collection

an art critic who became an authority on Egon Schiele, saw "studies drawn on sheets of paper that were piled up more than head high" in Klimt's studio; he says the artist destroyed thousands of them "if they had served their purpose for him or lacked a truly economical technique."[6] According to Roessler, many of the sheets ended up as playthings for the artist's pet cats. Even knowing that Klimt painted slowly and drew quickly, we cannot judge how much time he spent on his not very numerous paintings as compared to the drawings. Most contemporary commentaries on Klimt's draughtsmanship deal with his "modern" phase, that is the last two decades of his life; interest in his early work only came much later. Klimt himself was by no means dismissive of the roots of his art. In his comprehensive essay of 1912, Arpad Weixlgärtner reported that of all Klimt's teachers at Vienna's Kunstgewerbeschule (School of Applied Arts), it was the painter Ferdinand Laufberger to whom he was still grateful for "having taught him the most in terms of his craft."[7]

~

A highlight of Klimt's work on paper from the 1880s and 1890s is the relatively small but qualitatively important group of carefully executed pictorial compositions. Most of these drawings were created as the basis for reproductions; they are stylistically diverse—from academic historicism to the Symbolism of the early Vienna Secession—and are not only of great value artistically, but also demonstrate Klimt's superior technical ability.

In 1882, nearing the end of his training at the Kunstgewerbeschule, the twenty-year-old artist drew *The*

Realms of Nature (cat. 37). This meticulous composition was produced for the ambitious *Allegorien und Embleme* series published by Martin Gerlach. In the spirit of historicism, the German and Austrian artists involved in this project were asked to turn their attention to the "highest, simplest, and therefore eternally significant themes" that had been the basis for "the endeavours of all the periods and schools over the centuries."[8] Klimt, too, used a traditional iconography in *The Realms of Nature*. The man seated above, his pose a reference to Michelangelo's *Ignudi* in the Sistine Chapel, embodies the animal kingdom. The lion alludes to his physical strength; the book and the eagle are the attributes of his intellectual superiority. The vegetable and mineral kingdoms are subordinate to the animal kingdom—two young women sit at the man's feet. The symmetrical arrangement and the figures' poses conform to an imaginary architecture suggested by a simple lunette border. The obvious tension between the linear precision and the subtly nuanced surface effects clearly sets this image apart from those of the other contributors to the series. Moreover, Klimt breaks through the strict schema by giving special expression to the programmatic function of the three figures through their gestures and their facial expressions. "The questioning but affable way in which the charming young woman is looking up at the man expresses the relation of more lowly vegetable life to higher animal life," wrote art historian Albert Ilg in his introduction to the allegories.[9] After 1900, the "more lowly, vegetable" life of the delicate flower-adorned figure would find a symbolically amplified continuation in his passive, floating female nudes. The male–female polarity, in the sense of dominance and self-abandonment, would have a key impact on Klimt's later work. The serene openness of the young woman in the flowered garment and the introversion of the simply draped figure representing the mineral kingdom, which is turned away from the viewer, constitute an additional antithesis. The message here is of the contrast between organic and inorganic matter—a primary component in Klimt's allegories of the late 1880s and 1890s. The fact that he was already trying to link abstract allegorical content and evocations of mood is confirmed by the melancholy portrait study he did of his sister Johanna for the figure representing the mineral kingdom, sharply accentuating the delicate line of her profile (fig. 141).[10]

Whereas the putti figures in *The Realms of Nature* indicate Klimt's apprenticeship under Ferdinand Laufberger, the painterly nature of the allegory *Fairy Tale* (cat. 39) that Klimt drew two years later in 1884, after having begun his career as a decorative painter, recalls the influential Hans Makart (1840–1884). In this drawing, large areas of contrasting light and dark define the stagelike scene. One noteworthy feature is the rigidly frontal stance of the

oriental storyteller, and of the naked girl nestled against him, before a visionary setting that serves as a backdrop for the shadowy scenes of the tales. This compositional principle seems to anticipate solutions Klimt would later employ, for instance in his ghostly rendering of the background in *Allegory of Love* (cat. 8) of 1895. In the monumental *Philosophy* (fig. 1) of 1900, the main painting from Klimt's early Symbolist phase, "real" and "imaginary" planes are superimposed, as in a cosmic vision.

Although the four drawings that Klimt created for *Allegorien und Embleme* suggest later developments in many respects, they originated entirely in the spirit of historicism. Then in 1889 the artist made a decisive move towards modernity with his *Allegory of Sculpture* (cat. 45).[11] He created it as part of a joint project that was definitely historical in nature: the richly decorated deluxe volume that was presented to the Kunstgewerbeschule patron, Archduke Rainer, in 1889, to mark the twenty-fifth anniversary of the Museum for Art and Industry. The original contributions from various artists were to represent "the past, present and, in a certain sense, the future of the Kunstgewerbeschule."[12] In his illustration for the chapter on the faculty of sculpture, Klimt takes an innovative approach to combining these three elements. The slender, stylized, idealized figure of a young woman personifies the sculpture of the day, while simultaneously pointing towards the future in holding aloft a statue of Victory. She stands before an imaginary framework, with a freely arranged miscellany of antique sculptural fragments standing out in relief against a blank wall. The concepts of present and past are subtly played off against one another; at the same time, the living substance of the figure's skin and hair is in clever contrast to the "dead" materials of gold, bronze, and marble. The "modern" Klimt is already manifesting himself here, in the delicate gold accents of the ancient Greek jewellery worn by the young woman—the serpentine armband, wide necklace, and spiral hair ornament. The link that Klimt characteristically makes between Antiquity and the current Zeitgeist is apparent here: the allegorical figure wears a pensive, dreamy expression, an effect enhanced by her inclined head. In the pronounced planarity of the picture, Klimt is already in large measure departing from any illusion of reality. The figural and sculptural components are subordinate to a rigidly orthogonal framework, although its context outside the pictorial area remains hidden. The paper's borders dictate the inner order, but at the same time pose insoluble riddles for the viewer. It is this curious blend of emphasis and mystery that makes for the modernity of the work, which is also remarkable for its delicate, highly sophisticated technique. In many regards, *Allegory of Sculpture* heralds the Symbolism of Belgian artist Fernand Khnopff, who in turn would soon have a notable influence on Klimt.

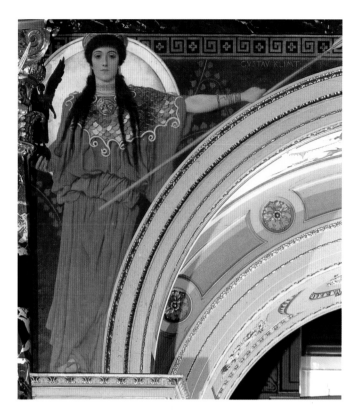

FIGURE 142
Art of Ancient Greece I
1890–91
Spandrel in the
staircase of the
Kunsthistorisches
Museum, Vienna

This work, which had lain in obscurity for many decades, was a sensation for the art world when it was published for the first time in 1979. It revealed that Klimt had been expressing himself as a "modern" artist much earlier than had previously been assumed. Moreover, it became apparent once again that major innovations in Klimt's work first took place within the intimate realm of drawing. The decorations he began in 1890 for the staircase of the Kunsthistorisches Museum show a comparable familiarity with the historical attributes, also presented here in a free arrangement behind the leading allegorical figures. Nonetheless, these representations of the various artistic eras seem more traditional than in the *Allegory of Sculpture*. We must bear in mind, of course, that the decorations were created in the context of unequivocal programmatic aims and an existing architectural structure. Still, the staircase paintings did signal the rudimentary beginnings of a new style: in this regard, repeated reference is made to the uncompromising frontality of the Pallas Athena figure for *Ancient Greece I* (fig. 142) and to the pensive Pre-Raphaelite facial expression of the *Girl from Tanagra* for *Ancient Greece II* (fig. 143).[13] Of interest here is the fact that in the first overview of Klimt's works presented in the third issue of the Secession journal *Ver Sacrum* (March 1898), the paintings for the Kunsthistorisches Museum were viewed as a precedent. Unfortunately, virtually none of the figure studies for these works has survived; but we are familiar with many of the compositions through the extant transfer sketches for *Egyptian Art II* (fig. 144; cat. 46).[14]

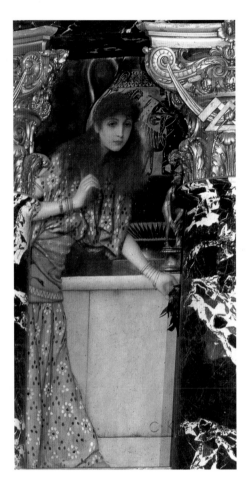

FIGURE 143

*Art of Ancient Greece II
(Girl from Tanagra)*
1890–91
Intercolumnar panel
in the staircase of the
Kunsthistorisches
Museum, Vienna

FIGURE 144

Egyptian Art II
1890–91
Intercolumnar panel
in the staircase of the
Kunsthistorisches
Museum, Vienna

From the outset, Klimt's drawings were primarily engaged with the human figure. In the tradition of historicism, figure drawing was the last step in an explicit hierarchy: the study was meant to serve the decoration, the decoration to serve the architecture, the architect in turn was meant to use his edifice to convey the programme of historicism. Without losing sight of this functional aspect, Gustav Klimt made a separate art form of the study of the human figure and its particulars, in a way none of his contemporaries did. In this respect, a highlight of his early career was the group of drawings for the decorations in the stairway of the Burgtheater of 1887–89 (cat. 40–43). One of the most striking of these is the head study of a sleeping girl, for the dead Juliet in *Shakespeare's Theatre* (cat. 40), which achieves a fascinating balance of contrasting effects. The sharp contours of Juliet's pale face, softly highlighted in white, contrast vividly with her mass of dark hair. (Klimt used a fine piece of black crayon to draw in the delicate hairs over an underlayer done in charcoal and partially smudged.) The concentrated, precise rendering of the head counters the sketchiness of the diaphanous white clothing; and the diagonal positioning of the head and shoulders across the paper intensifies the effect. This drawing transcends functionality to become a work of art in its own right. The arrestingly realistic portrayals of the head studies for the spectators in *Shakespeare's Theatre* can

likewise be viewed as autonomous works, and several of them bear the artist's signature (cat. 41, for example).

A key work in the evolution of Klimt's nude drawings is the study of a reclining woman (cat. 43) that he made for the maenad stretched out on the altar steps in the lunette picture *Altar of Dionysus* (fig. 145). This composition is considered the last and most mature of the Burgtheater decorations, and the maenad is regarded as probably Klimt's earliest portrayal of a femme fatale.[15] The study for this figure conveys organic life through the gentle rise and fall of its crayon lines, sharply accentuated in the hip area (with this particular line then drawn in a second time, above the reclining figure). The shimmering white highlights suggest a smooth, sensuous skin. The body, stretched out casually parallel to the picture plane, extends across the whole width of the sheet of paper, creating for Klimt a new and different tension between mass and negative space. Moreover, as far as we know, this constitutes Klimt's first depiction of a trancelike state. In the course of his career, the artist would depict many forms of rapt absorption in his female nudes—ranging from dream to erotic ecstasy.

The early figure studies for the large- and small-scale allegorical works were governed by Klimt's constant search for apt poses and gestures. Though remaining true to the tenets of his basic training, he was ever mindful of the overall decorative context, thus invariably creating figures apparently moving in a very controlled fashion. Utilizing precise yet delicate contours, he tried to distil what was for him the essence of a naked body, through careful observation of his models' anatomy. His perfectionism also extended to the studies of garments.

The group of small sketches done as part of his commission for the large gouache *Auditorium of the Old Burgtheater* (cat. 3) can be seen as unique among the early figure studies (fig. 146).[16] From a vantage point on the stage, Klimt drew numerous studies of male and female theatre-goers, deftly depicting their stances, their movements, and their clothes. Unlike a studio situation with nude models taking up their poses, the aim of these sketches was to capture fleeting impressions, and the artist was particularly interested in the chiaroscuro created by the artificial light. The islands of shadow in these studies were rendered with parallel hatching, the lively variations in the strokes accentuating the figures' movements. To some extent, the process anticipated Klimt's later studies for the large oil portraits; and he would study the effects of artificial lighting again, especially while working on the painting *Schubert at the Piano II*, 1899 (cf. cat. 51 recto, 52, 53).

It would appear that in the early 1890s Klimt produced somewhat fewer drawings. The premature death of his younger brother and fellow-painter Ernst Klimt in 1892—the year in which their father, Ernst senior, also

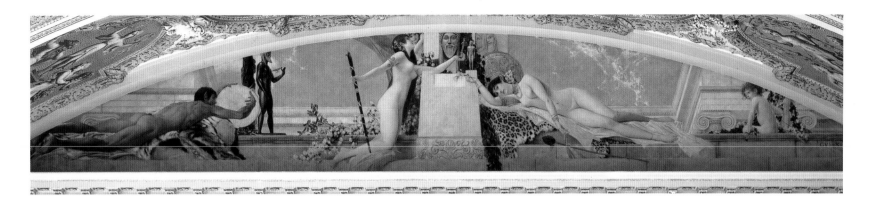

died—must have been a turning point for him, both personally and professionally. At this time, under the influence of international Symbolism, Klimt embarked on a new direction, the one foreshadowed by the *Allegory of Sculpture*. This breakthrough to a new style came in the mid-1890s, in the images he contributed to *Allegorien Neue Folge*, publisher Martin Gerlach's continuation of the earlier *Allegorien und Embleme* series. Klimt's new attitude manifests itself in the painting *Allegory of Love* (cat. 8) and in the drawings *June* (cat. 47), *Allegory of Sculpture* (cat. 48), and *Tragedy* (cat. 50). In *June*, the head of a girl with golden, spiral-shaped, filigree ornaments in her dark hair occupies a square central area on the page, and is flanked by the figures of two young women holding rose and fruit tree branches and standing on pedestals. The particular charm of this composition with its air of Antiquity lies in its fine lines, sophisticated contrasts of light and dark, and harmonious geometry.

Done in softly shaded greys, the drawing *Allegory of Sculpture* (cat. 48) clearly recalls the same subject (cat. 45) created seven years earlier for the anniversary volume; conceptually, though, the drawing is more multi-layered, reflecting the awakening of modernism on the eve of the founding of the Secession. The interplay of the symbols of the old and the new art is even more refined in this exactingly symmetrical composition; the contrast between cool, non-living matter and organic substance even more pronounced. The areas left blank form a striking contrast to the parts filled in with heads and figures. The explicit overlapping of areas is characteristic; this is especially true of the distinctly modern frontal view of a girl's head symbolizing the art of the future, which is placed at the bottom of the picture, within the viewer's grasp as it were.

Tragedy (cat. 50), Klimt's final contribution to *Allegorien Neue Folge*, was created in 1897, the year the Viennese Secession was founded.[17] Here, in a small format, are the essentials of his future monumental style. The main figure, in an Archaic Greek style and holding up a mask, is presented in hieratic frontality, a deliberate counterpoint to the profile poses of the two flanking figures, who seem resigned to their fates. The central figure stares fixedly at

the viewer with a look that contrasts eloquently with the closed or covered eyes of the figures in profile. Other contrasts can be termed decorative—dark and light, static elements versus animated lines, expansive areas and fine detailing—but they serve to accentuate the pictorial content. The magical effect of gestures is something novel here; they fit into the tectonics of their environment as if decreed by some mysterious power, right down to the figures' very fingertips. The important models for Klimt in this phase were two of Symbolism's chief representatives: Fernand Khnopff of Belgium and Jan Toorop of the Netherlands.[18] The menacing dragon at the top of the picture adds a touch of the Far East.

These sophisticated images, which are of great significance in Klimt's evolution, are characteristic of his transi-

tional phase. The pseudo-architectonic framing of the compositions and their didactic allegorical form testify to the historicist roots of the entire series. At the same time, Klimt uses these very traditional elements as a means of communicating modern metaphysical content and exploring new techniques. These endeavours would find monumental expression in his paintings for the University of Vienna, *Philosophy*, 1900, and *Medicine*, 1901.

Serious problems beset the commission awarded to Franz Matsch and Gustav Klimt in 1894 to decorate the ceiling of the University auditorium with allegorical paintings representing the faculties. Having made the transition to Symbolism, Klimt found it impossible to take a traditional, positivist approach to the themes he had been assigned: Philosophy, Medicine, and Jurisprudence. In the strict sense of fulfilling the commission, the outcome was a fiasco, and the paintings never would be mounted in the planned location. However, the episode was of crucial import for Klimt as an artist: the requisite subject matter demanded a sober examination of life's great questions, themes that would preoccupy him throughout the rest of his career.

This thematic shift had repercussions on Klimt's work as a graphic artist as well. After an interruption of several years' duration, he turned with renewed vigour to the study of the nude human figure. This occurred as he was preparing to execute the first of his University paintings, *Philosophy* (fig. 1), for which he had submitted an oil sketch in May 1898 to be evaluated by the Commission of Art.[19] The sketch, however, reveals nothing of the changes about to come. The main motifs are merely roughed in: a sibyl, a group of philosophers, a naked family, and a three-headed

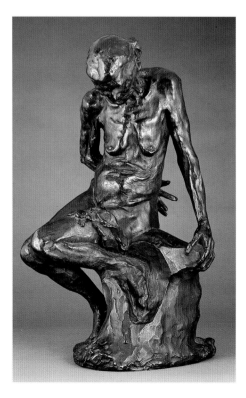

sphinx. In subsequent months—during the first year of the Secession—Klimt must have fundamentally altered his conception, as is apparent from the transfer sketch (cat. 59) approved in early 1899 at the latest. In this composition, the cycle of "genesis, fruitfulness, and decay" is but one detail in an endless stream of humanity being projected into the cosmos as if it were a pillar of thought emanating from the brooding sibyl who, for her part, is being almost crushed by the overpowering sphinx ("The Riddle of the World").[20] In the version of the painting that was exhibited in the Secession of 1900 (fig. 30), this allegorical figure had been replaced by a brightly illuminated, front-facing woman's head ("Knowledge"), with the colossal sphinx gleaming in the background.[21]

We know the painting only from a reproduction, but it shows even more clearly than the transfer sketch that the impression of a chain of humanity passing by is due not to any depiction of active movement, but to the mobile outlines of the people's bodies rhythmically intermeshing. This motion is also suggested by the veil of undulating lines swirling around the figures. The people themselves are passive and, with their eyes closed or their faces hidden, seem to be in a collective trance. Even the lovers locked in close embrace impart a mood of torpid self-absorption.

Klimt's new approach with nude models of all ages was of epoch-making significance for modern art in Vienna as it evolved into Expressionism. For the first time in Klimt's oeuvre, the unclothed state is associated with an expression of being handed over to fate, as is most evident in the extremely frank depiction of elderly people. Under Auguste Rodin's influence in particular (fig. 147), Klimt has begun to apply himself to the study of imperfect models who have suffered the ravages of time.[22]

The individual figure studies attest to Klimt's untiring search for the most suitable pose to render a given mood. The outlines drawn with fine black crayon are particularly important in this respect. Whether it is an old woman kneeling, lovers embracing, or the back of a male nude bending over, the figures seem to be oppressively isolated from their empty surroundings. At the same time, the sensitive body contours, imbued with organic life, seem eloquently to trace the boundaries between the inner and the outer world. The rhythmic vitality of these "intuitively responsive lines" is translated into a monumental reality in "the line and the distribution of mass" of the overall composition, to cite Ludwig Hevesi.[23]

In *Medicine* (fig. 3), the pendant to *Philosophy*, Klimt took these new possibilities of representation further. The men, women, and children—considerably more numerous than in *Philosophy*—are layered over each other, yet turned in on themselves; they represent all aspects of mental and physical suffering. They do not express personal pain,

however; but rather embody general psychological states, feelings, or basic existential situations. After *Medicine* was presented for the first time in 1901, Klimt proceeded to work on it in stages, and the many surviving figure studies document his diligent search for the appropriate emotive formula. They run the gamut from sharply defined set poses and angular forms to soft, flowing lines that suggest motion. Surely one focal point among the group of studies done for *Medicine* (cat. 65–70) is the series of drawings recording Klimt's search for the ideal pose for the young woman floating in the cosmos.[24] The end result of this quest (cat. 67)—one of the artist's most famous drawings—is a perfect correlation of style and expression. Leaving off the feet, sketching in the rudiments of the raised arm, and only hinting at the head, tilted as if in sleep, Klimt concentrates on the arcing, flowing movement realized by the unbroken contour and by the long parallel hatching of the shaded areas. On the one hand, his image communicates something fleeting and transitory: the figure emerges from the void only to disappear again in the cosmos above. On the other, the rhythmic, undulating line and the modelling effect of the hatching transform this partially visible figure into a sensuous presence. This image superbly demonstrates the balance that was characteristic of Klimt, as he hovered between linear dynamism and physical passivity, between sensuality and spirituality, and between proximity and distance. The drawing likewise documents his transition from atmospheric illusionism to the rigorous linearism of the "Stylist" art that came to fruition soon afterwards in the *Beethoven Frieze*.

~

The period when the first two University paintings were created coincided with the founding and early years of Vienna's Secession movement, with Gustav Klimt being elected its first president. This "sacred spring" was a time of awakening and euphoria; the new, temple-like Secession building designed by Josef Olbrich paid homage to the "world of the artist."[25] Apart from his work on the University paintings, much of Klimt's artistic endeavour was governed by the objectives of the young organization. Thus, like many of his colleagues, he drew illustrations for the journal *Ver Sacrum*. In addition to the square format, one very popular feature that first year (1898) was the Japanese-inspired, narrow, elongated format that Klimt also used for his allegorical works *Nuda Veritas* (cat. 60) and *Envy* (cat. 61). He executed these drawings in the black-and-white technique inspired by English book illustration. The "Naked Truth" motif reappears in a canvas that was probably completed in late 1898 and first exhibited in the 1889 Secession: *Nuda Veritas* (cat. 12), a provocative affirmation of the value of "true art." In Klimt's poster for the first Secession exhibition that opened in March 1898,

Theseus represents the young artist dealing a death blow to the Minotaur, which symbolizes the "indifference" of the Viennese public.[26] Pallas Athena, as patroness of the arts, keeps watch on the scene, and the menacing Gorgon's head on her breastplate grins at the viewer. In a move that was generally ridiculed, the Viennese censor ordered Theseus's nakedness to be concealed (despite a fig leaf already in place); Klimt complied, setting three slender tree trunks in the foreground. As was recently determined, the predominant red-and-green colour combination in the poster (symbolizing vitality and hope) played a central role in all facets of the organization's programme during its inaugural year—in its exhibition rooms, in the design of *Ver Sacrum*, and in its two-dimensional graphic art.[27]

In the period around the Secession's founding, the terms "Stimmungskunst" (mood art) and "Seelenkunst" (art of the soul) denoted such aspects as soft transitions in form and colour, flowing lines, or enigmatic contents. Klimt's drawings manifest this trend through their preference for buoyant and "intuitively responsive lines" or mysterious lighting. In the studies for *Schubert at the Piano I*, for example, the artist explores the effects of artificial light in various ways. Dense parallel hatching silhouettes a couple making music (cat. 51 recto), and a flamelike hairstyle adorns the brightly lit head of a woman facing the viewer and singing (cat. 53). Subtle light effects characterize the half-length portrait of a young woman (cat. 52): deeply shaded areas are effectively juxtaposed with muted transitions from light to dark.[28]

In the allegory *Thalia and Melpomene* (cat. 57) of late 1898, which Martin Gerlach did not include in his series, the faces of the two muses (Comedy and Tragedy), like the masks lined up at the top of the image, seem virtually to dissolve in the shimmering grey nuances of the "graphic rain." At the same time, the way the composition is organized along the horizontal and vertical axes already presages Klimt's future approach to his decorative commissions on a monumental scale.

Klimt took a fundamental step in this direction in the *Beethoven Frieze*, which he made in 1901–02 as part of the momentous "Beethoven Exhibition." In this Raumkunst project—wherein art and architecture merge to create an overall aesthetic environment—twenty-one Secession artists were asked to create an appropriate setting for the show's centrepiece, Max Klinger's recently completed sculpture of Beethoven. Following the dictate of "total design of the space," and inspired by Richard Wagner's interpretation of Beethoven's Ninth Symphony, Klimt grappled with the symbolism of mankind's redemption through the arts (fig. 148) on three walls of the ground-floor room.[29] Clearly outlined figures, contrasting decorative effects, and geometric designs characterize the frieze. Highly expressive

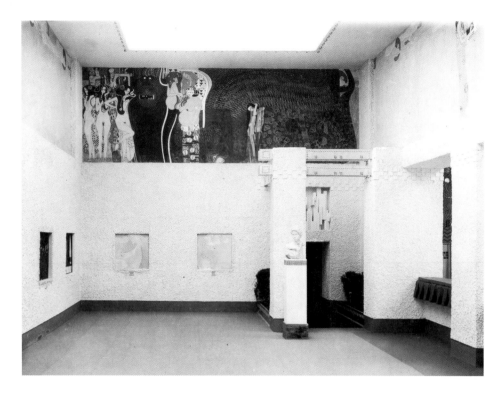

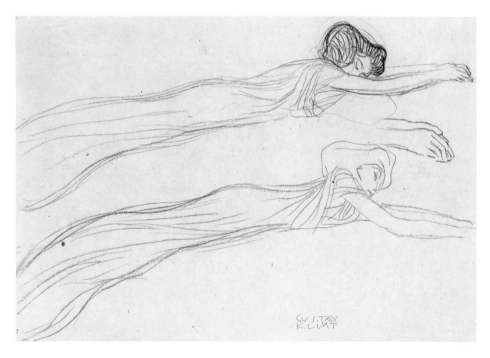

contouring was vitally important here, and was also notable in his sketches. Thus, the studies for the seductive *Three Gorgons* of the *Hostile Powers* (see fig. 5, 49; and cat. 73–75) are typified by voluptuous lines, with special emphasis on the flowing tresses. Viewed from behind, the outline of the couple in the *Realm of the Ideal* (cat. 76) exudes strength and vitality. If we were to categorize the linear styles of the allegorical figures, this back-view male figure is the most realistic, while the hovering figures of the *Longings and Desires of Mankind* (fig. 149) are the most immaterial.[30]

The *Beethoven Frieze* was another watershed in Klimt's artistic evolution. The experience of working directly on the

wall surface fundamentally changed his ideas about the function of painting and also affected his drawing. In Hans Koppel's interview with the artist, published 15 November 1903 during the Secession's Klimt retrospective, we find a key statement: "The artist is not called on to illustrate a concept through sensory means, but to decorate within a unified, designed space."[31] However, Klimt's avowal of modern *Raumkunst* cannot be understood in isolation. This prelude to the famous and monumental works of the "golden period" should also be viewed in the light of comparable trends elsewhere, particularly in neighbouring Germany,[32] where in the years after 1900 artists embraced a new monumental art in the context of New German Idealism. As Richard Hamann and Jost Hermand propound, that "solemn gestural style" has something formulaic about it, invariably expressed in geometric forms.[33] Thus, "compositional principles such as lines, circles, or triangles . . . are ubiquitous autonomous elements. Everything is geared to the rhythm of the forms, to the concordance of the lines."[34] About pictorial content, they say: "The basic form of this hieratic pictorial architecture was usually the human body, specifically as a nude, as a supra-individual figure, as an heroic exemplar, as an idea of mankind . . . In keeping with this was the growing preference for depicting certain 'elemental human situations': the simple acts of striding, sitting, walking, reclining, or standing."[35] All figures are arranged in accordance with "purely decorative perspectives . . . and captioned 'Man and Woman,' 'Arcadia,' 'The Ages of Man,' or 'Family'."[36]

The preceding description also applies to Klimt's monumental allegories of mankind, with their succinct titles: *Hope, The Three Ages of Woman, Expectation, Fulfilment,* or *The Kiss.* They had much in common with the work being produced in Germany, but there were basic differences, too—and these ultimately defined Klimt's uniqueness. One essential difference was the importance Klimt assigned to drawings: no German monumentalist brought a comparable intensity to bear on depicting the aforementioned "elemental situations." Time and again in his studies, the figures internalize the relationship of the individual to universal laws. Their poses and gestures are committed to paper in the elemental situations of standing, walking, sitting, reclining, or metaphysically hovering; they attest to his unceasing search for the ideal balance between inner truth and a higher order. Therefore, especially after 1902, each study seems to profess something crucial and definitive. The paper's dimensions become the determining factor in the dynamic process of structuring space by means of lines drawn with a natural ease. It is, above all, this ease that separates Klimt from his German colleagues.

Like his nude studies, those done in preparation for his monumental portraits concern the elemental situations of sitting or standing; in these works, though, the main

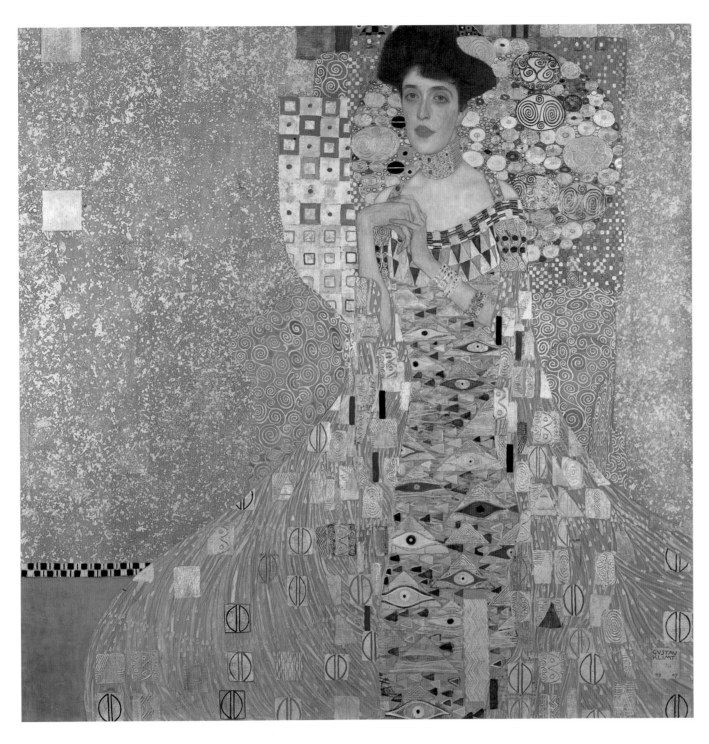

FIGURE 150
*Portrait of Adele
Bloch-Bauer I* 1907
Österreichische
Galerie Belvedere,
Vienna

emphasis is on rendering the sitter's apparel.[37] Thus, in the drawings from about 1903 (cat. 82–84) for the *Portrait of Adele Bloch-Bauer* (fig. 150), the artist yields quite naturally to page size as a higher order that imposes horizontal and vertical limits. The seated figure's garments spread in waves over the paper, only to be cut off at the bottom in many instances. In most of the Bloch-Bauer drawings, the top of the page crops the face at the forehead (though the earlier cat. 82 is an exception). As to the face, Klimt has sketched in only certain features, with the triangular, stylized mouth taking on special prominence. Several drawings reflect the principle of parallel, superimposed layers in a delicate interplay of flowing lines and angular geometric

forms. Negative space also figures actively in this complex of mutual dependencies and dynamic fields of tension.

In addition to their "spatial relativism," the Bloch-Bauer drawings reveal a new quality to Klimt's line. The crayon strokes truly walk a tightrope between individual characterization and sensibility, on the one hand, and the inherent higher law of overall context on the other. This linkage of sensitivity and sublimating strength typifies Klimt's drawing. For him, it is the line itself, quite apart from the object it represents, that simultaneously communicates sensuousness and transcendence.

In the Bloch-Bauer drawings, the cascading lines represent a farewell to the curvilinearity of the early

FIGURE 151
George Minne
Kneeling Youth 1898
Österreichische
Galerie Belvedere,
Vienna

Secessionist period, while the geometric nature of the cushions heralds future developments. The incorporeality of the structures made up of parallel lines is attributable to Jan Toorop, as are the angular gestures and the exaggeratedly slender, stylized bodies. The fragile geometry of the shoulders and the angular arms and hands are a reference to the "Gothic style" of the lean youths sculpted by George Minne of Belgium (fig. 151).[38]

Whereas Klimt was still using a slender piece of black crayon and sheets of packing paper for most of the

FIGURE 152
Study for the Portrait of Serena Lederer c. 1899
Graphische Sammlung
Albertina, Vienna

Bloch-Bauer studies, about a year later (1904–05) he used a lighter Japanese-type paper of somewhat larger dimensions for the studies for the portrait of Margaret Stonborough-Wittgenstein (cat. 95–97). Some of these drawings are in black crayon, others in pencil or coloured pencil (red, blue, or green). When combined with the paper's surface, these drawing materials produce a slight shimmering effect, reminiscent of the metallic sheen of the early works of the "golden period."[39] For these studies, Klimt adopted a compositional device frequently encountered in his work, first evident in the drawings (fig. 152) for Serena Lederer's portrait of 1899 (fig. 95): the standing figure is cut off at the top and bottom of the sheet, forcing it into an indeterminate spatial situation.[40] This dictate of the sheet's dimensions creates the ambivalent impression of a figure anchored on the surface, yet seemingly drifting; emphatically present, yet "not of this world." This characteristically Klimtian ambivalence is especially effective in the Stonborough-Wittgenstein studies.

~

In the monumental allegories of Gustav Klimt's "golden period," pregnancy is one of those elemental human situations that most preoccupied him. In the first version of *Medicine*, 1901, Klimt had included a heavily pregnant woman at top right. Subsequent to the *Beethoven Frieze*, inside a square border, he drew a small composition in black and red with a standing pregnant woman profiled in triplicate (cat. 80), her curved outline a continuation of the curvilinear ornamentation of the *Three Gorgons* in the *Beethoven Frieze*. The principle of rhythmically repeating, flat decorative motifs had been used to good purpose in the Beethoven exhibition, not only in Klimt's work but also in Alfred Roller's, and was evidently inspired by Toorop's monumental, characteristically linear composition *Fatalism*, 1893 (Kröller-Müller Museum, Otterlo, Netherlands), which together with other important works by the Dutch artist had been shown in the recent Secession exhibition.[41] The figure at the left in Klimt's small but effective composition is entwined with stylized flowers—an indication of the original concept for the painting *Hope I* (cat. 18), whose ground he had envisioned as a flower meadow.[42] The flowers may have been inspired by the background to the veiled middle figure in Toorop's *The Three Brides*, 1893 (fig. 159), recently established to be a pregnant woman.[43]

Hope I was followed by the studies (cat. 98–102) for *Hope II*, 1907–08 (cat. 24), some of them among the most arresting of Klimt's career.[44] Navigating between constraint and release, the artist has created such graphic *summa* as the 1904–05 study of a standing pregnant woman in a transparent wrap (cat. 100). The rhythmically pulsating vertical crayon strokes that denote the fabric intermingle with

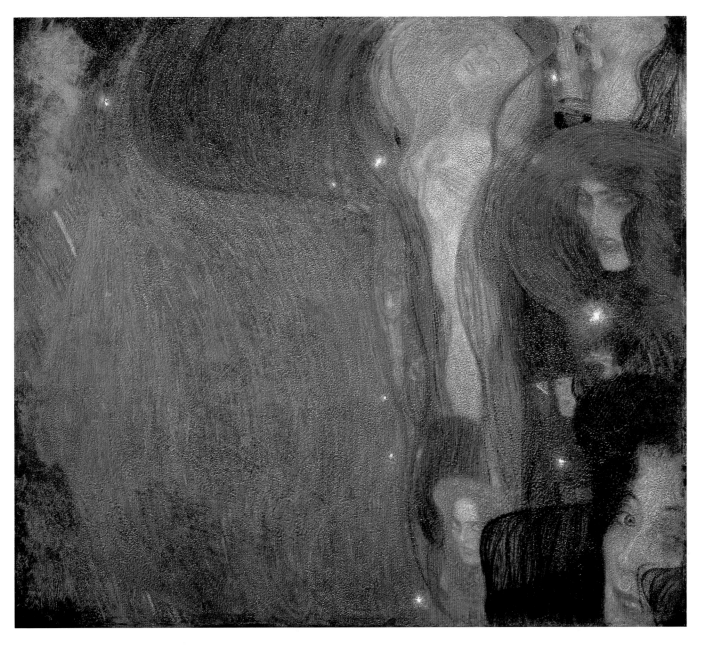

FIGURE 153
Hors catalogue
Irrlichter
(Will-o'-the-Wisps) 1903
Oil on canvas,
52 × 60 cm
Private collection
Courtesy Galerie
St. Etienne, New York
Not in Novotny/Dobai

a lively pattern of circles; under this deep black loosely-structured layer of lines gleam the grey-pencilled outlines of a pregnant woman in profile, her inclined head and downcast eyes imparting a solemn, meditative mood. This figure appears much as it would in the corresponding painting, whereas another study (cat. 102), masterfully executed in pencil with red and blue crayon, was discarded. In the allegory *The Three Ages of Woman*, 1905 (fig. 18; cat. 86), Klimt makes use of individual monumental figures to evoke the concept of "becoming, being, and passing," that derived ultimately from the painting *Philosophy*. Here, too, the main figures seem to be floating weightlessly on the surface of the picture, this time enveloped in ornamental cells that invade one another in an intentionally alienating effect. We are struck by the contrast between the emphatic realism of the old woman in profile (cat. 71, 72), bent with care (preparatory studies for the figure are markedly linear, almost

like woodcuts), and the stylized slenderness of the frontal depiction of the young mother holding her child (cat. 85). This woman's dreamy facial expression and the angularity of her gestures once again show the influence of George Minne and Jan Toorop. The veil of lines winding around her legs is likewise a Toorop motif, used by Klimt to emphasize the metaphysical nature of his figures.[45] The linear differentiations of the individual studies scarcely come into play in the transfer sketch; the functional aspect of transferring the work to the canvas takes priority here.[46]

An elemental situation of great consequence for Klimt was the act of floating, of being carried along horizontally or vertically, many variations of which are present in his work. The painting *Moving Water*, 1898 (cat. 10), seems to depict the motif of the "daughters of the Rhine," borne by the waves. The floating woman in *Medicine* embodies the life force, and the rhythmic string of floating figures in the

Beethoven Frieze symbolizes the "longing for happiness." The female figures drifting by vertically in the painting *Irrlichter* (*Will-o'-the- Wisps*), 1903 (fig. 153; cf. cat. 79), are the seductive variants of the floating woman in *Medicine*; the studies for the former particularly emphasize the curvilinearity of their exuberant movements.

After Klimt switched to a compositional method with geometric overtones, his figures' buoyant floating motion mutated into a static reclining condition. Nonetheless, because the images are usually cropped and because of the dynamic lines tracing their contours, these figures, placed parallel to the picture surface, seem to be integrated into an endless horizontal movement. The pictures *Water Serpents I*, 1904–07 (fig. 16), and *Water Serpents II*, 1907 (fig. 154), are the culmination of this large group of studies (cat. 87–94), often associated with the taboo themes of masturbation and lesbian love; many of the drawings depend upon a perfectly balanced structure, subtly enhanced by the "architecture" of the geometric cushion forms at the upper edge.[47] In 1904–05, Klimt wielded his pencil with an almost metallic precision, but also with great sensitivity. One fine example of this type of drawing is the study of a partially clothed woman stretched out, her eyes closed as if in a trance (cat. 91).

As Klimt made his preparations for the *Stoclet Frieze* (fig. 41) around 1906–07, he embarked on a series of studies to depict another elemental state: striding.[48] This heroic motif was not utilized, however; instead, for *Expectation* (fig. 53), he opted for an Egyptian-inspired dancer, who also occurs on a small scale in a draft done on glassine for the *Stoclet Frieze* (cat. 107). This three-part sketch, created in the summer of 1908 at the Attersee, has both documentary and artistic significance, given the vivid execution of the figures, the combination of watercolour, gouache, and gold, and the abstractly geometric ornamentation. A comparison with the final version in mosaic done in 1911 reveals that the originally envisaged family group of man, pregnant woman, and child in the third part has been replaced by lovers (*Fulfilment*, fig. 12).[49] In all likelihood, the broad and spiralling trees of life (fig. 100) were modelled on the thirteenth-century wrought-iron fittings on the door of the parish church at Pürgg am Grimming (in Styria, Austria)—an influence that has not previously been noted (fig. 155, 156).[50]

Thematically, the lovers in *Fulfilment* are closely linked with the 1908 painting *The Kiss*, indisputably the towering achievement of Klimt's "golden period." A series of studies was done for this apotheosis of the union of man and woman, which, like the embrace of the lovers in the *Beethoven Frieze*, can also be considered a metaphor for the redemptive role of the arts.[51] In these images, the artist invokes a variety of situations to symbolize the man–woman relationship, for instance capturing an intense look shared by the two (cat. 104), or showing the naked woman almost totally enveloped in the man's kimono (cat. 105).

Some of the high points of Gustav Klimt's draughtsmanship from the landmark period around 1908 are the images that feature a heavy woman in the company of two younger models (cat. 103). They are a sublime blend of

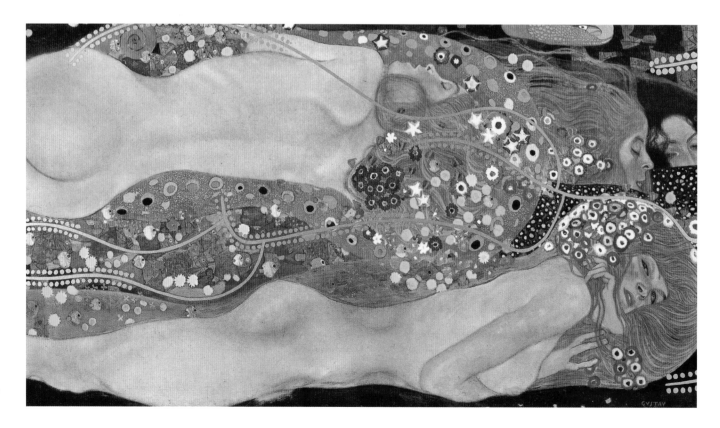

FIGURE 154
Water Serpents II 1907
Private collection
Courtesy Galerie Welz,
Salzburg

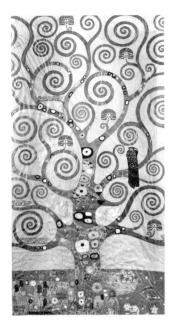

FIGURE 155
Detail of
*Cartoon for the Stoclet
Frieze: Tree of Life*
1905–09
Österreichisches
Museum für
angewandte Kunst,
Vienna

FIGURE 156
Detail of wrought-iron
work on church door
in Pürgg am Grimming,
Styria, 13th century

lively and varied strokes, rhythmic, overlapping forms, and balanced composition. But even with these realistically rendered figures, Klimt avoids any impression of their being "earthbound," by covering their feet with draped clothing. Ultimately, the drawings from the "golden period" communicate this message: the figures are merely transitory apparitions that will slip away from the viewer at the very moment of his trying to apprehend them.

The study for the mother in the melancholy *Mother and Children* of 1909–10 (cat. 108) approaches this metaphysical elusiveness in a very different manner.[52] A female figure in a dark robe crouches in a void; her closed eyes, and pale, partially visible face, with head bent to one side, express both sorrow and meditation. The fine black outlines filled in with grey and brown washes, together with the geometric positioning of the head, and the economic modelling of the lean face may indicate that Klimt also drew inspiration from Oskar Kokoschka's early forays into Expressionism. The watercolour drawing—it was rare for Klimt to use a brush in his figure studies—was produced either just before or just after his trip to Spain and Paris in the autumn of 1909, which marked another departure in the artist's development.

The paintings of El Greco made a deep impression on Gustav Klimt and fellow-artist Carl Moll when they visited Toledo in October 1909. The postcard Moll sent to their friend Josef Hoffmann, which Klimt also signed, announced: "Out with squares—in with naturalism."[53] Here Moll was poking fun at their friend's nickname of "Square Hoffmann"; however, in evoking the square he was also targeting the essence of flat decorative art after 1900. Looking back on his time in Spain and in Paris where the work of contemporarary artists had a profound impact, Klimt wrote: "Gained a lot—lost some, too—coming back a little downcast, but intact."[54] The journey marked the artist's rejection of the flat geometric style of the "golden period." But he returned "intact"—in other words, he sensed intuitively that he had remained true to his identity.

In his later years, Klimt continued to embrace Raumkunst, though not in the sense of being constrained by any architecture, existing or imaginary. His paintings no longer call to mind friezes, frescoes, or gilded mosaics; the works created after 1910 are testimony to a shift in emphasis away from planar spatial constraints and towards a wholeness, often with a cosmic dimension.

~

As a draughtsman, Klimt now devoted himself more intensively to the theme of female Eros, focusing on two major projects for paintings: *The Maiden*, 1913 (fig. 20; cat. 112–114), and the unfinished *The Bride*, 1917–18 (fig. 21; cat. 124, 125). In the seclusion of his last studio in Hietzing, surrounded by a wildflower garden, Klimt created the drawings that many regard as among his most characteristic works. In them we see his uninhibited models as they are portrayed in varying degrees of rapt absorption or erotic ecstasy. Klimt was not only a keen observer, he must also have had great charisma and a special appeal—qualities that doubtless proved useful as he stage-managed the poses and erotic acts of the women who modelled for him. Apart from the studies depicting the most intimate union of man and woman, the artist concentrated mainly on the various forms of self-gratifying female sexuality. However, he was always latently present—as the stable, male, dominant antithesis to the passive female emotional states. In the rare instances that he depicts men, they are usually muscular figures with oddly stereotypical facial features.[55]

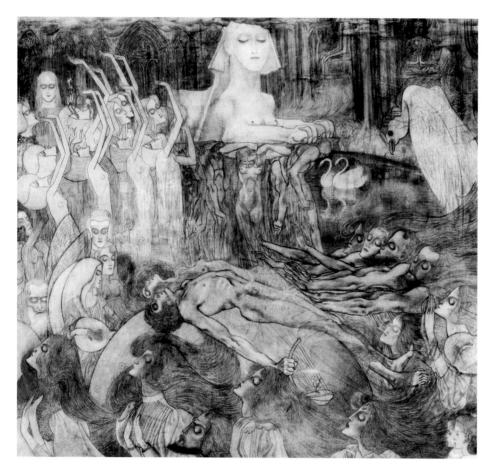

FIGURE 157
Jan Toorop
The Sphinx 1892–97
Gemeentemuseum,
The Hague

Why Klimt was so obsessed with this particular theme is a question answered to some extent by the works themselves. In image after image, he seizes moments of enrapturement, where his subjects seem to be directly touched by the Mystery of Life, as confirmed by their closed eyes and trancelike movements. Here, we glimpse again an analogy to Jan Toorop's monumental *Sphinx*, 1892–97 (fig. 157), which had been of paradigmatic importance for Klimt ever since he created his own *Philosophy*.[56] In Toorop's allegory, it is the immaterial female figures directly under the sphinx, with their closed eyes, faces in profile, and hands ecstatically held aloft, who are closest to the Mystery. Erotic Japanese woodcuts also influenced Klimt; Alice Strobl has underlined the great importance placed in Japanese culture on sex as one of life's mysterious principles.[57] We notice that, over and over, Klimt brings an almost sacred earnestness to his focus on exposed female genitals, intimating the beginnings of human life, yet also constituting the core element of sexual arousal. Cosmic/religious on the one hand, erotic/ecstatic on the other, nowhere is the duality of Klimt's relationship to sexuality better expressed than in one of the studies (fig. 158) for the central figure of *The Maiden*.[58] Here, the model's torso is obscured by fabric, but her thighs and genitals are bared. Her eyes are closed; her face is lifted ecstatically; her hands folded as in prayer. The triangle formed by the upper "chaste" part of her body is in a tension-filled dialogue with the "erotic" triangle below.

This demonstrates a further link with the symbolism of Toorop, the key to which is found in the previous study, and in another related one.[59] The upper part of the image has recently been shown to be a direct reference to the middle figure in Toorop's *The Three Brides* (fig. 159), an allegory that had inspired Klimt on several occasions.[60] Toorop's radiant figure has an aura of flowers and her naked form shines through the transparent veil. She combines chastity and sensuality, aspects that are personified by the "brides" to her left and right. Toorop once described *The Three Brides* as a "Dream of Becoming."[61] This aspect of dreaming predominates in Klimt's thematically-related canvases *The Maiden* and *The Bride*. In *The Maiden*, the characteristic Klimtian confusion between planes of reality takes place within this thematic realm. The "real-life" main figure seems a two-dimensional marionette compared with the more three-dimensional and realistic portrayals of the women who appear to her in a dream, and embody various psychological states and stages of erotic awareness. As for Toorop's flower aura, it has apparently found its echo in the garlands swirling around the women.

Alongside Klimt's efforts to capture moments of ecstasy as compellingly as possible came his labours to impose a higher geometric order or specific system of movement on his figures—as in the case of the triangular forms discussed above. Many of the models thus assume complicated and expansive positions. Moreover, the

FIGURE 158
Study for The Maiden
c. 1913
Historisches Museum
der Stadt Wien,
Vienna

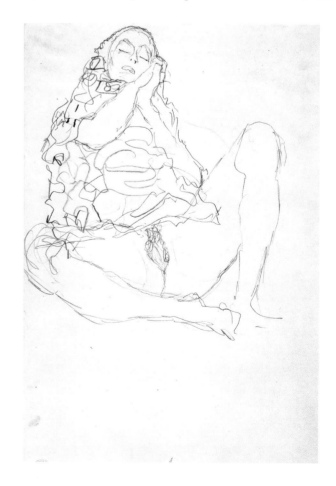

numerous studies for *The Maiden* cover a wide range of poses, types of women, and temperaments, and Klimt's language of line differs accordingly. The pencil will trace a smooth flowing line for a phlegmatic standing figure of generous proportions in a classical contrapposto (cat. 112). Certain curves will be more heavily accentuated, while the areas created with lighter pressure appear to be infused with light. In those works where the pencil point seems to be a direct conduit for erotic arousal, the strokes are more restless, breaking off more often, for example in the drawing of a rather muscular reclining model (cat. 114). Still, the law of equilibrium between negative and positive areas prevails here, too. In consequence, we often note drastic foreshortening, as in the drawing of a woman lying with her buttocks turned to the viewer (cat. 111).[62] The strong, intermittent lines that define this part of the body are in marked contrast to the lively strokes that delineate her rumpled garment, and the tone of the paper seems to glisten inside the contours more than in the surrounding area, which has been left blank. The body's intersection with the curved line in the background adds spatial tension and is an indication that in those years, a circular or swirling motion often enclosed Klimt's figures. The idea of self-absorbed female figures in motion, first utilized effectively in the sketches for the University paintings, is even more evident in Klimt's late studies. The depiction of a sleeping woman (cat. 113) in a dress patterned with circles, its whirl of lines conjuring up a flowing stream, can be read like a detail from one continuous horizontal movement—as in the studies for *Water Serpents* of the previous decade. The garments play an integral role here: they swirl around the female nudes, intensify the overall movement, and cunningly reveal the bare parts of the body, which, in the midst of the maze of lines, shine out as negative forms with even more pronounced contours. Two studies on one page, of a model viewed from above (cat. 116) with her dress gathered to her and legs drawn up, impart both relaxation and ecstasy; the figures seem to be floating in space, totally dematerialized. Chronologically, this drawing is situated between the monumental allegories *The Maiden* and *The Bride*. The studies for the latter were an apex in Klimt's oeuvre: neither his strokes nor his models' poses had ever been freer.

One of the many erotic drawings done around the time of the studies for *The Bride* shows a woman leaning backwards (cat. 120), the supple twists and turns of her pose filling the whole picture surface. The pencil lines that transcribe the posture like a seismograph fuse with the excited flow of white crayon that adds a bright gleam to the clothing of the masturbating model. There is something Baroque in the sense of movement that pervades this entire group of studies, and in the structural richness of the interplay

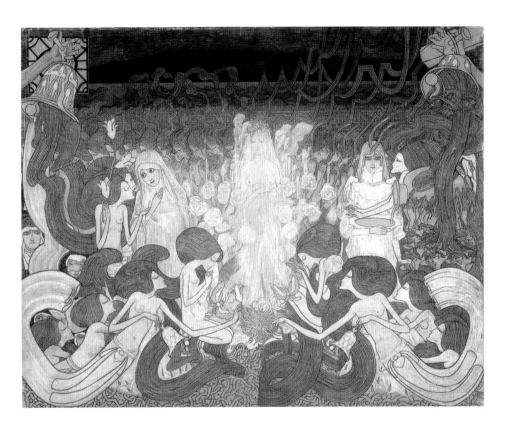

between parts of the body and fabrics. In all the drawings, erotic ecstasy melds with a lyrical rapture.

The figures in the preparatory studies for *The Bride* cover an even wider spectrum of types and moods than those for *The Maiden*. Many drawings epitomize sheer linear arousal, such as that of a reclining woman viewed from above (cat. 124), with the voluptuous forms of her bare thighs seeming to dissolve in an overall vibrating movement of vehement strokes. Even more intensely than in the study of the floating woman for *Medicine*, discussed above, this drawing charts the electric tension between physical presence and immateriality. In addition to this style of drawing characterized by lines repeatedly breaking off and forms dissolving, so to speak, we find those typified by rigorously closed forms. These studies hearken back to the two-dimensional rendering of figures in Klimt's early Secessionist years in their preference for strict profile and frontal poses. One eloquent example of this latter category is a study for the central figure in *The Bride* of a woman's face looking straight at the viewer (cat. 125). The models Klimt selected for *The Bride* range from the more mature and rounded to the overly slender ideal. The fragile, adolescent-seeming figure at far right, with thin, bent limbs and face turned to the side, suggests a rediscovery of once admired prototypes—Jan Toorop and George Minne in particular.[63]

In the last decade of his life, the artist produced more large-format portraits and, accordingly, more preparatory drawings. In the studies Klimt began in 1912 for his only portrait commission of a child (cat. 30), nine-year-old Mäda Primavesi wears facial expressions and strikes poses

FIGURE 159
Jan Toorop
The Three Brides 1893
Kröller-Müller
Museum, Otterlo,
Netherlands

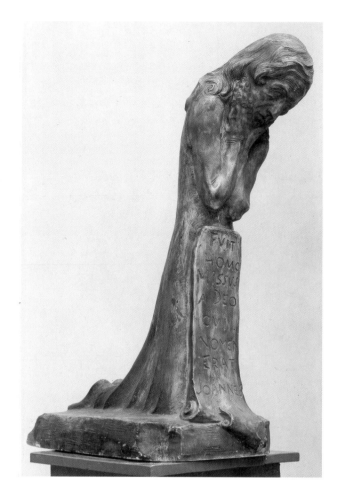

that are more natural and animated than any in the studies for portraits of adult women (cf. cat. 110). Time and again, Klimt needs but a few deft strokes to capture the essence of the young girl, playfully and effortlessly balancing vivid characterization and reference to the universal.

In the drawings for portraits, Klimt attends to individual temperament, but only to a certain degree. A vigorous, energetic stroke distinguishes the sketches for the portrait of Friederike Maria Beer, whose round face and regular features prompted several special studies.[64] In the drawing included in the present exhibition (cat. 118), Klimt again focuses on a frontal view; and by reducing the surroundings to the bare essentials he heightens the hypnotic effect. The artist first sketched the basic outlines in light-grey pencil, including the stand-up collar that forms a halo around her head, then used increasingly darker lines to continue his work. This oft-encountered Klimtian technique produces a lively alternation of light- and dark-grey lines, with the greatest concentration of gleaming pencil strokes at the chin. The studies for another frontal portrait, that of *Fräulein Lieser* (cat. 121), are noticeably more delicate and apparently convey a gentler disposition.

The unfinished *Portrait of Ria Munk III* was commissioned after the young woman killed herself in 1911 over an unhappy love affair, a circumstance that may have contributed to the ethereal nature of its preparatory studies.[65]

These drawings were done using several models, all of them wrapped mummylike in a kimono. In our example (cat. 122), as in all the others, the model stands like a column in the picture surface, her head and feet cropped by the edges of the page. The impression is of a weightless figure tarrying in infinity. The woman in the kimono is defined by the changing rhythms of the ever-circling pencil that has traced a profusion of patterns. This drawing achieves a fine balance between transparency and rigorous tectonics; even in this late phase of largely linear abstraction, blossoming artistic energy is subject to a higher order. To the end, Klimt obeyed the laws of the Gesamtkunstwerk.

~

This outline of Gustav Klimt's evolution as a graphic artist has occasionally touched on his openness to outside influences. In concluding, it seems important to recognize that his oeuvre of drawings and paintings would have been unimaginable without the stimulus of countless works by contemporary international artists or by artists from the past. Not that Klimt was ever a slavish copyist; that much is obvious from the many examples of his work that have come to light, whose scope cannot even be hinted at within the present context. Klimt internalized the motifs that made an impression on him—mainly in the realm of the human figure—by trying to translate them into his own idiom through the mechanism of drawing, as he had

learned to do during his training. Studying the live model, he would first test the applicability of certain poses, stylizations, or ideal types; his paintings would then reflect these often multi-layered inspirations. Max Eisler, author of the first comprehensive monograph on Klimt (1920), states that "natural gifts, in the form of good taste, adaptability, and receptivity" (qualities that would seemingly run counter to "talent as an original force") characteristically become "creative attributes" in Klimt.[66] Working in seclusion, the artist showed a degree of passivity in letting outside stimuli find him. In the early years of the Secession, it was his more organized friends who initiated international contacts and brought to Vienna many works by foreign colleagues, which were then often of pivotal significance for Klimt.[67] Later, the exhibitions that Carl Moll organized at the Galerie Miethke proved an important catalyst, as did Klimt's occasional trips abroad.[68] Remarkably, among his colleagues, it was Klimt who was the most determined in his efforts to come to grips with international trends and the most successful in mastering them (also in familiarizing himself extensively with what publications or photographs had to offer). Add to this a keen intuition for rapidly changing tastes and styles, which were immediately integrated into his work. For instance, in the early 1890s he was the first artist in Vienna to fully embrace Symbolism. Klimt's works, his drawings foremost, also attest to the changeover to monumental art that was taking hold of the entire German-speaking art world around 1900. The haggard, kneeling couple, *The Sufferings of Weak Humanity* (see fig. 48), and the cowering figure of *Nagging Care* (see fig. 49) in the *Beethoven Frieze* of 1902 were the first expression of the statuelike isolation of the individual, a theme that would resonate in Klimt's subsequent work; these are compelling portrayals of human vulnerability.[69] The influence of Belgian sculptor George Minne was fundamental here: his fountain with kneeling, lean young men had created a sensation at the Secession exhibition in November 1900. Klimt adopted not only Minne's attenuated "Gothic" ideal body type, but also his tension-filled contours, mapping the margins of the psyche.[70] Minne's stylized gestural language—the geometry of hands that are elongated or bent at right angles, the head held to one side—became integral elements in the flat decorative works of Klimt's "golden period." Minne was thus clearly the impetus for the "orants" (figures with hands lifted in prayer) in the lower part of the painting *Hope II*, 1907–08 (cat. 24); studies of an old man done in this connection (fig. 160), but never used, even prove to be a direct appropriation of Minne's sculptural motif of the kneeling figure of John the Baptist (fig. 161).[71]

The example of George Minne also serves to illustrate the pioneering role Klimt played in the perceptions of other artists. Minne's slim, expressive youths (fig. 151) would be a vital spark for the early Expressionism of Oskar Kokoschka and Egon Schiele in 1908–09. For this younger generation of artists, who would themselves soon be setting the trend, Klimt was the admired father figure (and sometimes someone to oppose). When, in 1909, Klimt abandoned the "golden period" style and withdrew increasingly from public life, his palette and technique began to reflect his experience of Henri Matisse, Vincent van Gogh, Ferdinand Hodler, and others. The background in his portraits often includes Far Eastern ornamentation; Klimt was an enthusiastic collector of Asian objets d'art and utensils. On the subject of Klimt's receptivity to the art of Antiquity and Modernity, Max Eisler recalled:

> He was a sight to behold as he examined a simple Korean vase in the diffused sunlight of the room, enthralled, excitedly tracing the flame-licks of the glazes that had run and then the matt clay from which they arose, his hand turning the vase and lingering over it and his eyes happily drinking it in. Again and again, it is that one soft touch by another hand on a violin—its rhythmic echo—that brings to life the mute reaches of one's own self.[72]

Eisler's words give us a valuable insight into the sensory immediacy and also the mental intensity with which Klimt absorbed outside impressions. They underscore, as well, the great importance of rhythmic line as an inspiration for his drawing.

Unlike the paintings, the drawings of Klimt's final years do not at first glance testify to his having been inspired by other artists or trends. But the excited lines in many of them, and the pencil strokes vehemently superimposed on one another do bear silent witness to the contemporaneous Expressionist movement. However, Klimt's graphic work is not driven by deep soul-searching, but rather by compliance with the higher order of the overall context. The later drawings are also governed by dialectic antitheses: sensuality versus spirituality, momentariness versus universality, turbulent line versus the limits imposed by the paper's dimensions. As before, this spirit of fusion gives voice to the aspiration of an ideal unity between art and life that was programmatically proclaimed at the *Kunstschau* of 1908: the transfiguring imperative of the historicist Gesamtkunstwerk connected with a thorough academic grounding in the art of drawing. In Max Eisler's words, Klimt's work "remained a celebration of unreality."[73] In this very particular linkage of tradition and modernity, of the local and the universal, Klimt was unique in all of Europe during his lifetime. Perhaps this fascinating contradictoriness was one of the reasons for his rediscovery decades later. Klimt's paintings undoubtedly enjoy greater popularity, but his drawings offer a much more subtly differentiated and immediate revelation of the originality of his talent.

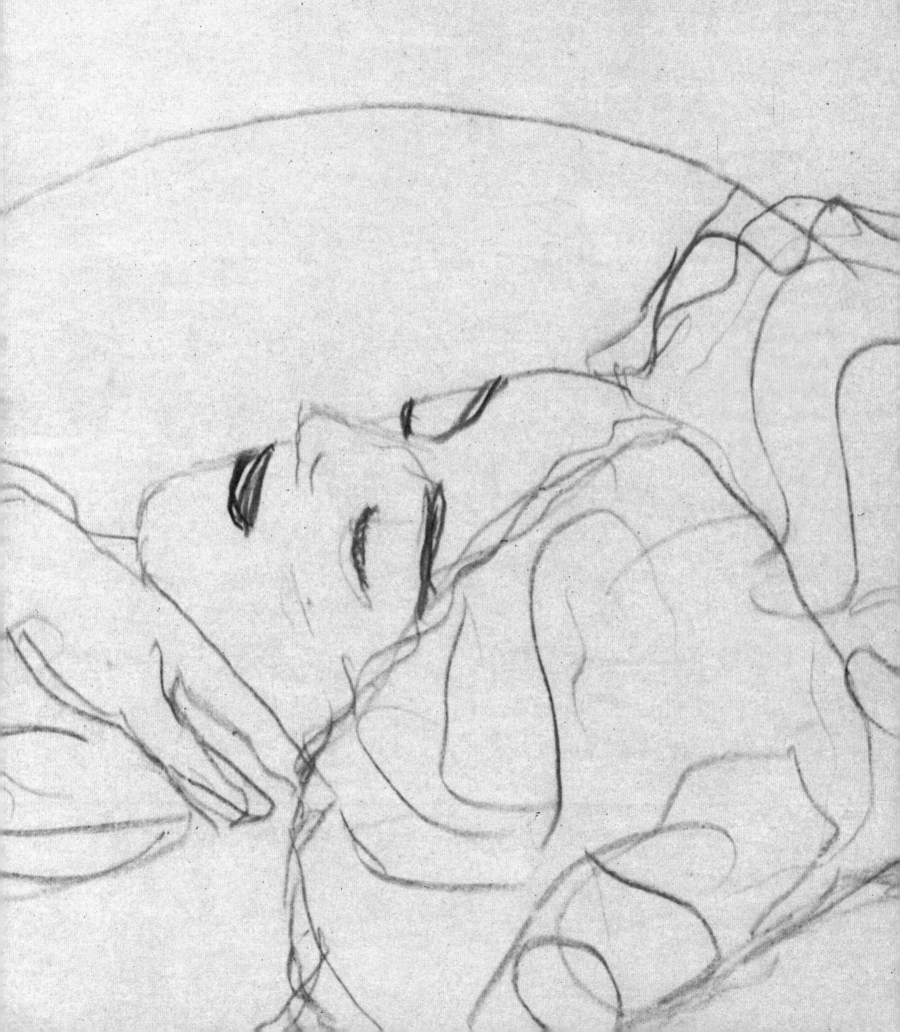

37

The Realms of Nature 1882
Published as no. 39 in *Allegorien und Embleme*
Graphite with white highlights, 27.5 × 53.1 cm
Historisches Museum der Stadt Wien, Vienna
Strobl 47

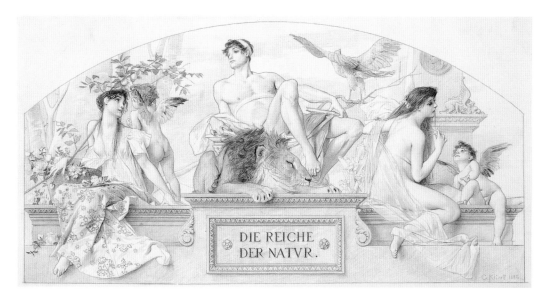

38

Child's Head with Closed Eyes c. 1883
Possibly study for a cherub in *Opera*,
no. 64a in *Allegorien und Embleme*
Graphite and sanguine, 45.2 × 31.4 cm
Historisches Museum der Stadt Wien, Vienna
Strobl 86

39

Fairy Tale 1884
Published as no. 74 in *Allegorien und Embleme*
Black crayon, ink, wash, and
white highlights, 63.9 × 34.3 cm
Historisches Museum der Stadt Wien, Vienna
Strobl 93

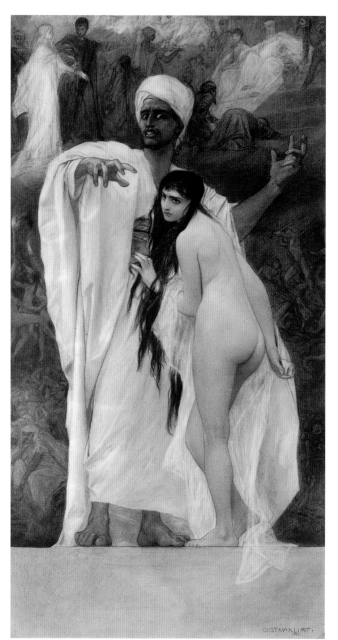

The Death of Juliet c. 1886–87
Study for *Shakespeare's Theatre*, Burgtheater
Black crayon with white highlights, 27.6 × 42.4 cm
Graphische Sammlung Albertina, Vienna
Strobl 142

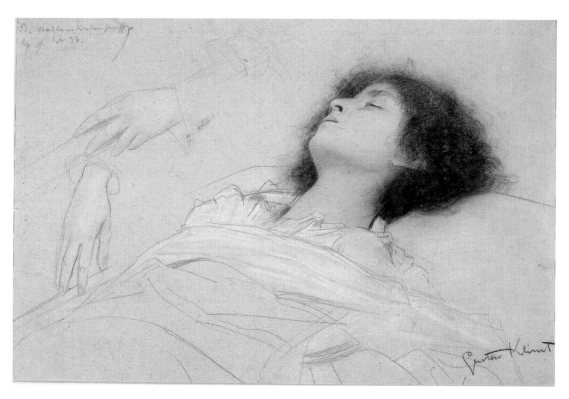

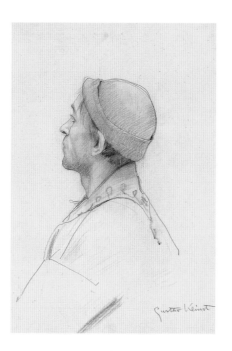

41

Man Wearing a Cap c. 1886–87
Study for *Shakespeare's Theatre*, Burgtheater
Black crayon with white highlights, 42.6 × 29 cm
Graphische Sammlung Albertina, Vienna
Strobl 154

42

Sitting Female Nude 1886–87
Study for *Theatre in Taormina*, Burgtheater
Graphite, black crayon, and white highlights, 45 × 31 cm
Historisches Museum der Stadt Wien, Vienna
Strobl 162

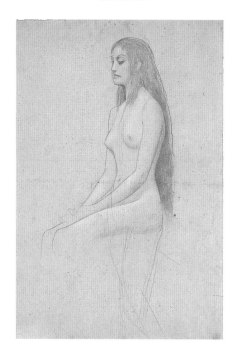

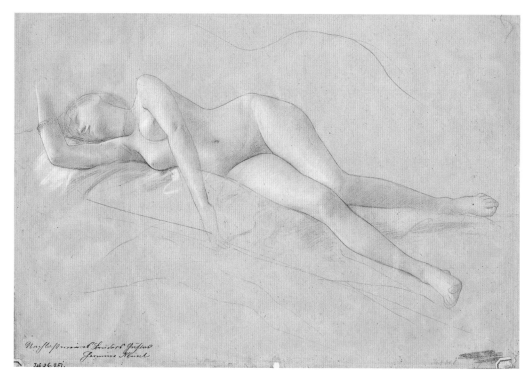

43

Reclining Nude c. 1886–87
Study for *Altar of Dionysus*, Burgtheater
Black crayon with white highlights, 28.7 × 42.5 cm
Graphische Sammlung Albertina, Vienna
Strobl 179

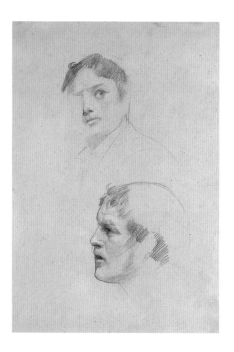

44

*Two Studies of the Actor
Max Devrient (1857–1929)* c. 1888
Possibly for the *Auditorium of the Old Burgtheater*
Black crayon with white highlights, 45 × 31.6 cm
Historisches Museum der Stadt Wien, Vienna
Strobl 188

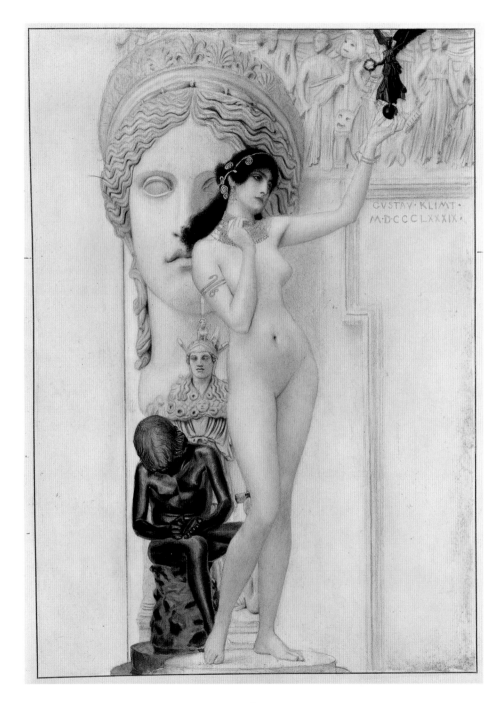

45

Allegory of Sculpture 1888–89
Bound in *Festschrift des Österreichischen*
Museums und der Kunstgewerbeschule, Vienna, 1889
Graphite and watercolour with gold highlights, 43.5 × 30 cm
MAK–Österreichisches Museum
für angewandte Kunst, Vienna
Strobl 235

46

Transfer Sketch for "Egyptian Art II" 1890–91
For the Kunsthistorisches Museum, Vienna
Black crayon and graphite, 38 × 20 cm
Historisches Museum der Stadt Wien, Vienna
Strobl 240

47

June 1896
Published as no. 53 in *Allegorien Neue Folge*
Black crayon, graphite, wash with gold, 41.5 × 31 cm
Historisches Museum der Stadt Wien, Vienna
Strobl 272

48

Allegory of Sculpture 1896
Published as no. 58 in *Allegorien Neue Folge*
Black crayon, graphite, wash with gold, 41.8 × 31.3 cm
Historisches Museum der Stadt Wien, Vienna
Strobl 276

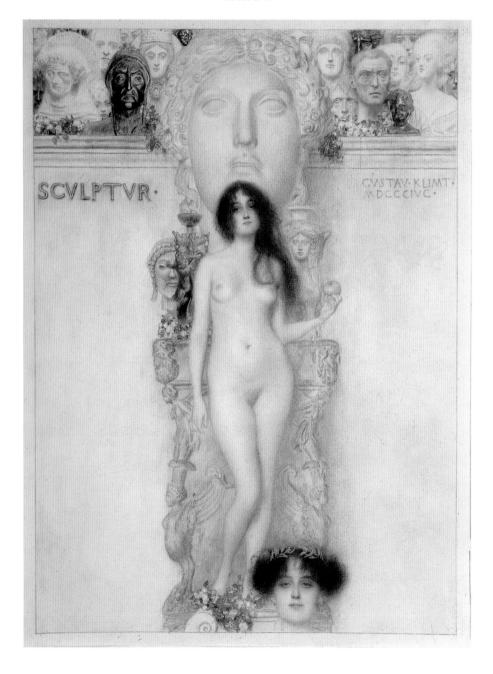

49

Two Studies of a Dancing Female Nude for "Tragedy" c. 1897
Black crayon with white highlights, 47.4 × 32.7 cm
Historisches Museum der Stadt Wien, Vienna
Strobl 341

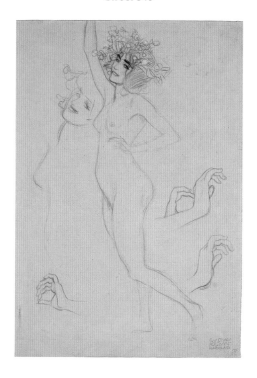

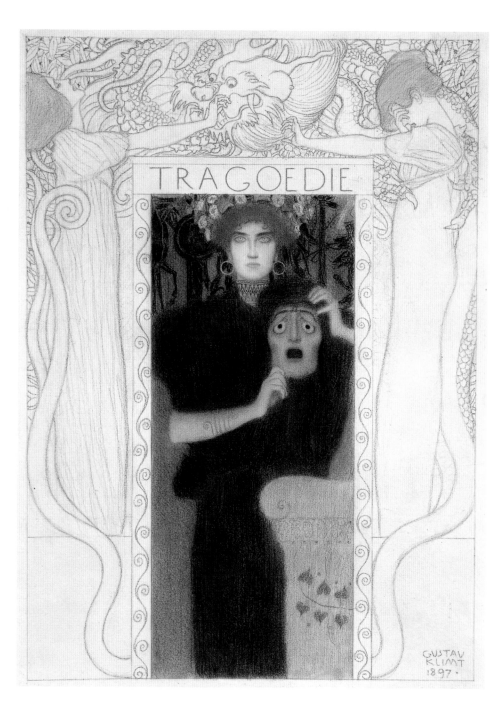

50

Tragedy 1897
Published as no. 66 in *Allegorien Neue Folge*
Black crayon, graphite, wash with gold, 41.9 × 30.8 cm
Historisches Museum der Stadt Wien, Vienna
Strobl 340

Study for "Schubert at the Piano" 1897–98
For the music room of Nikolaus Dumba, Vienna
Black crayon, 45.2 × 31.8 cm
Historisches Museum der Stadt Wien, Vienna
Strobl 315

Floating Woman 1897–98
Study for *Medicine*
Black crayon, 45.2 × 31.8 cm
Historisches Museum der Stadt Wien, Vienna
Strobl 529

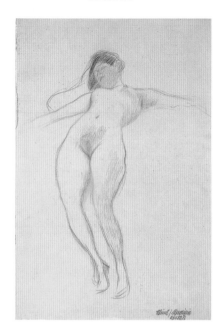

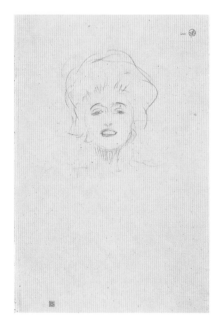

52 recto

Study for "Schubert at the Piano" 1897–98
For the music room of Nikolaus Dumba, Vienna
Graphite, 45.7 × 31.0 cm
Moravian Gallery, Brno, Czech Republic
Strobl 3302

52 verso

Study for "Schubert at the Piano" 1897–98
For the music room of Nikolaus Dumba, Vienna
Graphite, 45.7 × 31.0 cm
Moravian Gallery, Brno, Czech Republic
Not in Strobl

53

Study for "Schubert at the Piano" 1897–98
For the music room of Nikolaus Dumba, Vienna
Black crayon with white highlights, 44 × 21 cm
Oberösterreichisches Landesmuseum, Linz, Austria
Strobl 308

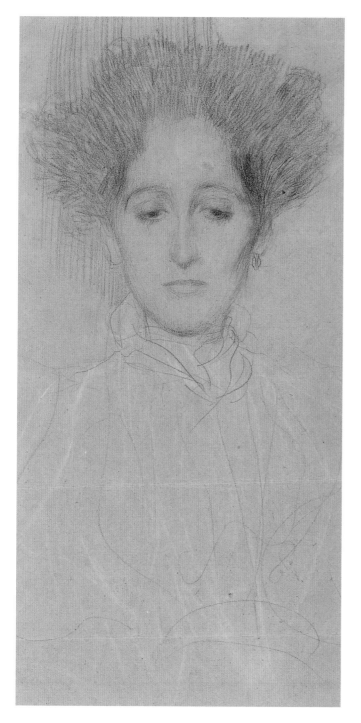

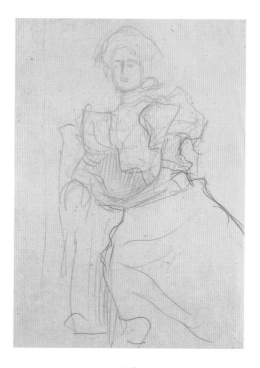

54

Study for the Portrait of Sonja Knips c. 1898
Black crayon, 45 × 31.7 cm
Historisches Museum der Stadt Wien, Vienna
Strobl 419

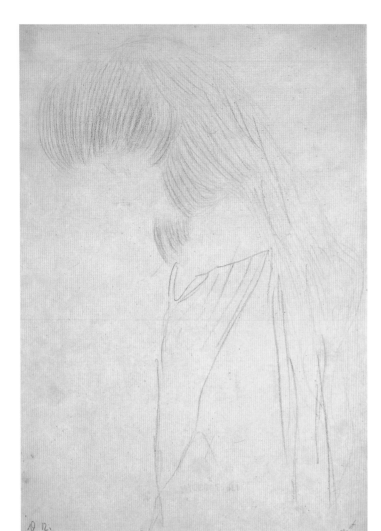

Girl with Long Hair in Profile c. 1898
Study for *Thalia and Melpomene*
Blue pencil, 42.7 × 28.7 cm
The Museum of Modern Art, New York
The Joan and Lester Avnet Collection
Strobl 432

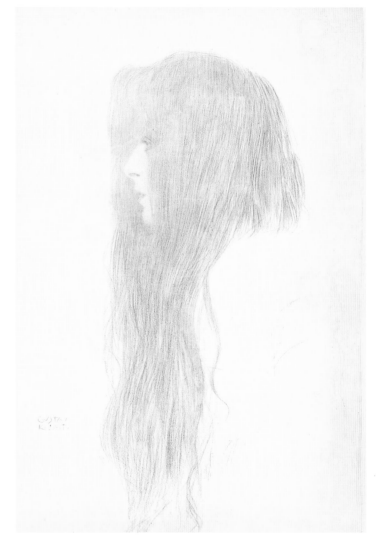

55

Profile of a Standing Girl with Long Hair c. 1898
Study for *Thalia and Melpomene*
Red and blue crayon, 45 × 31.6 cm
Historisches Museum der Stadt Wien, Vienna
Strobl 430

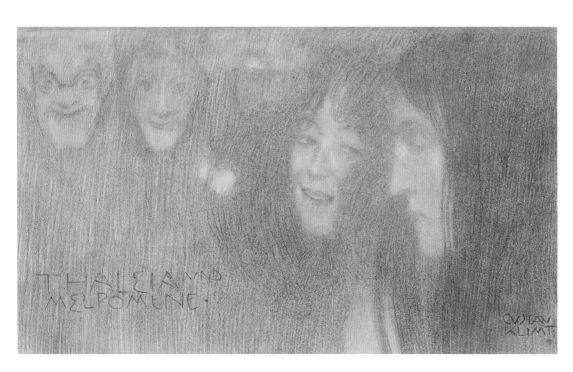

57

Thalia and Melpomene 1898
Graphite, 37.6 × 44.7 cm
Graphische Sammlung Albertina, Vienna
Strobl 441

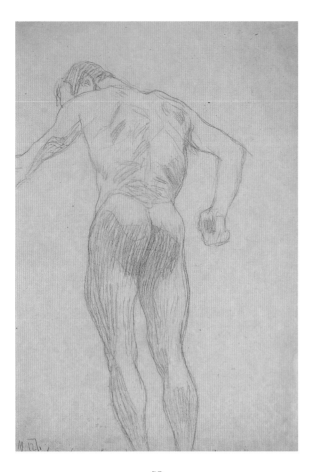

58

Standing Male Nude from Behind c. 1898
Study for the University painting *Philosophy*
Black crayon, 45.4 × 30.7 cm
Historisches Museum der Stadt Wien, Vienna
Strobl 461
Verso: Study in red crayon

59

Transfer Sketch for "Philosophy" c. 1898–99
Black crayon and graphite, 89.6 × 63.2 cm
Historisches Museum der Stadt Wien, Vienna
Strobl 477

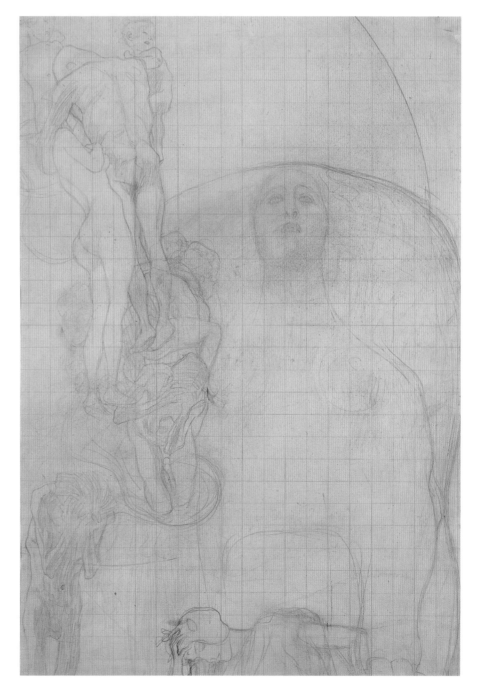

60

Nuda Veritas 1898
Published in *Ver Sacrum*, vol. I (March 1898)
Black crayon, graphite, pen, and brush in ink, 41.3 × 10.4 cm
Historisches Museum der Stadt Wien, Vienna
Strobl 350

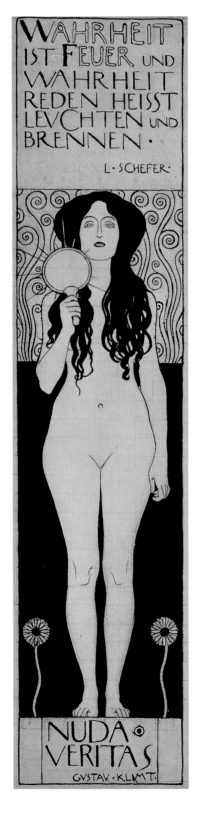

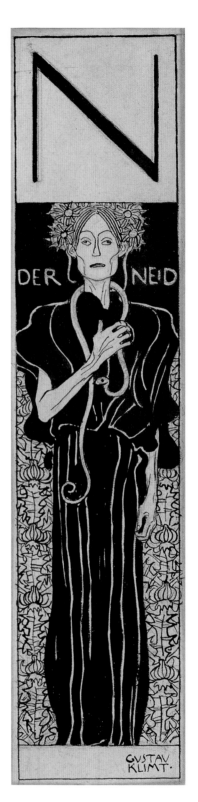

61

Envy 1898
Published in *Ver Sacrum*, vol. I (March 1898)
Black crayon, graphite, pen, and brush in ink, 41.5 × 9.8 cm
Historisches Museum der Stadt Wien, Vienna
Strobl 351

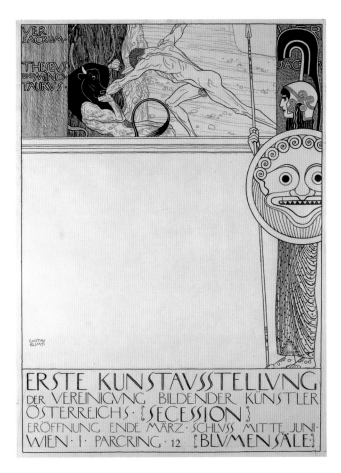

62

Finished Drawing for the First
Secession Exhibition Poster 1898
Graphite and ink, 130 × 80 cm
Historisches Museum der Stadt Wien, Vienna
Strobl 327

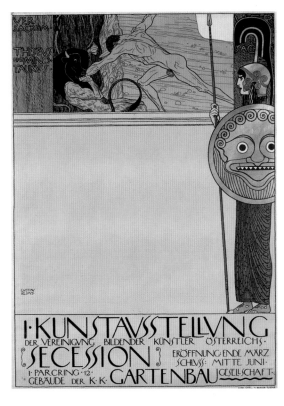

63

Poster for the First Secession
Exhibition (uncensored version) 1898
Colour lithograph, 97 × 70 cm
Historisches Museum der Stadt Wien, Vienna

64

Poster for the First Secession
Exhibition (censored version) 1898
Colour lithograph, 97 × 70 cm
Historisches Museum der Stadt Wien, Vienna

65

Floating Male Nude c. 1898
Study for the University painting *Medicine*
Black crayon, 43 × 28.4 cm
Graphische Sammlung Albertina, Vienna
Strobl 540

66

Standing Woman from Behind c. 1900
Study for *Medicine*, reproduced in
Ver Sacrum, vol. IV (March 1901)
Black crayon with white highlights, 44.5 × 31.1 cm
Historisches Museum der Stadt Wien, Vienna
Strobl 607

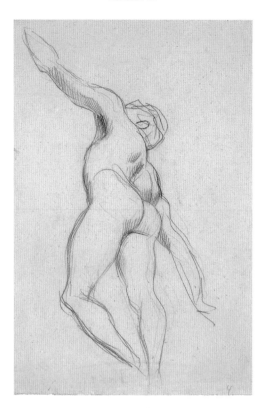

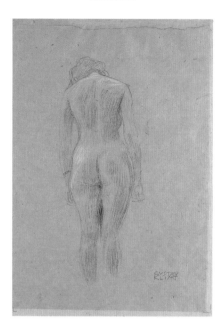

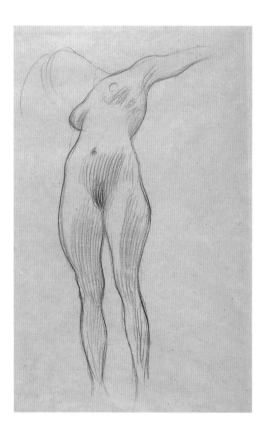

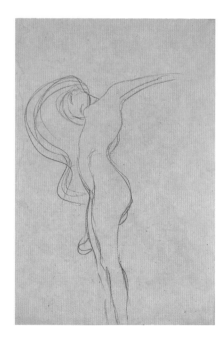

68

Floating Woman c. 1900
Study for the University painting *Medicine*
Black crayon, 44.6 × 30.6 cm
Historisches Museum der Stadt Wien, Vienna
Strobl 618

67

Floating Woman c. 1900
Study for the University painting *Medicine*
Black crayon, 41.5 × 27.3 cm
Graphische Sammlung Albertina, Vienna
Strobl 621

Standing Boy c. 1900
Study for the University painting *Medicine*
Black crayon with white highlights, 45 × 31 cm
Historisches Museum der Stadt Wien, Vienna
Strobl 633

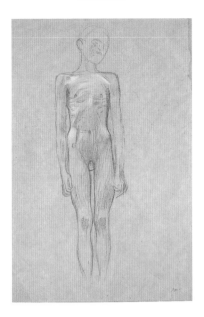

Sitting Old Woman in Profile c. 1901
Study for the University painting *Medicine*
Black crayon, 30.6 × 44.8 cm
Historisches Museum der Stadt Wien, Vienna
Strobl 669

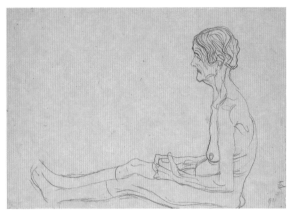

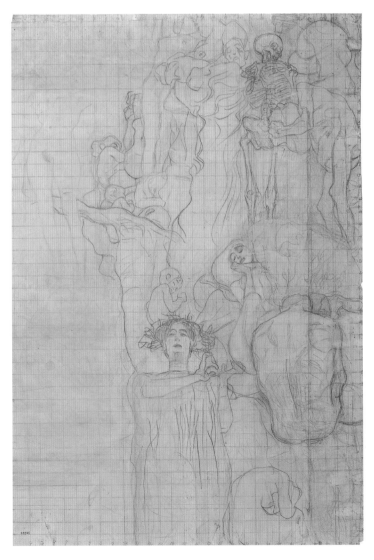

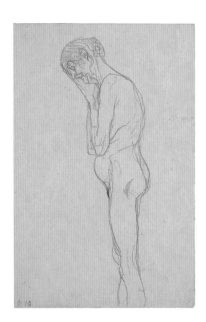

72

Standing Old Woman in Profile c. 1901
Study for the University painting *Medicine*
Black crayon, 45.1 × 30.5 cm
Historisches Museum der Stadt Wien, Vienna
Strobl 673

70

Transfer Sketch for "Medicine" c. 1900
Black crayon and graphite, 86 × 62 cm
Graphische Sammlung Albertina, Vienna
Strobl 605

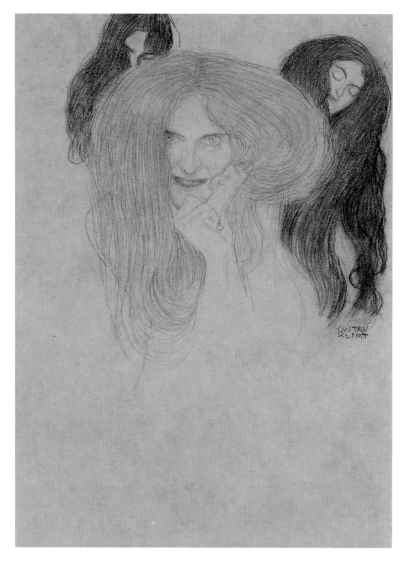

73

Study for the Gorgon Heads 1901–02
For the *Beethoven Frieze*, Fourteenth Secession, 1902
Black crayon, 43.5 × 31 cm
Historisches Museum der Stadt Wien, Vienna
Strobl 799

74

Study for the Left-hand Gorgon 1901–02
For the *Beethoven Frieze*, Fourteenth Secession, 1902
Black crayon, 45.2 × 31 cm
Graphische Sammlung Albertina, Vienna
Strobl 785

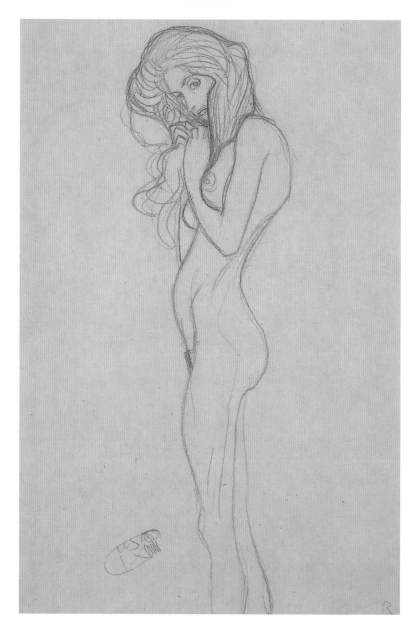

75

Female Head in Three-quarter Profile 1901–02
Study for the *Beethoven Frieze*, Fourteenth Secession, 1902
Black crayon, 45 × 31 cm
Graphische Sammlung Albertina, Vienna
Strobl 810

76

Embracing Couple 1901–02
Study for the *Beethoven Frieze*, Fourteenth Secession, 1902
Black crayon, 45 × 30.8 cm
Graphische Sammlung Albertina, Vienna
Strobl 853

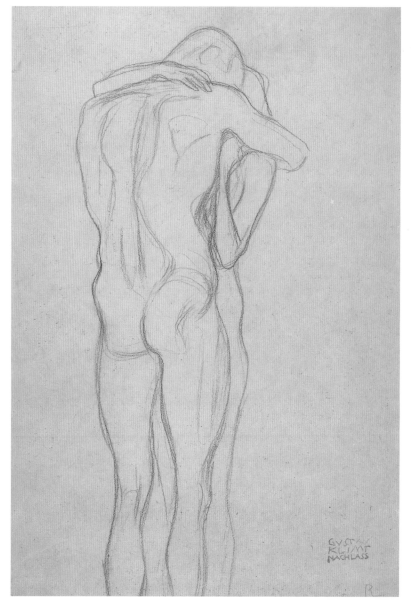

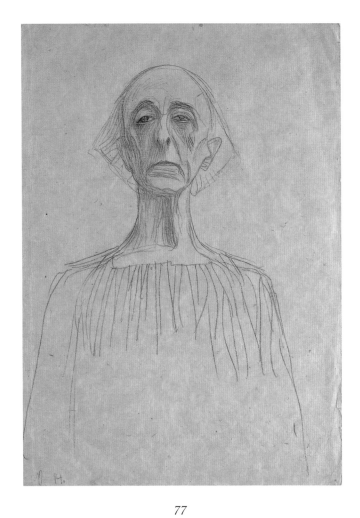

77

Bust of a Man in a Toga c. 1902–03
Study for the old judge in the University painting *Jurisprudence*
Black crayon, 44.1 × 32.4 cm
Historisches Museum der Stadt Wien, Vienna
Strobl 911

78

Marie Moll 1902–03
Various crayons, 45.2 × 31.4 cm
Historisches Museum der Stadt Wien, Vienna
Strobl 1152

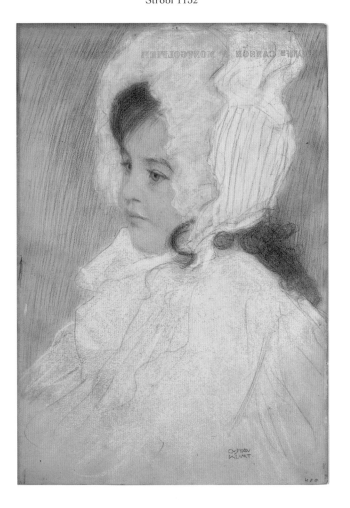

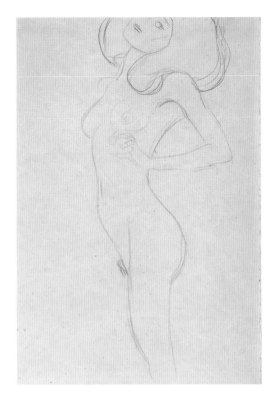

79

Standing Female Nude c. 1903
Study for *Irrlichter* (*Will-o'-the-Wisps*)
Blue and red crayon, 45 × 29.5 cm
Oberösterreichisches Landesmuseum, Linz, Austria
Strobl 705

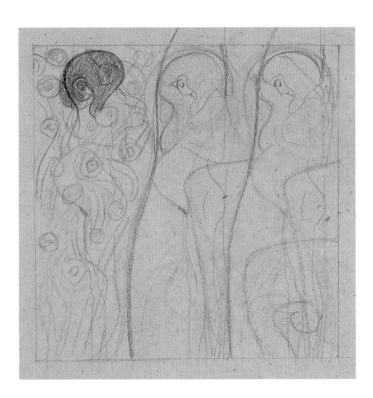

80

*Three Studies of Pregnant
Woman in Profile for "Hope I"* c. 1903
Graphite with red, black, and blue crayon, 45.7 × 31.6 cm
Historisches Museum der Stadt Wien, Vienna
Strobl 993

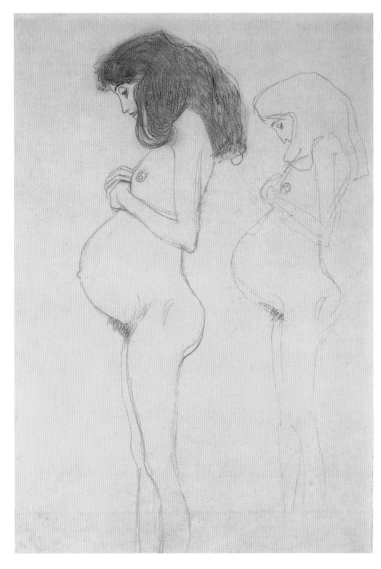

81

Study for "Hope I" c. 1903
Black crayon, 44.8 × 30.7 cm
Graphische Sammlung Albertina, Vienna
Strobl 3511a

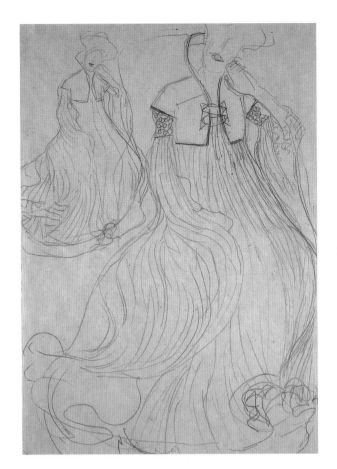

Study for the Portrait of
Adele Bloch-Bauer I c. 1904–06
Black crayon, 44.4 × 31 cm
National Gallery of Canada, Ottawa
Strobl 1118

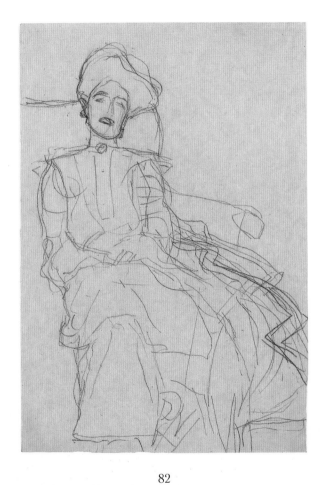

82

Study for the Portrait of
Adele Bloch-Bauer I c. 1903
Black crayon, 45 × 32 cm
National Gallery of Canada, Ottawa
Not in Strobl

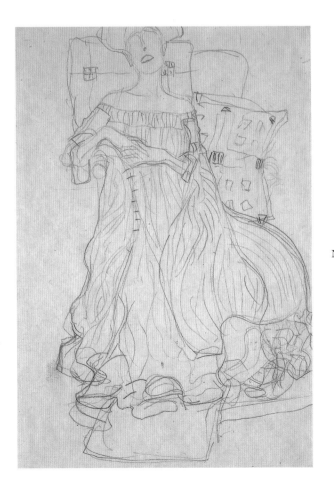

84

Study for the Portrait of
Adele Bloch-Bauer I c. 1904–06
Black crayon, 44.6 × 31 cm
National Gallery of Canada, Ottawa
Strobl 1137

Study for the
"Three Ages of Woman" c. 1905
Charcoal, 182.5 × 90 cm
Private collection, Australia
Courtesy Richard Nagy, Dover Street Gallery, London
Not in Strobl

85

Two Studies of an Infant for the
"Three Ages of Woman" c. 1904
Black crayon, 55 × 35 cm
Historisches Museum der Stadt Wien, Vienna
Strobl 1305

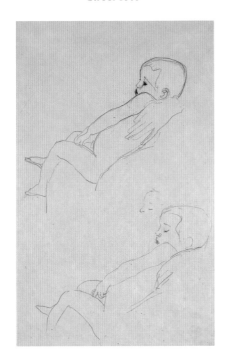

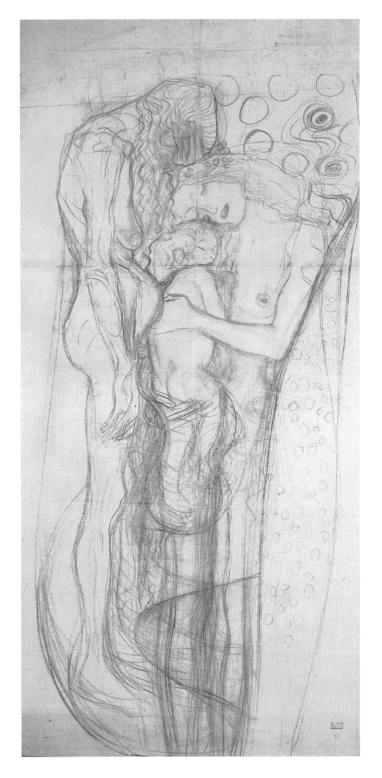

87

Embracing Lesbians c. 1903–04
Study for *Water Serpents I*
Red pencil, 55 × 35 cm
Historisches Museum der Stadt Wien, Vienna
Strobl 1342

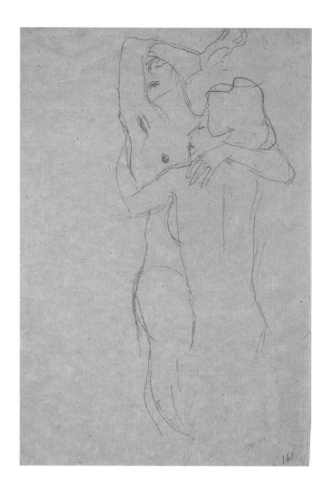

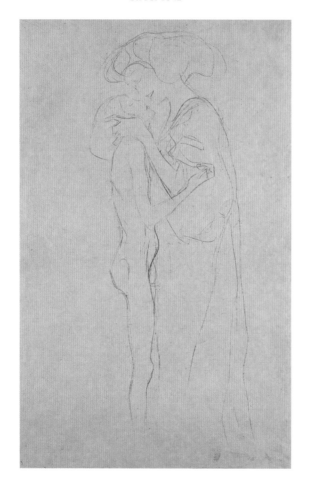

88

Embracing Lesbians c. 1903–04
Study for *Water Serpents I*
Black crayon, 45.2 × 31.2 cm
Historisches Museum der Stadt Wien, Vienna
Strobl 1351

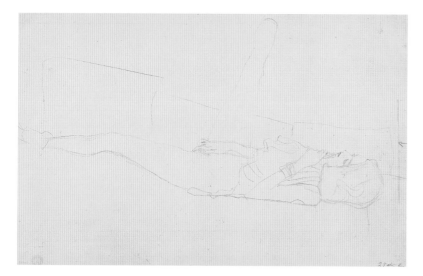

89

Reclining Nude with Raised Right Leg c. 1904
Reproduced in *Die Hetärengespräche des Lukian*
(*Lucian's Dialogues of the Courtesans*), 1907
Graphite, 35 × 55 cm
Graphische Sammlung Albertina, Vienna
Strobl 1395

90

Reclining Nude, Partially Draped c. 1904
Study for *Water Serpents II*
Graphite, 34.9 × 55.1 cm
Historisches Museum der Stadt Wien, Vienna
Strobl 1400

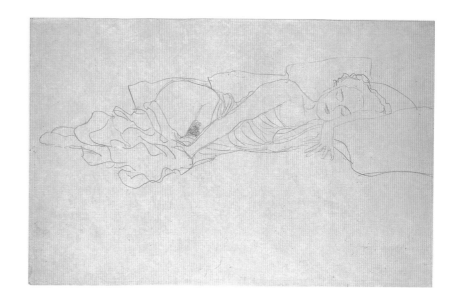

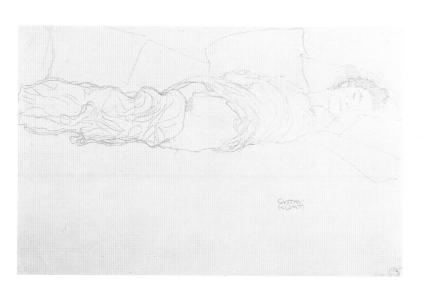

91

Reclining Nude, Partially Draped c. 1904
Study for *Water Serpents II*
Graphite, 35 × 55 cm
Graphische Sammlung Albertina, Vienna
Strobl 1401

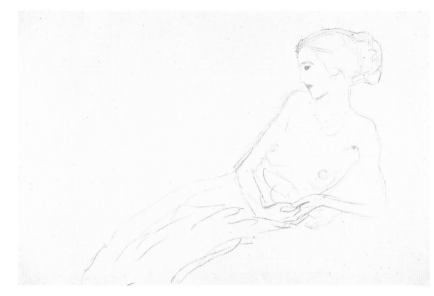

92

Nude Leaning Back on Her Elbow 1905–06
Study for *Water Serpents II*
Red pencil, 37 × 56 cm
Oberösterreichisches Landesmuseum, Linz, Austria
Strobl 1472

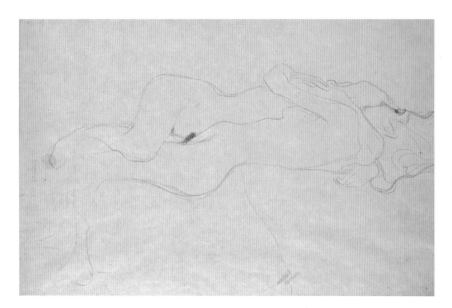

93

Lesbian Lovers 1905–06
Study for *Water Serpents II*
Violet pencil, 35 × 55 cm
Historisches Museum der Stadt Wien, Vienna
Strobl 1473

94

Reclining Female Nude 1905–06
Study for *Water Serpents II*
Graphite, 36.2 × 55.5 cm
Leopold Museum—Privatstiftung, Vienna
Strobl 1501

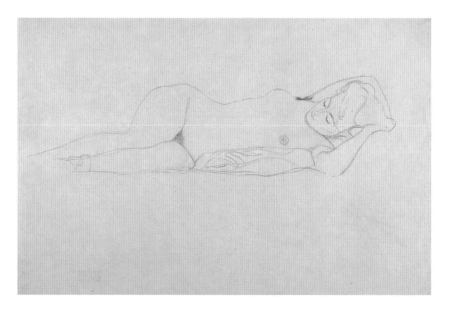

95

Study for the Portrait of
Margaret Stonborough-Wittgenstein 1904–05
Black crayon, 54.5 × 33.7 cm
Leopold Museum — Privatstiftung, Vienna
Strobl 1267

96

Study for the Portrait of
Margaret Stonborough-Wittgenstein 1904–05
Black crayon, 55 × 34.8 cm
Graphische Sammlung Albertina, Vienna
Strobl 1270

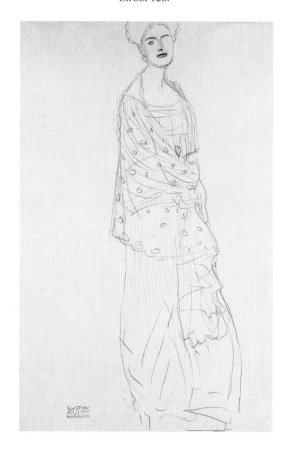

97

Study for the Portrait of
Margaret Stonborough-Wittgenstein 1904–05
Red pencil, 55.5 x 35 cm
Neue Galerie der Stadt Linz, Austria
Strobl 1271

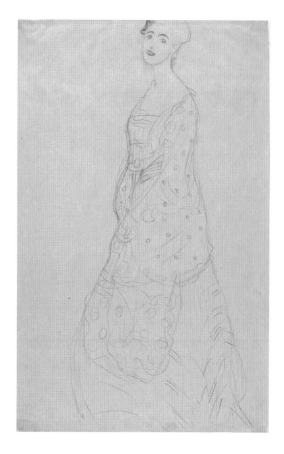

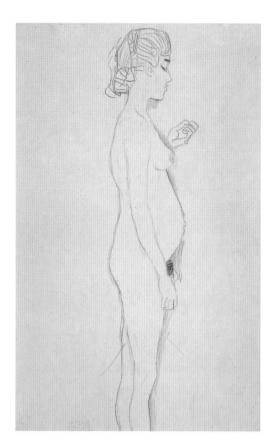

98

Standing Pregnant Woman in Profile 1904–05
Study for *Hope II*
Blue pencil, 54.7 × 34.4 cm
Leopold Museum—Privatstiftung, Vienna
Strobl 1748

99

Standing Pregnant Nude in Profile 1904–05
Study for *Hope II*
Black crayon, 44.8 × 31.4 cm
Historisches Museum der Stadt Wien, Vienna
Strobl 1750

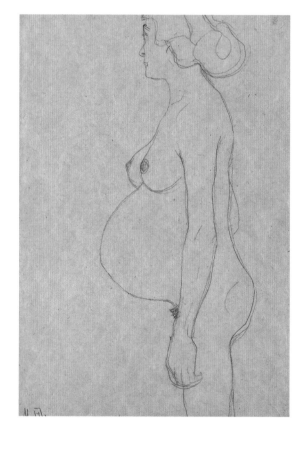

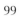

100

Standing Pregnant Woman in
Profile with Wrap 1904–05
Study for *Hope II*
Graphite and black crayon, 56 × 36 cm
Leopold Museum—Privatstiftung, Vienna
Strobl 1766

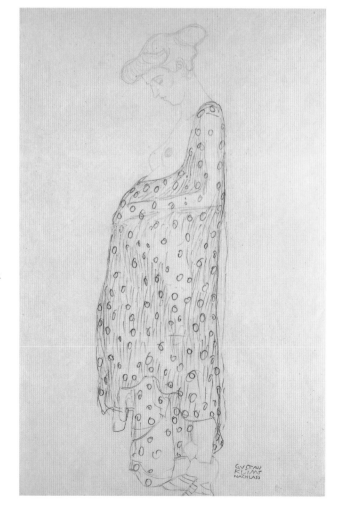

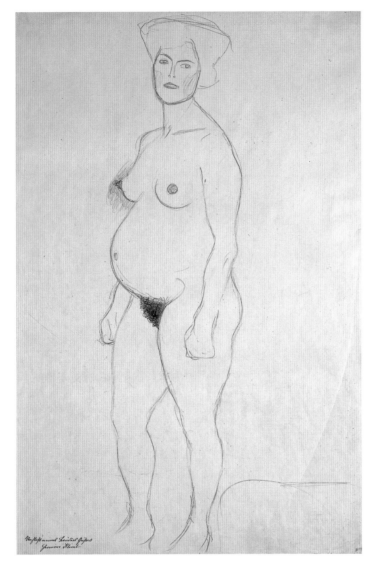

101

Standing Pregnant Nude 1907–08
Study for *Hope II*
Graphite, red and blue pencil, 55.9 × 37.1 cm
Historisches Museum der Stadt Wien, Vienna
Strobl 1771

102

Pregnant Woman in Profile 1907–08
Study for *Hope II*
Graphite, red and blue pencil, 55.7 × 37 cm
Graphische Sammlung Albertina, Vienna
Strobl 1776

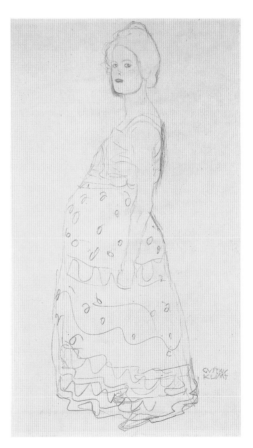

103

Three Standing Nudes
(called "The Three Courtesans") c. 1908
Graphite, 56 × 36.8 cm
The Museum of Modern Art, New York
W.B. Jaffe Fund
Strobl 1713

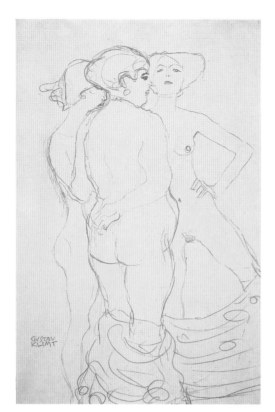

104

Standing Couple in an Embrace c. 1908
Study for *The Kiss*
Graphite, 54.9 × 34.9 cm
Historisches Museum der Stadt Wien, Vienna
Strobl 1739

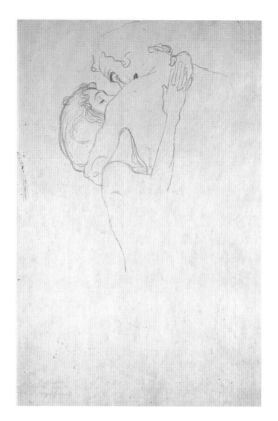

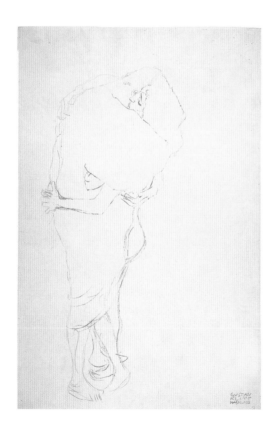

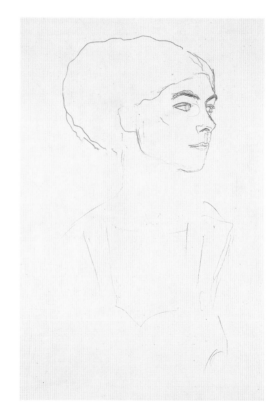

105

Standing Couple in an Embrace c. 1908
Study for *The Kiss*
Graphite, 55.8 × 36.7 cm
Leopold Museum—Privatstiftung, Vienna
Strobl 1788

106

Head Study c. 1908
Possibly for "Expectation" in the *Stoclet Frieze*
Graphite, 49.4 × 33.6 cm
Graphische Sammlung Albertina, Vienna
Strobl 1903

107

*Three Drawings for the Dining Room Frieze
of the Palais Stoclet, Brussels* 1905–11
Graphite and watercolour, each 22 × 75.3 cm
MAK–Österreichisches Museum für angewandte Kunst, Vienna
Strobl 3579, 3579a, 3579b

108

Crouching Female Figure c. 1909
Study for *Mother and Children*
Graphite, crayon, grey and brown wash, 54.9 × 34.8 cm
Historisches Museum der Stadt Wien, Vienna
Strobl 1865

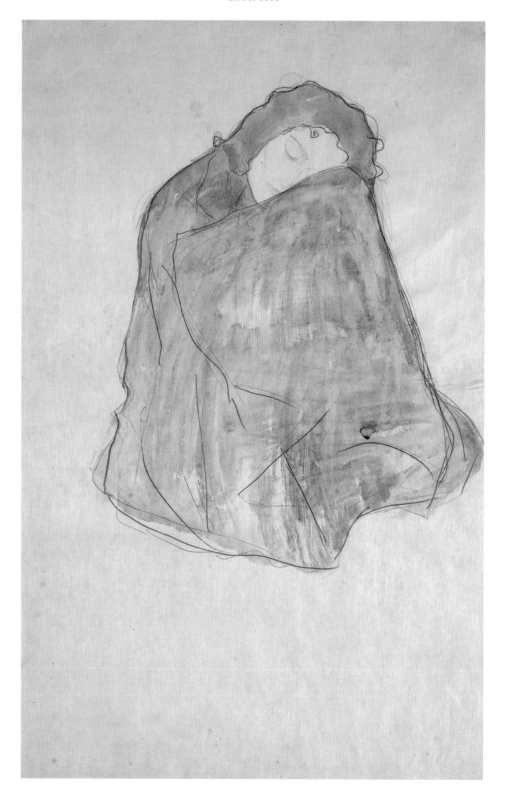

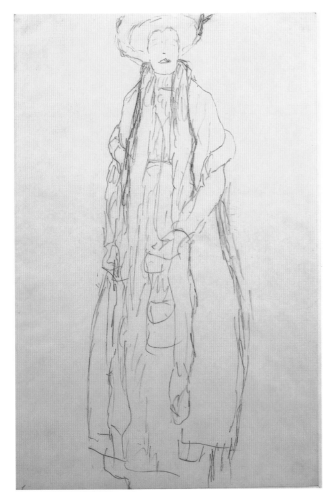

109

Study for the Portrait of Adele Bloch-Bauer II c. 1911
Graphite, 56.7 × 37.2 cm
Agnes Etherington Art Centre, Queen's University, Kingston, Ontario
Purchase, George Taylor Richardson Memorial Fund,
Walter and Duncan Gordon Foundation, and the Gallery Association,
2000
Strobl 2097

110

Study for the Portrait of Mäda Primavesi c. 1912
Graphite, 55.8 × 36.6 cm
Historisches Museum der Stadt Wien, Vienna
Strobl 2119

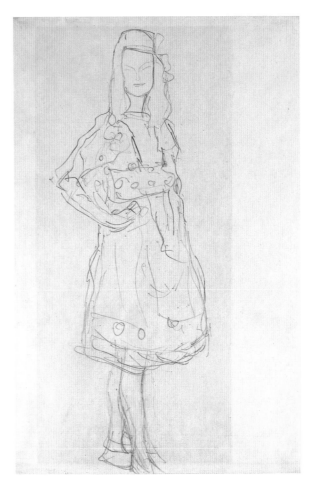

111

Reclining Nude with Legs Drawn Up 1912–13
Graphite, blue and red pencil,
white crayon, 37 × 55.8 cm
Historisches Museum der Stadt Wien, Vienna
Strobl 2317

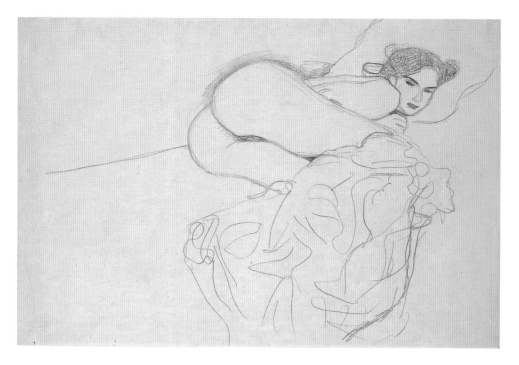

112

Standing Nude with Arms Folded Behind c. 1913
Study for *The Maiden*
Graphite, 56.4 × 36.9 cm
Graphische Sammlung Albertina, Vienna
Strobl 2194

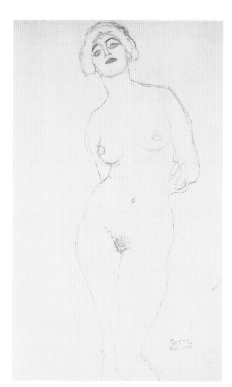

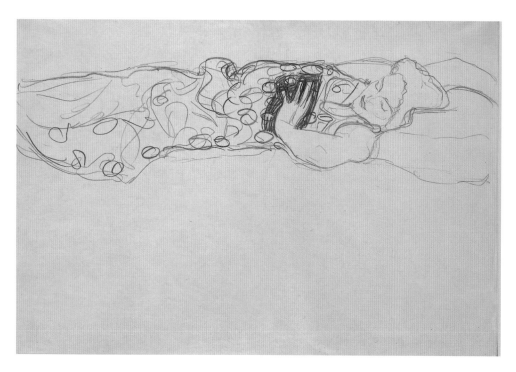

113

Sleeping Woman c. 1913
Study for *The Maiden*
Graphite and blue pencil, 37.2 × 56 cm
Historisches Museum der Stadt Wien, Vienna
Strobl 2234

114

Reclining Nude c. 1913
Study for *The Maiden*
Graphite, 37.5 × 57 cm
The Metropolitan Museum of Art, New York
Bequest of Scofield Thayer, 1982
Strobl 3664

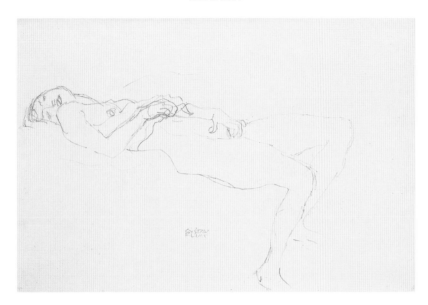

115

Reclining Nude (Self-embrace) c. 1913
Red pencil, 37 × 56 cm
Graphische Sammlung Albertina, Vienna
Strobl 2446

116

Two Reclining Nudes 1914–15
Graphite, 54 × 35.3 cm
The Metropolitan Museum of Art, New York
Bequest of Scofield Thayer, 1982
Strobl 2377

117

Reclining Nude 1914–15
Blue pencil, 37.1 × 55.8 cm
Historisches Museum der Stadt Wien, Vienna
Strobl 2405

118

Seated Woman 1916
Study for the *Portrait of Friederike Maria Beer*
Graphite, 57 × 37.4 cm
Graphische Sammlung Albertina, Vienna
Strobl 2537

119

Head and Shoulders of a Female Nude c. 1916
Graphite, 57 × 37.5 cm
Leopold Museum—Privatstiftung, Vienna
Strobl 2707

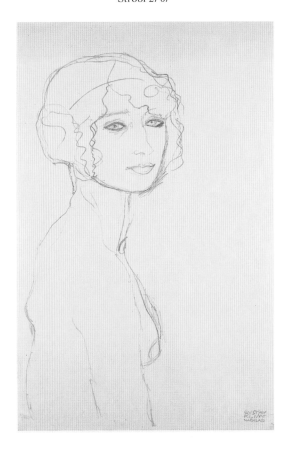

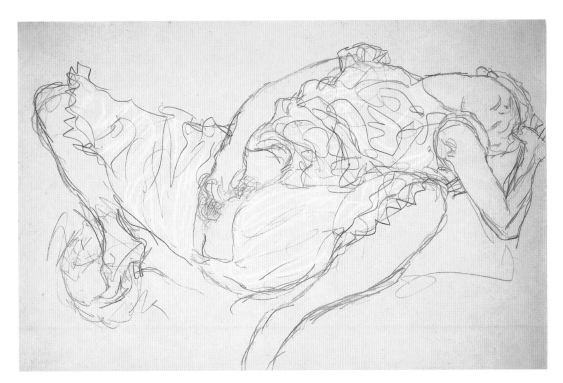

120

Reclining Woman in Lingerie 1916–17
Graphite with white highlights, 37 × 56.4 cm
Leopold Museum—Privatstiftung, Vienna
Strobl 2972

Woman in a Kimono 1917–18
Study for *The Portrait of Ria Munk III*
Graphite, 50 × 32.4 cm
The Museum of Modern Art, New York
Gift of Galerie St. Etienne
Strobl 2614

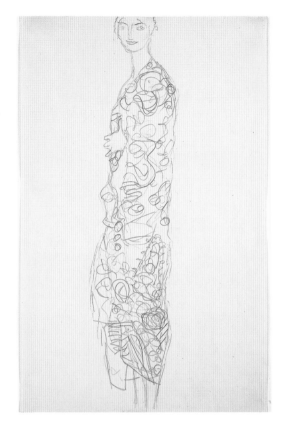

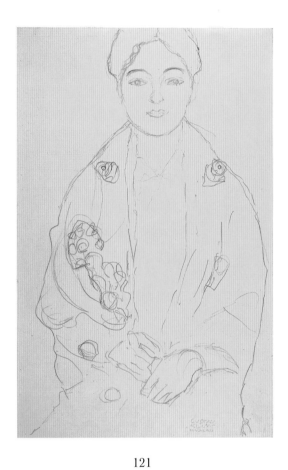

121

*Study for the Portrait of
Fräulein Lieser* 1917–18
Graphite, 50 × 32.4 cm
Leopold Museum — Privatstiftung, Vienna
Strobl 2603

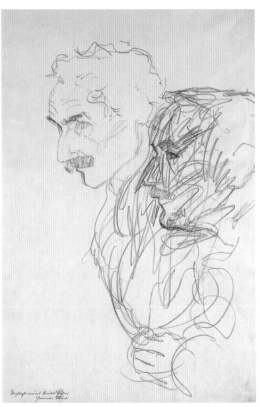

123

Two Head Studies of a Man 1917–18
For *Adam and Eve*
Graphite, 55.8 × 36.5 cm
Historisches Museum der Stadt Wien, Vienna
Strobl 2878

124

Study for "The Bride" 1917–18
Graphite, 56.6 × 37 cm
Graphische Sammlung Albertina, Vienna
Strobl 2986

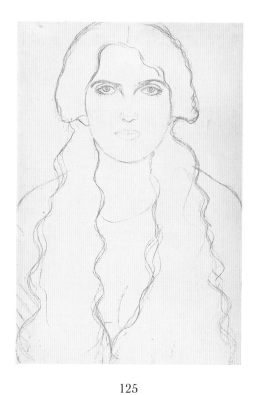

125

Young Woman with Unbraided Hair 1917–18
Study for *The Bride*
Graphite, 56.7 × 37.3 cm
Oberösterreichisches Landesmuseum, Linz, Austria
Strobl 3046

GVSTAV·KLIMT

1862

14 July: Gustav Klimt born in Baumgarten, then a suburb of Vienna, in a house located at 247 Linzerstrasse, since demolished. The second eldest of seven children of Ernst Klimt (1832–1892), a gold engraver whose family originated in Drabschitz (Trávčice), near Leitmeritz (Litoměřice) in Northern Bohemia (today Czech Republic), and Anna Finster (1836–1915) of Vienna.[1]

1867

Gustav attends elementary school in Vienna.[2]

1873

May: Stock market crash in Vienna causes financial difficulties for the family. Gustav obliged to stay home from school.[3]

1876

October: Enters the Kunstgewerbeschule (School of Applied Arts) of the Österreichisches Museum für Kunst und Industrie (Austrian Museum for Art and Industry), where he would remain as a student and apprentice until 1883.[4]

1877

Klimt's brother Ernst (1864–1892) also enters the Kunstgewerbeschule. The two originally trained as drawing teachers for secondary school.[5]

1878–79

Gustav Klimt, Ernst Klimt, and fellow student Franz Matsch (1861–1942) awarded stipends of twenty gulden a month to train as decorative painters in the Fachschule für Zeichnen und Malerei (Technical School for Drawing and Painting) of the Kunstgewerbe-

schule, under Ferdinand Laufberger. (At the time, one gulden would buy a good meal at a local restaurant.) To supplement their scholarship, Ernst and Gustav did technical drawings for ear specialist Adam Pollitzer and portrait drawings from photographs at five gulden each (fig. 163).[6]

1880

First decorative commission, for *Poetry*, *Music*, *Dance*, and *Theatre*, for the house of architect Johann Sturany.[7]

1881

After Laufberger's death, continues studies with Julius Berger. Begins work for publisher Martin Gerlach on *Allegorien und Embleme* (cat. 1 and 2) with *Times of Day*.[8]

1883

Moves into a studio at 8 Sandwirtgasse, in Vienna's 6th district, with brother Ernst and Franz Matsch; they form the Künstlerkompanie (Artists' Company) to carry out decorative commissions including tapestry designs and old master copies for the King of Romania, and ceiling paintings for theatres in Fiume (Rijeka, Croatia) and Karlsbad (Karlovy Vary, Czech Republic).[9]

1886

20 October: Contract issued to the Klimt brothers and Matsch by the Hof-Bau-Comité (Imperial Building Commission) for ceiling paintings in the two staircases of the new Burgtheater, on the recommendation of one of the architects, Baron Karl von Hasenaur. Klimt is responsible for the *Cart of Thespis*, *Shakespeare's Theatre* (fig. 38, cf. cat. 40, 41), *Altar of Dionysus* (fig. 145, cf. cat. 43), *Theatre in Taormina* (fig. 164, cf. cat. 42), and *Altar of Apollo*.[10]

1887

Recognized as "an artistic talent of first rank" for his work on the Burgtheater.[11]

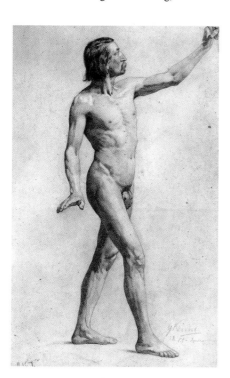

Opposite:
Detail of
Theater in Taormina
(fig. 164)

FIGURE 162
Study of a Male Nude
dated April 1879
Historisches Museum
der Stadt Wien, Vienna

FIGURE 163
Portrait Drawing
(possibly after
photograph) dated 1879
Private collection

FIGURE 164
Theater in Taormina
1886–88
Ceiling of the north
staircase of the
Burgtheater, Vienna

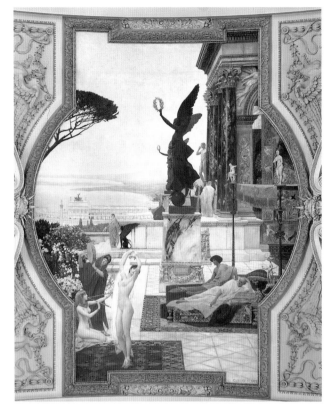

1888

Fortieth anniversary of Emperor Franz Josef's reign. On completion of Burgtheater murals, Klimt awarded "Golden Order of Merit with Crown."[12]

14 March: Klimt and Matsch write to Eduard Seis, curator, Bibliothek der Stadt Wien, that their gouache paintings of the Burgtheater (cat. 3) will be delayed past 15 March deadline because of the time-consuming work of auditorium measurements and portrait studies.[13]

August: With brother Ernst at Innsbruck, Salzburg, and Königsee.[14]

1889

Idyll (cat. 2) and *The Realms of Nature* (cat. 37) included in the German section of the Paris Universal Exposition.[15]

28 August: Gustav and Ernst at Sankt Wolfgang, in the Salzkammergut region of western Austria.

1890

26 April: Klimt awarded "Kaiserpreis" (Emperor's Prize) of 400 ducats (about $10,000 today) in recognition of *Auditorium of the Old Burgtheater* (cat. 3), exhibited at the Künstlerhaus, Vienna, in March.[16]

FIGURE 165
*Early Italian Art:
Florentine Quattrocento I
and Angel of the
Annunciation* 1890–91
Staircase of the
Kunsthistorisches
Museum, Vienna

Far right:

FIGURE 166
Portrait of Emilie Flöge
1891
Private collection

Work begins on the staircase paintings of the Kunsthistorisches Museum (fig. 165).

8 June: Klimt and Ernst in Venice.[17]

1891

Ernst Klimt marries Helene Flöge (1871–1936), the daughter of Hermann August Flöge (1837–1897), a manufacturer and exporter of meerschaum pipes.[18]

Klimt does first portrait of Helene's sister, Emilie (1874–1952), a pastel (fig. 166).

Joins the conservative Viennese artist's union (Künstlerhaus).[19]

1892

Klimt brothers and Matsch first suggested as possible candidates to execute the ceiling paintings of the Great Hall (Aula) of the University of Vienna.[20]

Takes studio at 21 Josefstädterstrasse, in Vienna's 8th district, with Ernst Klimt and Franz Matsch, where he will remain until 1914.

13 July: Death of Klimt's father.[21]

9 December: Brother Ernst dies and Klimt becomes guardian of niece, Helene Klimt Donner (1892–1980). Künstlerkompanie dissolved.[22]

1893

6 January: In Totis (Tata), Hungary, to paint *Auditorium of the Schloss Esterházy Theatre*, which wins silver medal at Künstlerhaus exhibition in March and grand prize at next year's Antwerp exhibition.[23]

October: Matsch becomes professor of painting at the Kunstgewerbeschule.[24]

21 December: Klimt nominated for professorship in the School of Historical Painting (Spezialschule für Historienmalerei) at the Vienna Academy (Akademie der bildenden Künste); prepares *Curriculum vitae*. Though Klimt was the only candidate recommended by selection committee, Polish painter Kasimir Pochwalski appointed.[25]

1894

4 September: On the basis of studies submitted, the Academic Senate of the University of Vienna awards Klimt and Matsch com-

mission for ceiling paintings.[26] Klimt is assigned *Philosophy*, *Medicine*, and *Jurisprudence* and ten spandrels related to these faculties.[27]
December: Exhibition of the Munich Secession at the Künstlerhaus, initiated by younger members.[28]

1895

Pauline Flöge (1864–1917), eldest sister of Emilie, starts a school for dressmakers at 18 Westbahnstrasse.[29]
Klimt meets Alma Schindler (later Mahler-Werfel) for the first time, at the unveiling of a monument to her father, landscape painter Emil Jakob Schindler (1842–1892).[30]
Begins work on over-door paintings for the Music Room of Nikolaus Dumba's palace on Vienna's Parkring.[31]

1896

February: Listed as belonging to the curatorial body (Curatorium) of the Society for Reproductive Art (Gesellschaft für Verfielfältigende Kunst), who had commissioned the *Portrait of Josef Lewinsky* (cat. 7).[32]

1897

3 April: Constitution of the *Vereinigung bildender Künstler Österreichs* (Union of Austrian Artists), known as the "Secession" following the example of the Munich Secession, as an exhibition society devoted to raising awareness of artistic developments outside Austria; Klimt named first president (fig. 167).[33]
14 April: In his first extant correspondence with Emilie Flöge, excuses himself from attending class, likely the French lessons they took together through July 1900.[34]
24 May: Writes letter of resignation from the Künstlerhaus, signed by twelve other artists.[35]
Summer: At Fieberbrunn, near Kitzbühel, in the Austrian Tyrol.[36]
28 December: Death of Emilie's father.[37]

1898

January: First issue of *Ver Sacrum*, official publication of the Vienna Secession.
Takes an additional studio at 54 Florianigasse to work on the University paintings, until 1906.[38]
March: Following censor's objections, alters design for poster of the first Secession exhibition (cat. 62–64), showing a nude Theseus battling the Minotaur.[39]
Member of the International Society of Painters, Sculptors and Engravers, chaired by James McNeill Whistler.[40]

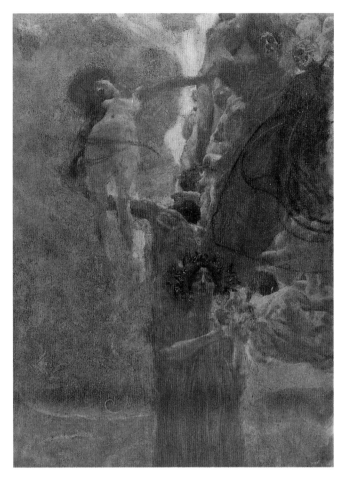

26 March–15 June: First Secession exhibition, held in the buildings of the Gartenbaugesellschaft, Vienna; 56,800 visitors and 85,000 gulden from sales of art works.[41]
18 April: Alma Schindler reports *Ver Sacrum* circulation as 2,000: "The Klimt number alone [March] caused it to rise by over 1,000."[42]
4 May: Despite resistance among Secession members, Klimt is re-elected as president.[43]
26 May: Artistic Commission of Ministry of Education finds the female figure representing "suffering mankind" in Klimt's study for *Medicine* obscene (fig. 168), and suggests she be replaced by the figure of a boy (cf. cat. 69).[44]
24 June: Tells Alma Schindler: "The only thing that might prevent me [from completing the University paintings] would be marriage or insanity."[45]
17 September: In Sankt Agatha, in the Salzkammergut, with Emilie Flöge, where he paints his first landscapes.[46]

Far left:
FIGURE 167
Group portrait at the time of the founding of the Secession, c. 1897–98
Klimt is third from left; Josef Hoffmann stands to his right, partially blocked by Carl Moll; Koloman Moser is in the back row (right) in a bowler hat; Fritz Waerndorfer sits at centre front, smoking

Above:
FIGURE 168
Sketch for the University Painting "Medicine"
1897–98
Private collection, Vienna

FIGURE 169
Secession Building, c. 1900
Austrian Archives / Christian Brandstätter, Vienna

12 November: Second Secession exhibition opens in new building designed by Josef Maria Olbrich (fig. 169), with these words over the entrance: "Der Zeit ihre Kunst, der Kunst ihre Freiheit" ("To every age its art and to art its freedom").

1899

18 March–31 May: Fourth Secession, including *Nuda Veritas* (cat. 12) and *Schubert at the Piano*, the second over-door for the Dumba Music Room (cf. cat. 51–53).

24 April: Arrives in Florence to visit the family of artist Carl Moll, touring there with Alma Schindler; according to Alma, Klimt is never without his copy of *Faust*.[47]

FIGURE 170

Alma Schindler with a bearskin (detail); Alma gave this photo to Klimt on 4 May 1899 in Venice

Bildarchiv, Österreichische Nationalbibliothek, Vienna

28 April: Alma comments on the artist's finances: "We were told that five women are completely dependent upon him: his mother, his sister, his sister-in-law, her sister and a young niece. It's all well and good, but nothing is getting sold." And: "Three sisters, one of them mentally unbalanced, his mother at times also off her head."[48]

On the train between Genoa and Verona, Klimt reveals his obsession with mental illness, citing from the Latin version of Sophocles' *Antigone*: "Quos deus perdere vult prius dementat" ("Whom a god would destroy, he first drives mad").[49]

1 May: In Verona, Klimt reportedly kisses Alma Schindler and says, "There's only one thing for it: complete physical union."[50]

3 May: In Venice with the Molls; departs 6 May.[51]

6 July: Meets Emilie Flöge at the Raimundtheater, Vienna, for an evening performance of Ibsen's *Ghosts* by the Deutsches Theater Berlin.[52]

Summer: Vacations at Golling, near Salzburg.[53]

August: A son, Gustav ("Gusterl"), is born out of wedlock to Klimt and Marie (Mizzi) Zimmermann, a model who first appears in *Schubert at the Piano*, 1899 (fig. 171).[54]

1900

12 February: Alma Schindler is told that the Academy had awarded Klimt an honorary fellowship. "It still needs to be confirmed by the Ministry and by that arch-booby, H.M. the Kaiser. Klimt deserves it—he's our leading artist, a true genius. I revere him as an artist and love him as a man." The fellowship was not confirmed.[55]

Appointed to the editorial committee of *Ver Sacrum* for the year.

8 March–6 June: Seventh Secession. Klimt's *Philosophy* exhibited for first time until end of March; immediately draws protest and 35,000 visitors, the most since the opening of the Secession in 1898.[56]

After the Rain, 1898 acquired by the Moderne Galerie, Vienna;[57]

Far right, above:

FIGURE 171

Schubert at the Piano II
1899
Destroyed by fire in 1945; Marie is at left, facing out

Far right, below:

FIGURE 172

Klimt paintings, including *Medicine*, at the Tenth Secession, 1901
Austrian Archives / Christian Brandstätter, Vienna

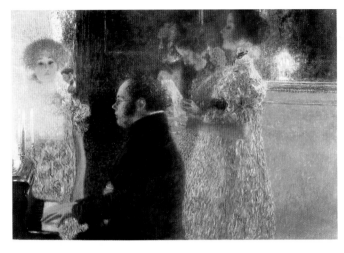

exhibition also includes Jan Toorop's *Three Brides*, 1893 (fig. 159).

15 April–12 November: Universal Exposition, Paris. Among forty-two works by Secession members are *Pallas Athena* (cat. 11), *Sonja Knips*, and *Philosophy*, which wins gold medal. German art critic Richard Muther comments: "When, in the year 2000, one looks back upon the source of the last century's developments, it will be to the venerable and everlasting youth of the Austrian 'Sacred Spring'."[58]

August: Vacationing at the Brauhof Litzlberg on the Attersee, where he has begun work on five paintings; returns to Vienna about 3 September.[59]

1901

Historisches Museum der Stadt Wien acquires Klimt's contributions to *Allegorien und Embleme* from an exhibition of the collection of publishers Gerlach und Schenk at Vienna City Hall.[60]

Sketch for *Music I*, 1895, acquired by the Bayerische Staatsgemäldesammlungen, Munich.[61]

15 March–12: May: *Medicine* and *Judith I* exhibited at the tenth Secession exhibition (fig. 172).

19 March: Public prosecutor applies for confiscation of the March issue of *Ver Sacrum* containing nude studies for *Medicine* (cf. cat. 66); overruled 21 March by the Vienna court (Landesgericht), on the basis that they were "studies of movements" for the use of artists.[62]

20 March: Parliamentary petition regarding Klimt's *Medicine*: "Which in its type of representation stands for a kind of artistic trend that without question goes against the aesthetic feelings of the majority of the population."[63]

22 November: Opening of the twelfth Secession exhibition, devoted principally to Scandinavian, Russian, and Swiss artists; included

Edvard Munch's *Anxiety*, 1894 (Munch Museet, Oslo) and a room with twenty-one works by Dutch Symbolist Jan Toorop.[64]
November–December: Nominated by the Akademie der bildenden Künste for a vacant professorship; proposal eventually rejected by the Ministry of Culture and Education.[65]

1902

15 April–27 June: Fourteenth Secession includes Klimt's *Beethoven Frieze* (fig. 173, 174). Critic Ludwig Hevesi comments: "This is a Church of Art, which one enters to be edified and leaves a believer."[66]
7 June: French sculptor Auguste Rodin, on a two-day visit to Vienna, meets Klimt and other Secession members at a banquet in his honour, and praises Klimt's *Beethoven Frieze*.[67]
22 June: A second son, Otto, born to Klimt and Marie Zimmermann; dies 11 September.[68]

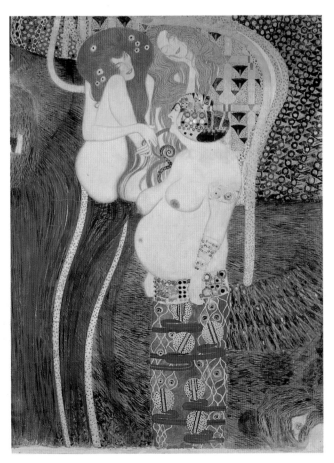

1903

17 January–28 February: Sixteenth Secession, "Development of Impressionism." *The Plain at Auvers-sur-Oise*, 1890 (fig. 175), one of five van Gogh paintings shown, is purchased by the Secession and donated to the Moderne Galerie, Vienna.[69]
8 May: In Venice, complains of cold and rain. The next day in Ravenna, sends his mother postcard of the interior of the Byzantine church of San Vitale.[70]
19 May: Registration of the Wiener Werkstatte, with architect Josef Hoffmann, chairman, manufacturer Fritz Waerndorfer, treasurer, and designer Kolo Moser, director.[71]
Summer: Vacations at the Attersee, until 7 September.[72] Studies Japanese art in the mornings; in the evenings looks for landscape subjects with his "finder," a piece of cardboard with a square hole cut into it.[73]
18 September: Fritz Waerndorfer, first owner of *Hope I* (cat. 18), writes Hermann Bahr about publishing a collection of writings critical of Klimt, as a way to expose the superficial nature of such opinion; this results in *Gegen Klimt* (*Against Klimt*) (1903).[74] Bahr notes in his journal: "Such passion, madness, why this hate . . . Bruckner, Hugo Wolf, Schopenhauer, but so specifically Austrian this masochism."[75]
21 October: The Secession appeals the Ministry of Culture and Education's decision to withhold Klimt's University paintings from upcoming *Klimt Kollektive* exhibition if the artist insists on showing *Hope I*. Klimt eventually withdraws the painting.[76]
1 November: Bahr is refused permission by the censor to give a reading of Arthur Schnitzler's *Reigen* (*Round Dance*), a play considered scandalous.[77]
13 November: Hevesi writes of seeing *Jurisprudence* (fig. 4) in Klimt's studio, and is reminded of the mosaics he had just seen in Italy.[78]
14 November–6 January 1904: Eighteenth Secession, *Klimt Kollektive* (fig. 176), with eighty works in catalogue, including many drawings, for example no. 49: "Movement Studies for a Portrait" ("Bewegungsstudien zu einem Bildnis"). *Jurisprudence* exhibited for the first time, together with *Philosophy* and *Medicine*, each listed as "unfinished." Klimt designs poster on the theme of "Ars" (Art) drawn from his painting *Pallas Athena* (fig. 177). Seven paintings sold opening day.[79]
21 November: Karl Kraus writes critically of *Jurisprudence* in *Die Fackel*: "Tipsy students who are fined ten crowns for calling a policeman 'octopus' [Polyp] must envy Herr Klimt for getting away with a painted insult."[80]
In the booklet *Gustav Klimt* (1903), Felix Salten writes: "Gustav Klimt is Viennese, but that much is known already, he is honoured throughout the world, and only insulted in Vienna."[81]
28 November–10 December: Returns to Italy via Villach (28 Nov.); Pontebba and Venice (29 Nov.), Padua (30 Nov.), Ravenna (2 Dec.): "Lots of miserable things in Ravenna—the mosaics are unbelievably wonderful." Florence (4 Dec.): "Artistic impressions very strong. Tomorrow Saturday Pisa—art pilgrimage over."[82]

FIGURE 176

Hallway of *Klimt Kollektive*, 1903; with *Pallas Athena* in background Bildarchiv, Österreichische Nationalbibliothek

Below:

FIGURE 177

Klimt's poster design for the Eighteenth Secession Bildarchiv, Österreichische Nationalbibliothek

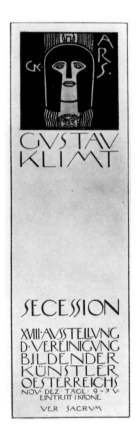

Right:

FIGURE 178

"At the Klimt Exhibition," cover of *Die Moden-Zeit* (Vienna), 15 December 1903

Far right:

FIGURE 179

Josef Hoffmann's proposal for the Secession room at the St. Louis World's Fair, 1904 Austrian Archives / Christian Brandstätter, Vienna

3 December: Peter Altenberg writes of Klimt: "His is a passionate, fervent, desirous nature that longs for the sun, that soars, that flies away from earthly difficulties! Like someone longing for a new, better, more redemptive religion, for a truth in enduring forms, for some ultimate object to bring serenity and peace!"[83]

1904

Paul Bacher (d. 1908), Viennese gold and silver maker, acquires Galerie Miethke, for which Carl Moll (1861–1945), a Secession founder, acts as artistic director. Galerie Miethke becomes principal representative of Klimt's work in Vienna.[84]

22 January–6 March: Nineteenth Secession includes retrospective of works by Ferdinand Hodler, who may have acquired Klimt's *Judith I*, 1901, from Dr. Anton Loew at this time.[85]

26 January: Ministry of Culture and Education rejects Secession's proposal to limit paintings section of Austrian exhibit at St. Louis World's Fair (fig. 179) to four Klimt works (*Philosophy*, *Jurisprudence*, and two landscapes), finding that too few artists would be represented; ultimately, no Klimt works included.[86]

1 July: The three Flöge sisters, Pauline, Helene, and Emilie, establish the fashion house *Schwestern Flöge* (active until 1938) in their apartment, Casa Piccola, 1b Mariahilferstrasse, Vienna. The showrooms would open with an interior designed by Hoffmann and Moser.[87]

29 July: From Brauhof Litzlberg, Attersee, Klimt orders monographs on Dürer, Michelangelo, Ghirlandaio, Mantegna, and Böcklin by Hermann Knackfuss from the bookseller Artaria, Vienna.[88]

1905

Mid-March: Begins portrait commission of Margaret Stonborough-Wittgenstein (fig. 180), for which he will be paid 5,000 gulden.[89]

3 April: Submits letter to the Ministry of Culture and Education withdrawing from the University commission, published 12 April in the *Wiener Allgemeine Zeitung*. Klimt later quoted as saying: "I will never, certainly not under the present ministry, have a part in an official exhibition, unless my friends force me to do so. Enough of censorship, it's time to take matters into my own hands."[90]

19–21 May: In Berlin for the second Deutscher Künstlerbund exhibition; fifteen of his paintings on view including *Hope I*, seen publicly for the first time.[91]

June: A split in Secession membership between what Hevesi calls the "Impressionists," around Josef Engelhart, who wish to arrange purely pictorial exhibitions, and the "Stylists," also known as the "Klimt-Gruppe." The latter includes Josef Hoffmann and Otto Wagner, and affirms the important role of the decorative arts in influencing modern life through art.[92]

3 October: Berta Zuckerkandl reports that the Wiener Werkstätte is being enlarged for the Stoclet commission: "Klimt is to give his decorative imagination a free rein, whether it be in the form of frescoes or mosaics, or as reliefs."[93]

9 December: Premiere in Dresden of Richard Strauss's opera *Salome*. Gustav Mahler denied permission by the censor to perform it at the Vienna Opera.[94]

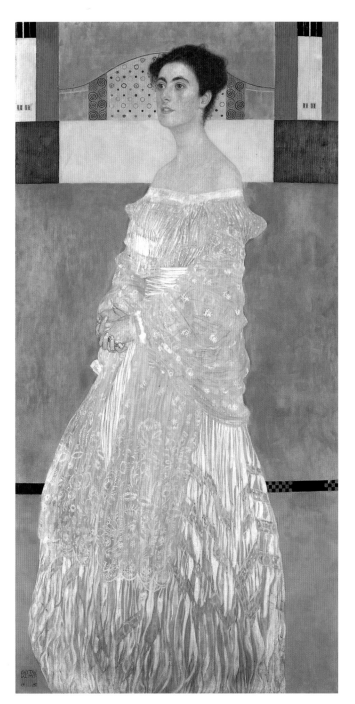

1906

January: Van Gogh exhibition at Galerie Miethke.[95]

12 March: Klimt named honorary member of the Königlich Bayerische Akademie der bildenden Künste, Munich (fig. 182), and is subsequently referred to as "professor" in the German press.[96]

1–8 May: After a stop in Brussels regarding the *Stoclet Frieze*, Klimt in London with designer Carl Otto Czeschka, Josef Hoffmann, and Fritz Waerndorfer on the occasion of the Wiener Werkstätte display at Earl's Court Imperial Royal Austrian Exhibition (fig. 183). Meets with Charles Rennie Mackintosh on opening day (5 May).[97] Reports to Emilie Flöge (7 May): "Metropolitan life overwhelming. The smell in the air is not very good at first, like the smoke from a coal-fired stove."[98]

10–12 May: Returns to Vienna via Berlin and Dresden.[99]

Summer: Photographs Emilie Flöge modelling his designs for ten dresses (fig. 184). Vacations at the Attersee.[100]

7 December: In Florence.[101]

Far left, above:
FIGURE 180
Portrait of Margaret Stonborough-Wittgenstein
1905
Bayerische Staatsgemäldesammlungen, Neue Pinakothek, Munich

Far left, below:
FIGURE 181
Klimt with Baroness Editha Sustenau von Schützenthal and her daughter Hertha von Mautner-Markhof
Bildarchiv, Österreichische Nationalbibliothek, Vienna

Above:
FIGURE 182
Certificate naming Klimt honourary member of the Bayerische Akademie, Munich, dated 12 March 1906
Klimt Archive, Graphische Sammlung Albertina, Vienna

FIGURE 183
Carl Otto Czeschka (left), Klimt (centre), and Fritz Waerndorfer on a boat crossing the English Channel, May 1906
Photograph by Josef Hoffmann
Bildarchiv, Österreichische Nationalbibliothek, Vienna

1907

February: Arthur Krupp (1856–1938), president of the Austrian Krupp works in Berndorf, and his wife, state their intention to sit for portraits by Klimt, apparently never completed.[102]

2 February–March: University paintings exhibited at Galerie Keller und Reiner, Berlin.[103]

22 March: Discusses "Spiritism etc." with playwright Arthur Schnitzler and other guests at Fritz Waerndorfer's home, where Schnitzler sees *Hope I*.[104]

May: Klimt's erotic drawings published in *Die Hetärengespräche des Lukian* (*Lucian's Dialogues of the Courtesans*), translated into German by Franz Blei (cat. 89).[105]

Summer: Meets Egon Schiele for the first time; start of a long and close relationship, as reflected in Schiele's *Hermits*, 1912 (fig. 192).[106]

Mid-July: Arrives at Brauhof Litzlberg on the Attersee for the summer.[107]

19 October: Opening of the Cabaret Fledermaus. The programme included Peter Altenberg's play *Masken* (*Masks*), with costumes designed by Klimt.[108]

8–11 November: In Berlin; visits architecture critic Hermann Muthesius, who helped found the German Werkbund in October.[109]

1908

May–June: *Kunstschau Wien* (fig. 186), organized by the "Klimt-Gruppe," with a strong arts and crafts theme.

Klimt delivers opening address: "No aspect of human endeavour is too small or insignificant to be considered outside the artistic sphere; that, in the words of [British designer William] Morris, the plainest object, when it is perfectly executed, helps to increase the beauty of this earth and that the advancement of culture is based upon the eventual permeation of artistic purpose through the whole of life." For Klimt, the show was "a review of Austrian artistic aspirations, a true reflection of the state of culture in our empire."[110]

Oskar Kokoschka (1886–1980) is given a small room to himself, but fearing criticism, refuses entry to Klimt, Hodler, and members of the jury. Klimt is recorded as saying, "Let the fellow get himself torn apart by the press, if that's what he wants."[111]

At this time, the Ministry of Education purchased *The Kiss* (then known as *Liebespaar*), 1908 (fig. 13), for the Moderne Galerie for 25,000 gulden; Klimt subsequently retouched the decorative details of the man's robe to heighten contrast with the woman's robe.[112]

June: Galerie Miethke publishes first installment of subscription portfolio of reproductions of the artist's work, *Das Werk Gustav Klimts*.[113]

Early July: Historisches Museum der Stadt Wien acquires *Portrait of Emilie Flöge*, 1902 (cat. 15) for 12,000 crowns.[114]

9–10 July: In Munich to see galleries and exhibitions; then to the Attersee where he spends his first summer at the Villa Oleander.[115]

1909

27 February: Attends performance of Johann Strauss's *Die Fledermaus*.[116]

5 March: Complains of exhaustion: "I am looking very pale and sickly. . . . And debt collecting—ugh!—getting money out of the rich—revolting!—and having to run round to boards and ministers in this shabby state of mind and body—to have to 'push around' for a few 'netsch' [bills of money]."[117]

9 March: Celebrates writer Peter Altenberg's fiftieth birthday with Josef Hoffmann and others.[118]

July: Second *Kunstschau* includes the first public exhibition in Vienna of *Hope I* (cat. 18), on view with *Hope II* (cat. 24); Schiele exhibits four paintings and proposes an international *Kunstschau* for

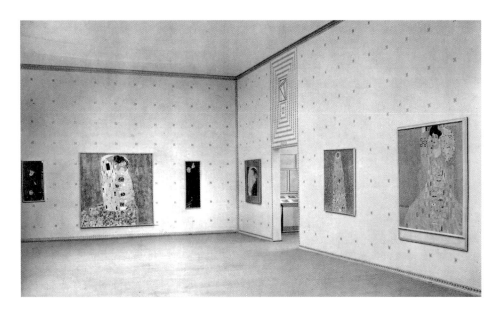

only fine arts.[119] Berta Zuckerkandl recalls that after the 1909 *Kunstschau*, Klimt claimed: "The young ones don't understand me any more. They are going in a different direction. I don't know whether they value me at all."[120]

July–September: Vacations at the Villa Oleander, Attersee.[121]

16–24 October: In Paris, sees Musée Guimet collection and admires Manet's *Olympia* at the Luxembourg Palace. Visits a private gallery with Hugo von Tschudi, director of the Staatliche Galerien, Munich, and is impressed by Cézanne and more Manet. In the evening goes to the Folies-Bergère.[122]

25–31 October: In Spain with Carl Moll, who was preparing a Goya show for Galerie Miethke. Klimt writes: "Spain a strange country! Wretched—desolate—monotonous—monochrome—lonely—lonely! And yet interesting—hard—dry in its beauty!" "Velasquez really *disappointing!*" In Toledo on 28 October, finds El Greco magnificent, the city to be "real Spain, just as you imagine it."[123]

November: Toulouse-Lautrec exhibition at the Galerie Miethke.[124]

1910

Fashion department of the Wiener Werkstätte founded under Eduard Josef Wimmer.[125]

National Gallery, Prague, acquires *Farm Garden* (cat. 23) and *Schloss Kammer on the Attersee I*, c. 1908.[126]

22 April–31 October: Ninth Biennale, Venice. Among the twenty-two paintings in Klimt room (fig. 23) are *Roses under Trees* (cat. 20), *Park* (cat. 27), *Pond at Schloss Kammer* (cat. 28), and *Vision (Hope II)* (cat. 24). *Judith II* (fig. 36) acquired by the Galleria Internazionale d'Arte Moderna, Venice.

July: Works intensely on the *Stoclet Frieze* at the Wiener Werkstätte; complains of "Arbeitssonntag" (working Sundays). Looking forward to the Attersee; reminds Emilie to order canvas and asks if she is painting.[127]

21 July: Visits the First International Hunting Exhibition with Josef Hoffmann, who designed the galleries. Show includes Egon Schiele's *Seated Female Nude with an Outstretched Arm*, 1910 (now lost).[128]

Late July: Invited by Alma Mahler to visit her in the Tyrol for a few days.[129]

3 August: With Flöge family at Villa Oleander, until the end of the month at least (fig. 189).[130]

1911

27–30 March: In Rome to participate in the *Esposizione internazionale*. Hoffmann's temple-like design for the Austrian pavilion allots the artist his own semi-circular room where *Jurisprudence* is hung on the axis (fig. 24). Klimt wins gold medal for *Three Ages of Woman*, 1905 (fig. 18), acquired by Galleria Nazionale d'Arte Moderna, Rome, in 1912.[131]

13 August: At the Attersee.[132]

1912

Moderne Galerie, Dresden, acquires *Beech Forest I*, c. 1902 (fig. 83), one of twelve works shown at the *Grosse Kunstausstellung Dresden*.[133] Klimt becomes president of the Österreichischer Künstlerbund, which would participate in the second Rome Secession of 1914.[134]

23 February: Writes to Emilie: "I really am getting my telephone today—who knows how much it will irritate me."[135]

27 June: Emilie Flöge's first summer at the spa in Bad Gastein, south of Salzburg. Klimt joins her there by 11 July; they both go on to Villa Oleander until second week in September. Klimt and Emilie will visit Bad Gastein each summer until his death.[136]

FIGURE 187

Klimt, from a series of photos taken 1908–09 by Studio d'Ora, Vienna
Bildarchiv, Österreichische Nationalbibliothek, Vienna

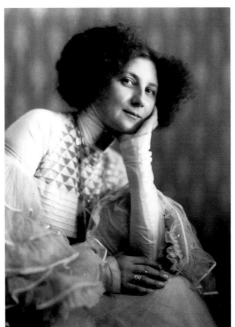

FIGURE 188

Emilie Flöge, 1908–09
Photograph by the Studio d'Ora
Bildarchiv, Österreichische Nationalbibliothek, Vienna

1913

10 July: Staying at the Villa Imperial, Bad Gastein, with Emilie and her mother, Barbara Flöge.[137]

31 July: In Italy, at the Albergo Morandi in Tremosine on Lake Garda, with Emilie, her mother, and sisters Helene and Pauline, until 10 September. Paints *Church in Cassone on Lake Garda* and *Malcesine on Lake Garda*.[138]

14 September: After a two-day visit with Emilie's brother Hermann and his wife, Therese (née Paulick), at Villa Paulick, in Seewalchen on the Attersee, Klimt departs for Vienna.[139]

1914

Moves into his last studio at 11 Feldmühlgasse (fig. 196) in the thirteenth district (Hietzing).[140]

National Gallery, Prague, acquires a second Klimt painting, *The Maiden*, 1912–13 (fig. 20).

February–June: *Portrait of Mäda Primavesi* (cat. 30) shown at the second Rome Secession (fig. 37).

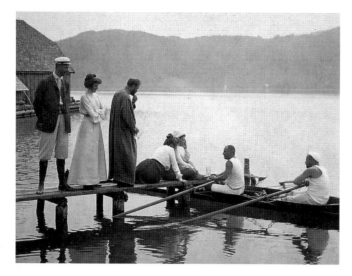

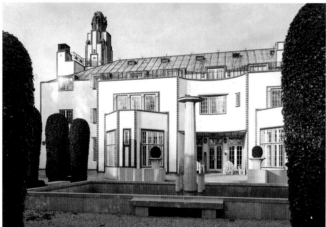

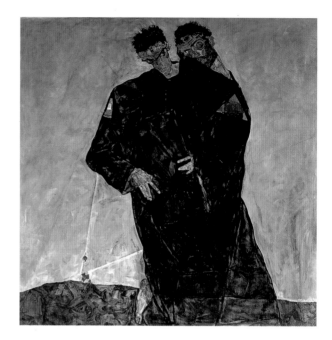

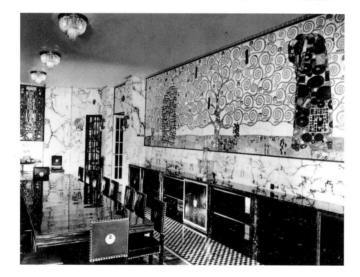

March: Financial restructuring of the Wiener Werkstätte after bankruptcy. Primavesi family gains largest block of shares.[141]

7 May: Fritz Waerndorfer, Klimt patron and Werkstätte supporter, now bankrupt, leaves for America.[142]

14 May: Arrives in Brussels. Stays until at least 22 May, while there begins a portrait, possibly of Suzanne Stoclet (see cat. 36). On 16 May he visits the Musée de Congo, Tervuren (today Musée Royal de l'Afrique Centrale): "The most beautiful things are the sculptures by these Congolese! They are splendid and magnificent—one is ashamed—that in their way they can do so much more than we can. I was completely captivated!" Klimt's own collection of African art may have been inspired by this experience.[143]

18 May: Meets Anton Hanak, Otto and Eugenia Primavesi (cat. 31), and Josef Hoffmann at the Palais Stoclet (they had driven up from the Cologne Werkbund exhibition): "Frau Primavesi said she was 'speechless' about the beauty of the house." Klimt's description of the mosaics suggests it is the first time he has seen them in situ.[144]

19 July: In Bad Gastein, about to leave with Emilie Flöge and her mother for Weissenbach on the Attersee, where he will stay until 11 September in the Forester's House. This will be his vacation home through 1916 and the subject of two paintings.[145]

28 July: Austria-Hungary declares war on Serbia, beginning World War I.

6 October: Meets Alma Mahler at the Vienna salon of collector Karl Reininghaus, who owned Klimt's *Beethoven Frieze* from 1907 until 1915 when it became part of the August Lederer collection.[146]

1915

6 February: Death of Klimt's mother.[147]

18 May: Arthur Schnitzler visits Klimt's studio: "With O. [Olga, his wife], afternoon: Hietzing, to Klimt. Studio, Feldmühlgasse, in middle of old garden. He shows me his drawings, some paintings, landscapes, portraits, fantasies, finished and unfinished; the landscapes especially: wonderful. He hasn't been 'happy' with any of them. He signs the purchased drawing for me [not identified], gives O. a photograph to take along. Takes us around the rooms and garden; and, all differences aside and in the face of the superiority of his artistry, I feel an inner affinity." In his diary, Schnitzler describes dreams in which Klimt appears.[148]

22 June: Otto Primavesi becomes commercial director of the Wiener Werkstätte.[149]

July: Soon after arriving at the Villa Paulick, asks sister Hermine Klimt to send his opera glasses. Klimt used opera glasses and a telescope for landscapes (fig. 198). Stays in Weissenbach until after 11 September.[150]

4–22 August: Has three paintings and twenty-two drawings in the *Wiener Künstler* (Viennese Artists) exhibition at Kunsthaus, Zurich.[151]

28 October: Briefly in Raab, Hungary, most likely to see August and Serena Lederer.[152]

10 December: Klimt visits the country house of Otto and Eugenia Primavesi in Winkelsdorf, Moravia (Czech Republic), designed by Josef Hoffmann.[153]

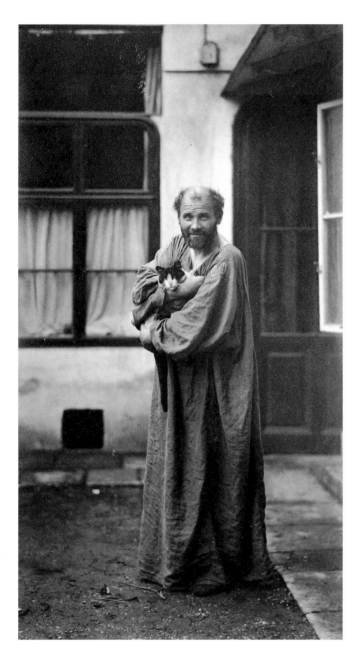

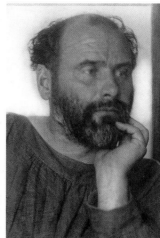

1916

12 March: Writes to Emilie at Dr. Mittner's in Steinakirchen am Forst in Lower Austria, where she is apparently staying for health reasons: "For the time being, only a hundred attempts. Today I will be especially industrious and bring a painting a little closer to an 'end.'"[154]

3 May: Informs Otto Primavesi that *Litzlbergerkeller on the Attersee* is finished, which suggests that he worked on it over the winter.[155]

25 May: Named member of the Sächsische Akademie der bildenden Künste, Dresden.[156]

28 May: Meets with Egon Schiele and painter Felix Albrecht Harta in Vienna. The two younger artists were then contributors to the Berlin journal *Die Aktion*.[157]

16 June: Remains involved in Wiener Werkstätte, attending a board meeting.[158]

Late July: Klimt, Emilie Flöge, and her mother arrive in Weissenbach.[159]

Summer: Photographed at Weissenbach with Friederike Maria Beer, whose portrait he had recently completed (fig. 199, 200).[160]

1917

6 January: From the Primavesi country house in Winkelsdorf, Klimt complains of exhaustion and health problems. He returns to Vienna by 11 January.[161]

2 March: Schiele lists Klimt as a co-founder of the "Kunsthalle," an exhibition and "work group" of artists, writers, and musicians, including composer Arnold Schönberg, architect Josef Hoffmann, and writer Peter Altenberg.[162]

Far left, above and below:
FIGURE 193
Klimt outside his Josefstädterstrasse studio, c. 1912–14
Photographs by Moriz Nähr
Bildarchiv, Österreichische Nationalbibliothek, Vienna

Above left:
FIGURE 194
Klimt by Moriz Nähr, c. 1912–14
Bildarchiv, Österreichische Nationalbibliothek, Vienna

Above right:
FIGURE 195
Klimt by Anton Josef Trčka, 1914
Bildarchiv, Österreichische Nationalbibliothek and Edition Skye, Vienna

FIGURE 196
Vestibule of Klimt's Feldmühlgasse studio, 1914, with furniture designed by Josef Hoffmann; Japanese prints on wall; and Asian decorative arts in cabinet
Photograph by Moriz Nähr
Bildarchiv, Österreichische Nationalbibliothek, Vienna

FIGURE 197
*Portrait of Elisabeth
Bachofen-Echt* c. 1914
Private collection

Below:
FIGURE 198
Klimt on the deck of
the boathouse of Villa
Paulick, Attersee
Austrian Archives /
Christian Brandstätter,
Vienna

Far right, above:
FIGURE 199
*Portrait of Friederike
Maria Beer* 1916
Tel Aviv Museum
of Art
Mizne-Blumental
Collection

Far right, below:
FIGURE 200
Klimt with Friederike
Maria Beer at
Wiessenbach,
summer 1916
Austrian Archives /
Christian Brandstätter,
Vienna

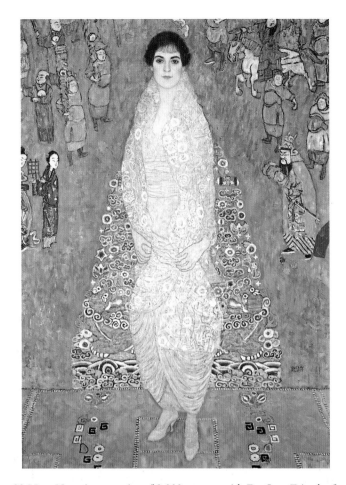

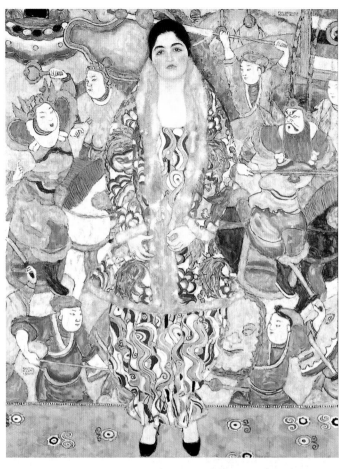

22 May: Negotiates a price of 8,000 crowns with Dr. Otto Fritsch of Vienna for the landscape *Schönbrunn Park*, but offers a ten percent discount for cash, plus two or three drawings. Mentions he would be finished *The Friends* by the end of May.[163]

10 July: Composes a melancholy, introspective poem, perhaps inspired by the war: "The water lily grows in the lake / It is in flower / Its soul is sad / Mourning for the handsome man."[164]

30 July: Taking the thermal baths at Bad Gastein.[165]

10 August: Back in Vienna to prepare his consignment of thirteen paintings and twenty drawings for the *Österrikiska Konstutställningen* (Exhibition of Austrian Art) to be held in Stockholm in September (fig. 202).[166] Two days later he writes Emilie, who is staying in Mayrhofen in the Austrian Tyrol: "Midi I'm still wandering around like a lost sheep. It seems that my urge to work which was weak anyway has been reduced even further. I'll have to send on the portrait

of [Emilie's] mother as it is—or not at all—nothing can be done like this."[167]

16 August: Leaves Vienna for Mayrhofen to be with Emilie.[168]

30 September: Writes in his notebook "Friede?" ("Peace?").[169]

26 October: Named honorary member of Akademie der bildenden Künste, Vienna (fig. 203).[170]

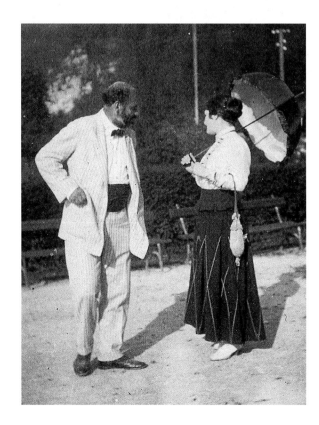

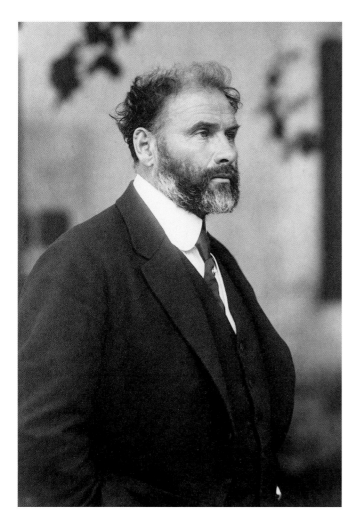

1918

11 January: Suffers thrombosis, is paralysed on right side and taken to hospital. Dies 6 February of the effects of a lung infection.[171]

9 February: Buried in the cemetery in Hietzing (fig. 204). His grave is marked by a simple marble slab.

Josef Hoffmann records: "I don't think I shall ever get over Klimt's death. I must confess, I am really beside myself. . . . For me, the world is out of joint. I feel as if I am left hanging in the air, as if the ground has been taken away from under my feet."[172]

Arthur Roessler writes: "Gustav Klimt has passed away . . . the insatiable eyes which saw only the beautiful in everything they contemplated are now unseeing. . . . Death, which Klimt often envisioned in his inspired imagination and, as an artist, rendered more than once in dreadful and grasping form, has now breathed coldly on him."[173]

Far left, above:

FIGURE 201

Gustav Klimt by Moriz Nähr, 1917

Austrian Archives / Christian Brandstätter, Vienna

Far left, middle:

FIGURE 202

View of Klimt's paintings at the *Österrikiska Konstutställningen*, Stockholm, September 1917

From left to right: *Leda*, *Portrait of Barbara Flöge*, and *Baby*

Far left, below:

FIGURE 203

Certificate of Klimt's appointment to the Vienna Akademie

Klimt Archive, Graphische Sammlung Albertina, Vienna

FIGURE 204

Gustav Klimt's funeral on 9 February 1918, cemetery at Hietzing; at bottom right, at the head of the cortège, just behind Emilie Flöge, can be seen Josef Hoffmann

Austrian Archives / Christian Brandstätter, Vienna

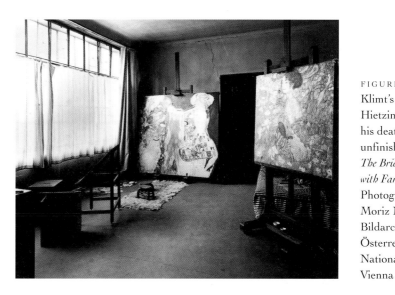

FIGURE 205

Klimt's studio in Hietzing shortly after his death, with two unfinished paintings, *The Bride* and *Woman with Fan*

Photograph by Moriz Nähr

Bildarchiv, Österreichische Nationalbibliothek, Vienna

COLIN B. BAILEY: PROLEGOMENA

1. National Gallery of Canada, Curatorial Files, Submission to Treasury Board, 22 June 1970.

2. Vergo 1981, p. 33. An installation shot of the painting, just visible behind the glazed doors, was published in Vergo 1983, p. 407, fig. 18; its spectral presence in this photograph seems not to have been previously noted.

3. Dobai 1971; *Hope I* is the subject of a forthcoming article by John Collins, which will appear in autumn 2001 in volume 2 of the newly revived *National Gallery of Canada Review*.

4. Varnedoe 1986, p. 150.

5. Roessler 1922b, p. 81.

6. Weixlgärtner 1912, quoted in Marian Bisanz-Prakken's essay in this catalogue.

7. Schorske 1980, p. 271.

8. Varnedoe 1986, pp. 152–57.

9. See Chronology; for Mäda Primavesi's recollection of sitting for Klimt, see Vienna 2000, p. 128.

10. For Klimt's Jewish patrons, see the material published in Vienna 2000.

11. Nebehay 1994, p. 253; "Aus ist's mit den Quadratln / naturalistisch ist Trumpf," Klimt's postcard to Hoffmann from Toledo, Spain, October 1909.

12. See the excellent article by Florman 1990.

13. Quoted, most recently, in Willsdon 1996, p. 44.

14. Rosenblum 2000, p. 34.

15. Quoted in Hofmann 1972, p. 12.

16. From a contemporary German review of Klimt's *Philosophy*, quoted in Hofmann 1972, p. 23.

17. "Freud kept aloof from the modern poets and painters and café philosophers, and pursued his researches in the austere isolation of his consulting rooms." Peter Gay, *Freud: A Life for our Time*, New York: W.W. Norton, 1988, p. 130.

18. Schorske 1980, pp. 244–45.

19. Schnitzler's journal entry for 5 December 1912, quoted in Vienna 2000, p. 27.

PETER VERGO: BETWEEN MODERNISM AND TRADITION

1. For the past few years, the Viennese firm of Julius Meinl has been selling its "Jubiläum" blend of coffee in metal canisters labelled "Klimt-Kaffee," decorated with illustrations of some of Klimt's best-loved paintings. Among these are *Judith I*, *Portrait of Emilie Flöge*, and *The Kiss*. The same few images can also be found reproduced on ceramic plates and bowls produced by the manufacturer Goebel, and on numerous other ornaments and items of everyday use on sale in tourist shops in Vienna and elsewhere.

2. See further below, pp. 21–22.

3. Several recent works of Klimt scholarship have attempted to probe more deeply behind the artist's seemingly anti-intellectual facade, of which perhaps the most rewarding are the articles by Florman (1990) and Willsdon (1996) cited in the Bibliography.

4. Florman also acknowledges that Klimt's development was "not strictly linear," stressing that his progress "came in fits and starts and even backtrackings, with patrons' demands and other interests intervening all the while." Florman 1990, p. 315.

5. These early collaborative works, and the probable division of responsibilities between the artists concerned, are discussed in Giese 1978–79, pp. 48ff; see also Nebehay 1969, pp. 71ff.

6. The Burgtheater frescoes have also been preserved, and are still *in situ*, but they are so finely painted and at such a height that they are difficult to see properly.

7. A fragment of a handwritten curriculum vitae, merely listing in prosaic fashion the date and place of Klimt's birth, the details of his education, the names of his teachers, and his first public commissions, is reproduced in Sabarsky 1984, p. 6.

8. In a brief character sketch, perhaps dictated to an unknown interviewer, Klimt declared: "Even the prospect of writing a simple letter fills me with fear and trembling, like the onset of seasickness. For this reason, the world will have to manage without my artistic or literary self-portrait." Typescript preserved in the Bibliothek der Stadt Wien, inv. no. 152980; see also Nebehay 1969, p. 32.

9. Frodl 1992, p. 16.

10. Nebehay 1969, p. 509 ("Anhang II: Orden, Ehrungen, etc.").

11. At least some of Klimt's biographers have seen the narrow and seemingly "abstract" panel designed for the end wall of the dining room of the Palais Stoclet in Brussels as a significant milestone in the evolution of non-representational art: see for example Nebehay 1969, p. 29; Hofmann 1972, pp. 28ff. It is, nonetheless, only one element (and a relatively insignificant one) within an overall decorative scheme that is unmistakably narrative and representational in intent, despite the fact that the branches of the "tree of life" that adorns the two long walls of the room are reduced to a repeating pattern of stylized abstractions.

12. According to Matsch's unpublished recollections, the commission for the University paintings had originally gone to him alone, and it was only on his insistence that Klimt was subsequently invited to participate; see Giese 1978–79, especially pp. 64ff.

13. Ibid.

14. If Matsch's recollections are to be believed, it was Klimt's sketches that were criticized, not his own. He also alleges that he tried to persuade Klimt to take more account of the circumstances of the commission, and to alter several of the more "offensive" motifs; see Giese 1978–79, pp. 64–65.

15. Vergo 1993, p. 61.

16. All three paintings, by this time privately owned, were destroyed at Schloss Immendorf, where they had been stored for safekeeping, when at the end of World War II retreating Nazi forces set fire to the castle; see Nebehay 1969, pp. 221ff, also p. 229 and n. 26.

17. *Die Fackel* (1900), no. 36.

18. *Ver Sacrum* I (1898), no. 1, p. 27; see especially paragraph two, which announces that the organization "einen lebhaften Contact mit hervorragenden fremdländischen Künstlern anstrebt . . . und zur Aufklärung des österreichischen Publicums über den Gang der allgemeinen Kunstentwicklung die bedeutendsten Kunstleistungen fremder Länder heranzieht."

19. For an account of these early contacts, see Engelhart 1943, pp. 79–80.

20. Kokoschka 1971, p. 49.

21. Florman, drawing on Nebehay, notes that Klimt had standing orders with Viennese booksellers for the supply of multi-volume illustrated editions such as B. Gräf's *Die Antiken Vasen der Akropolis zu Athen* (1909–25); see Florman 1990, p. 314 and n. 18, also Nebehay 1969, pp. 52ff and nn. 3a, 3b.

22. The importance of Belgian and Dutch Symbolism in relation to Klimt is also discussed in Bisanz-Prakken 1978–79.

23. Georg Fuchs, "Die Belgische Abteilung auf der Turiner Ausstellung," *Deutsche Kunst und Dekoration* XI (October 1902–March 1903), no. 1, p. 148.

24. Peter Altenberg, "Der Freund," in *Was der Tag mir zuträgt*, Berlin 1901, quoted after Nebehay 1979a, pp. 18–19. According to Weiermair 1966, p. 71, the text was originally published in *Wiener Rundschau* in 1898; see also Scheichl 1988, p. 333 and n. 4.

25. Waerndorfer to Bahr, 18 January 1900: Theatersammlung der Österreichischen Nationalbibliothek (Handschriftenabteilung), Vienna, inv. no. A Ba M 25003.

26. Comini also remarks that "the bewildering iconography of nameless, naked humans floating in a cosmic cluster was contrary to the 'School of Athens' hall-of-fame concept." Comini 1975, p. 7.

27. Karl Schreder, *Deutsches Volksblatt*, 17 March 1900.

28. See Vergo 1978–79, pp. 69ff; for a recent analysis of the influence exerted by Schopenhauer's ideas in turn-of-the-century Vienna, especially on the thinking of both Freud and Kokoschka, see Claude Cernuschi, "Oskar Kokoschka and Sigmund Freud: parallel logics in the exegetical and rhetorical strategies of expressionism and psychoanalysis," *Word and Image* 15:4 (October–December 1999), pp. 351–80.

29. See n. 21 above.

30. Alma Mahler-Werfel, *Mein Leben*, Frankfurt: Fischer, 1960, p. 91; in the same passage, however, Alma also describes Klimt's education as "limited."

31. See for example Nebehay 1987a, p. 88 for discussion of this question.

32. See further below, pp. 29ff.

33. Both Florman and Willsdon likewise emphasize the importance of the prevalent Nietzsche cult in Vienna at this time, and its relevance for any interpretation of the content of works such as the University paintings and the *Beethoven Frieze*; see Florman 1990, especially pp. 314ff, also Willsdon 1996, especially pp. 45ff.

34. *Berliner Lokalanzeiger*, 23 April 1901.

35. *Die Kunst für Alle* XV (1900), p. 500.

36. On the so-called "protest of the professors" (in reality a petition addressed to the minister of education, Wilhelm von Hartel, the purpose of which was to prevent Klimt's *Philosophy* from being installed in its intended setting), see Lachnit 1986. The organizers of this petition were mainly, but by no means exclusively scientists, as well as philosophers and theologians.

37. A similar point about the discrepancy between the presumably triumphalist expectations of the University authorities and the scathingly critical attitude to science expressed in Klimt's paintings is made, albeit briefly, in Hofmann 1972, pp. 23ff.

38. The University paintings, despite being conceived as ceiling decoration, were in fact executed in oil on canvas; for a more detailed description of medium and support, see Novotny-Dobai 1968, nos. 105, 112, 128.

39. Typhon, "the largest monster ever born," was according to legend "nothing but coiled serpents" from the thighs down. Graves describes him as having "arms which, when he spread them out, reached a hundred leagues in either direction," "serpents' heads instead of hands," and a "brutish ass-head;" see Robert Graves, *The Greek Myths: 1*, rev. ed., Harmondsworth: Penguin, 1960, pp. 133–34. It will be seen from an examination of the *Beethoven Frieze* that Klimt has here taken considerable liberties with the iconography.

40. *Vereinigung bildender Künstler Österreichs (Secession), Katalog* . . . [of the fourteenth exhibition], Vienna 1902.

41. See Dobai 1968, p. 108 and n. 131.

42. R. Wagner, "Beethoven" (1870), in *Richard Wagner. Gesammelte Schriften und Dichtungen in zehn Bänden*, W. Golther, ed., Leipzig: Goldene Klassiker-Bibliothek, 1907, pp. 61ff.

43. Willsdon also cites works such as *Fish Blood* or *Watersnakes* (both of 1898) as examples of "watery" pictures; see Willsdon 1996, p. 65.

44. *Procession of the Dead* is often reproduced as if Klimt had conceived it as a vertical composition. However, an old photograph of the picture gallery of Fritz Waerndorfer's house is just clear enough to allow us to see the picture hanging horizontally, with the chain of figures occupying the upper part of the canvas; see Vergo 1983, p. 407, fig. 18.

45. *Ver Sacrum* IV (1901), p. 214.

46. For discussion of these drawings, and their relationship both to *The Kiss* and to the panel *Fulfilment* from the *Stoclet Frieze*, see Strobl 1980–89, II, pp. 161ff, followed by illustrations of the drawings in question.

47. Munch was apparently very keen on the idea of a Vienna showing for the *Frieze of Life*. On 29 January 1903, he wrote to Franz Servaes: "I would like very much to show this Frieze in Vienna sometime . . . the Viennese artists are the only ones who could help me display the Frieze well in an architectonic setting;" quoted after Reinhold Heller, "Love as a Series of Paintings," in Rosenblum 1978, p. 108.

48. *Vereinigung bildender Künstler Österreichs (Secession), Katalog* . . . [of the nineteenth exhibition], Vienna 1904. Munch had painted at least three oil versions of *The Kiss* during the 1890s.

49. Gustav Schiefler, *Verzeichnis des graphischen Werks Edvard Munchs bis 1906*, Berlin: Bruno Cassirer, 1907.

50. In the case of Munch's 1897 oil version of *The Kiss*, which shows perhaps the greatest similarity to Klimt's 1908 painting, the encompassing shape that forms the background to the embracing figures has been identified with an erect phallus; see "Major Paintings. Commentaries by Arne Eggum," in Rosenblum 1978, p. 55. For the various woodcut versions of this subject, all of which exhibit the same feature, see Schiefler, op. cit., cat. no. 102A, etc.

51. Nebehay 1969, p. 304.

52. *Ver Sacrum* III (1900), p. 5.

53. See n. 57 below.

54. A photograph showing the first state of this painting is reproduced in Nebehay 1969, p. 338, fig. 455.

55. For illustrations, see Strobl 1980–89, I, pp. 168–69. This and other figures occupying the bottom right-hand corner were painted out in the final version of the composition.

56. See Novotny-Dobai 1968, no. 183 and pp. 357–58 for discussion of the dating of this picture.

57. *The Maiden*, 1912–13 (N/D 184), oil on canvas, 190 × 200 cm; *The Bride*, 1917–18 (N/D 222), oil on canvas, 166 × 190 cm. The notes to the entry in the oeuvre catalogue relating to the latter painting also remark that it "forms a cyclical unit" with *The Maiden*; see ibid., p. 376.

58. *Danae* has often been dated to 1908, principally because, when first exhibited at the *Kunstschau* exhibition in Vienna that year, it was described as "brand new." Strobl, however, has shown that sketches for the picture go back as far as 1903, and it appears that the painting itself was probably completed, apart from a few retouchings, by 1907; see Strobl 1980–89, I, pp. 287ff, also Novotny-Dobai 1968, no. 151 and pp. 341–42.

59. Strobl, in her catalogue raisonné of Klimt's drawings, likewise comments specifically on the artist's "repeated practice" of exploiting "unused" motifs and poses from earlier drawings; see Strobl 1980–89, I, p. 287.

60. See for example Strobl 1980–89, I, nos. 478–480.

61. However, see Lachnit 1986, Dok. 1, p. 207, for a contemporary objection to the subject of sexual coupling depicted in Klimt's painting. By this time, however, the artist had considerably toned down his treatment of the theme of copulation, in comparison with his initial drawings for the embracing couple who appear as part of the chain of human figures in the left-hand section of the composition.

62. Strobl 1978–79, p. 124.

63. Ibid.

64. Nebehay 1969, p. 214, fig. 311.

65. A satirical allusion to Klimt's well-known studio habits can be found in the caricature by fellow-Secessionist Remigius Geyling which shows the artist, hard at work on *Philosophy*, being kept supplied with food and drink by a bevy of naked female models; for illustration, see Nebehay 1969, p. 221, fig. 319.

66. Strobl 1980–89, I, no. 642.

67. Comini 1975, p. 5; despite the interest of her account, the author's description of Klimt's manner of working as a "'dirty old-master' technique" is scarcely acceptable.

EMILY BRAUN: KLIMTOMANIA / KLIMTOPHOBIA

Several colleagues assisted in the preparation of this essay: I thank Elisabeth Easton, Pepe Karmel, Gertje Utley, and my research assistants, Jennifer Hirsh and Anna Jozefacka.

1. Janik and Toulmin 1973, as in Chapter 2, "Habsburg Vienna: City of Paradoxes," pp. 33–66.

2. Kallir 1980, pp. 15–27.

3. The quote is by William Ritter (1911, p. 184). For the previously undocumented importance of Ritter's role as Klimt's champion in French and Italian art journals of the period, see below.

4. Outside of Germany and the Austro-Hungarian Empire, Klimt's few foreign shows were the Universal Exposition, Antwerp, 1895, where he won a Grand Prix; the Salon d'Automne, Paris, 1898, the Universal Exposition, Paris, 1900; and Zürich in 1918, where a large group of his works was included in *Ein Jahrhundert Wiener Malerei.* According to Novotny-Dobai 1968, pp. 303–06, Klimt's *Death and Life* was shown in Stockholm in 1916–17. On Klimt's four Italian exhibitions, see below.

5. On the difference between Art Nouveau in France under the Third Republic and its ideological repercussions in other nations, see Silverman 1989, especially pp. 225–28.

6. E. Bénézit, *Dictionnaire critique et documentaire des peintres, sculpteurs, dessinateurs et graveurs,* vol. 2, Paris, 1913, p. 787, and 1924, vol. 2, p. 787. In the 1952 edition, vol. 5, p. 268, Klimt rates a few more lines, but still much less than Klinger.

7. Salten 1903, p. 43, and again in Salten, "Gustav Klimt," in *Geister der Zeit — Erlebnisse,* Vienna, 1924, pp. 42–43, cited in Kallir 1980, p. 22.

8. Janik and Toulmin 1973, p. 39. As William M. Johnston writes in *The Austrian Mind. An Intellectual and Social History 1848–1938,* Berkeley and Los Angeles, 1972, p. 29: "The Habsburg Empire was par excellence the abode of the stranger, where clashing nationalities heightened achievement." On the political challenge to liberalism posed by conflicting versions of German nationalism, the rise of anti-Semitism under Karl Lueger, and of Zionism under Theodor Herzl, see Schorske 1981, especially pp. 116–80.

9. Elaine Showalter, *Sexual Anarchy. Gender and Culture at the Fin de Siècle,* New York and London, 1990, especially Chapter 9, "Decadence, Homosexuality and Feminism," pp. 169–87.

10. Max Nordau, *Degeneration.* Introduction by George L. Mosse, Lincoln, Nebraska, and London, 1968 (originally published in German in 1892, and in English in 1895). The implications of degeneration as "degenderation" are discussed by Barbara Spackman, *Decadent Geneologies. The Rhetoric of Sickness from Baudelaire to D'Annunzio,* Ithaca and London, 1989.

11. Rossana Bossaglia, *Il Liberty in Italia,* Milan, 1965 and 1977, and "Testimonianze critiche dell'età Liberty in Italia," in *Arte I Europea. Scritti di Storia de'arte in onore di Edoardo Arslan,* vol. 1, Milan, 1966, pp. 903–50. Though Bossaglia's texts provide a survey of Klimt's influence in Italy, they do not deal in depth with the contemporary criticism on the artist, or the larger significance of the discourse per se. On the Klimt exhibition in Rome in 1911 and the Austrian pavilion in an international context, see Gianna Piantoni, ed. *Roma 1911* (exh. cat.) Galleria Nazionale d'Arte Moderna, Rome, 1980, especially the essay by Piantoni, "Nell'Ideale Città dell'Arte," pp. 71–88.

12. Comprehensive histories of these respective exhibitions are found in *Venezia, gli anni di Ca' Pesaro 1908/1920* (exh. cat.), Venice: Ala Napoleonica and the Museo Correr, 1987, and *Secessione Romana 1913–1916* (exh. cat), Rome: Palazzo Venezia, 1987.

13. *Terza Esposizione internazionale d'Arte della Città di Venezia. Catalogo illustrato,* Venice, 1899, p. 33, nos. 56 and 57; *IX Esposizione internazionale d'Arte della Città di Venezia. Catalogo illustrato,* Venice, 1910, pp. 58–60, nos. 1–22; *Internationale Kunstausstellung Rom 1911. Österreichischer Pavillon,* Rome, 1911, p. 31, nos. 105–107; p. 32, no. 112; and p. 84, nos. 102, 105–107, 109, 110, 112, 114, 115, 117–119; *Seconda Esposizione internazionale d'Arte "della Secessione." Catalogo illustrato,* Rome, 1914, p. 29, no. 12.

14. Ardengo Soffici, "Picasso e Braque," *La Voce,* 3 (24 August 1911).

15. Austro-Italian relations are the subject of a special issue of *Il Veltro,* 21 (September–December 1977), which includes the essay by Guido Perocco, "Il fenomeno della Secessione austriaca e alcuni aspetti dell'arte italiana," pp. 645–49; see also the exhibition catalogue *Artisti austriaci a Roma dal Barocco alla Secessione,* Museo di Roma, Palazzo Braschi, 1972.

16. Giuseppe Prezzolini, "Austria o Francia," *La Voce,* 2 (8 December 1910). The entire issue was devoted to the question of *irredentismo.*

17. Wilhelm Schölermann, "Modern Fine and Applied Art in Vienna," *The International Studio,* 7, 1899, p. 36. One of the few features on Klimt in the Anglo-Saxon press was the essay by his Austrian champion Ludwig Hevesi in Charles Holme, ed., "The Art Revival in Austria," special number of *The Studio,* London, Paris, and New York, 1906.

18. Pica 1900, p. 94.

19. Roger-Marx, "Les Arts à l'Exposition Universelle de 1900: La Décoration et les industries d'art," *Gazette des Beaux-Arts,* 8, 1900, p. 368, and see also Gabriel Mourey, "L'Art décoratif à l'Exposition Universelle," in *Revue Encyclopédique,* vol. X, Paris, 1900, p. 303.

20. National rivalries and interests at the Exposition Décennale are discussed by Maryanne Stevens in "The Exposition Universelle: 'This vast competition of effort, realisation and victories'," in *1900: Art at the Crossroads* (exh. cat.), London, Royal Academy of Arts, 2000, pp. 55–71. On French cultural chauvinism in international art criticism of the period, see also Emily Braun, "Scandinavian Painting and the French Critics," *Northern Light* (exh. cat.), Brooklyn Museum of Art, New York, 1982, pp. 67–75.

21. "Harlor," "La Semaine artistique. Les Beaux-Arts à l'Exposition: Quelques écoles de peinture étrangère," *La Fronde* (Paris), 28 May 1900, described the installation as "du goût le plus élégant," an opinion seconded by Arsène Alexandre, "Continental Pictures at the Paris Exhibition," *The Paris Exhibition 1900. The Art Journal* (special number) London, 1901, p. 329, who wrote that Austria, of all the foreign countries, "has probably excelled the most with respect to the elegance, distinction, and harmonious refinement of its installation."

22. Léonce Bénédite, "Les Arts à l'Exposition Universelle de 1900. La Peinture étrangère," *Gazette des Beaux-Arts,* 8, 1900, p. 591. The original reads: "C'est un mélange sans conviction de toutes les inspirations et de toutes les écoles, qui produit un dilettantisme facile, dangereux et très souvent sans grand intérêt."

23. Favourable reviews of the Austrian section at the Décennale by French critics include: Arsène Alexandre, "Les Beaux-Arts à la section Autrichienne du Grand Palais," *Figaro Illustré,* 18 (special number, "L'Autriche à l'Exposition"), pp. 5–10; and Auguste Marguiller, "L'Art étranger (Exposition Décennale, 1890–1900)," in *Revue Encyclopédique,* vol. X, Paris, 1900, pp. 744–45.

24. "Les Sections étrangères à l'Esplanade des Invalides," *L'Art Décoratif,* 1, 1900, pp. 158–59. The original reads: "C'est une atmosphère artistique particulière que celle de Vienne, point de rencontre de tant de races dont chacune a fait couler de son sang dans la vie de tous. L'art viennois est comme les Viennoises: ni Allemandes, ni Françaises, ni Italiennes, ni Slaves, ni Hongroises, et un peu de tout cela Son originalité, sa saveur, c'est que chaque peuple y trouve quelque chose de lui dans un tout qui n'est pas lui. Et par ces affinités avec chacun, il plaît à tous."

25. The influence of Besnard on Klimt was opined by Alexandre, "Les Beaux-Arts à la section Autrichienne du Grand Palais," p. 10, Pica 1901, p. 251, and Bénédite, "Les Arts à l'Exposition Universelle de 1900. La Peinture étrangère," p. 591. Klimt and Besnard have been more recently compared by Debora Silverman (1989, pp. 225–28), who argues that their respective university murals "suggest striking differences between the forms and institutional settings of artistic modernism in the painters' societies." In contrast to the "adaptive powers of the Third Republic," in "fin-de-siècle Austria, resources for integration eluded the agents of politics and culture."

26. Pica 1901, p. 252; Rowland Strong, "Art in Paris. Pictures by Foreign Artists at the Exhibition," *The New York Times,* 16 June 1900. Another American review, that by W. Walton, "The Art of Austria," in *Exposition Universelle 1900. The Chefs-d'Oeuvre,* vol. 2, Philadelphia, 1900, pp. 52–55, was among the most detailed and favourable towards Klimt. See also Alexandre, "Les Beaux-Arts à la section Autrichienne du Grand Palais," p. 10.

27. Julius Meier-Graefe, "Die Kunst auf der Weltausstellung," in *1900. Die Weltausstellung in Paris,* J. Meier-Graefe, ed., Paris and Leipzig, 1900, p. 92.

28. Maurice Pernot, "Correspondance de Berlin. Exposition de panneaux décoratifs de M. Gustave Klimt," *La Chronique des Arts,* 9 March 1907, p. 78.

29. A.-F. Seligmann, "Correspondance de Vienne," *Gazette des Beaux-Arts,* 7 (January 1912), p. 81. The original reads: "À vrai dire, en Autriche, la vie artistique — tout comme la politique — est très dispersée par suite du contraste des nationalités — Allemands, Tchèques, Polonais, Hongrois — et, tout comme ailleurs, on y rencontre l'hostilité des diverses tendances: ancienne, moderne et ultra-moderne."

30. Julius Meier-Graefe, *Die Entwicklungsgeschichte der modernen Kunst,* 2 vols. (1914; reprint edition, Munich, 1966); Henri Focillon, *La Peinture aux XIX^e et XX^e siècles. Du Réalisme à nos jours,* Paris, 1928, p. 398.

31. William Ritter (Neuchâtel 1867–Melide 1955) was a literary critic and ethnologist who championed Czech culture; he also wrote several novels and

travelogues. Among his non-fiction works are *Smetana* (Paris, 1907), on masters of contemporary music, and *Études d'art étranger* (Paris, 1906). For reviews by him in *L'Art et les Artistes*, see Ritter 1908, 1909a, 1910, 1911, and 1912. In addition, see his review in *Emporium*, Ritter 1909b.

32. The cultural policy of the Austrian bureaucracy under the enlightened leadership of Ernest von Koerber and Wilhelm Ritter von Hartel (no relation to the above-named art critic) from 1900 to 1904 is discussed by Carl E. Schorske (1981, pp. 236–39). Klimt, of course, was the chief beneficiary of the government backing of the Secession, although the University commission soon proved a personal and political disaster.

33. In a much earlier article on the Secession's second exhibition of November–December 1898, William Ritter gives Klimt only brief attention, noting the influence of Stuck and Khnopff on his youthful portrait style, and positioning him as the heir to Makart. Ritter 1898, pp. 165–76, especially p. 171.

34. Ivan Meštrović (Vrpolje 1883–South Bend, Indiana 1962) trained at Vienna's Akademie der bildenden Künste, and resided in Paris in 1907, where he was influenced by Rodin, Bourdelle, and Maillol. He also sojourned frequently in Italy.

35. In the words of S.W. Seton Watson, "With his chisel, the Dalmatian David set out to demolish the Austrian Goliath," "Ivan Meštrović and the Yugoslav Idea," in *Ivan Meštrović. A Monograph*, London, 1919, pp. 55–59. Planned on a cathedral scale, the temple included some 100 sculptures by Meštrović and other Yugoslav artists. It was to be financed by Serbia, but was never realized. The centrepiece of Meštrović's ensemble was the equestrian statue of Marko Kraljević—"the Serbian Siegfried"—symbol of the liberation of the Yugoslav people. Meštrović had already exhibited numerous groupings at the 1910 Secession and then in Zagreb; according to Dusko Kečkemet, *Ivan Meštrović*, New York, 1970, Franz Ferdinand forbade the purchase of some of the sculptures chosen for the Belvedere. For the Rome exhibition, which included a model of the temple, sculptural fragments, and the plaster of Marko Kraljević, Meštrović declined to show the ensemble with either Austria or Hungary unless they granted a separate Croat pavilion, which, as expected, they refused to do. The Serbian pavilion and catalogue of 1911 marked a prime occasion for the expression of insurgent southern-Slav nationalism: see the catalogue texts in *Esposizione di Roma. Padiglione del Regno di Serbia*, Rome, 1911.

36. Here, one can only broach the complicated history of the Balkans in the most general terms. Serbs and Croats share the same race and language—the fundamental difference is religion: the Serbs are Eastern Orthodox and the Croats, Catholic. Croatia was under Austro-Hungarian rule until after World War I, when the Empire was dismantled, and newly created Yugoslavia placed under the rule of the Serbian royal house. The two key figures of Croat nationalism since the late nineteenth century were both Catholic bishops, first Josip Strossmayer, then during the Nazi period, Alojzije Stepinac. Strossmayer envisioned a united Slav state tolerant of both religions; Stepinac promoted a purely Catholic one. As a measure of the complexity, the Dalmatian-born, and hence Croatian Meštrović was known as the sculptor of Serbia, and among other nationalist monuments made commemorative statues of both Strossmayer and Stepinac (both in Zagreb). On the recent crises in the Balkans and their historical origins, see Robert D. Kaplan, *Balkan Ghosts*, New York, 1994, especially pp. 3–48. Kaplan acknowledges the inspirational influence of Rebecca West's monumental travelogue and history of Yugoslavia, *Black Lamb and Grey Falcon*, 1941, which includes several treatments of Meštrović's sculptures in the context of Yugoslav nationalism.

37. A year earlier, Ritter (1910, p. 231) praised Meštrović's work on view at the Secession; like Klimt and Mahler, Meštrović epitomized the modern Viennese school for his mix of "ultra-modern and archaic-asiatic" sources. Meštrović's manifesto is quoted in Ritter (1911, p. 184), and merits being reprinted in full, given the recent Serb-Croatian conflict: "Serbe et Croate, c'est deux noms pour un seule et même nation. Mais c'est sous le nom de Serbe que celle-ci a gardé son indépendance et sa liberté nationales. C'est pourquoi ce nom m'est plus sympathique. Mon pays natal, la Dalmatie, a gardé toutes les particularités nationales serbes. Toutefois, si l'on m'appelle Croate, cela m'est encore agréable, car l'homme qui affirme cela affirme du même coup notre unité. Je serai heureux quand nous serons arrivés tous à le comprendre. Nous du moins, artistes serbes et croates, nous prouvons cette unité nationale dans le pavillon du royaume de Serbie et nous serons désormais les fils solidaires de la même nation."

38. "Mostra individuale di Gustav Klimt," *IX Esposizione internazionale d'Arte della Città di Venezia. Catalogo*, Venice, 1910, p. 58.

39. Damerini 1910.

40. The metaphor was used by Ettore Cozzani (1910, p. 248) in describing

the relationship between Klimt's art and the architecture of "Otto Wagner or one of his followers."

41. The terms are those of G. Antonelli (1912, p. 79). In ancient Greek architecture, the *pronaos* was a porch that preceded the main room (*cella*) of the temple. Ferdinand Georg Waldmüller (1793–1865) painted realist landscapes and genre scenes.

42. See, in particular, Cozzani 1910; Damerini 1910; and Cecchi 1914. In addition to these and other essays cited specifically below, the following reviews were also consulted: Lancelloti 1926 and 1931; Diego Angeli, "Dai Giardini a Vigna Cartoni," *Il Marzocco*, 14 May 1914, p. 23; Enrico Thovez, "Il problema dello stile moderno," *La Stampa*, 24 July 1911, p. 3; and De Benedetti 1911.

43. Cozzani 1910, p. 250.

44. Damerini 1910 and Pica 1913, p. 109. Filippo Sacchi (1911, pp. 49–56) also focused on Klimt's achievement as a decorative painter whose purely formal interests transcended the accidental or episodic.

45. Pilo 1910, pp. 18–19.

46. Ibid., p. 18.

47. Nordau, *Degeneration*, p. 27. See also Daniel Pick, *Faces of Degeneration. A European Disorder, c. 1848–c. 1918*, Cambridge and New York, 1989, especially Chapter 5, "Lombroso's Criminal Science," pp. 109–52.

48. Damerini 1910.

49. Lombroso, *Genio e degenerazione*, Palermo, 1897. The relationship between scientific and aesthetic theories of the "mad genius" are treated in full by Patricia Mathews, *Passionate Discontent. Creativity, Gender, and French Symbolist Art*, Chicago and London, 1999, especially Chapter 3, "The Ecstasy and the Agony," pp. 46–63. Nordau and Lombroso differed on the issue of genius: for the former, true genius was within the realm of normalcy and had nothing to do with the "mysticism" of degenerate modern artists. Significantly, Klimt was familiar with Lombroso's work. According to Franz Matsch: "Klimts Geistesrichtung verwandelte sich auffallend. Seine Lieblingslektüre sind beispielsweise Lombroso und dgl. gewesen, ja er vertiefte sich in derlei Werk." See Giese 1978–79, p. 65. I thank John Collins for this information.

50. Sacchi 1911, p. 49; Pilo 1910, p. 17.

51. See the review in "Nona Esposizione internazionale di Venezia," *Arte e Storia*, 29 (October 1910), p. 297.

52. Ozzòla 1912, p. 92.

53. Damerini 1910.

54. On stereotypes of the feminine and their application to cultural and social criticism in the *fin-de-siècle*, see Rita Felski's excellent study *The Gender of Modernity*, Cambridge, Mass., and London, 1995.

55. See the analyses of Klimt's depiction of women and ornament by Damerini 1910; Sacchi 1911, p. 56; Ozzòla 1912, pp. 92–93; Antonelli 1912, pp. 77–79; Pilo 1910, p. 19; and Lancelloti 1931, p. 105.

56. Adolf Loos, quoted in Comini 1975, p. 6.

57. Ardengo Soffici, "L'Esposizione di Venezia," *La Voce*, November 1910, reprinted in *Scoperte e massacri. Scritti sull'arte*, Florence, 1995, p. 279.

58. Cecchi, 1914.

59. Cecchi's opinions were echoed with startling similarity some seventy-five years later by Kirk Varnedoe (1986, pp. 154–57). In his consideration of *Jurisprudence*, Varnedoe concurs that "for all the effort toward portentous gloom, there is something unconvincing about the conceit . . . neither this nor the other allegorical paintings have aged well as embodiments of grand ideas When Evil and Good and Life and Art were at issue—the music went tinny and the poetry cloyed." While Klimt "doubtless felt this kind of monumental expression should be his highest goal," Varnedoe continues, his real talent lay in being a decorative (read modernist) artist: "Ornamental richness does not embellish the content of Klimt's art, it *is* the content."

60. Damerini 1910.

61. The leaflets were dropped during the Futurist "happening" on 8 July 1910, and contained an inflammatory text against "past-loving Venice" by the Futurist leader and poet F.T. Marinetti. This was followed by Marinetti's "Futurist Speech to the Venetians" at the theatre La Fenice. Both texts are reprinted in F.T. Marinetti, *Let's Murder the Moonshine. Selected Writings*, trans. R.W. Flint and Arthur A. Coppotelli, Los Angeles, 1991, pp. 63–66.

62. Umberto Boccioni, "Arti Plastiche," *Gli Avvenimenti*, 2 (2–9 April 1916), reprinted in *Archivi del Futurismo*, vol. 2, eds. Maria Drudi Gambillo and Teresa Fiori, Rome, 1960, p. 27. See also Carlo Carrà's criticism of Klimt and the Secession and other Symbolists as purveyors of "illustrazionismo" in "Pittura Passata=Illustrazionismo. Pittura Futurista=Pittura," *Lacerba*, 15 October 1913, reprinted in *Archivi del Futurismo*, op. cit., vol. 1, pp. 169–70. In a letter to Gino Severini, dated 13 March 1914, Carrà claims that "four years

ago" (roughly the time of the first Futurist manifesto), Boccioni still "loved Klimt more than Renoir" and "didn't understand Matisse or Picasso at all."
63. On the Futurists' aesthetics of the machine and their repudiation of Symbolism, see the manifestos "Let's Murder the Moonshine" (1909); "We Abjure our Symbolist Masters, the Last Lovers of the Moon" (1911–15); "Down with the Tango and Parsifal" (1914); and "Against Amore and Parliamentarianism" (1911–15), all reprinted in Marinetti, *Let's Murder the Moonshine*, op. cit. The Futurists' attack on Decadent art in the context of the "feminine other" is also the subject of Cinzia Sartini Blum's *The Other Modernism. F.T. Marinetti's Futurist Fiction of Power*, Los Angeles and Berkeley, 1996.

JANE KALLIR: "HIGH" AND "LOW" IN IMPERIAL VIENNA

1. In Austria, native Art Nouveau is sometimes referred to as *Secessionstil* or *Jugendstil*. However, the first term belies Art Nouveau's important subsequent manifestations among the artists who split from the Secession in 1905. *Jugendstil*, on the other hand, is a fundamentally German concept and as such distinct from its Austrian counterpart. Although "Art Nouveau" is a French term, it connotes an international phenomenon having a broad variety of manifestations over time and place. From a North American perspective, it therefore seems most appropriate to use the term "Art Nouveau" to describe Austria's contributions to that movement between c. 1897 and 1914.
2. Some twenty-eight years later, Oskar Kokoschka would enter the Kunstgewerbeschule with the same intention.
3. Ulrike Scholda, "Die ausführende Hand der Theoretiker," in Noever 2000, p. 219.
4. See Paul Greenhalgh, "The Style and the Age," in Greenhalgh 2000, pp. 19–20.
5. Scholda in Noever 2000, pp. 220–22. During the period when Klimt attended the Kunstgewerbeschule, the preparatory school was a separate institution under the direction of Michael Rieser. In 1888, it was incorporated as a division within the Kunstgewerbeschule, offering an independent programme of three to four years for less able students, most of whom would not qualify for entry to the specialized departments. Klimt studied two years under Rieser before advancing to Laufberger's class.
6. The Künstlerkompanie designed curtains for the theatre in Reichenberg (Liberec, Czech Republic), curtains and ceiling paintings for the theatre in Fiume (Rijeka, Croatia), and ceiling paintings for Karlsbad (Karlovy Vary, Czech Republic).
7. Karlheinz Roschitz, "Der Traum vom Raum," in Roschitz 2000, pp. 22–24.
8. Nebehay 1994, p. 169.
9. See Roschitz 2000, "Der Traum vom Raum," pp. 22–29, and "Magie des Kunstgewerbe Schönen," pp. 72–85.
10. Greenhalgh 2000, "Alternative Histories," p. 37.
11. According to Wolfgang Fischer (1987, pp. 95–97), the dresses, photographed for publication in *Deutsche Kunst und Dekoration*, were intended not for manufacture by the Flöge Salon, but merely to help promote it.
12. See Fischer 1987, pp. 47–48. Diana Reynolds ("Die österreichische Synthese," in Noever 2000, p. 218) has suggested that the Austrian folk textiles that were introduced to Vienna via the provincial branches of the Kunstgewerbeschule had a formative impact on the turn-of-the-century avant-garde. The Österreichisches Museum mounted an influential folk art exhibition in 1906.
13. The Secession's much-reviled predecessor, the Künstlerhaus, had focused on the fine arts, and for the most part the Secession movements in Germany did not go so far as that in Vienna when it came to embracing the decorative arts.
14. Fischer 1987, p. 35.
15. Nebehay 1979b, p. 284, n. 11.
16. The Wiener Werkstätte did occasionally receive official commissions, but mostly for minor items. The only significant official project to engage the *fin-de-siècle* Austrian avant-garde after 1905 was the 1908 celebration of the 60th anniversary of the Emperor Franz Josef's reign. Many artists designed costumes for a "Festival Parade" that recalled Makart, and the Klimt-Gruppe arranged the 1908 *Kunstschau* as a showcase for their efforts since leaving the Secession.
17. Although the Imperial programme of grand public works more or less ended with the completion of the Ringstrasse, the Museum für Kunst und Industrie and the Kunstgewerbeschule survive to this day, under the names Österreichisches Museum für angewandte Kunst and Hochschule für angewandte Kunst, respec-

tively. The more progressive artists of the Secession and Wiener Werkstätte established a stronghold at the Kunstgewerbeschule and helped mould the direction of the Austrian applied arts well into the twentieth century.
18. *Vereinigung bildender Künstler Österreichs (Secession), Katalog* . . . [of the fourteenth exhibition], Vienna 1902, pp. 9–10.
19. The *Beethoven Frieze*, possibly Klimt's most important single work, has inspired several monographic studies; see Bisanz-Prakken 1977 and Bouillon 1987.
20. Roessler 1922a, p. 51. Although the *Beethoven Frieze*, like the rest of the exhibition's murals, was intended to be temporary, it was removed from the walls and purchased by the industrialist Carl Reininghaus. Schiele subsequently facilitated the frieze's sale to the collector August Lederer, whose son Erich sold it to the Austrian State many years later.
21. *Vereinigung bildender Künstler Österreichs (Secession), Katalog* . . . [of the fourteenth exhibition], Vienna 1902, pp. 25–26.
22. Nebehay 1994, p. 108.
23. Philip Ursprung ("Wir wollen eure Herolde sein," in Zürich 1992, p. 316) has noted that the three critics most responsible for defending Klimt—Hermann Bahr, Ludwig Hevesi, and Berta Zuckerkandl—all took great pains to make the artist seem like an ordinary member of the bourgeoisie.
24. The Palais Stoclet has become one of the most frequently reproduced of the Wiener Werkstätte's commissions, though in its day it was surprisingly little publicized. Klimt's frieze, of course, has always been off limits to the general public and is known chiefly from reproductions of the cartoons.
25. Kallir 1986, p. 22.
26. Schorske 1980, p. 339.
27. Fischer 1987, p. 162.

JOHN COLLINS: CATALOGUE

Cat. 1
1. James Michie, ed., *Aesop's Fables*, London: Cape, 1989, pp. 116–17.
2. Ibid., p. 132.
3. Martin Gerlach, ed., *Allegorien und Embleme. Originalentwürfe von den hervorragendsten modernen Künstlern, sowie Nachbildungen alter Zunftzeichen und moderne Entwürfe von Zunftwappen im Charakter der Renaissance*. With explanatory texts by Dr. Albert Ilg (1863–1929), Vienna: Gerlach and Schenk, 1882–[1885].
4. From the preface of the English edition, *Allegories and Emblems*, edited by Martin Gerlach, Vienna: Gerlach and Schenk, 1882, p. 3.
5. *Kunstausstellung Gerlach und Schenk in den Festräumen des Wiener Rathauses*, City Hall, Vienna, 1901. Inventarbuch Historisches Museum der Stadt Wien, It. Akt St. S. Zl. 338/19 indicates a price of 216,000 crowns for the entire Gerlach and Schenk collection. My thanks to Susanne Winkler for this information.
6. Berger's contributions included *Youth* (no. 7) and *Times of Day* (no. 24 and 25), while Matsch provided *Antiquity, Middle Ages, Modern Times* (no. 5), *Water–Earth* (no. 38), and others.

Cat. 2
1. In 1882–83, Klimt prepared ceiling paintings for the Municipal Theatre in Reichenberg (Liberec, Czech Republic), N/D 7 and 8. In 1885, he would carry out decorative programmes for the National Theatre in Bucharest, N/D 20–22, the Hermesvilla near Vienna, N/D 23, and the Municipal Theatre in Fiume (Rijeka, Croatia), N/D 24. With his brother and Franz Matsch, Klimt also painted theatre curtains at this time, N/D 9 and 28.
2. See Birnie Danzker 1997, pp. 124–25. For Michelangelo's nudes, see De Tolnay 1949, II, pp. 63 and 72.
3. Andrew Wilton, "Idyll," in Wilton et al., *The Age of Rossetti, Burne-Jones and Watts. Symbolism in Britain 1860–1910*, Tate Gallery, 1997, pp. 170–71.
4. Ralph Waldo Emerson, "The Poet," in *The Works of Ralph Waldo Emerson*, I, London, 1889, p. 164.
5. "Die poetische form der *Idylle* ist dem wirklichen oder geträumten Leben eines schlichten Menschengeschlechtes entsprossen, dessen stilles Glück zu schildern sie sich zur einfachen Ausgabe gestellt hat. Der Künstler hat an Theokrit und Vergils Bucolica gedacht, als er hier ein Hirtenvolk hinmalte, das in gesunder Kraft beneidenswerther Ruhe genießt und dessen Erlebnisse auf der Bühne der unverdorbenen Natur sich abspielen." Albert Ilg, introduction to *Allegorien und Embleme*, 1882–[1885], p. 21.
6. Ibid. "So gehören Satyre und Witz jenem hypercultivirten Zustande an."
7. Walton 1889, vii and 10, labelled as part of the German Section. My thanks to Ted Dalziel Jr., National Gallery of Art Library, Washington, D.C., for his research assistance.

Cat. 3

1. Yates 1996, Czeike 1992–94, I, pp. 522–23, and Nebehay 1969, pp. 84–98.

2. The exterior was documented in a series of watercolours by Rudolf von Alt, see Koschatzky 1984, pp. 71 and 138. The last performance was on 21 October 1888.

3. For Klimt's Burgtheater murals, see Novotny-Dobai 1968, nos. 38–43, and Strobl 1988. Klimt's brother Ernst also participated in the Künstlerkompanie.

4. Yates 1996, pp. 5ff. Details recorded by Klimt probably date from a renovation of 1845, Czeike 1992–94, p. 523.

5. Schreyvogel 1965, p. 46.

6. *Guide to Vienna* 1884, pp. 40–41.

7. Identified in a printed guide to Klimt's painting in the Historisches Museum der Stadt Wien, inv. no. 31813.

8. "Jedes der Bilder enthält mehr als hundert wohlgetroffene Bildnisse von hervorragenden und in diesen Räumen oft gesehenen Persönlichkeiten, welche durch alle Ränge und Plätze verteilt sind." Reported in *Zeitschrift für Bildende Kunst. Neue Folge*, vol. 1 (1890), p. 54.

9. As noted in Nebehay 1969, p. 86. For Schratt's relationship with the Kaiser, see *Briefe Kaiser Franz Josef an Frau Katharina Schratt*, edited by J. de Bourgoing, Vienna, 1949. In addition to Billroth's prodigious medical texts, see also *Billroth und Brahms im Briefwechsel*, Berlin, 1935.

10. Letter written by Gustav Klimt and his partner Franz Matsch to Eduard Seis, curator, Bibliothek der Stadt Wien, 14 March 1888: "It is with deepest regret that we have to tell you, Sir, that we have been unable to meet the deadline (15 March) set for the completion of the two watercolours depicting the interior of the old Burgtheater, although we have been working exclusively on these watercolours. The delay can be explained in large part by the fact that the only floor plan available cannot claim to be correct; therefore, we first had to measure the auditorium in its entirety and draw up our own plans. Furthermore, since it is most important that the paintings be as authentic and correct as possible, so many (!) extremely accurate studies need to be carried out on the spot, studies not only of the premises, but also of the audience, work that, of course, is very time-consuming, all the more so as the time we can spend working in the theatre is very limited." Bibliothek der Stadt Wien, inv. no. 94682, as cited in Nebehay 1969, p. 97.

11. Compare the photograph of Theodor Billroth (Österreichische Nationalbibliothek, Bildarchiv, 513.697). See Nebehay 1969, pp. 93–94, for photographs used for the Burgtheater murals.

12. "Viele Intrigen hat es gegeben und viele Tränen sind aus mehr oder wenigen schönen Augen geflossen," from "Gespräch mit dem 74jährigen Franz von Matsch," *Neues Wiener Journal*, 10 July 1933, as cited in Nebehay 1969, p. 97.

13. Schorske 1980, p. 227.

14. Zweig 1964, p. 15.

15. Ibid., p. 16, and Schreyvogel 1965, p. 87.

16. Announcement of the Kaiserpreis, as cited in Nebehay 1994, p. 32.

Cat. 4

1. Others include Franz Trau, 1893 (N/D 63, private collection), and the actor Josef Lewinsky, 1895 (N/D 67, Österreichische Galerie Belvedere, Vienna).

2. Franz Matsch's memoirs printed in Giese 1978–79, p. 63. In *Guide to Vienna* 1909, p. 3, a Löwenbräu Tavern was located at 10 Teinfaltstrasse in Vienna's 1st district.

3. Kilinski 1979 and 1982 for sources of frame motifs in Archaic vase painting.

4. "Since I, at first on the misty sea in the form of a dolphin, leaped onto the swift ship, so pray to me as Delphinios." "The Hymn to Apollo," in *The Homeric Hymns*, translated by A.N. Athanassakis, Baltimore, 1978, p. 29, lines 493–95. First pointed out by Kilinski 1979, p. 96.

5. Nebehay 1969, p. 116, identifies the trademark.

6. "Seine kirchlichen Werke durchweht ein Hauch echter Frömmigkeit und bewahren, wenn auch die Hand des modernen Musiker verrathend, die nöthige Einheit des Stils, ohne jemals in die Tonart einer dürren und steifen Dogmatik auszuweichen." Adolf Ruthardt, "Josef Pembaur," *Chormeister-Büchlein*, Leipzig, 1890, p. 37.

7. There is no entry for Pembaur in the *New Grove Dictionary of Music*. The principal sources used for this entry include Ruthardt, op. cit., Franz Tafatscher, "Josef Pembaur d. Ä.," *Tiroler Heimatblätter* 11:2 (February 1933), pp. 50–59, and W. Senn, "Josef Pembaur d. Ä.," *Österreichisches biographisches Lexikon 1815–1950*, 1978, pp. 402–03.

8. Tafatscher, op. cit., p. 52. On Wüllner see Gaynor G. Jones, "Franz Wüllner," *New Grove Dictionary of Music*, vol. 20, 1980, p. 546. Hey was the author of *Deutscher Gesangs-Unterricht. Lehrbuch des sprachlichen und gesanglichen*

Vortrags, 3 vols., Mainz: Schott's, [1882–87]; on Hey see Elizabeth Forbes, "Julius Hey," *New Grove*, vol. 8 (1980), p. 544.

9. "Als das Waltherdenkmal in Bozen geplant wurde, war er im vorbereitenden Ausschuß," from "Josef Pembaur und das Tiroler Musikleben," in *Alpenbote. Familienkalender für Stadt und Land*, 1948, p. 114. Pembaur also composed the music for an oratory, "Bilder aus dem Leben Walthers von der Vogelweide," based on a text by Zingerle (Senn 1978, p. 402). See *Baedeker Guide for Northern Italy* (1909), p. 20, and 1928, p. 59) for more on the monument, placed in Walther Platz, which was renamed Piazza Vittorio Emanuele in 1925.

10. Giese 1978–79, p. 63.

11. Ibid.

12. On 13 March 1887, Hugo Wolf reported on the fundraiser, Hugo Wolf, *The Music Criticism of Hugo Wolf*, New York and London: Holmes and Meier, 1979, p. 268.

13. Senn 1978, p. 403.

14. "Die Musik ist tönende Architektur," cited in Tafatscher, op. cit., p. 50. Here Pembaur reverses the line by German philosopher Friedrich von Schelling that "Architecture in general is frozen music," from *Philosophie der Kunst* (1809).

15. "Jeder musikalische Gedanke bedingt seine Form, man komponiert nicht mehr in die vorliegende Form, sondern bringt den in charakteristischen Motiven und Phrasen präzisierten Gefühlsausdruck in eine durch sein Wesen bedingte, mit seinem Inhalte übereinstimmende äußere Gestaltung." From *Über das Dirigieren. Die Aufgaben des Dirigenten beleuchtet vom Standpunkte der verschiedenen Disciplinen der Kompositionslehre*, Leipzig, 1892, as cited in Tafatscher, op. cit., p. 55. The lecture is cited in the *National Union Catalogue* record for the 1892 edition, in the Library of Congress, Washington, D.C.

16. "Der Dirigent eines Gesangvereines hat ausser seiner Aufgabe, Gesangschule zu halten, stets die ernste Pflege der Musik als Hauptaufgabe des Vereines zu betonen. Vereine, welche nur Unterhaltung pflegen, welche nur Operetten, Trinklieder und Tänze singen, kommen immer weiter vom Kunstideal ab und sind deshalb in ihrem Wirken der Kunst schädlich Alle Vokalmusik ist in ihrem Wesen, abgesehen von ihrer absoluten musikalischen Bedeutung, als Illustration des poetischen Vorwurfes aufzufassen." *Über das Dirigieren*, as cited in Tafatscher, op. cit., p. 53.

17. Ibid., p. 54.

Cat. 5

1. This painting remained absent in the Klimt literature until it was brought to light by Otto Kallir in the 1960s. There is no reference previous to Dobai's publication in 1968 (Novotny-Dobai 1968, p. 296), and it was not included in the comprehensive list in Pirchan 1956.

2. For the relationship between Klimt and Alma-Tadema, see Edwin Becker, "The Soul of Things. Alma-Tadema and Symbolism," in *Sir Lawrence Alma-Tadema* (exh. cat.), New York: Van Gogh Museum and Walker Art Gallery / Rizzoli, 1997, pp. 79–88.

3. *The Oleander* and *Unconscious Rivals* have been catalogued in Vern G. Swanson, *The Biography and Catalogue Raisonné of the Paintings of Sir Lawrence Alma-Tadema*, London: Garton & Co. and Scolar, 1990, no. 281, pp. 218–19, and no. 358, p. 248.

4. For this commission Klimt became somewhat of an Italian Renaissance specialist, providing representations of the art of the Trecento (N/D 54), the Florentine Quattrocento (N/D 49 and 53), and Florentine Cinquecento (N/D 50), the Roman and Venetian Quattrocento (51 and 52), as well as the art of Egypt (N/D 47 and 55) and Ancient Greece (N/D 48 and 56).

5. Isabella was the daughter of King Alfonso II of Naples, and the bust is thought to date to just prior to her marriage to the Duke of Milan in 1489. Laurana's bust was available to Klimt for viewing in the Ambras Collection housed in the Lower Belvedere prior to the opening of the Kunsthistorisches Museum in 1891. My thanks to Dr. Manfred Leithe-Jasper for this information. Kruft has recently identified the bust as Isabella's mother-in-law Ippolita Maria Sforza (1445–1488). Hanno-Walter Kruft, *Francesco Laurana. Ein Bildhauer der Frührenaissance*, Munich: C.H. Beck, 1996, pp. 384–85.

6. Klimt's preparatory drawing for this figure (Strobl 3291b, private collection) is also posed like the Laurana bust with her hair drawn up in a headdress. The drawing for the second figure, Strobl 246, reveals more of her Italian-style tunic and may have been of the same model.

7. W.J. Conybeare and J.S. Howson, *The Life and Epistles of St. Paul*, 2 vols., new ed., London: Longman, 1862, I, p. 158.

8. "Etwas von dem Geist der 'Salome', so wie die Moderne in Dichtung und Plastik sie auffaßt." Fritz Burger, *Francesco Laurana*, 1907, p. 115, cited in

Kruft, op. cit., p. 132. Laurana busts were integrated into the modern Jugendstil interior by Patriz Huber, see *Deutsche Kunst und Dekoration*, XIII, 1904, pp. 286–87.

9. *À travers les âges* reproduced in *The Studio*, IV, 1894, opposite p. 37.

10. Khnopff's *Offering* also recalls the floral offerings to the *Altar of Dionysus* (N/D 35) made by the maenads in Klimt's Burgtheater painting of 1886–88.

11. "Bei Klimt fühlen wir immer, dass er noch mehr zu sagen hätte, aber es nicht will, weil er von schamhafter und schweigsamer Natur ist. Darum hört man die Leute so oft von ihm sagen, dass er an Khnopff erinnert. Er hat mit Khnopff jene Eleganz der Seele gemein, die lieber gar nicht verstanden sein will, als dass sie sich entschließen könnte, laut zu werden und zu lärmen." Bahr, "November–December 1898," *Secession*, Vienna: Rosner, 1900, p. 74. On Khnopff and Vienna see Brussels 1987.

Cat. 6

1. For biographical information on Heymann, see Ludwig Hevesi, "Sammlung Dr. Heymann," 7 March 1902, in Hevesi 1909a, pp. 201–06; "A. Heymann zum Gedenken," Rathaus Korrespondenz, 24 May 1957, pp. 950–51, Wiener Stadt- und Landesbibliothek; Vienna 1982–83, pp. 42–43; Czeike 1992–94, III, p. 180; see also sale catalogue of Gilhofer and Ranschburg, Vienna, *Die Sammlungen Dr. Richard Breitenfeld und Dr. August Heymann*, 4 and 5 April 1935.

2. Dr. Franz Glück's remarks noted in Novotny-Dobai 1968, p. 298.

3. Information provided by Dr. Ferdinand Opll, Wiener Stadt- und Landes-archiv, 25 November 1999. Regarding the Heymann marriage: "Ehe geschlossen am 19.7.1904, Pfarre Wien III, Schützengasse" (Konfession evangelisch AB). Correspondence from Dr. Opll, 12 April 2000. Another possibility is that the sitter is one of the daughters—Marie or Caroline—of Franz Trau (1842–1905), whose portrait, and that of his wife, Klimt painted in 1893 (N/D 63 and 64). See Trau's death notice in *Neue Frei Presse*, 1 February 1905, p. 20, and 12 February, p. 9. He and his son, Franz Trau, also collected Austriaca and Viennensia, catalogued in the sale at Gilhofer and Ranschburg, Vienna, 2–3 April 1935. My thanks to Ted Dalziel and Michael Kalwoda for this information.

4. "Everyone knew how much he possessed or what he was entitled to, what was permitted and what forbidden." Zweig 1964, p. 1.

5. Heymann's 1898 deluxe edition of *Ver Sacrum* entered the collection of the Historisches Museum der Stadt Wien in 1962, see Vienna 1982–83, p. 42. Nebehay 1975, p. 34, indicates that Dumba, Heymann, and Klimt were sub-scribers to the 1899 "Gründerausgabe" of *Ver Sacrum*.

Cat. 7

1. Stadtbibliothek Wien, inv. no. 18571, as cited in Nebehay 1969, p. 121. Baron Wieser was one of the administrators of the Society for Reproductive Art (Gesellschaft für Vervielfältigende Kunst) to which Klimt would belong from 1896 to 1899. Published as unnumbered plate in Oscar Teuber, *Das k.k. Hofburgtheater seit seiner Begründung*, in *Die Theater Wiens*, vol. 2, nos 1–2, 1896–1903. My thanks to John Charles, Bruce Peel Special Collections Library, University of Alberta, Edmonton.

2. Nebehay 1969, p. 121. There appears to have been little further contact between the two men. An auction of Lewinsky's considerable collection of theatrical memorabilia in 1907 (Dorotheum, Vienna) contained a heliograph of Klimt's *Auditorium of the Old Burgtheater* (cat. 3).

3. For more on Lewinsky's role as Carlos, see Helene Richter, "Clavigo im Alten Burgtheater. Adolf Sonnenthal: Clavigo. Josef Lewinsky: Carlos," *Goethe-Jahrbuch* (Frankfurt), vol. 32, 1911, pp. 121–29, and Helene Richter, *Josef Lewinsky. Fünfzig Jahre Wiener Kunst und Kultur*, Vienna: Deutscher Verlag für Jugend und Volk, 1926, pp. 52ff.

4. A part of his larger work, *Quatrième mémoire à consulter contre M. Goezman* (1744), reprinted in *Œuvres complètes de Beaumarchais*, Paris: A. Laplace, Sauchez & Cie, 1884, pp. 319–32.

5. See introduction to William White, ed., *Goethe Clavigo. Ein Trauerspiel*, Oxford: Basil Blackwell, 1973.

6. See Richter, op. cit. (1911), p. 124.

7. Rudolf Valdek, in the *Ostdeutsche Post*, 20 May 1858, as cited in Richter, op. cit. (1911), p. 125.

8. Florman 1990, p. 320.

9. The portrait was mentioned in passing in Weixlgärtner 1912, p. 62; Eisler 1920, p. 19; and Pirchan 1956, p. 44 (catalogued only). Exhibited in *XCIX. Ausstellung der Vereinigung bildender Künstler Wiener Secession. Klimt Gedächtnis-Ausstellung*, 27 June–31 July 1928, Vienna, no. 29. Acquisition information from Gerbert Frodl, *Gustav Klimt in der Austrian Gallery Belvedere*, Verlag Galerie Welz, Salzburg, n.d., p. 14.

Cat. 8

1. *Allegorien. Neue Folge. Originalentwürfe von namhaften modernen Künstlern, mit erläuterndem Text*, edited by Martin Gerlach, Vienna: Gerlach and Schenk, 1896[–1900?], followed by drawings representing *Junius* 1896, *Sculpture*, 1896, and *Tragedy*, 1897. Gerlach was a supporter of younger artists and an advocate of modernity, and his *Allegorien* series stands as an important bridge between the Kunstgewerbeschule's "design reform" and the Secessionists' more radical break with tradition, along with the alliances they forged with the European avant-garde. Future Secession members Josef Engelhart, Rudolf Jettmar, Koloman Moser, and Rudolf Bacher would all contribute to the new series of *Allegorien*, and Gerlach and Schenk would publish the first issue of the Secession's journal *Ver Sacrum* in January 1898.

2. "Ich wählte zunächst das Lust und Leben athmende Thema: Liebe, Gesang, Musik und Tanz, an welches sich später das figural unerschöpfliche Gebiet der Künste und Wissenschaften und der frohe Reigen der Jahrzeiten mit dem heiteren Treiben des Sportes anschließen sollen." Novotny-Dobai 1967, p. 298.

3. See, for example, Schnitzler's play *Anatol*, first published in 1892. Anatol is a dandified young man, hungry for new ideas, who is also an amateur hyp-notist. Doubting the sincerity of his lover, Hilda, he places her under hypno-sis and proceeds to question her about her faithfulness, yet is unable to complete his task for fear of eliciting unwelcome responses. From Arthur Schnitzler, *Anatol: A Sequence of Dialogues*, translated by G. Barker, New York, 1911, pp. 3–18. In the way it blends reality and dream to explore the sexual psychoses of relationships, Klimt's *Love* also recalls Max Klinger's cycle of etchings *The Glove*, 1878–81.

4. Rodin's work was originally conceived for *The Gates of Hell*, to represent the adulterous lovers Paolo and Francesca of Dante's *Inferno*, de Caso and Sanders 1977, pp. 149–53.

5. "Sinnbilder von Liebeslust und Liebesweh." Eisler 1920, p. 20.

6. A face that Klimt based on his drawing of an old man, inscribed "Johann Mayerbäuerl," Albertina Collection, Strobl 260.

7. Novotny-Dobai 1968, p. 299.

8. Zweig 1964, p. 77.

9. "Interpretation of Dreams," cited in Peter Gay, ed., *The Freud Reader*, New York: W.W. Norton and Co., 1989, p. 142.

Cat. 9

1. "Ganz meisterhaft sind einige Porträtstudien Klimts, in seltsam schönen Beleuchtungen." "Die Ausstellung der Sezession," 25 March 1898, in Hevesi 1906, p. 16. Identified by Nebehay (1969, p. 143) as catalogue no. 199, "Pastellstudie."

2. Khnopff sent twenty works including *The Offering*, 1891 (fig. 62), and *The Red Lips*, 1897 (private collection, Brussels), see Brussels 1987, pp. 93–94; Carrière's as yet unidentified "Family Group" was described by Hevesi (1906, p. 14) as a "Dämmerungsbild" (twilight painting).

3. Whistler's lithographic work was exhibited at the first Secession, see Hevesi 1906, p. 15. Unfortunately, the works were not identified by title in the catalogue.

4. "Die Frau L. war durch 14 Jahre Schülerin Klimts," Schiele to Arthur Roessler, 24 December 1912, in Roessler 1921, p. 75. The past tense suggests that she may have begun lessons with Klimt in the mid-1890s.

5. Catalogue no. 42, "Junges Mädchen, Pastell. 1898." The catalogue numbering corresponded to the order of installation. A second "Junges Mädchen, Pastell. 1898" was listed in the catalogue as no. 28. Although fig. 71 is dark, the essential details of the Oberlin pastel are clearly visible on the original in the collection of the Bildarchiv of the Österreichische Nationalbibliothek, no. 238.319–B.

6. *Die Zeit*, 15 November 1903, p. 4, reported that seven pictures sold on opening day, including "Junges Mädchen," either no. 28 or 42.

7. Kallir 1999, pp. 41ff.

Cat. 10

1. "[Vollends jenes 'bewegte Wasser', in dem sich] helle Wellen und weiße Leiber ineinander aufzulösen scheinen, ein flüchtiges Traumbild aus einer Sonntagsnatur heraus, von einem Sonntagskinde gehascht Solche Phantasien fließen aus einem ehrwürdigen Urtrieb des Menschengeschlechts; der Pantheismus wird niemals aussterben." "Verkannte Kunstwerke. Ausstellung der Sezession," in Hevesi 1906, p. 81.

2. "The Water Nixie," *Grimm's Tales for Young and Old. The Complete Stories*, New York, 1977, p. 275.

3. For the related theme of the "Irrlichter," see Strobl 1978–79, pp. 147–79.

4. *Nixies*, 1899 (Bank Austria, Vienna) and *Irrlichter*, 1903 (private collection) are drawn from the water spirits of German folklore. In *The Goldfish*, 1901–02

(Kunstmuseum Solothurn), water nymphs become Klimt's allies in his scorn for unfavourable criticism, and with *Wasserschlangen* (*Water Serpents*) *I* and *II* (Österreichische Galerie Belvedere, Vienna, and private collection) they appear in a more sinister guise. See also Dijkstra 1986, pp. 83ff, for a discussion of the "weightless woman."

5. "Abneigung gegen die 'Seelenlosigkeit' des modernen Wirtschafts- und Großstadtlebens," from "*Undinen-Zauber*, zum Frauenbild des Jugendstils," in Hermand 1972, p. 147. My gratitude to Professor David Ehrenpreis of James Madison University, Harrisonburg, Virginia, for bringing this article to my attention.

6. Catalogued in Nebehay 1979c, no. 6.

7. See also "Nixie" illustrations for *Ver Sacrum* by Kolo Moser and Ernst Stöhr, reproduced in Nebehay 1975, pp. 178, 188, and 228.

8. Mahler-Werfel 1999, p. 213, entry for 3 December 1899.

9. Weininger 1906, p. 73. See Wagner 1994, p. 208, and Cernuschi 1999, p. 144, for further discussion of Weininger and the Secession.

10. "Ebenso [gespenstisch-verlassen] sind sie nackten Leiber aller dieser Frauen, asketisch-mager-*zärtlich-zart*, die Finger, die Hände, die Arme, die Beine dieser Holdesten, von der öden bösen, nur Geist und Seele *belastenden* Materie fast *Erlösten*! Phantastischer Naturalismus der modernen echtesten Schönheits-Ideales!" From a speech by Peter Altenberg, delivered 12 September 1917, published as a foreword to *Das Werk Gustav Klimts*, Vienna and Leipzig: Hugo Heller, [1914]–1918, as cited in Barker and Lensing 1995, p. 101. See also Barker 1996, p. 115.

11. See Bisanz-Prakken 1978–79 for Toorop's influence on Klimt.

Cat. 11

1. "In der Nachbarschaft hängt die bête noire des großen Publikums, die berüchtige Pallas Athena," reported in Ludwig Hevesi's review of the Secession, 9 November 1898, as cited in Hevesi 1906, p. 81.

2. "Das Publikum ist an Pallasse gewöhnt, denen man deutlich ansieht, daß sie eigentlich angestrichene Marmorstatuen sind." Hevesi 1906, p. 82.

3. By the sculptor Johannes Benk (1844–1914).

4. Schorske 1980, pp. 43–44. The city's relationship with Pallas Athena reached back more than a century, when no less a figure than the Empress Maria Theresia was cast in the goddess's role as patron of the Vienna Academy in F.A. Maulbertsch's canvas *The Academy with Her Attributes*, 1750 (Österreichische Galerie Belvedere, Vienna). Toman 1999, p. 118.

5. Alexander S. Murray, *Manual of Mythology*, New York: Charles Scribner's Sons, 1885, pp. 88–96 (reprinted from 2nd rev. London ed.; facsimile by Gale Research, Detroit, 1970).

6. Bisanz-Prakken 1976b, p. 10, claims Klimt copied it from a reproduction in Eduard Gerhard's *Auserlesene griechische Vasenbilder*, Berlin, 1843, II, plate CXI. Kilinski 1982, p. 106, identifies the hydria as one in the collection of the Toledo Museum of Art, Ohio. In the upper right, above Athena's shoulder, Hercules and the Triton are locked in mortal combat. To the left, a Nereid, or sea nymph, indicates her alarm with a raised hand, while her father, Poseidon, is obscured behind Athena's helmet.

7. See also Florman 1990 for Klimt's use of Archaic Greek sources.

8. "Das ist keine Statue aus der Erde und keine Frau aus dem Leben, es ist eine Erscheinung, die Materialisation einer Stimmung von schaffenskräftigem Trotz und souveränem Bildnerdrang Dafür ist sie aber auch eine lebendige Pallas, keine Kopie aus dem Gipsmuseum, sondern eine Pallas von heute, die Pallas ihrer Zeit, ihres Ortes und ihres Machers." Hevesi 1906, p. 82.

9. Khnopff took part in both the first and second Secession exhibitions of 1898. Delevoy 1979, pp. 426–27.

10. Stuck had introduced Pallas Athena into Secessionist politics four years earlier for the poster design of the 1893 Munich Secession exhibition. See Birnie Danzker 1997, pp. 154–55.

11. This was a flagrant contravention of the goddess's appearance, which Marian Bisanz-Prakken claims was suggested to Klimt by the helmeted *Sphinx* of Dutch Symbolist artist Jan Toorop. Bisanz-Prakken 1976b, p. 11. As if to acknowledge Klimt's parody and his own conceit, Stuck would paint Pallas Athena as living model in 1899, see Makela 1990, p. 112. Klimt has followed closely the design of a 7th-century B.C. Corinthian helmet, see Kilinski 1979, p. 98.

12. "Why are we publishing a journal?" in Harrison and Wood 1998, p. 918, published in *Ver Sacrum* in January 1898. Bahr is identified as the author in Clair 1986, p. 204.

Cat. 12

1. Schorske 1982, p. 33. For a recent discussion of *Nuda Veritas* and an account of its restoration, see Pausch 1997.

2. "Der Zeit ihre Kunst, der Kunst ihre Freiheit," words mounted over the door of the Secession exhibition building in 1898.

3. First published in 1797 as part of the "Tabulae Votivae von Schiller und Goethe," as cited in Friedrich Schiller, *Sämtliche Gedichte*, vol. 2, Munich: Deutsches Taschenbuch, 1965, p. 81.

4. Then it carried a different inscription: "Wahrheit ist Feuer und Wahrheit reden heisst leuchten und brennen" ("Truth is fire and speaking truth means radiating and burning") by the poet Leopold Schefer, a reference to the traditional representation of Truth holding a radiating disc. Leopold Schefer (1784–1862) was born and died in Muskau, Germany. "Verità," in Cesare Ripa, *Iconologia*, Padua edition, 1618, reprinted by Milan: TEA, 1992, p. 464.

5. See Fritz Saxl, "Veritas Filia Temporis," *Philosophy and History. Essays presented to Ernst Cassirer*, Oxford, 1936, pp. 203ff, and Donald Gordon, "Veritas Filia Temporis," *Journal of the Warburg and Courtauld Institutes*, vol. 3, 1939–40, pp. 228–40.

6. *Allegorien und Embleme*, plate 113, "Die Wahrheit" by Otto Seitz, and plate 114, "Wahrheit und Lüge" by Alfred Miessner. See Hansjörg Krug, "Gustav Klimt: 'Nuda Veritas', 1899," in Pausch 1997, p. 17.

7. "Aus der Sezession," 29 March 1899, in Hevesi 1906, p. 148.

8. Ibid.

9. Nebehay 1969, p. 143; Dijkstra 1986, pp. 311–13; and Birnie Danzker 1997, pp. 64–71.

10. Among Bahr's most important publications is *Overcoming Naturalism* (1891), which heralded the arrival of Symbolist literature in Vienna and advocated greater freedom of expression. "Jung Wien" included Karl Kraus, Hugo von Hofmannsthal, Arthur Schnitzler, and Felix Salten; for the latter's book about Klimt, see Salten 1903.

11. First issue of *Moderne Dichtung*, 1 January 1890, as cited in Waissenberger 1984, p. 244.

12. *Ver Sacrum*, May–June 1898, p. 5, as cited in Nebehay 1994, p. 88. The public garden of the Palais Liechtenstein is in Vienna's 9th district; the Kahlenberg is a peak in the Wienerwald, just north-west of the city.

13. Three of Klimt's receipts are published in Nebehay 1969, p. 204, and together with new material in Pausch 1997, pp. 10–12. Bahr's house was designed by Josef Maria Olbrich, who was also the architect of the Secession building, inaugurated in November 1898.

14. Hermann Bahr, foreword to *Gustav Klimt. 50 Handzeichnungen*, Leipzig and Vienna: Thyrsos Verlag, 1922, n.p. [4]. In 1912, Bahr moved to Salzburg where he became an early supporter of the Salzburg Festival, see Steinberg 1990, p. 134.

Cat. 13

1. *Secluded Pond*, 1899 (N/D 108, Leopold Collection, Vienna). See Alfred Weidinger's entry on the painting in Zürich 1992, p. 114. Renate Vergeiner, "Kühe im Stall," in Weidinger and Vergeiner 1988, pp. 67–71, suggests *Cows in a Stable* was painted at Litzlberg in 1900, a date that accords with Dobai in Novotny-Dobai 1968, p. 321.

2. From the Attersee, Klimt mentions he was painting "a bull in a stable" in a letter to Marie Zimmermann, as cited in Nebehay 1994, p. 268, who dates it to August 1900 and identifies it as "Der schwarze Stier" (N/D 115), Nebehay 1969, p. 249. Helene Donner, the artist's niece, identifies the bull as the steer "Martin," cited in Nebehay 1969, p. 255.

3. See Nebehay 1969, pp. 249–50. In addition to *The Black Bull*, the paintings Klimt mentions have been identified as *The Marsh* (N/D 109), *Young Birches* (N/D 110), *Tall Poplars* (N/D 111), and *On the Attersee* I or II (N/D 116 or 116a). By 1904 he was painting on 110 × 110 cm canvases, see *Roses under Trees* (cat. 20). Bisanz-Prakken 1982 discusses the prevalent use of the square format among Secession members.

4. "Es gibt noch eine andere, eine völlig andere Art von Klimt-Bildern. Die sind nicht stürmisch und nicht rätselhaft und nicht prunkvoll. Da sind die Wellen eines Bergsees, die in der Sonne glitzern Dann ein Stall, ganz in das tiefe Dämmer getaucht . . . der tiefen Ruhe, mit der hier alles erfasst ist." Salten 1903, pp. 30–31.

5. On the sacred bull in Egyptian art, see Veronica Ions, *Egyptian Mythology*, Feltham: Hamlyn Publishing, 1968, pp. 122–24. According to Nebehay 1969, p. 52, Klimt's library would eventually include Gaston Maspero's *Essais sur l'art égyptien*, Paris: Guilmoto, 1912, and Jean Caspart's *L'art égyptien*, Paris: Guilmoto, 1909.

6. Bahr 1901, p. 16.

Cat. 14

1. Novotny-Dobai 1968. Johannes Dobai 1988 remains the most thorough study of Klimt landscapes in English. Weidinger and Vergeiner 1988 and Weidinger, "Der Landschaftsmaler," in Zürich 1992 bring to the subject a sensitive and highly original interpretation.

2. In May 1899, Alma Schindler noted in her diary a conversation with Klimt about his financial affairs: "We were told that five women are completely dependent upon him: his mother [Anna], his sister [Klara or Hermine?], his sister-in-law [Helene Flöge?, widow of Ernst], her sister [Emilie or Pauline Flöge?], and a young niece [Helene Klimt]," Mahler-Werfel 1998, p. 124. Hermann Flöge, Emilie's father, passed away in December 1897 (Bisanz-Prakken 1996). While working on the Stoclet frieze, Klimt wrote to Fritz Waerndorfer: "I am as busy as ever—always Stoclet—I haven't yet started a single landscape. It's costing me a fortune." As cited in Schweiger 1984, p. 55. Letter undated, probably summer of 1910 when Klimt's summer vacation was delayed due to the Stoclet commission (see Chronology).

3. "Sezession," 13 February 1902, in Hevesi 1906, p. 370.

4. A summer vacationer at the Attersee wrote of Klimt at work: "Once during a period of bad weather and cold, when it was gloomy and rainy, we went out walking on the empty road. In Litzlberg—the place that lies next to the Kammer—sat a man at an easel before a large field. In spite of the drizzle and cold, he sat there and painted an apple tree with photographic sharpness. As we came nearer, he said not a friendly word, but remained absorbed in sullen silence." Recollections of Irene Hölzer-Weineck, quoted in Weidinger and Vergeiner 1988, p. 13.

5. Reproduced in Dobai 1988, plate 13.

6. See Dobai 1988 for the most complete illustration of Klimt's landscape series.

7. The affinity between Klimt and Prince Eugen was noted on the occasion of the tenth Secession exhibition (15 March–12 May 1901): "Wie er weisse Birkenstämme auf hellgrüne Wiesen setzt, den perlgrauen Himmel malt, den weisse Wanderwolken durchziehen, oder Wogen leuchten und phosphorescieren lässt in tausend malvenfarben, violetten und bleichgrünen Nuancen—das hat nur in der raffinierten Art des Prinzen Eugen von Schweden seinesgleichen." From "Fall Klimt und Künstlerhaus," in Muther 1900–01, II, p. 246. For Prince Eugen's contribution to Nordic art, see Varnedoe 1988, pp. 70–72.

8. For example, Piet Mondrian's *Woods*, 1898–1900 (Gemeentemuseum, The Hague), and Fernand Khnopff's *Under the Fir Trees*, 1894 (Galerie Isy Brachot, Brussels), both reproduced in Varnedoe 1988, p. 70. For a discussion of Symbolist landscape and "Stimmungslandschaft," see Nasgaard 1984, pp. 11–13. The term "Stimmungslandschaft" had been applied to Klimt's landscapes as early as March 1900 by Ludwig Hevesi (1906, p. 234), on the occasion of the seventh Secession show: "Von Klimt sind dann noch drei köstliche Stimmungslandschaften zu sehen." It was a term that art historian Alois Riegl described in his 1899 essay "Stimmung as the Content of Modern Art" as characteristically German art, see Margaret R. Olin, *Forms of Representation in Alois Riegl's Theory of Art*, University Park, Pa.: Pennsylvania State University Press, 1992, pp. 122–27.

9. "Man betrachte in einem seiner beiden Waldbilder, die auf den ersten Blick bloß dunkles Dickicht sind, die zarten Durchbrüche von sonniger Luft. An einer Stelle geht eine ganz schmale, unregelmäßige Lücke herab, wie die Ritze in einer Türe, auch sie immer wieder verlegt und verdunkelt. Durch diese Ritze strahlt die ganze taghelle Landschaft jenseits des Waldes herein: unten das sonnige Gelb der Grashalde, dann die fröhlichen Töne der Hügel, oben die blauen Launen des Himmels. Man spürt den Aufbau einer ganzen Welt hinter dem dunklen Walde. Überhaupt ist Klimt der Meister im Erratenlassen dessen, was außerhalb seiner Landschaft liegt." "Sezession," 13 March 1902, in Hevesi 1906, p. 370.

10. *The Studio*, 1902, p. 268. For an excellent chronology of Klimt's time at the Attersee, see Weidinger and Vergeiner 1988, pp. 5–27.

Cat. 15

1. "I often had to work late into the night which probably explains why I have foot ailments nowadays." "Recollections of Elisabeth Schironi, the last mannequin of 'Schwestern Flöge'," in Fischer 1992, p. 170.

2. Recollections of Herta Wanke, in Fischer 1992, p. 171.

3. "Ein anderes [Damenporträt], unvollendetes, ist wie aus einer blaubunten Welt von Majolika und Mosaik herübergekommen." In "Sezession," 14 November 1903, Hevesi 1906, p. 444. "Das Wiener Damenbildnis hat hier eine neue Eigenart erlebt, oder eine neue Stilisierung." In "Weiteres zur Klimt-Ausstellung," 21 November 1903, Hevesi 1906, p. 452.

4. This interest anticipates Klimt's visit to Ravenna on 9 May 1903, where he was impressed by the mosaics at San Vitale (see Chronology).

5. For a discussion of the Dress Reform Movement and Klimt, see Fischer 1992, pp. 78ff, and Ulrike Steiner, "Die Frau im modernen Kleid—Emilie Flöge und die Lebensreformbewegung," in Hölz 1996, pp. 56–79.

6. As Hermann Bahr would write in *Ver Sacrum* in 1898, "We make no distinction between 'fine art' and the 'minor arts'." Varnedoe 1986, p. 204.

7. "Van de Velde in Wien," 7 March 1901, reprinted in Hevesi 1906, pp. 313–16. See also Van de Velde 1902, illustrated with his own clothing designs. The Belgian had exhibited decorative items at the eighth Secession in November 1900, and his lecture in Vienna called for the application in women's clothing of the same kind of artistic principles that currently guided the reform of architectural design. He had also shown bookbindings and graphics at the first Secession in March 1898, Nebehay 1969, pp. 143 and 232. For his own account of "Reform der Frauenkleidung," see Van de Velde 1962, pp. 151–54.

8. Ernst Klimt died a year later. "Emilie and Gustav were never really lovers! Never! This is the only explanation I have for Emilie's lifelong extremely nervous disposition!" Testimony of Hedwig Paulick, confirmed by Klimt's niece Helene Donner, as cited in Fischer 1992, pp. 128–29. Alice Strobl (1980–89, II, p. 162) sees Emilie's features in the female model of *The Kiss*.

9. Catalogued in Fischer 1987, pp. 169–88. The majority of the cards are of Wiener Werkstätte design.

10. Ibid., nos. 164–171, p. 176.

11. Fischer 1992, p. 136, and Fischer 1987, no. 10, p. 170. Henrik Ibsen's *Ghosts* (1881) gained notoriety for its theme of hereditary venereal disease.

12. "Recollections of Elisabeth Schironi," in Fischer 1992, p. 170.

13. Tietze 1919, p. 10, as cited in Partsch 1989, p. 185.

14. Nebehay 1995, p. 183, who seems assured of the figure.

15. Mahler-Werfel 1999, p. 338.

16. *Deutsche Kunst und Dekoration*, XIX (October 1906–March 1907), pp. 65–73.

17. Klimt to Emilie, 6 July 1908, Fischer 1987, no. 94, p. 173. As translated in Fischer 1992, p. 125.

Cat. 16

1. Catalogue documented by Nebehay 1969, p. 314.

2. "Die Leiden der schwachen Menschheit: Die Bitten dieser an den wohlgerüsteten Starken als äußere, Mitleid und Ehrgeiz als innere treibende Kräfte, die ihn das Ringen nach dem Glück aufzunehmen bewegen." *Vereinigung bildender Künstler Österreichs (Secession), Katalog . . .* [of the fourteenth exhibition], Vienna, April–June 1902, p. 25, text describing Klimt's *Beethoven Frieze*. Willsdon 1996, pp. 65ff, argues that Klimt's knight imagery is drawn from his reading of Goethe's *Faust*.

3. Peg Weiss, *Kandinsky in Munich: The Formative Jugendstil Years*, Princeton, N.J.: Princeton University Press, 1979, pp. 146–48.

4. "Karl Wittgenstein als Kunstfreund," *Neue Freie Presse*, 21 January 1913. Wittgenstein, father of the philosopher Ludwig Wittgenstein, made his fortune in the Austrian iron industry. Before retiring in 1899, he had a share in fourteen concerns, including the Aussig–Teplitz Railway and the Gelsenkirchen Mining Society. Hermine Wittgenstein's unpublished *Family Reminiscences* (1944), as cited in Nebehay 1994, pp. 206–07.

5. In addition to *Life Is a Struggle*, Wittgenstein owned *Water Serpents I*, 1904–07 (N/D 139), and *Cottage Garden with Sunflowers*, c. 1905–06 (N/D 145, both Österreichische Galerie Belvedere, Vienna); as well as, *The Sunflower*, 1906–07 (N/D 146, private collection), and *Schloss Kammer on the Attersee IV*, 1910 (N/D 172, private collection). As cited in Nebehay 1994, p. 208.

6. "Er verstand das Leben und Wirken als einen Kampf, und so war ihm auch in der Kunst nichts sympathischer, als die Auseinandersetzung zwischen künstlerischen Energien." *Neue Freie Presse*, 21 January 1913.

7. On Waerndorfer, see Vergo 1981 and Vergo 1983.

8. Klimt described the mosaic as a "mein armer Ritter" in reference to his disappointment with its final colouring, correspondence with Emilie Flöge, 18 May 1914, Fischer 1987, no. 324, p. 184.

9. Alice Strobl has described the Stoclet knight as a symbol of the exaltation of life through art or through the artist: "Mit dem Ritter dürfte Klimt . . . auf eine Überhöhung des Lebens durch die Kunst bzw. durch den Künstler hingewiesen haben, der sich gleichsam als der Schöpfer eines irdischen Paradieses . . . erweist." Strobl 1980–89, IV, p. 152.

Cat. 17

1. Prof. Josef Lange, "Secession," in *Die Waage*, IV, 1903, as cited in Zürich 1992, p. 63.

2. For a discussion of Klimt's use of contrasts in his landscapes, see Anselm Wagner, "Aspekte der Landschaft bei Gustav Klimt," in Weidinger and Vergeiner 1988, pp. 40–65. Such meditations on the tree were inherited from

the German Romantic tradition and also appear in the work of Piet Mondrian, see Rosenblum 1975.

3. As translated and dated in Nebehay 1994, p. 268.

4. Klimt's return to Vienna is documented in a postcard to Emilie Flöge, postmarked 7 September 1903, cited in Fischer 1987, no. 35, p. 170.

5. "Klimt Ausstellung," 21 November 1903, Hevesi 1906, p. 451.

6. See Sármány-Parsons 1990–91, and Natter 1997.

7. Rysselberghe had a room at the third Secession (12 January–20 February 1899) and Signac sent six paintings and seven watercolours to the seventh Secession (8 March–6 June 1900). Nebehay 1969, p. 194. Many thanks to Marina Ferretti for identifying the works exhibited by Signac.

8. As cited in Harrison and Wood 1998, p. 979.

9. *Orchard*, 1901 (N/D 119, private collection). Ludwig Hevesi used the word "Forellentupfen" in his review of the 1903 retrospective (Hevesi 1906, p. 451) to describe *Tall Poplars II*, 1902 (N/D 135, Leopold Collection, Vienna), usually dated to 1903. But in a letter to Marie Zimmermann, Klimt mentions both this painting and his son Otto, who died in September 1902 (see Chronology), and therefore it must have been painted a year before *Pear Tree*.

Cat. 18

1. First noted by Gwenda Lambton, translator of Johannes Dobai's excellent study of the painting, Dobai 1971. *Hope I* has been discussed as a portrayal of motherhood in Di Stefano 1985.

2. Other studies are catalogued in Strobl 1980–89, I, pp. 276–79, nos. 943–963.

3. Bouillon 1987, pp. 24–25.

4. Koppel 1903. "Alles ist häßlich, sie, und was sie sieht—nur in ihr liegt werdende Schönheit, die Hoffnung. Und ihre Augen sagen das."

5. "Zur Klimt Ausstellung. Sezession," 15 November 1903, Hevesi 1906, p. 446. Zuckerkandl 1909 mentions Hartel's intervention.

6. Extract from the minutes of the Committee meeting of 20 October 1903, Vereinigung bildender Künstler Österreichs [Secession], Österreichisches Staatsarchiv, Vienna. Allgemeines Verwaltungsarchiv, Ministerium für Kultus und Unterricht, 33.219/03, fol. 1–18. This document will be published as part of an article to appear in the next issue of the *National Gallery of Canada Review* (vol. 2, 2001).

7. Zuckerkandl, *Wiener Allgemeine Zeitung*, 12 April 1905, as cited in Dobai 1971, p. 2.

8. "Haus Wärndorfer," 26 November 1905, reprinted in Hevesi 1909a, p. 223. The frame was in Klimt's studio at the time Koppel interviewed him in 1903: "A frame with fold-back doors, as used for old altarpieces, will hold the painting; someone already owns it, and I envy him."

9. "Es [*Die Hoffnung*] ist bis auf einige Kleinigkeiten fertig, kommt aber nicht in die Ausstellung: den Hintergrund will er [Klimt] noch einmal ummalen. Ursprünglich stellte er eine Landschaft vor, jetzt zeigt er einen gemusterten Teppich; daraus sollen nun charakteristische Köpfe werden, die den Gedankeninhalt verdeutlichen." Koppel 1903.

10. Strobl 1980–89, I, p. 274.

11. Hevesi 1909a, p. 223, as cited in Dobai 1971, p. 7.

12. Servaes 1909–10, p. 590.

13. "'In ihrem blanken Schoße ruht die Zukunft. Verwahrerin des kommenden Geschlechts, Hervorbringerin einer neuen Menschheit, Ermöglicherin einer relativen Unsterblichkeit', gleicht sie einer Priesterin des Reinmenschlichen, Nurmenschlichen." Roessler 1922b, p. 87, who uses quotation marks but gives no source. The concept of the "Übermensch" was most fully articulated in Friedrich Nietzsche's *Thus Spake Zarathustra* (1882–93). Jean Clair (1999, p. 328) suggests that Dix's painting reflects his reading of *Thus Spake Zarathustra*.

Cat. 19

1. See Strobl 1980–89, I, pp. 293–99.

2. Novotny-Dobai 1968, p. 313.

3. For the sixth Secession (20 January–25 February 1900), 691 pieces of Japanese decorative and graphic art from Adolf Fischer's collection were catalogued. See Vienna/Tokyo 1994, pp. 54 and 88. In 1898, Whistler chaired the International Society of Painters, Sculptors and Engravers, to which Klimt belonged, see Novotny-Dobai 1968, p. 384. He also exhibited lithographs in the first Secession exhibition of March 1898.

4. Hermine's dress reveals the influence of the Dress Reform style of Wiener Werkstätte designer E. Josef Wimmer-Wisgrill, see Fischer 1992, p. 95.

5. "Im höchsten Moment ihres ganzen Daseins," in Bahr 1901, pp. 16–17. For a discussion of Bahr's writings on Klimt, see Breckner 1978, pp. 225ff.

6. Auszug aus dem Trauungsbuche, no. 497, Moriz Gallia and Hermine

Hamburger, 16 May 1893, Matrikelamt der Israelitischen Kultusgemeinde, Vienna.

7. Auer'schen Gasglühlicht Fabrik. Ibid. Lane 1984, p. 13, completes the family history with reference to von Auer.

8. Ernst, born in 1895, Margarete, 1896, twins, Katharina and Helene, 1899, listed in Moriz Gallia's "Todfallsaufnahme" (death registration), 11 September 1918, p. 2, as part of the "k.k. Handelsgericht" (Imperial and Royal Commercial Court Document), Wiener Stadt- und Landesarchiv, A 158/18. Alma Schindler notes in her journal on 24 March 1901, "Frau Gallia collected me from the Prater. High tea at home with her," and on 4 December 1901, "At Spitzer's. Had my photograph taken. Then to Gallia—Gound (Robert, the composer)." Identified as Hermine Gallia in Mahler-Werfel 1999, pp. 392 and 450. Alistair Smith in Lane 1984, p. 64, refers to Hermine as "musically and artistically talented." Lane 1983, p. 233, suggests that Hermine's brother, Paul Hamburger, was prominent in artistic circles, but does not elaborate.

9. *Beech Forest II*, c. 1903 (N/D 137, location unknown). Lane 1983, p. 233, lists ten paintings by Moll in the Gallia collection by 1913, as well as a landscape by Alma's father, Emil Jakob Schindler. In November 1900, Karl Kraus would write in *Die Fackel* that "Herr Moll is known to be art-agent to the share pusher [Wilhelm] Zierer and the coal-usurer [Oskar] Berl," see translated text in Mahler-Werfel 1999, p. 348.

10. Catalogued in Lane 1984.

11. Sekler 1985, pp. 357–58 and 386. Hoffmann designed the gravestone of Hermine's sister-in-law, Henrietta (Henny) Hamburger, in 1913, also that of a Dr. Hamburger in Freudenthal, in 1919, and furnishings for Hermine's son, Ernst Gallia, in 1921. Hoffmann's engagement by the Gallias coincided with his participation in the official founding of the Österreichischer Werkbund, a society of industry leaders, educators, and designers devoted to the promotion of Austrian arts and crafts; and he may have been influential in the Gallias' decision to become members of the ÖW in 1914. Gmeiner and Pirhofer 1985, p. 227. For the founding of the Austrian Werkbund, see Schweiger 1984, pp. 93–94, and Long 2000.

12. Schweiger 1984, p. 250.

13. Date given in correspondence from Mrs. H. Weiss, Matrikelamt der Israelitischen Kultusgemeinde, Vienna, 22 September 1999. Moriz Gallia is listed as Roman Catholic in his "Totenbeschauprotokoll" (death certificate), 17 August 1918 (1918 G—Bd. 1037), Wiener Stadt- und Landesarchiv. The most notable example of this practice was the composer Gustav Mahler, who converted to Catholicism in 1897, just prior to his appointment as director of the Imperial Opera in Vienna, see Egon Gartenberg, *Mahler: The Man and His Music*, New York, 1978, pp. 47–52. Mahler later admitted he took this action from an "instinct for self-preservation," but regretted doing so, cited in Steinberg 1990, p. 186.

14. The company's accounts were frozen after Moriz's death, precipitating a lengthy legal action by his brother Adolf. "Die Firma [Joh. Timmel], welche sich mit der Fabrikation von Essig befasst und bedeutende Aufträge der Heeresverwaltung zu effektuieren hat," in the "k.k. Handelsgericht," with Moriz Gallia, "Todfallsaufnahme," 11 September 1918, Wiener Stadt- und Landesarchiv, A 158/99.

Cat. 20

1. Novotny-Dobai 1968, p. 339, dates *Roses under Trees* to c. 1905; however, based on a stylistic relationship with *Pear Tree* (cat. 17), Alfred Weidinger has shifted this date back to 1904 (Zürich 1992, p. 138).

2. From the sketchbook owned by Sonja Knips, see Nebehay 1987a, p. 43.

3. Compare, for example, the contrast of shadow and sunlight in *Orchard*, 1901 (N/D 119, private collection), sale at Sotheby's London, 8–9 December 1997, no. 30.

4. Bahr 1901, p. 16.

5. See Arthur Schopenhauer's discussion of landscape as Platonic idea in *The World as Will and Idea*, I, London, 1950, p. 231.

6. For example *The Woodpecker Tapestry* by William Morris, 1885, William Morris Gallery, Walthamstow. See also Parry 1996.

7. Alice Strobl's (Kurrent and Strobl 1991, pp. 69–70) analysis of the *Stoclet Frieze* confirms that Klimt had initially included views of water suggestive of the Attersee landscape (see cat. 107).

8. "Kunstschau 1908," in Altenberg 1909, pp. 115–16.

Cat. 21

1. Nebehay 1969, p. 308. The date assigned here follows Alfred Weidinger's identification of *Orchard* as painted at the Brauhof Litzlberg on the Attersee, 1905–06, in Zürich 1992, p. 142.

2. A second photograph taken at the same time is dated 1907 in Weidinger and Vergeiner 1988, p. 9.

3. The single exception is *Schönbrunn Park*, 1916 (N/D 194, location unknown), where the figures are on a minute scale.

4. "Physiognomy of Landscape," 1885–86, as translated and dated in Peter Selz, *Ferdinand Hodler* (exh. cat.) Berkeley: University Art Museum, 1972, p. 112.

5. Varnedoe 1986, p. 161.

6. As cited in Nebehay 1994, p. 269, but dated to August 1903; however, as Klimt mentions his and Mizzi's son Otto in the letter, it must date to August 1902, as Otto died 11 September 1902 (see Chronology). The "small beech wood" has been identified by Nebehay 1994, p. 270, n. 17, as *Beech Forest II*, c. 1903 (N/D 137, location unknown), and the "big poplar at dusk" is undoubtedly that of *Tall Poplars II*, 1902 (N/D 135, Leopold Collection, Vienna).

Cat. 22

1. Weidinger in Zürich 1992, p. 55.

2. See Klimt's letter to Marie Zimmermann, August 1902, quoted in the entry for *Orchard* (cat. 21).

3. In 1905, Klimt and his "Stylist" followers, including Hoffmann, broke with the "Naturalist" faction led by Josef Engelhart, and left the Secession (see Chronology).

4. Haberfeld 1912, pp. 180–82.

5. "Klimt ließ den Garten um das Haus in der Feldmühlgasse alljährlich mit Blumenbeeten zieren—es war eine Lust, inmitten von Blüten und alten Bäumen dahin zu kommen." Egon Schiele's recollections recorded in Karpfen 1921, p. 89

6. Klimt to Emilie Flöge, 11 March 1916, Fischer 1987, no. 345, p. 186, as translated in Fischer 1992, p. 165.

7. "Ein Lebensbild: Gustav Klimts Werkhaus. Den Rahmen bildet ein Überbleibsel aus dem ländlichen Wien, das Adalbert Stifter in seinem Büchlein "Feldblumen" anheimelnd schilderte: eine dörflich-stille Seitengasse in Hietzing." Roessler 1922b, p. 84.

8. Sixteenth Secession, *Entwicklung des Impressionismus in der Malerei und Plastik* (17 January–28 February 1903), reviewed 17 January 1903 by Hevesi 1906, p. 406. On the donation of van Gogh's *Plain at Auvers* to the Moderne Galerie, see Sotriffer 1964.

9. "Vincent van Gogh," 17 January 1906, Hevesi 1909a, pp. 526–29. Most of the paintings belonged to the Berlin dealer Paul Cassirer.

10. "Weiteres vom Klimt," 9 August 1908, Hevesi 1909a, p. 319.

Cat. 23

1. Dobai 1988, p. 19.

2. For the Cabaret Fledermaus, see Schweiger 1984, pp. 138–40. Klimt attended the cabaret's opening on 19 October 1907, and designed costumes for Peter Altenberg's play *Masken*, performed that evening. Reported in "Kabarett 'Fledermaus,'" *Neue Wiener Journal*, 20 October 1907, p. 12.

3. "Die Blumenwiesen sind noch einmal so schön, seit sie Klimt gemalt hat; der Künstler gibt uns ein Auge, das leuchtende Prangen ihrer Farben zu sehen; die Natur lernen wir niemals in ihrer zauberhaften Schönheit ergreifen, wie durch die Kunst, die ihr Bild stets erneuert." Lux 1908–09, p. 44.

4. "Auffällig ist Klimts neueste Vorliebe für Wiesenblumen und was im Bauerngarten an Gewächsen gezogen wird. Diese derbfarbigen Kelche und Sterne mischt er jetzt gern in die ornamental gemeinten Flecke; aber er hat sie auch an und für sich, an Ort und Stelle, in üppiger Sommerpracht wuchernd gemalt, und eben diese 'Naturausschnitte' bezeugen, daß Klimt immer wieder die engste Berührung mit der Natur sucht, daß er sie nie verloren hat." Kuzmany 1908, p. 518.

5. First published as part of series of photographs of Emilie wearing Klimt dress designs in *Deutsche Kunst und Dekoration*, XIX (October 1906–March 1907), p. 73.

6. Hoffmann's plans for the grounds of Palais Stoclet were reproduced in a special issue of *Moderne Bauformen*, 1914, reprinted in Kurrent and Strobl 1991, p. 30. In his report on English architecture, Muthesius observed: "In England the garden that surrounds the house is no longer designed to imitate the fortuities and chaos of nature but is set out in an orderly and regular fashion. This at least is the case with all houses designed by architects and owned by persons who keep abreast of the latest ideas." Muthesius 1979, p. 105.

7. Remarked by Johannes Dobai (1988, p. 19). See also Johanna Gisler, "Heimatstil," in *Dictionary of Art*, New York: Macmillan, 1996, pp. 311–12.

Cat. 24

1. *Hope I* and *Hope II* will be discussed with new documentation in the next issue of the *National Gallery of Canada Review* (vol. 2, 2001). *Hope II* entered the collection of Eugenia Primavesi on Christmas eve 1914, see Vienna 2000, p. 130.

2. "'Die Hoffnung', an dem jetzt alle Kaffeehäuser und Five o'Clocks zehren." Hevesi 1909b, p. 221. The continuing controversial nature of the pregnant nude is reflected in Berta Zuckerkandl's (1909, p. 2) defence of Klimt's *Die Hoffnung* in April 1909, just prior to its appearance at the second *Kunstschau*.

3. Described by Ludwig Hevesi (1909b, p. 224) on the occasion of the 1909 *Kunstschau* as "eine *Vision* (der Allfruchtbarkeit) in purpur und gold" ("a *vision* of universal fertility in crimson and gold"). See also the exhibition history in Novotny-Dobai 1968, p. 345.

4. Also, the abundant and flowing hair of the subject of *Hope I*, so typical of Klimt's allegorical females, is absent in *Hope II*, where the model's hair hangs in unwashed strands that lie close against her neck. See, for example, Hevesi's (1906, p. 449) comments on Klimt's drawings on the occasion of his 1903 retrospective: "Dann schließlich, das Klimtsche Haar. Dieses proteische Element, das ornamentale Prinzip an sich. Ein ins Unendliche behandelbarer Urstoff, spinnbar, krämpelbar, schlängelbar, knüpfbar."

5. See Warlick 1992.

6. Strobl 1980–89, II, p. 172.

7. Clark 1959, pp. 231–34.

8. Novotny-Dobai 1968, p. 345.

9. Probably for the painting's installation at the Venice Biennale (April to October 1910). In a view of the Klimt room at the Biennale (see fig. 23), *Three Ages of Woman*, 1905 (Galleria Nazionale, Rome) is visible in a frame with the same S-curve design. Wimmer is cited by Rizzi and Di Martino 1982, p. 27, as the designer of the room.

10. Compare, for example, his changes to *Death and Life*, 1908–15 (Leopold Collection, Vienna), Novotny-Dobai 1968, p. 183.

11. In yet another change, the model's hair, which originally covered her chin (see the photograph reproduced in Pirchan 1956, plate 92, as *Legende*) was lowered to below the chin.

Cat. 25

1. For a thorough discussion of Vuillard's decorative work, see Gloria Groom, *Édouard Vuillard. Painter-Decorator. Patrons and Projects, 1892–1912*, New Haven and London: Yale University Press, 1993.

2. *The Sisters* (N/D 157) and *Portrait of a Woman in Red and Black* (N/D 158), Novotny-Dobai 1968, p. 345.

3. "Bis zu einem gewissen Grad leitet es sich noch von den Porträtzeichnungen um 1898 ab, sodaß eine Entstehung 1903 nicht ausgeschlossen erscheint." Strobl 1980–89, IV, p. 225.

4. Novotny-Dobai 1968, p. 345.

5. Ibid.

6. See Strobl 1980–89, IV, p. 225, for Klimt sales records. Novotny-Dobai 1968, pp. 350–51, lists the provenance of *Pond at Schloss Kammer*. Both the present *Pale Face* and *Pond at Schloss Kammer* were subsequently handled by Galerie Neumann, Vienna, before entering the collection of the American architect Bruce Goff. Novotny-Dobai 1968, pp. 345 and 351.

Cat. 26

1. For Klimt and fashion, see Kallir 1986, Fischer 1992, and Brandstätter 1998.

2. Fischer 1992.

3. According to Schweiger 1984, pp. 220ff, textiles were manufactured by the Wiener Werkstätte from 1905, and a fashion department was established in 1910 under Eduard Josef Wimmer (1882–1961).

4. See, for example, Strobl 388, *Ver Sacrum*, January 1898, p. 23; Strobl 389 (Albertina, Vienna, inv. no. 36058), *Ver Sacrum*, March 1898, p. 18; Strobl 390 (private collection), *Ver Sacrum*, Special Issue II, 1898, p. 17.

5. Compare also Klimt's *Portrait of Rose von Rosthorn*, 1900–01 (private collection; not catalogued in Novotny-Dobai 1968), see Zürich 1992, no. G 24, and *Silver Fish*, c. 1899 (N/D 95, Bank Austria, Vienna).

6. See discussion by Natter in Vienna 2000, p. 120.

7. The treatment is discussed in Stöbe 1995. The work is reproduced in its pre-cleaned condition as the frontispiece to Partsch 1989.

8. For Vienna fashion at this time, see Faber 1983, p. 60, and Denscher 1999, p. 22.

9. Nebehay 1969, p. 464, reproduces Asian artefacts in Klimt's collection.

10. V.-F. Weber, *"Ko-Ji Hô-Ten". Dictionnaire à l'usage des amateurs et collectionneurs d'objets d'art japonais et chinois*. New York: Hacker Art Books, 1965, pp. 218–19.

11. "Gestern Musée Guimet—sehr interessant," Klimt postcard to Emilie Flöge, 23 October 1909, Fischer 1987, no. 194, p. 177.

Cat. 27

1. *Bauerngärtchen* (*Farm Garden*), 1905–06 (N/D 144 or 145) and *Wasserschloss* (*Schloss Kammer on the Attersee I*), 1908 (N/D 159, National Gallery, Prague).
2. Weidinger (Zürich 1992, p. 154) identifies the setting as the park at Schloss Kammer.
3. This relationship between Klimt's landscapes and Mondrian's later abstracts was first pointed out by Anselm Wagner in Weidinger and Vergeiner 1988, p. 47. The near/far, small/large contrast emerges earlier, for example in *Island on the Attersee*, c. 1901 (N/D 117, private collection).
4. For a discussion of the differences between the "Raumkünstler" (decorative artists) and the "Nur-maler" (pure painters), see Vergo 1993, p. 84.
5. Berta Zuckerkandl, "Gustav Klimt (Zum fünfzigsten Geburtstag)," *Wiener Allgemeine Zeitung*, 13 July 1912, p. 2, as cited by Weidinger in Zürich 1992, p. 63.
6. Heck 1988, p. 75.
7. Teplitz (Teplice, Czech Republic) is home to a famous mineral spa. For more on Alt, see Koschatzky 1975.

Cat. 28

1. The December 1898 issue of *Ver Sacrum* was devoted to Khnopff. For Khnopff and Vienna, see Brussels 1987. *Still Water* is catalogued in Delevoy 1979.
2. According to Varnedoe's definition of Symbolist landscape (1988, p. 72), these qualities place Klimt and Khnopff close to the Nordic tradition.
3. Servaes 1909–10, p. 590. "Die wollüstige Fülle der Natur, das schwere Bangen der Atmosphäre, die paradiesische Ruhe weltfernen Träumens hat kaum ein Zweiter so sublim und so vibrierend ausgedrückt wie Klimt; oft mit Linien von beseeligender Einfachheit und Stille; zuweilen mit Farben, die wie in astraler Leuchtkraft brennen."
4. The Schloss Kammer landscapes are N/D 159, N/D 165–167, N/D 171, N/D 172, N/D 181. The Villa Oleander was built as a summer house in 1879 by Gräfin Khevenhüller, whose family had originally acquired the estate in the 16th century, see Weidinger and Vergeiner 1988, p. 27, and Kegele 1898, p. 170. At the time of Klimt's tenancy, the Villa Oleander belonged to Dr. Alois Scherer of nearby Vöcklabruck. Information courtesy of Alfred Weidinger.
5. "Heute hat das Schloss nicht mehr den alleinigen Zweck, mit seiner reichen Ahnengallerie das Andenken der einstigen Besitzer, der Schaumberger und der Khevenhüller, zu wahren, sondern es ist seit dem Jahre 1872 in ein Hotel allervornehmsten Ranges umgebaut worden und vermag nun mit seinen 300 gastlichen Wohnräumen allsommerlich eine große Zahl ständiger Gäste und Touristen zu beherbergen." Kegele 1898, 170.
6. "Gross ist auch die Zahl jener Erholungsbedürftigen, die hier in dem kleinen Paradiese von Kammer Heilung und Erfrischung suchen und auch finden. Wahre Wundercuren werden hier bei so einfachen und natürlichen Mitteln gemacht Alleen, prächtige Park- und Gartenanlagen in der Umgebung des Schlosses, eine Schwimm- und Badeanstalt, ein Kranz schöngebauter, zum Schlosse gehöriger Villen, als Oleandervilla, Seevilla, Waldhütte und Nussvilla . . . die Hügelreihen der nahen Umgebung sich hinschlängelnde Spazierwege sind alles Dinge, die auf des Menschen Herz erhebend und seine Gesundheit fördernd wirken." Kegele 1898, p. 170.

Cat. 29

1. Unpublished biographical details from Sterbematrikeln der Israelitischen Kultusgemeinde, transmitted in correspondence from Dr. Ferdinand Opll, 12 November 1999.
2. Bisanz-Prakken (1996, p. 32) first proposes this interpretation. It is the colour of the flowing robe of Death in the mural of *Medicine* and also *Hope I*. Hevesi 1906, p. 317, mentions: "Das schneidende Blau des Schleiers, der am Gerippe des Todes niederwallt." In his book *On the Spiritual in Art*, 1912, Wassily Kandinsky claimed: "The deeper the blue becomes, the more strongly it calls man toward the infinite It is the colour of the heavens," cited in Vergo and Lindsay, I, 1982, p. 181.
3. According to Nebehay (1969, p. 223), August Lederer, a distiller, helped Klimt with money to buy back the three University paintings. Lederer owned them after they were returned to the artist in 1905. They were destroyed with thirteen other Klimt paintings from the Lederer collection in Schloss Immendorf in 1945, see Nebehay 1987b, p. 17. Also Roessler 1921, p. 75.
4. At the time of her death, Maria Munk was identified as "Fabrikantentochter" (industrialist's daughter) living in Vienna's 18th district at 52 Sternwartestrasse. Correspondence from Dr. Ferdinand Opll, 12 November 1999. Erich Lederer's comments recorded in Novotny-Dobai 1968, p. 352. Alexander Munk was born on 10 October 1852 in Mikusovce (Poland?). When Maria was born he

was a merchant in Hernals (now Vienna's 17th district) and lived in the 1st district at 7 Bösendorferstrasse. Information kindly forwarded by Mrs. H. Weiss, Matrikelamt der Israelitischen Kultusgemeinde, Vienna.
5. N/D 190, location unknown. Klimt also painted Serena's daughter Elisabeth Bachofen-Echt in 1914 (N/D 188, private collection).
6. The sitters for Klimt's *Auditorium of the Old Burgtheater*, 1888, have been identified in a printed schematic copy of the work now in the Historisches Museum der Stadt Wien, inv. no. 31813.
7. Correspondence from Dr. Opll, 12 November 1999: "Selbstmord durch Erschiessen, am 28 Dezember 1911 registriert." Arthur Schnitzler records in his diary, 1 January 1912, that he had a discussion "über den Selbstmord des Frl. Munk wegen H.H. Ewers," in Schnitzler 1981–2000, vol. 1, p. 294. On Ewers, see Faber 1983, pp. 13 and 172.
8. Nebehay 1994, p. 208. Another member of the Pulitzer family, Anna, committed suicide on 17 May 1910, see Thomas Harrison, *1910: The Emancipation of Dissonance*, Berkeley: University of California, 1996, p. 2.
9. "Scientific Meeting, 20 April 1910," Nunberg and Federn 1962, II, pp. 479–97.
10. Nunberg and Federn 1962, II, p. 494, and Paul Friedman, ed., *On Suicide. With Particular Reference to Suicide among Young Students*, New York: International Universities Press, 1967, p. 27.
11. Ariès 1985, pp. 241ff.
12. Zweig 1964, p. 18. Ludwig Hevesi, the art critic who provided the Secession motto, "To every age its art, to art its freedom," committed suicide in 1910.
13. Bisanz-Prakken 1996, p. 36. "Die unüberbrückbare Distanz zwischen physischer Nähe und seelischer Unerreichbarkeit zum Ausdruck."
14. Strobl 999, private collection.
15. Friederike Maria Beer (fig. 199) persuaded a reluctant Klimt to paint her portrait, because "through Klimt I wanted to be made immortal, and he accepted that." After an interview with Alessandra Comini, in Comini 1974, p. 130.
16. "Das Munkporträt wird schon ein wunder schmerzhafter Punkt — bring' es nicht zusammen! Wird einfach nicht ähnlich!" Klimt postcard to Emilie Flöge, 28 February 1913, cited in Fischer 1987, no. 297, p. 182. And "plage mich fruchtlos mit den Todten herum," 4 March 1913, Fischer 1987, no. 305, p. 183. Alice Strobl (1980–89, III, p. 111, and 1980–89, IV, p. 187) has proposed that Klimt eventually abandoned this portrait and reworked it as *The Dancer*, c. 1916–18 (N/D 208, private collection).

Cat. 30

1. Biographical details kindly supplied by Herbert Koch, Wiener Stadt- und Landesarchiv, in correspondence of 21 July 1999.
2. Klimt painted his six-year-old niece Helene Klimt in 1898 (N/D 92, private collection).
3. Catalogued in Essen/Zürich 1987–88, no. 65. Hans Bisanz (1963, p. 86) identifies the painting as one of those included in the 1904 Vienna exhibition.
4. Fischer 1987, no. 274, p. 181, Klimt to Emilie Flöge, 27 February 1912: "Heute wieder in's Joch — Primavesi erschwert noch die Sache — Helene wird telefonieren — Herzlichste Grüße GUS." Studies reproduced in Strobl 1980–89, II, pp. 272–81.
5. Exhibition history in Novotny-Dobai 1968, p. 355. A "Porträtt av en ung flicka. Privat ägo" is listed in *Österrikiska Konstutställningen*, Liljevalchs Konsthall, Stockholm, 1917, no. 97.
6. Images of birds and fish appear as decoration on the robe of the male figure of *Fulfilment* in the Stoclet Frieze, and such motifs reappear in Klimt's design of signets in 1914 for *Das Werk Gustav Klimts*, see Strobl 1980–89, IV, p. 286.

Cat. 31

1. Evidence of her temper emerges in disputes with Wiener Werkstätte staff in the 1920s, see Schweiger 1984, p. 122.
2. Fischer 1987, no. 278, p. 182, 28 February 1912: "Heute kommt Frau Primavesi — bin neugierig! — malen kann ich jetzt nix. Herzlichste Grüße GUS."
3. See Strobl's account (1980–89, II, p. 273), drawn from Hedwig Steiner, "Gustav Klimts Bindung an Familie Primavesi in Olmütz," *Vierteljahresschrift 'Mährisch-Schlesische Heimat'* (1968). Dobai, who interviewed Eugenia, mentions her acting career, Novotny Dobai 1968, p. 356 and 360. Otto Primavesi and Eugenia were married 19 September 1895, according to his "Totenbeschau-Befund" (death certificate), 9 February 1926 (he died on 8 February), Wiener Stadt- und Landesarchiv.
4. Photographs of the villa interior with descriptions of the colour scheme

were published in *Deutsche Kunst und Dekoration*, see Zuckerkandl 1916. See also Sekler 1985, pp. 128–29, who mentions Eugenia Primavesi's interest in popular culture, apparently based on interviews with Mäda Primavesi.
5. Fischer 1987, no. 341, p. 185, 10 December 1915: "LIEBE EMILIE! WINKELSDORF Gestern neunstündige Bahnfahrt—dreistündige Wagenfahrt—(offene) im Pelz gehüllt. Ankunft um 8 Uhr Abends—Winkelsdorf gerädert und wolbehalten!—spät zu Bett.... Heute schäbiges Wetter—trüb—finster und Regen. Mittags starkes Krennfleischessen—Apfel und Krautstrudel—Abends wahrscheinlich Bratwürste—morgen Blut und Leberwürste—irrsinnig!" As translated in Fischer 1992, p. 159.
6. Strobl 1980–89, II, p. 273.
7. Ibid., apparently based on information in Hedwig Steiner, op. cit.
8. Sale information for *Portrait of Emilie Flöge* (cat. 15) provided by Historisches Museum der Stadt Wien, Inventarbuch: "Ankaufsjahr 1908, Ankaufspreis: 12.000."
9. For Wiener Werkstätte textiles, see Völker 1994.
10. From a personal interview, 25 August 1963, recorded by Alessandra Comini (1974, p. 130). Beer-Monti went on to remark on Klimt's "animalism": "I felt he did not study me at all with the shy aloofness that Schiele had."
11. Schweiger 1984, pp. 96 and 267.
12. Fischer 1987, no. 323, p. 184, 18 May 1914, Klimt to Emilie Flöge: "Frau Primavesi war 'sprachlos' wie sie mir sagte, über die Schönheit des Hauses."

Cat. 32
1. A rare preparatory drawing for *Garden Path with Hens*, 1916 (N/D 215, destroyed), containing written instructions for colours, is reproduced in Nebehay 1994, p. 200.
2. As cited and translated in Nebehay 1994, p. 268.
3. *Österrikiska Konstutställningen*, Liljevalchs Konsthall, Stockholm, 1917. Fischer 1987, no. 357, 10 August 1917, and no. 361, 13 August 1917, p. 187, as translated in Fischer 1992, p. 166.

Cat. 33
1. For the tradition of picturesque postcard views of the Salzkammergut region favoured by 19th-century Austrian artists such as Adalbert Stifter or Ferdinand Georg Waldmüller, see Liechtenstein 1951, and Grimschitz 1961.
2. Letter from Klimt to F.A. Harta, signed from Bad Gastein, 30 July 1917, and reproduced in Nebehay 1969, p. 504, now in the collection of the Albertina Klimt Archive. See also the list of the artist's travels in Nebehay 1969, pp. 501ff, and Fischer 1992, p. 164, who quotes Klimt's letter to Emilie about her benefiting from the waters (27 June 1912).
3. Fischer 1987, nos. 356, 9 August 1917, and 362, 15 August 1917, p. 187.
4. Baedeker 1929, p. 268. The town was built up around the Schloss Unterach, which in 1660 belonged to Konrad Balthasar, Graf von Starhemberg, see Kegele 1898, pp. 176–77.
5. Klimt's use of the telescope to "zoom in" on landscape subjects across the lake has been discussed by Alfred Weidinger (Zürich 1992, pp. 54ff) and even captured on film (see fig. 198). Altogether, there are four views of Unterach from Weissenbach, revealing varying degrees of telescopic assistance, N/D 192, 198, 199, and the painting under discussion, N/D 218.
6. There were seven Cézannes exhibited in the sixteenth Secession, *Entwicklung des Impressionismus*, in January 1903.
7. From a speech by Peter Altenberg, delivered 12 September 1917, published as a foreword to *Das Werk Gustav Klimts*, Vienna and Leipzig: Hugo Heller, [1914]–1918, as cited in Barker and Lensing 1995, p. 101.

Cat. 34
1. Catalogued in Vienna 1988, pp. 82ff.
2. From Altenberg's speech, cited in cat. 33, n. 7.
3. See the entry on *Sleeping Chinese Boy* by James T. Ulak in *Twelve Centuries of Japanese Art from the Imperial Collections* (exh. cat.), Freer Gallery of Art and Arthur M. Sackler Gallery, 1997, pp. 152–53; see also Comini 1974, pp. 168–69, for discussion of Schiele's *Mother and Two Children*.
4. *Österrikiska Konstutställningen*, catalogue no. 8, Stockholm: Liljevalchs Konsthall, September 1917. I thank Ulla Bergman of the Konstbiblioteket, Nationalmuseum, Stockholm, for sending me a copy of this catalogue.
5. "Heut will ich mit dem Kinderbild anfangen—mit kleiner Hoffnung." Klimt to Emilie Flöge in Mayrhofen, 11 August 1917, Fischer 1987, no. 358, p. 187.
6. "Heute fang ich am Kinderbild mit Farben an," 12 August 1917, Fischer 1987, no. 359, p. 187; and "Das Kinderbild halb fertig—heute soll's damit Schluss sein," 13 August 1917, Fischer 1987, no. 361, p. 187.
7. "Ich fahre morgen Donnerstag abends [16 August 1917] hier ab bin Freitag

früh in Jenbach von dort Mayrhofen." 15 August 1917, Fischer 1987, no. 362, p. 187. This was Klimt's last recorded written communication with Emilie. *Baby* (*Barn*) is no. 106 in the catalogue of the *Österrikiska Konstutställningen*.
8. The question of Cézanne's unfinished paintings has recently been addressed in *Cézanne: Vollendet—Unvollendet* (exh. cat.), see Schröder 2000.

Cat. 35
1. Interviewed by Alice Strobl (1980–89, III, p. 132). Biographical details from Staude's "Todesbescheinigung" (death certificate), Standesamt Wien-Penzing, courtesy of Dr. Kinschner, Magistrat der Stadt Wien.
2. Study for *The Friends*, 1916–17 (private collection, Strobl 2771). *The Friends* (*Die Freundinnen*) (N/D 201) was destroyed with the Lederer collection in a fire at Schloss Immendorf in 1945.
3. My thanks to Dr. Georg Kugler for supplying details of the design; also discussed in Völker 1994, pp. 147–50.
4. Christian Nebehay interview with Staude, as cited in Zürich 1992, p. 184.
5. Around 1900, Klimt approached theatre critic Hermann Bahr about using his contacts to find a position in a chorus line for his model Therese Tischler. Correspondence, Klimt to Bahr, n.d., cited in Nebehay 1969, p. 437.
6. Schiele to Anton Peschka, 2 March 1917, cited in Roessler 1921, p. 122.
7. "Meine heilige Freundin, die *geschiedene* Frau Johanna Staude als Wirtschafterin über das ganze Kriegsküchen–Getriebe." Correspondence from Altenberg to Eugenie Scharzwald, 19 December 1918, as cited with emphasis in Barker and Lensing 1995, p. 103. Altenberg wrote in his diary on 23 December 1918: "There were three 'holy admirers,' Johanna St., Josefine Kirchoff and Lina Ertl, who devoted themselves unselfishly to me.... They saved the miserable, flickering flame of this waning, deeply tormented poet's and sinner's life, as much as these three holy women, modern saints, were able to do with their gentle, unselfish souls." Translated from Altenberg 1925, p. 141.
8. Strobl 2726 (private collection). Inscribed: "Gustav Klimt, almost unconsciously you have drawn near to the ideals of Nature, and even your simple almost aristocratic farm gardens with sunflowers and weeds contained a waft of the Creator's poetry! So gradually you held yourself apart from those that had no understanding of these things! Gustav Klimt, you were a man!!! Peter Altenberg, 21.2.1918." As translated in Novotny-Dobai 1968, p. 393.
9. Christian Nebehay (1969, p. 436) met Johanna Staude in 1963.
10. "Staude, Johanna, Kunstmalerin, 6, Chwallagasse 2," *Herold Adressbuch von Wien—früher Lehmann*, vol. 1, *Einwohnerverzeichnis*, Vienna: 'Herold' Vereinigte Anzeigengesellschaft, 1963, p. 1765. There is no mention of Johanna Staude's artistic career in the records of the Belvedere or the Österreichische Nationalbibliothek, and she does not appear in either the Thieme-Becker *Allgemeines Lexikon*, Leipzig: Engelmann, 1907–50, or Bénézit's *Dictionnaire critique et documentaire*, Paris: Gründ, 1976. Nor is she included in the index of turn-of-the-century Austrian women artists currently being prepared by Elfriede Wiltschnigg, University of Graz, "Österreichische Künstlerinnen der Jahrhundertwende und ihr Beitrag zur Österreichischen Moderne."

Cat. 36
1. Recently discussed by Peter Baum in *l'Anima e il Volto. Ritratto e Fisiognomica da Leonardo a Bacon* (exh. cat.), Palazzo Reale, Milan: Electa, 1998, p. 468; and Tobias Natter in Vienna 2000, p. 144.
2. Edith Krebs in Zürich 1992, p. 182.
3. Strobl 1980–89, IV, p. 188.
4. Fischer 1987, no. 329, p. 185.
5. Strobl 1980–89, III–IV, nos. 2663, 2664, 2665, 2666, 2666a, 3705, 3705a, and 3707.
6. Provenance documented in Novotny-Dobai 1968, p. 371.
7. "Mit der Autonomie des Unvollendeten kommt das 'non finito' als eine mögliche Form der Totalität zu seinem eigentlichen Recht." Schröder 2000, p. 9.
8. Roessler 1921, pp. 118–22. Schiele also sketched Klimt on his deathbed (Kallir 1998, p. 633, nos. 2442, 2443, 2444).

MARIAN BISANZ-PRAKKEN: GUSTAV KLIMT'S DRAWINGS

1. Cited in Pirchan 1942, pp. 79–80.
2. Carl Moll, "Meine Erinnerungen an Klimt. Aus dem Leben und Schaffen des Meisters der Secession," *Neues Wiener Tageblatt*, 24 January 1943, cited in Nebehay 1969, p. 54, n. 7b.
3. Strobl 1980–89, vol. I–IV. All Strobl numbers are from this source.

4. Some relevant commentaries: In his 1903 description of the studio Klimt occupied on Josefstädterstrasse until 1912, Hans Koppel talks about three small rooms: a room with articles of daily use and tools of the trade; a work-room with a "worn-out sofa" where he "truly lives"; a room with "a winter-garden feel to it," where plants were kept. See Koppel 1903, no. 406, p. 4; from her own portrait sittings, Friederike Beer-Monti reported on the situa-tion in Klimt's last studio, on Feldmühlgasse (as of 1912): "He also stopped working every hour to relax for quite some time in the side room, talking to the models, who were always on hand." Cited in Nebehay 1969, p. 433. Journalist Berta Zuckerkandl, who was among the artist's closest friends, recalled: "There was always one or several models in the anteroom, to ensure he would have a continuous and varying selection of prototypes for the innu-merable variations on the theme of 'woman'." Berta Zuckerkandl, 6 February 1936, cited in Nebehay 1969, p. 437.

5. Berta Zuckerkandl, 6 February 1936, cited in Nebehay 1969, p. 427.

6. Arthur Roessler, "In Memoriam Gustav Klimt," Vienna, Officina Vindobo-nensis 1926, cited in Nebehay 1969, p. 356.

7. Weixlgärtner 1912, p. 51.

8. Martin Gerlach, foreword to Gerlach 1882–85, p. 1.

9. Albert Ilg in Gerlach 1882–85, p. 13.

10. Graphite, 16.0 x 14.4 cm, dated "1882" at bottom right (private collection, Strobl 34).

11. First published in Mrazek 1978–79, nos. 66–67, pp. 37–47, colour plate I; Strobl 1980–89, I, no. 235, p. 79, colour plate p. 78. See also Strobl 2000, pp. 44–45, colour plate p. 45.

12. "Eine Huldigungsgabe für den Erzherzog Rainer," *Mitteilungen des k.k. Österreich. Museum für Kunst und Industrie, Neue Folge*, vol. 2, Vienna, 1889, p. 411.

13. See Novotny-Dobai 1975, p. 381.

14. Cat. 46, the transfer sketch for *Egyptian Art II*, shows these motifs: sar-cophagus, Isis, Hathor capital, Ptah, papyrus of the dead, suggestion of a sphinx towards the right).

15. The pose was inspired by Alexandre Cabanel's *Phaedra*, 1880 (Musée Fabre, Montpellier). The "porcelain-like smoothness and three-dimension-ality" of the woman's body accords with the salon painting of Lawrence Alma-Tadema. Strobl 1980–89, I, pp. 56–57.

16. The gouache *Auditorium of the Old Burgtheater* (cat. 3): Strobl 1980–89, I, no. 191, colour plate p. 68. The study reproduced is: *Sketch of a Man with Opera Glasses*, black crayon with white highlights, 43.1 × 27.5 cm (Albertina Wien, inv. no. 27928, Strobl 221).

17. The overall composition was inspired by Dante Gabriel Rossetti's *Astarte Syriaca*, 1877 (City Art Galleries, Manchester). See Strobl 1980–89, I, pp. 112–13.

18. The centre figure generally owes to Fernand Khnopff, possibly also to the frontal figure in Jan Toorop's *Fatalism*, 1893. The figure at the left was inspired by the book cover Toorop designed for the novel *Metamorfoze* (1897) by Dutch author Louis Couperus. See Bisanz-Prakken 1976a, pp. 77ff; and Bisanz-Prakken 1978–79, nos. 66–67, pp. 150–52.

19. For the latest information on the background to *Philosophy*, see Strobl 1980–89, IV, pp. 73–74.

20. See ibid. for the various sources of inspiration for *Philosophy* (Hans Canon, Fernand Khnopff, Auguste Rodin, Albert Besnard, etc.). On the con-cept of the stream of humanity passing by the sphinx as the embodiment of "The Riddle of the World," which is the most significant difference from the oil sketch, and its correspondence to Toorop's *Sphinx*, 1892–97, see Bisanz-Prakken 1976a, pp. 191–96b, and Bisanz-Prakken 1978–79, pp. 155–61.

21. The head described as "Knowledge," illuminated like a character in a stage production, was in all likelihood inspired by the goddess Erda, who comes out of the depths in Wagner's opera *Das Rheingold*. See Bisanz-Prakken 1976a, pp. 201–02, and Vergo 1978–79, nos. 66–67, pp. 94–97. Previously overlooked was the fact that *Rheingold* was actually performed in Vienna's Hofopern-Theater (Imperial Opera House) on 3 December 1899. Considering the date, it may well have been a source of inspiration for Klimt; given what we now know, he must have incorporated the change involving "Knowledge" some-time between early 1899 and early 1900. See Strobl 1980–89, IV, pp. 73–74.

22. For the studies of elderly models, see Strobl 467–476; Strobl 3360.

23. Hevesi 1906, p. 262.

24. The group of studies for the "floating woman": Strobl 520–538; Strobl 3354–3368 (earliest studies and those for the painted draft of 1897–98); Strobl 618–621 (studies for the first version of 1901).

25. On the general topic, see Bisanz-Prakken 1998.

26. It was Carl Moll who used the word "indifference" in this connection; see his article "Osterstimmung im Wiener Kunstleben," *Osterbeilage der Wiener*

Allgemeinen Zeitung, 1898, first published in Bisanz-Prakken 1998, p. 211.

27. Bisanz-Prakken 1998, pp. 97–98.

28. Strobl 2000, p. 45, plate p. 46.

29. On Richard Wagner as a source of inspiration, see Bisanz-Prakken 1977, pp. 32ff.

30. On the various degrees of linear stylization in the *Beethoven Frieze*, see ibid., pp. 42–45; with reference to Toorop, see Bisanz-Prakken 1978–79, pp. 179ff.

31. Koppel 1903, p. 5.

32. For more on this subject, see Bisanz-Prakken 1998, pp. 26ff.

33. Hamann and Hermand 1977, vol. 4, p. 366.

34. Ibid.

35. Ibid.

36. Ibid.

37. See Marian Bisanz-Prakken, "Klimt's Studies for the Portrait Paintings," in Vienna 2000, p. 199.

38. On George Minne's significance for the Vienna Secession, see Marian Bisanz-Prakken, "Belgische Kunstenaars en de Wiener Secession," in Brussels 2000, pp. 191–94 (includes list of my other publications on this topic). On Minne and the studies for Adele Bloch-Bauer's portrait, see Marian Bisanz-Prakken, op. cit., in Vienna 2000, p. 201.

39. See Strobl 1980–89, IV, p. 137.

40. On the use of this device throughout the studies for Serena Lederer's por-trait, see Marian Bisanz-Prakken, op. cit., in Vienna 2000, p. 199.

41. See Bisanz-Prakken 1978–79, pp. 168 and 187; Bisanz-Prakken 1998, p. 136.

42. See Strobl 1980–89, I, p. 274.

43. I am currently preparing an article on this subject, including the theme of pregnancy as treated by both artists.

44. The studies for *Hope II*: Strobl 1745–1776; Strobl 3607–3609.

45. See Bisanz-Prakken 1978–79, pp. 206–08.

46. Charcoal and black crayon, 182.5 × 90 cm (private collection). This trans-fer sketch came to light only after the publication of Alice Strobl's catalogue raisonné and will be included in my forthcoming supplementary volume.

47. The lesbian motif is represented here by cat. 87. The influence of Toorop and Minne is perceptible in the angular gestures, ecstatically raised head, and slim figure of the girl (cat. 88 and 93). Individual reclining figures for *Water Serpents II*: cat. 89, 90, 91, 94. Cat. 89 was reproduced in the 1907 publication *Die Hetärengespräche des Lukian* (Lucian's Dialogues of the Courtesans), opposite p. 26. Regarding Minne's influence on the studies for *Water Serpents I* and *II*, see Marian Bisanz-Prakken in Brussels 2000, p. 193.

48. Strobl 1533–1570. Cat. 106, c. 1907–08, presumably was made in con-nection with the somewhat later group of studies for the *Dancer* in the *Stoclet Frieze*.

49. See Alice Strobl, "Klimts Fries für den Speisesaal des Palais Stoclet in Brüssel," in Kurrent and Strobl 1991, p. 75, where a postcard Klimt wrote to Emilie Flöge on 8 July 1908 was used to clarify that the drafts were made during Klimt's stay at the Villa Oleander on the Attersee in August 1908, pp. 68–69.

50. The branches in both feature a pattern of closely spaced large and small spiral motifs. In both the door design and the *Stoclet Frieze*, which (as the *Beethoven Frieze*) blends the various periods of "temple art," this decorative motif serves a purpose architecturally. Although Klimt had employed the spiral motif previously, this marks the first time he used it to such a large extent. He may have become aware of the medieval door motif through pho-tographs or contemporary publications. On the tree of life motif see Alfred Weidinger, "Natursehen am Attersee: Aspekte der Landschaftsmalerei Gustav Klimts," in Weidinger 2000, pp. 64–65 (lists related publications by this author on p. 69).

51. Strobl 1739–1744 (1904–05); Strobl 1786–1793 (1907–08); Strobl 3613–3614 (1907–08).

52. Alice Strobl (1980–89, II, p. 198) refers to Klimt's having been inspired by Andrea Mantegna's *Madonna*, late 1480s (illustrated in H. Thode, *Mantegna*, Bielefeld, Leipzig, 1897, p. 116, fig. 96). Egon Schiele's 1910 canvas *The Dead Mother* presumably bears a relation to Klimt's *Mother and Children*; see Johannes Dobai in Novotny-Dobai 1975, no. 163, p. 347.

53. Cited in Fischer 1987, p. 500. See Strobl 1980–89, IV, p. 165.

54. Fischer 1987, p. 179, no. 228.

55. As, for instance, in the studies for *Adam and Eve* and *The Bride*. Cat. 123, a study of the heads of two men (Strobl 2878), done in connection with *Adam and Eve*, is an exception to this, as Klimt has paid closer attention to the models' facial features.

56. For Toorop's influence on Klimt, see Bisanz-Prakken 1976a and 1978–79.

57. Strobl 1980–89, III, p. 12.

58. Strobl 2275; closely related study: Strobl 2273.

59. Strobl 2274; colour plate p. 9.

60. Koppel 1903, p. 5.

61. The term "Dream of Becoming" is used in a commentary on *The Three Brides* written by Toorop, translated by Hans von Bartels, and published in *Die Kunst für Alle*, 9:3 (1 November 1893).

62. In this late phase as well, the combination of pencil with red and blue and white crayon was used to great effect. See Strobl 2000, p. 54.

63. Bisanz-Prakken 1978–79, p. 209.

64. Done in 1916: Strobl 2524–2624; Strobl 3688–3689b.

65. Strobl 2609–2618; Strobl 3695–3696a.

66. Eisler 1920, p. 5.

67. See Bisanz-Prakken 1998, p. 73.

68. For the most recent information on exhibitions at the Galerie Miethke, see Tobias G. Natter in Vienna/Salzburg 1998, pp. 129–93. Among the important international artists exhibited were: Aubrey Beardsley (1904–05); Wilhelm Leibl et al. (March–April 1905); Toulouse-Lautrec et al. in the exhibition of Modern French Graphic Art (September 1905); Modern Munich Painters (November–December 1905); George Minne (December 1905); Vincent van Gogh (January 1906); Paul Gauguin (March–April 1907); Paul Cézanne et al. (March–April 1907); Toulouse-Lautrec (October–December 1909); and Ferdinand Hodler (1909–1910). On Klimt's trips abroad (to Munich, Ravenna, Brussels, London, Rome, etc.), see Nebehay 1969, pp. 491–508.

69. Bisanz-Prakken 1977, pp. 48ff.

70. Marian Bisanz-Prakken in Brussels 2000, pp. 191–94.

71. John the Baptist, plaster, 72 cm (Museum voor Schone Kunsten, Ghent, Belgium, inv. no. 1921–CH). The angular, stylized gestures of the hands, which are held at oblique angles, are characteristic of Klimt's golden period and might also have been inspired by Minne's "Gothic-style" woodcut, *Baptism of Christ*, which was exhibited in the Secession in the winter of 1900–01. See Bisanz-Prakken 1998, p. 169.

72. Eisler 1920, p. 5.

73. Eisler 1920, p. 6.

JOHN COLLINS: CHRONOLOGY

1. On Drabschitz (Trávčice), see *Special-Orts-Repertorium von Böhmen*, Vienna: k.k. Statistische Central-Commission, 1893, p. 380. Reference kindly provided by Dr. Rainer Egger, Kriegsarchiv, Österreichisches Staatsarchiv, Vienna. Nebehay 1969, p. 11.

2. "Bürgerschule" on *Curriculum vitae*, handwritten document by Klimt dated 21 December 1893, submitted as part of his application for a professorship to the Spezialschule für Historienmalerei, Archive of the Akademie der bildenden Künste, Vienna, reproduced in Strobl 1980–89, IV, pp. 48–53.

3. Mahler-Werfel 1999, p. 125.

4. *Curriculum vitae*, op. cit.

5. Giese 1978–79, p. 60.

6. Ibid., pp. 60–61; Nebehay 1969, pp. 26, 60; "Frequentations-Zeugniss" (Certificate of Attendance), Kunstgewerbeschule, Vienna, 24 July 1879, Graphische Sammlung Albertina; Mahler-Werfel 1999, p. 125.

7. N/D 1–4. *Curriculum vitae*, op. cit.

8. Strobl 42, Historisches Museum der Stadt Wien. Novotny-Dobai 1968, p. 380.

9. *Curriculum vitae*, op. cit.

10. N/D 38–42. Ibid.; Strobl 1980–89, I, p. 55; Novotny-Dobai 1968, pp. 286–91.

11. *Kunst für Alle*, 2nd year, 1887, p. 324.

12. *Curriculum vitae*, op. cit.

13. Nebehay 1969, p. 97; Strobl 1980–89, I, p. 55.

14. Nebehay 1969, p. 491.

15. Walton 1889, pp. vii, 10. This is not included in the complete listing of Klimt's exhibitions outside the Secession and Kunstschau found in Nebehay 1969, pp. 516–20.

16. No. 485. Künstlerhausarchiv, Vienna, Protokoll der Commission der Genossenschaft der bildenden Künstler Wiens, 26 April 1890; Nebehay 1994, p. 32.

17. Nebehay 1969, p. 492.

18. Vienna 1988, p. 22.

19. Strobl 1962, p. 12.

20. Strobl 1964, p. 139.

21. Hölz 1996, p. 36.

22. Nebehay 1969, p. 27.

23. N/D 62. Novotny-Dobai 1968, p. 297; Nebehay 1969, pp. 27, 493.

24. Thieme-Becker, *Allgemeines Lexikon der bildenden Künstler*, 1907–50, vol. 24, p. 250.

25. *Curriculum vitae*, op. cit.; Strobl 1980–89, IV, p. 53; Wagner 1967, p. 251.

26. Nebehay 1969, p. 494; Nebehay 1994, p. 61.

27. Strobl 1964, p. 141; Novotny-Dobai 1968, p. 383.

28. Vergo 1993, p. 21.

29. Nebehay 1994, p. 23.

30. Ibid., p. 252.

31. *Music I* (N/D 69), dated "95"; Nebehay 1969, p. 177.

32. *Die Graphischen Künste*, no. 3 (1896).

33. Neuwirth 1964, p. 30.

34. Fischer 1987, pp. 169–70.

35. Neuwirth 1964, p. 31.

36. Nebehay 1969, p. 494.

37. Bisanz-Prakken 1996, p. 21.

38. Nebehay 1994, p. 270.

39. Hevesi 1906, pp. 12–13.

40. *Ver Sacrum*, March 1898, p. 23; Novotny-Dobai 1968, p. 384.

41. *Ver Sacrum*, May 1898, p. 1; Breckner 1978, p. 190.

42. Mahler-Werfel 1999, p. 24.

43. Ibid., p. 29.

44. Strobl 1964, p. 142.

45. Mahler-Werfel 1999, p. 40.

46. N/D 98. Ibid., p. 58.

47. Ibid., pp. 123, 144.

48. Ibid., p. 124.

49. Ibid., p. 147.

50. Ibid., p. 125.

51. Ibid., p. 129.

52. Fischer 1992, p. 136.

53. Nebehay 1969, p. 494.

54. N/D 101, destroyed. Nebehay 1994, p. 268.

55. Mahler-Werfel 1999, p. 247.

56. Strobl 1964, pp. 152–54; *Ver Sacrum* III (1900), p. 186, as cited in Nebehay 1969, p. 208.

57. N/D 107, now the Österreichische Galerie Belvedere.

58. Muther 1900–01, vol. I, p. 334.

59. For titles of paintings, see cat. 11, n. 3. Nebehay 1994, p. 270; Fischer 1987, p. 170.

60. *Fable* (cat. 1), *Idyll* (cat. 2), *Love* (cat. 8), *Allegory of Sculpture* (cat. 48), *June* (cat. 47), *Tragedy* (cat. 50). Strobl 1980–89, IV, p. 223.

61. N/D 69; now the Neue Pinakothek.

62. Bahr 1903, pp. 47–49, cited in Novotny-Dobai 1968, p. 386.

63. Bahr 1903, pp. 46–47, cited in Novotny-Dobai 1968, p. 386.

64. Nebehay 1969, p. 258.

65. Wagner 1967, p. 255; Zuckerkandl 1905, p. 186.

66. Hevesi 1906, p. 384.

67. Berta Szeps-Zuckerkandl, *My Life and History*, J. Sommerfield, trans. New York: A Knopf, 1939, pp. 180–81; Auguste Rodin, *Correspondance*, vol. 2, Alain Beausire and Hélène Pinet, eds. Paris: Musée Rodin, 1985, p. 62.

68. The artist drew the infant on his deathbed, wrapped in a white shroud (Strobl 999, private collection). Dates cited by Strobl 1980–89, I, p. 274.

69. Nebehay 1969, p. 308.

70. Ibid., p. 495.

71. Schweiger 1984, p. 27.

72. Fischer 1987, no. 35, p. 170.

73. Nebehay 1994, p. 268.

74. See Bahr 1903.

75. Bahr 1987, pp. 149–50.

76. Österreichisches Staatsarchiv, Vienna, Akt. AVA, K.u.U. 33.219/03, fol. 1–18.

77. Daviau 1978, pp. 24, 48 n. 53.

78. Hevesi cited in Vergo 1993, p. 81.

79. Including *Fütterung* (Feeding, N/D 107 or 114 [cat. 13]), *Aus dem Reiche des Todes* (Procession of the Dead, N/D 131), *Pallas Athena* (cat. 11), *Buche* (Beech Forest, N/D 137), *Nixen* (Nixies, N/D 95), *Insel* (Island, N/D 117), *Junges Mädchen* (Young Girl, N/D 82 [cat. 8?]). *Die Zeit*, 15 November and 31 December 1903. Total sales for the exhibition amounted to 36,455 crowns. Sales statement reproduced in Nebehay 1994, p. 228.

80. Nebehay 1994, p. 74.

81. Salten 1903, p. 43.

82. Fischer 1987, pp. 170–71.

83. Peter Altenberg, *Kunst* (Vienna), 3 December 1903, vol. 7, pp. 20ff.

84. Bacher was married to Emma Paulick, sister-in-law of Hermann Flöge, Emilie's brother. The Bachers vacationed on the Attersee at the Villa Paulick. Weidinger and Vergeiner 1988, pp. 5–6; Hölz 1996, p. 36; Schweiger 1984, p. 45.

85. Nebehay 1969, pp. 333–36.

86. Vienna 1982–83, pp. 119–20.

87. Sekler 1985, p. 290; Fischer 1992, p. 27.

88. Earlier orders (20 September 1900) included a subscription to *Japanische Erotik* (Munich: Piperverlag). Nebehay 1969, p. 53.

89. Nebehay 1994, p. 207.

90. Zuckerkandl 1908, pp. 154–55; Strobl 1964, p. 162.

91. *Katalog der zweiten Ausstellung des Deutschen Künstlerbundes*, Berlin: Ausstellungshaus, 1905, p. 21; Fischer 1992, p. 139.

92. Hevesi 1906, p. 504; Kossatz 1975, p. 23; Nebehay 1969, pp. 348–50.

93. *Wiener Allgemeine Zeitung*, 3 October 1905, in Schweiger 1984, p. 52.

94. Egon Gartenberg, *Mahler: The Man and His Music*, New York, 1978, p. 130.

95. Hevesi 1909a, pp. 526–29.

96. Nebehay 1969, p. 511; *Deutsche Kunst und Dekoration*, vol. 19 (1906–07), pp. 65ff.

97. Nebehay 1969, p. 497; Vergo 1981, pp. 33, 35 n. 7; Fischer 1992, p. 139.

98. Fischer 1992, p. 141.

99. Fischer 1987, p. 172.

100. *Deutsche Kunst und Dekoration*, vol. 19 (October 1906–March 1907), pp. 65–73; Fischer 1992, p. 95.

101. Postcard to his sister, Fanny Klimt, in Nebehay 1969, p. 498.

102. Krupp to Wagner, 9 February 1907, Getty Research Institute, Otto Wagner Correspondence, 870399.

103. M. Pernot, "Exposition de Panneaux Décoratifs de M. Gustave Klimt," *La Chronique des Arts et de la Curiosité*, March 1907, p. 78; invitation reproduced in Nebehay 1969, p. 518.

104. Diary entry for 22 March 1907, Schnitzler 1981–2000, vol. 1, p. 262.

105. Nebehay 1969, p. 379.

106. Karpfen 1921, p. 87.

107. Fischer 1987, p. 172.

108. "Kabarett 'Fledermaus'," *Neue Wiener Journal*, 20 October 1907, p. 12.

109. Fischer 1987, no. 89, p. 172; Schweiger 1984, pp. 85–86.

110. Breicha 1978, pp. 137–38; Hofmann 1971, p. 16.

111. Kokoschka 1974, p. 21.

112. Strobl 1980–89, II, p. 162; Hevesi 1909a, p. 316.

113. Novotny-Dobai 1968, p. 391.

114. Fischer 1987, p. 173; Inventarbuch Historisches Museum der Stadt Wien "Zuwachspotokoll" Z AR 108/21, courtesy of Susanne Winkler.

115. Fischer 1987, p. 173.

116. Ibid., p. 174.

117. Fischer 1992, pp. 144–53.

118. Ibid., p. 137.

119. Nebehay 1969, pp. 416–19; Fischer 1987, p. 176; Comini 1974, p. 38.

120. Zuckerkandl, "Einiges über Klimt," *Volkszeitung* (Vienna), 6 February 1936, as cited in Sármány-Parsons 1987, p. 72.

121. Weidinger and Vergeiner 1988, pp. 17–18.

122. Fischer 1987, p. 177.

123. Ibid., p. 178.

124. *La Chronique des Arts*, 6 November 1909.

125. Schweiger 1984, p. 224.

126. N/D 159.

127. Fischer 1987, pp. 179–81, 237.

128. Ibid., p. 180; Sekler 1985, p. 338; Kallir 1998, p. 394.

129. Fischer 1987, no. 253, p. 180.

130. Weidinger and Vergeiner 1988, p. 18.

131. Novotny-Dobai 1968, p. 324; Nebehay 1969, p. 500; Sekler 1985, pp. 338–39.

132. Weidinger and Vergeiner 1988, pp. 18–19.

133. N/D 122. Novotny-Dobai 1968, p. 324.

134. Ibid., p. 390.

135. Fischer 1987, p. 181.

136. Ibid., p. 182; Nebehay 1969, p. 501.

137. Nebehay 1969, p. 501; Weidinger and Vergeiner 1988, p. 23.

138. N/D 185, location unknown; N/D 186, destroyed. Weidinger and Vergeiner 1988, pp. 23–24; Nebehay 1969, pp. 501–02.

139. Weidinger and Vergeiner 1988, p. 25; Fischer 1992, pp. 68–70.

140. Nebehay 1969, p. 51.

141. Schweiger 1984, pp. 96, 267.

142. Vergo 1983, p. 410.

143. Strobl 1980–89, IV, p. 188; Fischer 1987, nos. 314, 320, 326, p. 184; Nebehay 1969, p. 464.

144. Fischer 1987, no. 323, p. 184.

145. N/D 182 and 189. Nebehay 1969, p. 456; Weidinger and Vergeiner 1988, p. 25.

146. Nebehay 1969, p. 291; Mahler-Werfel 1960, p. 57; Monson 1983, p. 164.

147. Hölz 1996, p. 36.

148. Diary entry for 18 May 1915, Schnitzler 1981–2000, vol. 2, pp. 198, 261, and 273.

149. Schweiger 1984, p. 96.

150. Weidinger and Vergeiner 1988, p. 26.

151. No. 47, *Bäume in Wiese* [Trees in a meadow], oil, 9,500 francs; no. 48, *Die Seelen der Verschiedenen* [Souls of the departed], gouache, 6,000 francs; no. 49, *Landschaft* [Landscape], oil, 3,600 francs; and nos. 54–75, all drawings, from "Wiener Künstler," in Kunsthaus Zürich, *Ausstellung* (exh. cat.), 4–22 August 1915, pp. 6-7.

152. Fischer 1987, no. 340, p. 185; Sotheby's 1999, no. 65, p. 53.

153. Fischer 1987, no. 341, pp. 185–86.

154. Ibid., no. 346, p. 186.

155. N/D 193. Liechtenstein 1951, p. 315.

156. Nebehay 1969, p. 511.

157. Roessler 1921, p. 197; Comini 1974, p. 151–52.

158. Wiener Werkstätte Archive, MAK, Vienna, Protocol of Board Meetings, kindly transmitted by Dr. Elisabeth Schmuttermeier.

159. Weidinger and Vergeiner 1988, p. 26.

160. Nebehay 1994, p. 218.

161. Fischer 1987, nos. 351, 353, p. 186.

162. Roessler 1921, pp. 118–22.

163. *Schönbrunn Park* (N/D 194), *The Friends* (*Die Freundinnen*) (N/D 201). Nebehay 1969, p. 504.

164. Fischer 1992, p. 134.

165. Nebehay 1969, p. 504.

166. *Österrikiska Konstutställningen*, Liljevalchs Konsthall, Stockholm, 1917 (exh. cat.), Konstbiblioteket, Nationalmuseum, Stockholm; Kallir 1998, p. 700.

167. *Portrait of Barbara Flöge* (N/D 191). Fischer 1987, nos. 356, 357, p. 187.

168. Ibid., no. 362, p. 187.

169. Nebehay 1969, p. 479.

170. Ibid., p. 511.

171. Vergo 1993, pp. 237–38.

172. Ibid., p. 238.

173. Roessler 1922b, p. 81.

Bibliography

Alofsin 1992
Anthony Alofsin. "The Kunsthistorisches Museum: A Treasure House for the Secessionists," *Jahrbuch der Kunsthistorischen Sammlungen in Wien* vol. 88 (New Series), vol. 52 (1992), pp. 189–203.

Altenberg 1903
Peter Altenberg. "Gustav Klimt," *Kunst* (Vienna), vol. 7 (3 December 1903), pp. 20 ff.

Altenberg 1909
Peter Altenberg. *Bilderbögen des kleinen Lebens*. Berlin: Erich Reiss, 1909.

Altenberg 1925
Peter Altenberg. *Der Nachlass*. Berlin: S. Fischer, 1925.

Antonelli 1912
Giuseppe Antonelli. *La Pittura a Valle Giulia. Esposizione internationale di Roma del 1911*. Rome: G. Romagna & Co., 1912, pp. 78–79; 140–43.

Ariès 1985
Philippe Ariès. *Images of Man and Death*. Janet Lloyd, trans. Cambridge, Mass.: Harvard University Press, 1985.

Baedeker 1929
Karl Baedeker. *Austria, together with Budapest, Prague, Karlsbad, Marienbad*, 12th rev. ed. Leipzig: Karl Baedeker, 1929.

Bahr 1900
Hermann Bahr. *Secession*, 2nd ed. Vienna: Wiener Verlag, 1900.

Bahr 1901
Hermann Bahr. *Rede über Klimt*. Vienna: Wiener Verlag, 1901.

Bahr 1903
Hermann Bahr. *Gegen Klimt*. Vienna and Leipzig: Verlag J. Eisenstein, 1903.

Bahr 1987
Hermann Bahr. *Prophet der Moderne. Tagebücher 1888–1904*. Vienna: Böhlau, 1987.

Barker 1996
Andrew Barker. *Telegrams from the Soul: Peter Altenberg and the Culture of Fin-de-siècle Vienna*. Columbia, S.C.: Camden House, 1996.

Barker and Lensing 1995
Andrew Barker and Leo A. Lensing. *Peter Altenberg: Rezept die Welt zu Sehen*. Vienna: Braumüller, 1995.

Birnie Danzker 1997
Jo-Anne Birnie Danzker, ed. *Franz von Stuck. Die Sammlung des Museums Villa Stuck*. Munich: Villa Stuck, 1997.

Bisanz 1963
Hans Bisanz. "Edvard Munch og portrettkunsten i Wien etter 1900," *Årbok*, Oslo Kommunes Kunstsamlinger, 1963, pp. 68–101.

Bisanz-Prakken 1976a
Marian Bisanz-Prakken, "Jan Toorop en Gustav Klimt. Een analyse van de betekenis van Jan Toorop voor Gustav Klimt," *Nederlands Kunsthistorisch Jaarboek*, 1976, pp. 175–209.

Bisanz-Prakken 1976b
Marian Bisanz Prakken. "Zum Gemälde 'Pallas Athene' von Gustav Klimt," *Alte und Moderne Kunst* 21:147 (1976), pp. 8–11.

Bisanz-Prakken 1977
Marian Bisanz-Prakken. *Gustav Klimt: Der Beethovenfries, Geschichte, Funktion und Bedeutung*. Salzburg: Residenz Verlag, 1977. Unabridged edition, 1980.

Bisanz-Prakken 1978–79
Marian Bisanz Prakken. "Gustav Klimt und die 'Stilkunst' Jan Toorops," *Mitteilungen der Österreichischen Galerie, Klimt-Studien* 22/23: 66/67 (1978–79), pp. 146–214.

Bisanz-Prakken 1982
Marian Bisanz-Prakken. "Das Quadrat in der Flächenkunst der Wiener Secession," *Alte und moderne Kunst* nos. 180–181 (1982), pp. 40–46.

Bisanz-Prakken 1991
Marian Bisanz-Prakken. *Jan Toorop — Die Träumerin. Eine Neuerwerbung der Albertina*, exh. cat. Vienna: Albertina, 1991.

Bisanz-Prakken 1996
Marian Bisanz-Prakken. "Im Antlitz des Todes. Gustav Klimts 'Alter Mann auf dem Totenbett,' ein Portrait Hermann Flöges?," *Belvedere* 2: 1 (1996), pp. 20–39.

Bisanz-Prakken 1998
Marian Bisanz-Prakken. *Heiliger Frühling. Gustav Klimt und die Anfänge der Wiener Secession, 1895–1900*, exh. cat. Vienna: Graphische Sammlung Albertina / Verlag Christian Brandstätter, 1998.

Bouillon 1987
Jean-Paul Bouillon. *Klimt: Beethoven: The Frieze for the Ninth Symphony*. Geneva and New York: Skira–Rizzoli, 1987.

Brandstätter 1998
Christian Brandstätter. *Klimt und Die Mode*. Vienna: Verlag Christian Brandstätter, 1998.

Breckner 1978
Egon W. Breckner. *Hermann Bahr and the Quest for Culture. A Critique of His Essays*. Ph.D. thesis, University of Wisconsin–Madison, 1978.

Breicha 1978
Otto Breicha, ed. *Gustav Klimt. Die Goldene Pforte. Werk-Wesen-Wirkung. Bilder und Schriften zu Leben und Werk*. Salzburg: Galerie Welz, 1978.

Broch 1984
Hermann Broch. *Hugo von Hofmannsthal and His Time. The European Imagination 1860–1920*. Michael P. Steinberg, trans. Chicago: University of Chicago, 1984.

Brussels 1987
Fernand Khnopff et ses rapports avec la Sécession viennoise, exh. cat. Brussels: Musées royaux des Beaux-Arts de Belgique, 1987.

Brussels 2000
Robert Hoozee, ed. *Kruispunt van Culturen*, exh. cat. Brussels and Antwerp: Paleis voor Schone Kunsten / Fonds Mercator, 2000.

Cecchi 1914
Emilio Cecchi. "L'occhio della colomba," *Il Marzocco*, 14 May 1914, p. 3.

Cernuschi 1999
Claude Cernuschi. "Pseudo-Science and Mythic Misogyny: Oskar Kokoschka's *Murderer, Hope of Women*," *The Art Bulletin* 81:1 (March 1999), pp. 126–48.

Clair 1986
Jean Clair, ed. *Vienne, 1880–1938: l'apocalypse joyeuse*, exh. cat. Paris: Éditions du Centre Pompidou, 1986.

Clair 1999
Jean Clair, ed. *Cosmos: du romantisme à l'Avant-garde*, exh. cat. Montreal, Munich, New York: Musée des beaux-arts de Montréal / Prestel, 1999.

Clark 1959
R.T. Rundle Clark. *Myth and Symbol in Ancient Egypt*. New York: Grove Press, 1959.

Comini 1974
Alessandra Comini. *Egon Schiele's Portraits*. Berkeley: University of California Press, 1974.

Comini 1975
Alessandra Comini. *Gustav Klimt*. New York: George Braziller, 1975, reprint 1988; also London: Thames & Hudson, 1975.

Cozzani 1910
Ettore Cozzani. "Gustav Klimt: l'orchidea," *Vita d'Arte* no. 5 (January–June 1910), pp. 248–50.

Czeike 1992–94
Felix Czeike. *Historisches Lexikon Wien*. 5 vols. Vienna: Kremayr and Scheriau, 1992–94.

Czernin 1999
Hubertus Czernin. *Die Fälschung. Der Fall Bloch-Bauer* and *Die Fälschung. Der Fall Bloch-Bauer und das Werk Gustav Klimts*, 2 vols. Vienna: Czernin Verlag, 1999.

Damerini 1910
Gino Damerini, "Gustav Klimt," *Il Gazzettino di Venezia*, 23 April 1910.

Daviau 1978
Donald G. Daviau, ed. *Letters of Arthur Schnitzler to Hermann Bahr*. Chapel Hill: University of North Carolina, 1978.

De Benedetti 1911
Michele de Benedetti. *L'Esposizione internazionale di Belle Arti in Roma nel 1911*. Rome: Nuova Antologia, 1911, pp. 26–89.

De Caso and Sanders 1977
Jacques de Caso and Patricia B. Sanders. *Rodin's Sculpture. A Critical Study of the Spreckels Collection, California Palace of the Legion of Honor*. San Francisco: The Fine Arts Museums, 1977.

Delevoy 1979
Robert L. Delevoy. *Fernand Khnopff*. Lausanne and Paris: La Bibliothèque des arts, 1979.

De Tolnay 1947–60
Charles De Tolnay. *Michelangelo*. 5 vols. Princeton, N.J.: Princeton University Press, 1947–60.

Denscher 1999
Barbara Denscher, ed. *Kunst & Kultur in Österreich: Das 20. Jahrhundert*. Vienna and Munich: Verlag Christian Brandstätter, 1999.

Dijkstra 1986
Bram Dijkstra. *Idols of Perversity. Fantasies of Feminine Evil in Fin-de-siècle Culture*. New York: Oxford University Press, 1986.

Di Stefano 1985
Eva di Stefano. "Die zweigesichtige Mutter," in *Début eines Jahrhunderts. Essays zur Wiener Moderne*. Wolfgang Pircher, ed. Vienna: Falter, 1985, pp. 109–26.

Dobai 1968
Johannes Dobai. "Zu Gustav Klimts Gemälde 'Der Kuß'," *Mitteilungen der Österreichischen Galerie* 12:56 (1968), pp. 83–142.

Dobai 1971
Johannes Dobai. "Gustav Klimt's 'Hope I'," *Bulletin. National Gallery of Canada* (17), 1971, pp. 2–15.

Dobai 1988
Johannes Dobai. *Gustav Klimt. Landscapes*. Ewald Osers, trans. Boston: Little, Brown and Co., 1988. German edition: Salzburg: Galerie Welz, 1981.

Eisler 1920
Max Eisler. *Gustav Klimt*. Vienna: Österreichische Staatsdruckerei, 1920.

Engelhart 1943
Josef Engelhart. *Ein Wiener Maler Erzählt*. Vienna: Wilhelm Andermann, 1943.

Essen/Zürich 1987–88
Edvard Munch, exh. cat. Essen and Zürich: Museum Folkwang Essen / Kunsthaus Zürich, 1987–88.

Faber 1983
Monika Faber. *Madame d'Ora. Wien-Paris. Portraits aus Kunst und Gesellschaft 1907–1957*. Vienna: Verlag Christian Brandstätter, 1983.

Fischer 1987
Wolfgang G. Fischer. *Gustav Klimt und Emilie Flöge. Genie und Talent, Freundschaft und Besessenheit*. Vienna: Verlag Christian Brandstätter, 1987.

Fischer 1992
Wolfgang G. Fischer. *Gustav Klimt and Emilie Flöge. An Artist and His Muse*. Woodstock, N.Y.: Overlook Press, 1992.

Florman 1990
Lisa Florman. "Gustav Klimt and the Precedent of Ancient Greece," *The Art Bulletin* 72:2 (June 1990), pp. 310–26.

Frankfurt 1995
Sabine Schulze, ed. *Sehnsucht nach Glück. Wiens Aufbruch in die Moderne. Klimt, Kokoschka, Schiele*, exh. cat. Frankfurt and Ostfildern-Ruit: Schirn Kunsthalle / G. Hatje, 1995.

Frodl 1992
Gerbert Frodl. *Klimt*. Alexandra Campbell, trans. New York: Konecky & Konecky, 1992. German edition: Cologne: DuMont, 1992.

Gerlach 1882 (English)
Allegories and Emblems. Original Designs by the Most Distinguished Modern Artists; also Reproductions of Old Trade Arms and Designs for Modern Ones in the Renaissance Style. With explanatory texts by Dr. Albert Ilg. Vienna: Gerlach and Schenk, 1882.

Gerlach 1882–85 (German)
Martin Gerlach, ed. *Allegorien und Embleme. Originalentwürfe von den hervorragendsten modernen Künstlern, sowie Nachbildungen alter Zunftzeichen und moderne Entwürfe von Zunftwappen im Charakter der Renaissance.* With explanatory texts by Dr. Albert Ilg. Vienna: Gerlach and Schenk, 1882–85.

Gerlach 1896
Martin Gerlach, ed. *Allegorien. Neue Folge. Originalentwürfe von namhaften modernen Künstlern, mit erläuterndem Text.* Vienna: Gerlach and Schenk, 1896[–1900?]

Giese 1978–79
Herbert Giese. "Matsch und die Brüder Klimt. Regesten zum Frühwerk Gustav Klimts," *Mitteilungen der Österreichischen Galerie, Klimt-Studien* 22/23: 66/67 (1978–79), pp. 48–68.

Greenhalgh 2000
Paul Greenhalgh, ed. *Art Nouveau 1890–1914.* London: Victoria and Albert Publications, 2000.

Grimschitz 1961
Bruno Grimschitz. *Die Altwiener Maler.* Vienna: Kunstverlag Wolfrum, 1961.

Gmeiner and Pirhofer 1985
Astrid Gmeiner and Gottfried Pirhofer. *Der Österreichische Werkbund.* Vienna: Residenz Verlag, 1985.

Guide to Vienna 1884
Guide to Vienna. The Traveller's Companion through the Austrian Metropole and Its Environs. Vienna: William Braumüller, 1884.

Guide to Vienna 1909
The Newest Plan and Guide to Vienna and Environs, 12th ed. Vienna: R. Lechner, 1909.

Haberfeld 1912
Hugo Haberfeld. "Gustav Klimt," *Kunst für Alle* 27:8 (15 January 1912), pp. 173–87.

Hamann and Hermand 1977
Richard Hamann and Jost Hermand. *Stilkunst um 1900. Epochen Deutscher Kultur von 1870 bis zur Gegenwart,* vol. 4. Frankfurt: Fischer Taschenbuch Verlag, 1977 (1st edition: Berlin: Akademie Verlag, 1959).

Harrison and Wood 1998
Charles Harrison and Paul Wood, eds. *Art in Theory, 1815–1900: An Anthology of Changing Ideas.* Malden, Mass.: Blackwell, 1998.

Heck 1988
Christian Heck. "De 'L'École du Danube' à la Vienne de la Secession. Klimt et Altdorfer," *Cahiers du Musée national d'art moderne* no. 23 (Spring 1988), pp. 75–81.

Hermand 1972
Jost Hermand. *Der Schien des Schönen Lebens. Studien zur Jahrhundertwende.* Frankfurt: Athenäum, 1972.

Hevesi 1906
Ludwig Hevesi. *Acht Jahre Secession: Kritik, Polemik, Chronik 1897–1905.* Vienna: Carl Konegen, 1906. Reprint 1984, Klagenfurt: Ritter Verlag.

Hevesi 1909a
Ludwig Hevesi. *Altkunst–Neukunst: Wien 1894–1908.* Vienna: Carl Konegen, 1909. Reprint 1986, Klagenfurt: Ritter Verlag.

Hevesi 1909b
Ludwig Hevesi. "Internationale Kunstschau Wien 1909," *Zeitschrift für Bildende Kunst* vol. 20, 1909, pp. 221–26.

Hofmann 1971
Werner Hofmann. *Gustav Klimt.* Inge Goodwin, trans. New York: Graphic Society, 1971.

Hofmann 1972
Werner Hofmann. *Gustav Klimt.* London: Studio Vista, 1972.

Hölz 1996
Christoph Hölz, ed. *Gegenwelten. Gustav Klimt: Künstlerleben im Fin de Siècle.* Munich: Bayerische Vereinsbank, 1996.

Janik and Toulmin 1973
Allan Janik and Stephen Toulmin. *Wittgenstein's Vienna.* New York: Simon and Schuster, 1973.

Kallir 1980
Jane Kallir. "Kallir, Klimt and Schiele," in *Gustav Klimt / Egon Schiele,* exh. cat. New York: Galerie St. Etienne / Crown Publishers, 1980.

Kallir 1986
Jane Kallir. *Viennese Design and the Wiener Werkstätte.* New York: Galerie St. Etienne–George Braziller, 1986.

Kallir 1998
Jane Kallir. *Egon Schiele: The Complete Works.* New York: Harry N. Abrams, 1998.

Kallir 1999
Jane Kallir. *Saved from Europe: Otto Kallir and the History of the Galerie St. Etienne.* New York: Galerie St. Etienne, 1999.

Karpfen 1921
Fritz Karpfen, ed. *Das Egon Schiele Buch.* With contributions by Arthur Roessler and Gustinus Ambrosi. Vienna: Wiener Graphische Werkstätte, 1921.

Kegele 1898
Leo Kegele. *Das Salzkammergut nebst angrenzenden Gebieten in Wort und Bild.* Vienna: A. Hartlebens Verlag, 1898.

Kilinski 1979
Karl Kilinski. "Classical Klimtomania: Gustav Klimt and Archaic Greek Art," *Arts Magazine* 53:8 (April 1979), pp. 96–99.

Kilinski 1982
Karl Kilinski. "Classical Klimtomania: An Update," *Arts Magazine* 56:7 (March 1982), pp. 106–07.

Kokoschka 1971
Oskar Kokoschka. *Mein Leben. Vorwort und dokumentarische Mitarbeit von Remigius Netzer.* Munich: Bruckmann, 1971.

Kokoschka 1974
Oskar Kokoschka. *My Life.* David Britt, trans. London: Thames and Hudson, 1974.

Koppel 1903
Hans Koppel. "Wiener Neuigkeiten. Bei Gustav Klimt," *Die Zeit* (Vienna) no. 406, 15 November 1903, pp. 4–5.

Koschatzky 1975
Walter Koschatzky. *Rudolf von Alt, 1812–1905.* Salzburg: Residenz Verlag, 1975.

Koschatzky 1984
Walter Koschatzky. *Rudolf von Alt, 1812–1905: die schönsten Aquarelle aus den acht Jahrzehnten seines Schaffens,* exh. cat. Vienna: Graphische Sammlung Albertina, 1984.

Kossatz 1975
Horst-Herbert Kossatz. "Der Austritt der Klimt-Gruppe—Eine Presse-nachschau," *Alte und Moderne Kunst* 20:141 (1975), pp. 23–26.

Kurrent and Strobl 1991
Friedrich Kurrent and Alice Strobl. *Das Palais Stoclet in Brüssel*. Salzburg: Galerie Welz, 1991.

Kuzmany 1908
Karl M. Kuzmany. "Kunstschau Wien 1908," *Die Kunst* vol. 18 (September 1908), pp. 513ff.

Kuzmany 1909
Karl M. Kuzmany. "Die 'Kunstschau' Wien 1909," *Die Kunst* vol. 21 (October 1909), pp. 20–22.

Lachnit 1986
Edwin Lachnit. "Neuentdeckte Dokumente zum Professorenstreit um Klimts 'Philosophie'," *Wiener Jahrbuch für Kunstgeschichte* vol. 39 (1986), pp. 205–20.

Lancelloti 1926
Arturo Lancelloti. *Le Biennale Veneziane dell'ante guerre*. Rome: Casa d'Arte Ariel, 1926, pp. 142–44.

Lancelloti 1931
Arturo Lancelloti. *Le mostre romane del Cinquantenario*. Rome: Fratelli Palombi, 1931, pp. 93–106.

Lane 1983
Terence Lane. "The Gallia Collection," *Apollo* 118: 259 (September 1983), pp. 233–38.

Lane 1984
Terence Lane. *Vienna 1913: Josef Hoffmann's Gallia Apartment*, exh. cat. Melbourne: National Gallery of Victoria, 1984.

Liechtenstein 1951
Marie-José Liechtenstein. "Gustav Klimt und seine Oberösterreichischen Salzkammergutlandschaften," *Oberösterreichische Heimatblätter* 5:3/4 (1951), pp. 297–317.

Long 2000
Christopher Long. "'A Symptom of the Werkbund': The Spring 1912 Exhibition at the Austrian Museum for Art and Industry, Vienna," *Studies in the Decorative Arts* 7:2 (Spring–Summer 2000), pp. 91–121.

Lux 1908–09
Josef August Lux. "Kunstschau Wien 1908," *Deutsche Kunst und Dekoration* vol. 23 (October 1908–March 1909), pp. 33–61.

Mahler-Werfel 1960
Alma Mahler-Werfel. *Mein Leben*. Frankfurt: Fischer Bücherei, 1960.

Mahler-Werfel 1999
Alma Mahler-Werfel. *Diaries 1898–1902*. Antony Beaumont, trans. Ithaca: Cornell University Press, 1999.

Makela 1990
Maria Martha Makela. *The Munich Secession: Art and Artists in Turn-of-the-century Munich*. Princeton, N.J.: Princeton University Press, 1990.

Monson 1983
Karen Monson. *Alma Mahler, Muse to Genius: From Fin-de-siècle Vienna to Hollywood's Heyday*. Boston: Houghton Mifflin, 1983.

Mrazek 1978–79
Wilhelm Mrazek. "Die *Allegorie der Skulptur* vom Jahre 1889, Ein neuent-decktes Frühwerk von Gustav Klimt," *Mitteilungen der Österreichischen Galerie, Klimt-Studien* 22/23: 66/67 (1978–79), pp. 37–47.

Muther 1900–01
Richard Muther. *Studien und Kritiken*, 2 vols. Vienna: Wiener Verlag, 1900–01.

Muthesius 1979
Hermann Muthesius. *The English House*. New York: Rizzoli, 1979. Translation of *Das Englische Haus*, 1904–05, by Janet Seligmann.

Nasgaard 1984
Roald Nasgaard. *The Mystic North: Symbolist Landscape Painting in Northern Europe and North America 1890–1940*, exh. cat. Toronto: Art Gallery of Ontario / University of Toronto, 1984.

Natter 1997
Tobias G. Natter. "Poussière du monde et tourbillon d'atomes. L'accueil du pointillisme à Vienne," in *Signac et la libération de la couleur: de Matisse à Mondrian*, exh. cat. Paris: Réunion des musées nationaux, 1997, pp. 357–63.

Nebehay 1969
Christian M. Nebehay. *Gustav Klimt: Dokumentation*. Vienna: Galerie Christian M. Nebehay, 1969.

Nebehay 1975
Christian M. Nebehay. *Ver Sacrum, 1898–1903*. Vienna: Edition Tusch, 1975.

Nebehay 1979a
Christian M. Nebehay. *Ver Sacrum*. Munich: dtv, 1979.

Nebehay 1979b
Christian M. Nebehay. *Egon Schiele: Leben, Briefe, Gedichte*. Salzburg and Vienna: Residenz Verlag, 1979.

Nebehay 1979c
Christian M. Nebehay. *Josef Engelhart, 1864–1941: Ölbilder, Aquarelle & Zeichnungen, Kunstgewerbe*, exh. cat. no. 62. Vienna: Galerie Christian M. Nebehay, 1979.

Nebehay 1987a
Christian M. Nebehay. *Gustav Klimt. Das Skizzenbuch aus dem Besitz von Sonja Knips*. Vienna: Edition Tusch, 1987.

Nebehay 1987b
Christian M. Nebehay. *Gustav Klimt, Egon Schiele und die Familie Lederer*. Bern: Galerie Kornfeld, 1987.

Nebehay 1994
Christian M. Nebehay. *Gustav Klimt: From Drawing to Painting*. New York: Harry N. Abrams, 1994.

Nebehay 1995
Christian M. Nebehay. *Das Glück auf dieser Welt. Erinnerungen*. Vienna: Verlag Christian Brandstätter, 1995.

Neuwirth 1964
Walther Maria Neuwirth. "Die sieben heroischen Jahre der Wiener Moderne," *Alte und Moderne Kunst* 9:74 (May-June 1964), pp. 28–31.

Noever 2000
Peter Noever, ed. *Kunst und Industrie*. Ostfildern-Ruit: Hatje Cantz, 2000.

Novotny-Dobai 1968
Fritz Novotny and Johannes Dobai. *Gustav Klimt. With a Catalogue Raisonné of His Paintings*. London and New York: Thames & Hudson / Frederick A. Praeger, 1968.

Novotny-Dobai 1975
Fritz Novotny und Johannes Dobai. *Gustav Klimt*. Salzburg: Galerie Welz, 1975 (1st edition, 1967).

Nunberg and Federn 1962
H. Nunberg and E. Federn, eds. *Minutes of the Vienna Psychoanalytic Society*, 4 vols. New York: International Universities Press, 1962[–1975].

Ozzòla 1912
Leandro Ozzòla. *L'Arte contemporanea alla Esposizione di Roma del 1911*. Rome: Gaetano Garzoni Provenzani, 1912, pp. 91–95.

Parry 1996
Linda Parry, ed. *William Morris*, exh. cat. London: Victoria and Albert Museum / Philip Wilson, 1996.

Partsch 1989
Susanna Partsch. *Klimt: Life and Work*. London: Bracken Books, 1989.

Pausch 1997
Oskar Pausch, ed. *Nuda Veritas Rediviva. Ein Bild Gustav Klimts und seine Geschichte*, Mimundus 8, Wissenschaftliche Reihe des Österreichischen Theatermuseums. Vienna: Böhlau Verlag, 1997.

Pica 1900
Vittorio Pica. "Pittori Tedeschi," in *L'Arte mondiale a Venezia nel 1899*. Bergamo: Istituto Italiano d'Arti Grafiche, 1900, p. 94.

Pica 1901
Vittorio Pica. "La Pittura all'Esposizione di Parigi," *Emporium* no. 13 (April 1901), p. 251.

Pica 1910
Vittorio Pica. "L'arte mondiale alla IX Esposizione di Venezia," *Emporium* no. 32 (December 1910), pp. 451–66.

Pica 1913
Vittorio Pica. *L'Arte mondiale a Roma nel 1911*. Bergamo: Istituto Italiano d'Arti Grafiche, 1913, pp. 109, 222–25.

Pilo 1910
Mario Pilo. *La IX Esposizione internazionale d'Arte a Venezia*. Venice: Istituto Veneto di Arti Grafiche, 1910, pp. 18–19.

Pirchan 1942
Emil Pirchan. *Gustav Klimt, Ein Künstler aus Wien*. Vienna: Bergland Verlag, 1942.

Pirchan 1956
Emil Pirchan. *Gustav Klimt*. Vienna: Bergland Verlag, 1956.

Ritter 1898
William Ritter. "Correspondance d'Autriche: Les Expositions internationales de Vienne," *Gazette des Beaux-Arts* no. 20 (August 1898), pp. 165–76.

Ritter 1908
William Ritter. "Autriche," *L'Art et les Artistes* no. 7 (1908), p. 287.

Ritter 1909a
William Ritter. "Autriche," *L'Art et les Artistes* no. 9 (1909), p. 39.

Ritter 1909b
William Ritter. "La X Esposizione internazionale di Monaco," *Emporium* no. 30 (November 1909), pp. 323–42.

Ritter 1910
William Ritter. "Autriche-Hongrie," *L'Art et les Artistes* no. 11 (1910), pp. 231–32.

Ritter 1911
William Ritter. "Autriche-Hongrie," *L'Art et les Artistes* no. 13 (1911), pp. 184–85.

Ritter 1912
William Ritter. "Autriche-Hongrie," *L'Art et les Artistes* no. 15 (1912), p. 45.

Rizzi and Di Martino 1982
Paolo Rizzi and Enzo Di Martino. *Storia della Biennale, 1895–1982*. Milan: Electa, 1982.

Roessler 1921
Arthur Roessler. *Briefe und Prosa von Egon Schiele*. Vienna: Richard Lanyi, 1921.

Roessler 1922a
Arthur Roessler. *Erinnerungen an Egon Schiele*. Vienna and Leipzig: Verlag Karl Konegen, 1922.

Roessler 1922b
Arthur Roessler. *Schwarze Fahnen. Ein Künstlertotentanz*. Vienna and Leipzig: Verlag Carl Konegen, 1922.

Roschitz 2000
Karlheinz Roschitz. "Der Traum vom Raum" and "Magie des Kunstgewerbe Schönen," *Parnass* 20, Sonderheft 17, 2000, pp. 72–79.

Rosenblum 1975
Robert Rosenblum. *Modern Painting and the Northern Romantic Tradition: Friedrich to Rothko*. New York: Harper & Row, 1975.

Rosenblum 1978
Edvard Munch: Symbols and Images, exh. cat. With an introduction by Robert Rosenblum. Washington, D.C.: National Gallery of Art, 1978.

Rosenblum 2000
Robert Rosenblum. *1900: Art at the Crossroads*, exh. cat. London: Royal Academy of Arts, 2000.

Sabarsky 1984
Serge Sabarsky, ed. *Gustav Klimt: Drawings*. London: Gordon Fraser, 1984.

Sacchi 1911
Filippo Sacchi. *Colori in un Prisma* (IX Esposizione d'Arte di Venezia). Milan: Baldini & Castoldi, 1911, pp. 49–56.

Salten 1903
Felix Salten. *Gustav Klimt. Gelegentliche Anmerkungen*. Vienna and Leipzig: Wiener Verlag, 1903.

Salten 1924
Felix Salten. "Gustav Klimt," in *Geister der Zeit — Erlebnisse*. Vienna: Paul Szolnay Verlag, 1924.

Sármány-Parsons 1987
Ilona Sármány-Parsons. *Gustav Klimt*. New York: Crown Publishers, 1987.

Sármány-Parsons 1990–91
Ilona Sármány-Parsons. "Der Einfluss der Französischen Post Impressionisten in Wien und Budapest," *Mitteilungen der Österreichischen Galerie* 34/35:78/79 (1990–91), pp. 61–101.

Scheichl 1988
Sigurd Paul Scheichl. "La place des revues et journaux dans la vie littéraire à Vienne autour de 1900," in *Vienne au tournant du siècle*. F. Latraverse and W. Moser, eds. Paris: Albin Michel, 1988.

Schnitzler 1981–2000
Arthur Schnitzler. *Tagebuch, 1879–1931*, 10 vols. Vienna: Österreichische Akademie der Wissenschaften, 1981–2000.

Schorske 1980
Carl E. Schorske. *Fin-de-siècle Vienna: Politics and Culture*. New York: Alfred A. Knopf, 1980.

Schorske 1981
Carl E. Schorske. "Generational Tension and Cultural Change. Reflections on the Case of Vienna," in *The Turn of the Century. German Literature and Art 1890–1915*, G. Chapple and H. Schulte, eds. Bonn: Bouvier Verlag, 1981, pp. 415–31.

Schorske 1982
Carl E. Schorske. "Mahler and Klimt: Social Experience and Artistic Evolution," *Daedalus* 3:3 (Summer 1982), pp. 29–49.

Schreyvogl 1965
Friedrich Schreyvogl. *Das Burgtheater. Wirklichkeit und Illusion*. Vienna: Speidel Verlag, 1965.

Schröder 2000
Klaus Albrecht Schröder et al., eds. *Cézanne: Vollendet — Unvollendet*, exh. cat. Vienna and Ostfildern-Ruit: Kunstforum Wien / Hatje Cantz, 2000.

Schweiger 1984
Werner J. Schweiger. *Wiener Werkstätte. Design in Vienna, 1903–1932*. New York: Abbeville Press, 1984.

Sekler 1985
Eduard F. Sekler. *Josef Hoffmann. The Architectural Work*. Princeton, N.J.: Princeton University Press, 1985.

Servaes 1909–10
Franz Servaes. "Ein Streifzug durch die Wiener Malerei," *Kunst und Künstler* vol. 8 (1909–10), pp. 587–98.

Silverman 1989
Debora L. Silverman. *Art Nouveau in Fin-de-siècle France. Politics, Psychology and Style*. Berkeley and Los Angeles: University of California Press, 1989.

Soffici 1910
Ardengo Soffici. "L'Esposizione di Venezia," *La Voce*, November 1910, reprinted in Soffici, *Scoperte e massacri. Scritti sull'arte*. Florence: Vallecchi Editore, 1995, p. 279.

Sotheby's 1999
Sotheby's, London. *Gustav Klimt and Emilie Flöge: Artist and Muse. Property from the Estate of Emilie Flöge*, sale catalogue, 6 October 1999.

Sotriffer 1964
Kristian Sotriffer. "Vincent van Gogh und sein Einfluß in Wien," *Alte und Moderne Kunst* no. 74 (May–June 1964), pp. 26–27.

Steinberg 1990
Michael P. Steinberg. *The Meaning of the Salzburg Festival: Austria as Theater and Ideology, 1890–1938*. Ithaca, N.Y.: Cornell University Press, 1990.

Stöbe 1995
Erhard Stöbe. "Die Rückkehr eines Bildtitels. Die Restaurierung von Gustav Klimts 'Der Violette Hut'," *Belvedere* no. 1 (1995), pp. 70–73.

Strobl 1962
Alice Strobl. *Gustav Klimt. Zeichnungen und Gemälde*. Salzburg: Galerie Welz, 1962.

Strobl 1964
Alice Strobl, "Zu den Fakultätsbildern von Gustav Klimt," *Albertina Studien* no. 4 (1964), pp. 138–69.

Strobl 1978–79
Alice Strobl "Klimts 'Irrlichter.' Phantombild eines verschollenen Gemäldes," *Mitteilungen der Österreichischen Galerie, Klimt-Studien* 22/23:66/67 (1978–79), pp. 119–45.

Strobl 1980–89
Alice Strobl. *Gustav Klimt. Die Zeichnungen*, 4 vols. Salzburg: Galerie Welz, 1980–89.

Strobl 1988
Alice Strobl. "'Hanswurst auf der Stegreifbühne zu Rothenburg.' Das Burgtheater- und das Staffeleibild-Aufklärung eines Mißverständnisses der Klimtliteratur," in *Kunst um 1800 und die Folgen. Werner Hofmann zu Ehren*. C. Beutler, ed. Munich: Prestel, 1988, pp. 336–45.

Strobl 2000
Alice Strobl. "Vom Begriff des 'Malerischen,' Gustav Klimts Zeichenstil und Zeichenweise," in *Parnass* 20, Sonderheft 17 (2000), pp. 44–55.

Szeps 1939
Berta Szeps. *My Life and History*. John Sommerfield, trans. New York: Alfred A. Knopf, 1939.

Tietze 1919
Hans Tietze. "Gustav Klimts Persönlichkeit. Nach Mitteilungen seiner Freunde," *Wiener Jahrbuch für Bildende Künste* 2:1–2 (1919), pp. 1–10.

Toman 1999
Rolf Toman, ed. *Wien: Kunst und Architektur*. Cologne: Könemann, 1999.

Van de Velde 1902
Henry Van de Velde. "Das neue Kunst Prinzip in der modernen Frauen-Kleidung," *Deutsche Kunst und Dekoration* vol. 10 (April–September 1902), pp. 363–86.

Van de Velde 1962
Henry Van de Velde. *Geschichte meines Lebens*. Hans Curjel, ed. Munich: Piper, 1962.

Varnedoe 1986
Kirk Varnedoe. *Vienna 1900: Art, Architecture and Design*, exh. cat. New York and Boston: Museum of Modern Art / New York Graphic Society / Little, Brown, 1986.

Varnedoe 1988
Kirk Varnedoe. *Northern Light: Nordic Art at the Turn of the Century*. New Haven, Conn., and London: Yale University Press, 1988.

Vergo 1978–79
Peter Vergo. "Gustav Klimt's *Philosophie* und das Programm der Universitäts-gemälde", *Mitteilungen der Österreichischen Galerie, Klimt-Studien* 22/23:66/67 (1978–79), pp. 69–100.

Vergo 1981
Peter Vergo. "Fritz Waerndorfer as Collector," *Alte und Moderne Kunst* 26:177 (1981), pp. 33–38.

Vergo 1983
Peter Vergo. "Fritz Waerndorfer and Josef Hoffmann," *The Burlington Magazine* 125:964 (July 1983), pp. 402–10.

Vergo 1993
Peter Vergo. *Art in Vienna 1898–1918: Klimt, Kokoschka, Schiele, and their contemporaries*, 3rd rev. ed. London: Phaidon, 1993 (1st edition, 1975).

Vergo and Lindsay 1982
Peter Vergo and Kenneth C. Lindsay, eds. *Kandinsky. Complete Writings on Art*, 2 vols. Boston: G.K. Hall, 1982.

Vienna 1982–83
Ver Sacrum. Die Zeitschrift der Wiener Secession 1898–1903, exh. cat. no. 77. Vienna: Museen der Stadt Wien, 1982–83.

Vienna 1988
Emilie Flöge und Gustav Klimt. Doppelporträt in Ideallandschaft, exh. cat. no. 112. Vienna: Museen der Stadt Wien, 1988.

Vienna 2000
Tobias G. Natter and Gerbert Frodl, eds. *Klimt's Women*, exh. cat. Vienna and Cologne: Österreichische Galerie Belvedere / DuMont, 2000. English version of *Klimt und die Frauen*, 2000.

Vienna/Salzburg 1998
Tobias G. Natter und Gerbert Frodl. *Carl Moll (1861–1945)*, exh. cat. Vienna and Salzburg: Österreichische Galerie Belvedere / Galerie Welz, 1998.

Vienna/Tokyo 1994
Johannes Wieninger and Aiko Mabuchi, eds. *Japonisme in Vienna*, exh. cat. Vienna and Tokyo: Austrian Museum of Applied Arts / The Tokyo Shimbun, 1994.

Völker 1994
Angela Völker. *Textiles of the Wiener Werkstätte, 1910–1932*. New York: Rizzoli, 1994.

Wagner 1967
Walter Wagner. *Die Geschichte der Akademie der Bildenden Künste in Wien*. Vienna: Brüder Rosenbaum, 1967.

Wagner 1994
Monika Wagner et al., eds. *Allegorien und Geschlechterdifferenz*. Cologne: Bohlau, 1994.

Waissenberger 1984
Robert Waissenberger, ed. *Vienna, 1890–1920*. New York: Rizzoli, 1984.

Walton 1889
William Walton. *Chefs-d'oeuvre de l'Exposition Universelle de Paris, 1889*. Philadelphia and Paris: George Barrie / Barrie Frères, 1889.

Warlick 1992
M.E. Warlick. "Mythic Rebirth in Gustav Klimt's Stoclet Frieze: New Considerations of Its Egyptianizing Form and Content," *The Art Bulletin* 74:1 (March 1992), pp. 115–34.

Weidinger 2000
Alfred Weidinger, "Natursehen am Attersee: Aspekte der Landschaftsmalerei Gustav Klimts," in *Parnass* 20, Sonderheft 17, 2000, pp. 56–69.

Weidinger and Vergeiner 1988
Alfred Weidinger and Renate Vergeiner. *Inselräume: Teschner, Klimt und Flöge am Attersee*. Seewalchen am Attersee: Secession, 1988.

Weiermair 1966
Helmut Weiermair. *Literarische Zeitschriften Österreichs von 1890–1900*. Ph.D. thesis, University of Graz, 1966.

Weininger 1906
Otto Weininger. *Sex and Character*, translation of 6th German edition. London and New York, 1906. First published in Vienna in 1903.

Weixlgärtner 1912
Arpad Weixlgärtner. "Gustav Klimt," *Die Graphischen Künste* vol. 35 (1912), pp. 49–66.

Werkner 1987
Patrick Werkner. "Hermann Bahr und seine Rezeption Gustav Klimts: Österreichertum, 'sinnliches Chaos' und Monismus," in *Hermann Bahr Symposion (1984). Bericht*, M. Dietrich, ed. Linz: Bruckner Haus, 1987, pp. 65–76.

Willsdon 1996
Claire A.P. Willsdon. "Klimt's Beethoven Frieze: Goethe, *Tempelkunst* and the fulfilment of wishes," *Art History* 19:1 (March 1996), pp. 44–73.

Yates 1996
W.E. Yates. *Theatre in Vienna. A Critical History, 1776–1995*. Cambridge: Cambridge University Press, 1996.

Zuckerkandl 1905
Berta Zuckerkandl. "Wiener Situationsbild," *Die Kunst* vol. 11 (1905), pp. 185–87.

Zuckerkandl 1908
Berta Zuckerkandl. *Zeitkunst Wien 1901–1907*. Vienna and Leipzig: Hugo Heller, 1908.

Zuckerkandl 1909
Berta Zuckerkandl. "Die Hoffnung," *Wiener Allgemeine Zeitung*, 26 April 1909, p. 2.

Zuckerkandl 1916
Berta Zuckerkandl. "Ein Landhaus in Winkelsdorf bei Mährisch-Schönberg," *Deutsche Kunst und Dekoration* vol. 19 (June 1916), pp. 198–224.

Zürich 1992
Toni Stooss and Christoph Doswald, eds. *Gustav Klimt*, exh. cat. Zürich: Kunsthaus Zürich, 1992.

Zweig 1964
Stefan Zweig. *The World of Yesterday*. Lincoln: University of Nebraska, 1964.

This selected index contains the names of key persons and exhibitions, as well as works by artists other than Klimt illustrated in this catalogue. For works by Klimt, see List of Illustrations below. Page numbers given in italics refer to illustrations.

List of Illustrations

Works by Gustav Klimt illustrated in this volume.

Photographs have been provided by the owners or custodians of the works reproduced, except for the following: